PROPUGATOR PROPUGATOR

Other books by James Craig

Designing with Type:
A Basic Course in Typography

Phototypesetting: A Design Manual

Graphic Design Career Guide

Thirty Centuries of Graphic Design

Fol 244 .C78 1974

Copyright © 1974 by Watson-Guptill Publications

First published 1974 in the United States and Canada by Watson-Guptill Publications, a division of Billboard Publications, Inc., 1515 Broadway, New York, N.Y. 10036

Library of Congress Cataloging in Publication Data

Craig, James, 1930-

Production for the graphic designer.

Bibliography: p

1. Printing, Practical. 2. Book design.

I. Title.

Z244.C78 1974 686.2 74-836

ISBN 0-8230-4415-7

All rights reserved. No part of this publication may be reproduced or used in any form or by any means—graphic, electronic, or mechanical, including photocopying, recording, taping, or information storage and retrieval systems—without written permission of the publishers.

Manufactured in U.S.A.

First Printing, 1974 12 13 14 15/90 89 88 Dedicated to every graphic designer whose printed piece did not quite measure up to his expectations!

Contents

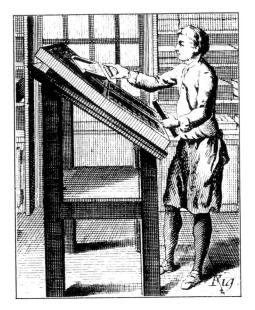

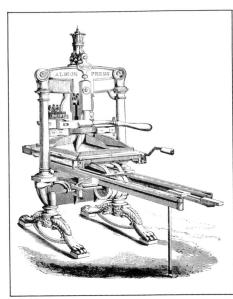

Acknowledgments, 8 Introduction, 9

TYPESETTING, 11

Typography, 12

Handset, 16

Machine Set, 20

Linotype and Intertype, 20

Monotype, 22

Ludlow, 24

Typewriter, 25

IBM Selectric, 25

VariTyper, 28

Phototypesetting, 29

Keyboard, 30

Computer Unit, 34

Photounit, 36

Editing and Correcting, 38

OCR Systems, 40

Photocomposing Systems, 41

CRT Systems, 42

Photodisplay Units, 44

Manufacturers of Phototypesetting

Equipment, 47

Table of Phototypesetting Systems, 48

Type Specimens, 56

Cross Reference Chart, 64

Choosing the Right System, 65

PRINTING, 69

Copy, 70

Process Camera, 72

Halftone Screens, 74

Halftones, 76

Platemaking, 78

Letterpress, 79

Gravure, 84

Offset Lithography, 86

Other Printing Processes, 90

Printing Terms and Techniques, 92

Printing Problems, 93

Quality Control, 97

COLOR PRINTING, 99

Flat Color, 100

One-Color, 100

Multicolor, 102

Specifying Flat Color, 104

Four-Color Process, 105

Color Separations, 106

Proofs, 110

Process Color as Flat Color, 112

Tips and Suggestions, 113

INKS, 115

Basic Ingredients of Ink, 116 Ink-Drying Processes, 117 Ink and the Printing Process, 118 Specialty Inks, 119

PAPER, 121

History of Paper, 122
Papermaking, 124
Mechanical Process, 125
Chemical Process, 126
Characteristics of Paper, 130
Printing Papers, 133
Newsprint, 133
Writing Papers, 133
Cover Papers, 133
Book Papers, 133

Choosing the Right Paper, 135

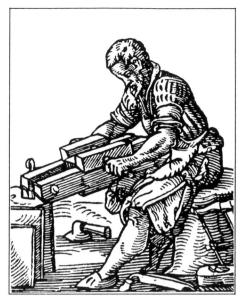

IMPOSITION, 137

Basic Impositions, 138
Imposition and Color, 140
Imposition and Gang-ups, 141

FOLDING, 143

Folds and Folders, 144 Cutting Chart, 145 Envelopes, 145

Binding Methods, 148

BINDING, 147

Wire Stitching, 148
Mechanical Binding, 150
Perfect Binding, 150
Edition Binding, 151
Book-Covering Materials, 152
Woven, 152
Non-woven, 153
Other Binding Materials, 154
Bindery Facilities, 155

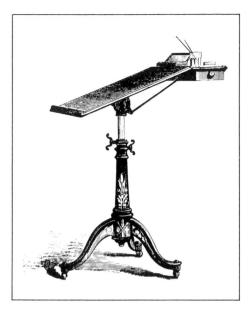

MECHANICALS, 157

Scaling Art, 158
Photostats, 160
Veloxes, 162
Line Conversions, 164
Preparing Mechanicals, 166
Color Mechanicals, 172

APPENDIX

Glossary, 176 Credits, 201 Bibliography, 203 Index, 205

Acknowledgments

Every section of this book has drawn upon the skills and combined knowledge of a different group of professionals in the field; I'd like to thank all those individuals who gave information, advice, and enthusiastic support to help make this the best book possible:

Typesetting, Harold Black of Black, Inc., Robert Crowley of Photon, Inc., Morton Friedman of Alphatype Corp., Norman G. Hansen of Mergenthaler Linotype Co., R.W. Hummerston of VariTyper, A.D.B. Jones of Monotype Corp., Richard Jones of Harris Corp., George W. Kovatch of Singer Graphics Systems, Jerry Levitz of Berthold Fototype Co., Fran Mendoza of Automix Keyboards, Inc., Ed Snyder of Adcraft Typographers, Adrian Stapfer of Graphic Systems, Inc., Tony Taylor of Berthold Fototype, Paul Thiel of Compugraphic Corp., Mark Weinstein of Graphic Systems, Inc., Dick Weltz of Weltz Ad Service, and Martin Ziegenhorn of Berthold Fototype Co.

Printing. Bill Anderson of World Color Press, Inc., Joe Cavallo of Howson-Algraphy Ltd., Paul Kwiencinski of Halliday Lithograph Corp., Lou LaSorsa of Algen Press Corp., Pete Peterson of Halliday Litho, Ray Prince of Azoplate, Irwin Roth of Pioneer Moss Inc., Charles Shapiro of Graphic Arts Technical Foundation, Jack Siderman of Pantone, Inc., Dan Soskin of Printing Industries of Metropolitan New York, Inc., and Ed Sturmer of Colorline.

Paper. Ralph Heilman of Canfield Paper Co., Dave Knauer of S.D. Warren Co., Tom Kramer of the American Paper Institute, Jon Moberg of Mead Paper Co., Jack Robinson of Andrews, Nelson, Whitehead, and Steve True of Lindenmeyr Paper Corp.

Imposition, Folding, and Binding.
W.P. Bourquin of Harris Corp.,
George Clark, Jr. of Holliston Mills, Inc.,
Paul M. Grieder of Joanna Western Mills
Co., Ted Tuck of Charles Bohn & Co.,
and Milton A. Walberg of Scott Graphics,

Mechanicals. Leonard Hyams of Parsons School of Design.

In the Watson-Guptill organization, I would like to thank Don Holden and Jules Perel for giving the author and designer the ultimate gift-freedom to do as he wishes. I would also like to thank Bob Fillie for his assistance in design and mechanicals, and Frank DeLuca for his help and cooperation in the production of this book. A word of thanks, too, to all the staff at Watson-Guptill, who for two years have avoided me for fear that I would start talking about "the Book." And a special thank you to Bob Lewis and Dave Gerard of Billboard Publications, Inc., who supervised the setting of type for this book.

In every undertaking there are a few who contribute much more than is expected. There are three people whose extra effort on the book's behalf is appreciated: Carl Palmer of the Du Pont Company, who gave generously of his time and his wide knowledge of phototypesetting and production and who cheerfully took on the awesome job of reading and re-reading the glossary under pressure of time; Bob Loekle of Amalgamated Lithographers of America, Local 1, for his expertise in color printing; and Margit Malmstrom, my editor, who when she's good is very good . . .

Introduction

Although specifically written for the graphic designer and the design student, this book is equally intended for anyone connected with the production of printed matter, whether in editorial, promotion, or even production. It is also intended for those in specific areas of production—typographers, printers, etc.—who would like to learn more about how the other areas operate. So although the reader is addressed throughout as "the designer," it is hoped that non-designers, too, will find this book a helpful tool.

My purpose in writing Production for the Graphic Designer was to enable a person wishing to understand any area of production to locate the desired information, fast, within the covers of a single book. It was also my purpose to present the information in as simple and straightforward a manner as possible. To this end, the concepts have been kept basic enough to serve one purpose: to give the designer the facts he needs to be able to make the most informed decisions all along the way, from rough comp to finished printed piece. The designer should know enough about production to understand: (1) what the possibilities are in terms of typesetting, printing, paper, etc., (2) what factors to consider when choosing between systems, methods, processes, etc., and (3) how to communicate specifications to the people responsible for translating the designer's ideas into a printed piece.

For example, in typesetting, which is the fastest-changing area of production today, a knowledge of the basic systems is vital if the designer is to take full advantage of the vast range of options open to him. With the advent of phototypesetting, many designers, familiar with the older methods of setting type, have become confused by the number of different systems available. Gone are the days when all type was set by Linotype or Intertype and all typographers had the same equipment and used the same terminology.

Paper is another area that can be very confusing. Every paper manufacturer has his own trade names for the different papers, which means that the same grade of paper, manufactured by several different companies, will carry several different names. To clarify the situation, I have given a detailed description of how paper is made: the basic process, what ingredients are added and why, and how it is finished. In this way, the different kinds of paper can be broken down into their broad generic catagories (i.e., coated and uncoated, calendered), enabling the designer to choose paper in terms of characteristics rather than brand names.

In general, I have tried to keep the book simple and free from unnecessary or overly technical information. And I have tried to maintain the concept of the book as a working tool; that is, a book that contains *useful* information rather than information for information's sake. Because the book was written with the visually oriented graphic designer in mind, I have also included over 400 illustrations that actually *show* what is described in the text.

Finally, the glossary, which contains over 1,100 entries, brings together definitions and explanations from every area of production to offer an up-to-date, comprehensive, single reference source for students, teachers, and professionals.

It is my hope that this book will help fill the gap between design and production, expanding the potential of the graphic designer, easing the transition from older methods to newer ones, and helping the designer plan ahead and work with production to get the results he wants in his work.

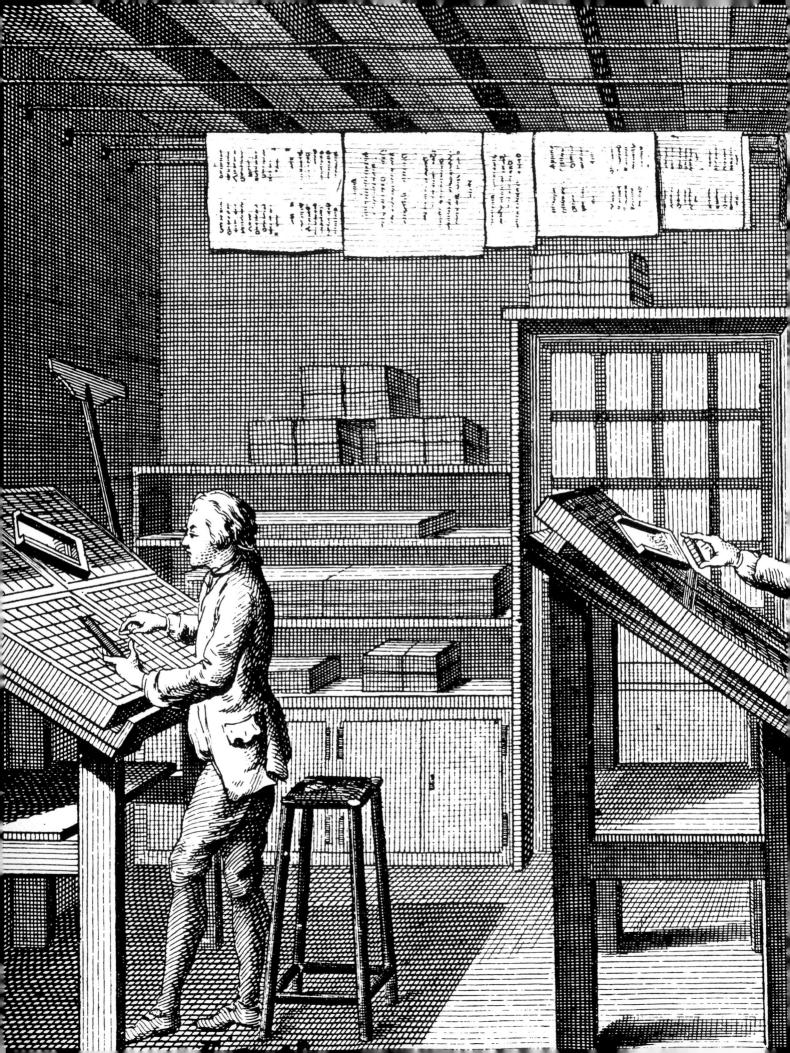

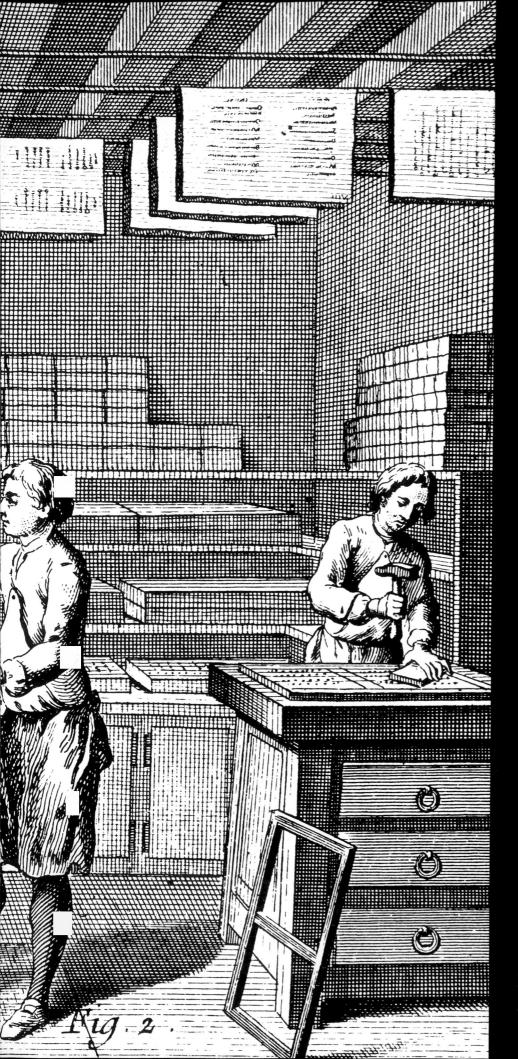

Typesetting

Typesetting, also called composition, was traditionally done by the printer. Until this century most printing shops had their own composing room and compositor, or typesetter. Today, most printers have given over the function of typesetting to the typographer, who operates independently.

In this section we shall discuss the four ways type is set: by hand, machine (casting), typewriter, and phototypesetting. We shall begin with a brief review of the basics of typography in order to define the terminology that we will be using throughout.

An 18th century composing room. The two compositors at left and center are setting type in composing sticks and assembling lines of type into wooden trays, called galleys. The "stoneman" at right is using a planer to level a form made up of pages of type locked up in a metal chase, like the one in the foreground.

Typography

The basic terminology used in all typesetting methods is derived from metal type. As we shall see later, some of the terms have been modified to accommodate the newer typesetting methods, such as phototypesetting, but most are still in use today, regardless of the typesetting method.

ABCD
EFGHIJK
LMNOPQRST
UVWXYZ
abcdefghijklmno
pqrstuvwxyz
1234567890
& .,:;""?!()
• /#\$%¢*

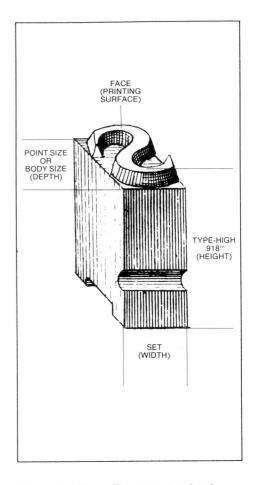

Type. The individual letter, figure, or punctuation mark is called a *character*. The large letters are called *caps* or *uppercase* characters; the small letters are called *lowercase* characters. A complete alphabet of one style of uppercase and lowercase characters, with figures and punctuation marks, is called a *font*. If we group together all the type sizes and type styles of a particular typeface (roman, italic, bold, extended, condensed, etc.), we get a *family* of type.

Measuring Type. There are two basic units of measurement in typography: points and picas. There are 12 points in a pica and 6 picas in an inch. Type is measured in points; the line length, or measure, is measured in picas.

To understand how we arrive at the point size of type, let's examine a piece of type: it is a rectangular block of metal with a printing surface on top. The block is called the *body* and the printing surface is called the *face*.

The height of the body is .918" and is known as *type-high*. Although this dimension is not important to the designer, it is very important to the printer that all type be exactly the same height in order to print evenly and consistently.

The width, which is called the set width, is dictated by the width of the individual letter, the letters M and W being the widest and I being the narrowest.

The depth, known as the *point* or *body size*, is the dimension by which we measure and specify type.

Type comes in many sizes, the most popular typefaces ranging from 5 point to 72 point. Type sizes 14 point and smaller are called *text types*, those larger are called *display types*.

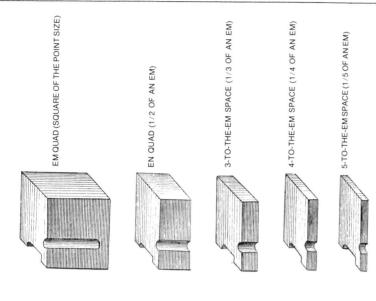

This line is spaced with em quads This line is spaced with en quads This line is spaced with 3-to-the-em spaces This line is spaced with 4-to-the-em-spaces This line is spaced with 5-to-the-em spaces

LETTERSPACE

LETTERSPACE

LETTERSPACE

LETTERSPACE

LETTERSPACE 4 POINT

Wordspacing. Spacing between words. Wordspacing is accomplished mechanically by inserting pieces of metal (spaces) between words. Being lower than the printing face of the type itself, they do not come in contact with the paper and therefore do not print. These pieces of metal, called spaces and quads, are related in size to the em quad, which is the square of the type size. For example, if the type is 60 point, the em quad is a square 60 points x 60 points; if the type is 10 point, the em quad is 10 points square. Since an em quad would produce too much space between words, smaller pieces of metal, which are subdivisions of the em quad, are used. Normal wordspacing assumes the use of 3-to-the-em spaces.

Letterspacing. Spacing between letters. The spacing materials used for letterspacing are very thin. Most fonts have spaces of 1 point (made of brass) that can be used singly or in groups. Others are even thinner: ½ point (copper) and ¼ point (stainless steel). There is even a letterspace made of paper. Consider how thin a piece of paper is—this will give you an indication of just how finely letterspacing can be adjusted.

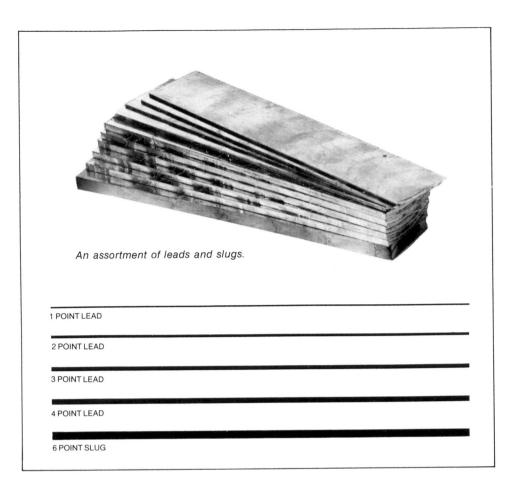

There are five basic ways to arrange lines of type on a page; the style you choose is dictated by esthetics, legibility, and the amount of copy to be set.

There are five basic ways to arrange lines of type on a page; the style you choose is dictated by esthetics, legibility, and the amount of copy to be set.

There are five basic ways to arrange lines of type on a page; the style you choose is dictated by esthetics, legibility, and the amount of copy to be set.

There are five basic ways to arrange lines of type on a page; the style you choose is dictated by esthetics, legibility, and the amount of copy to be set.

There are five basic ways to arrange lines of type on a page; the style you choose is dictated by esthetics, legibility, and the amount of copy to be set.

Leading. In addition to the space between words and letters, it is also possible to vary the space between the lines of type. To accomplish this, metal strips of various thickness are placed between the lines. This is called leading (pronounced ledding). The metal strips, called leads (leds), are measured in points. The most common sizes are 1, 2, 3, and 4 point. Leads 6 points or more in thickness are called slugs and are cast in 6, 12, 24, and 36 point. Both leads and slugs are less than type-high and therefore do not print.

Type that is set without leading is said to be set solid. If 10-point type is set with 1-point leading, it is set "10 on 11," which is indicated 10/11: the first figure indicates the type size; the second figure, the type size plus the leading. The type you are now reading is 9/11 Helvetica; that is, 9-point type with 2 points of leading.

Arranging Lines of Type. There are five basic ways to arrange lines of type on a page. (1) Justified: all the lines are the same length and align both on the left and on the right. (2) Unjustified: the lines are of different lengths and align on the left and are ragged on the right. (3) A similar arrangement, except now the lines align on the right and are ragged on the left. (4) Centered: the lines are of unequal lengths with both sides ragged. (5) An asymmetrical arrangement with no predictable pattern in the placement of the lines.

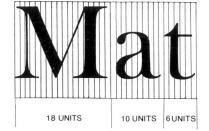

36-POINT FM

36-POINT EM DIVIDED INTO 18 UNITS

72-POINT EM DIVIDED INTO 18 UNITS

PLUS 1 UNIT LETTERSPACING

The quick brown fox jumped over the lazy sleeping dog.

NORMAL LETTERSPACING

The guick brown fox jumped over the lazy sleeping dog.

MINUS 1 UNIT LETTERSPACING

The quick brown fox jumped over the lazy sleeping dog.

MINUS 2 UNITS LETTERSPACING

The quick brown fox jumped over the lazy sleeping dog.

MINUS 3 UNITS LETTERSPACING

The quick brown fox jumped over the lazy sleeping dog.

Unit System. The unit system is a measuring and counting system used by phototypesetting machines to determine when a line of type is ready to be justified. It is based on the em of any point size of type being divided into equal, machine-recognizable increments called units.

What Is a Unit? A unit is a subdivision of the em (the square of the type size). The number of units to the em varies from one manufacturer to another, although the most common number is 18. (We shall use an 18-unit system for our discussion.) Also, the size of the unit, like the size of the em, varies from one type size to another. For example, a unit of 72point type will be larger than a unit of 36point type. A simple method to determine the size of a unit is to think of it as 1/18 of the type size.

Measuring Type in Units. The set width of the individual characters and spaces must be measurable in units. Therefore, each character is designed with a fixed unit width or unit value. This unit value also includes a small amount of space on either side of the characters to prevent them from touching when set.

To get an idea how this system works let's set the word Mat on an 18-unit system. The cap M is 18 units wide, the lowercase a 10 units wide, and the lowercase t 6 units wide. So the entire word is 34 units wide, regardless of the type size. By thus totaling the unit values of the characters and the spaces between the words, a counting mechanism (which can be part of the keyboard, computer, or phototypesetter) is able to measure a line of type in units and determine when it is ready to be justified.

Advantages of the Unit System. One advantage of using the unit system is that the "color" of the setting can be controlled by adjusting the units of space between the letters. This means that the type can be set with regular, loose, or

tight letterspacing. Letterspacing can also be adjusted on a selective basis, reducing space between certain letters while the rest of the setting remains the same. This is called kerning and is usually used in letter combinations that are improved by the deletion of one or two units of space, such as Te, Ta, Ve, AW, YA, etc.

Although the most common, the 18unit system is not an industry standard. The number of units to the em varies with the manufacturer and may be 4, 9, 12, 18, 32, 36, 48, or 64. The more units to the em. the closer together the letters can fit (letterfit) and the more flexibility there is in wordspacing and letterspacing. However, although a greater number of units to the em results in a greater possibility of typographic refinement, for the average job there is a point beyond which further refinement is neither necessary nor noticeable.

Handset

The process of setting type by hand has not changed since Gutenberg's time in the mid-15th century. The compositor, or typesetter, works with the same tools now as he did then: a composing stick, a type case (a shallow tray, divided into compartments, that holds the type), and the metal type itself (letters, punctuation marks, figures, and spaces). The type is known collectively as the *font* and individually as *characters*. Characters not part of a regular font are called *sorts*.

Setting. First, the compositor adjusts the composing stick to the desired pica measure, or line length. To set type, he holds the composing stick in one hand and with the other he picks type from the type case. To justify the lines of type he adds additional wordspaces and/or letterspaces.

To create the proper amount of leading, the compositor inserts metal strips called *leads* between the lines. When the composing stick is full, the lines of type are transferred to a long shallow tray called a *galley*. The compositor continues to set type until the galley is full or the job is completed. The next step is to "make up" the job; that is, to assemble

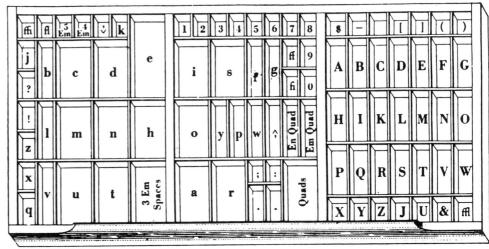

California type case.

the various elements (text type, display type, rules, cuts, etc.) according to the designer's layout. If the job is small, it may be made up directly on the galley; if larger or more complex, it may be made up on an imposing table, traditionally known as the "stone." Because the type consists of hundreds of individual pieces, it is important that they be held together securely, or "locked up." This is done by tying up the type with string,

or by surrounding it with "furniture": strips of wood, metal, or plastic. These in turn are held firmly in place with metal clips or magnets. Type can be locked up in three ways: on the galley, in a metal frame called a *chase*, or directly on the bed of the press.

Collectively, type and other printed matter locked up and ready to be proofed or printed is called a *form*.

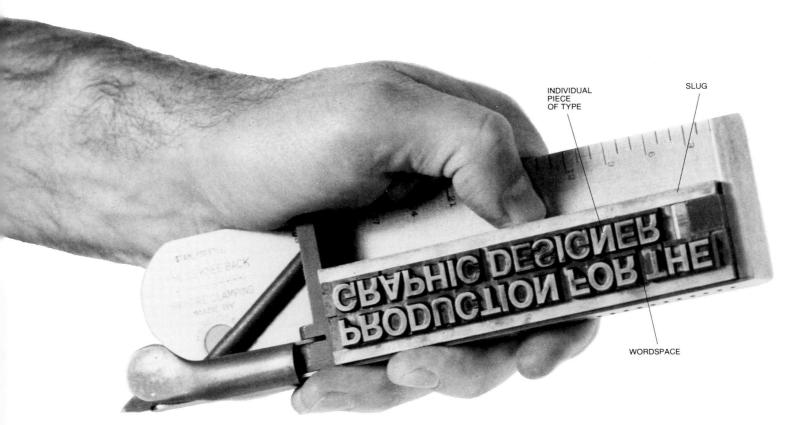

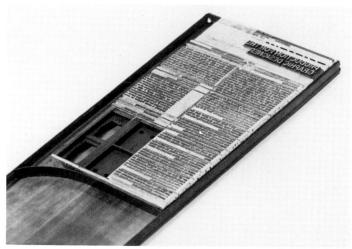

Type in a galley, held in position with galley clips.

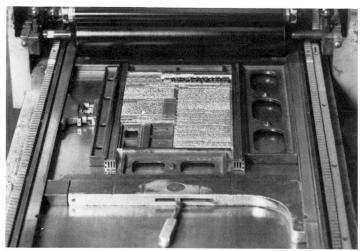

Type form, locked up on the bed of a proofing press.

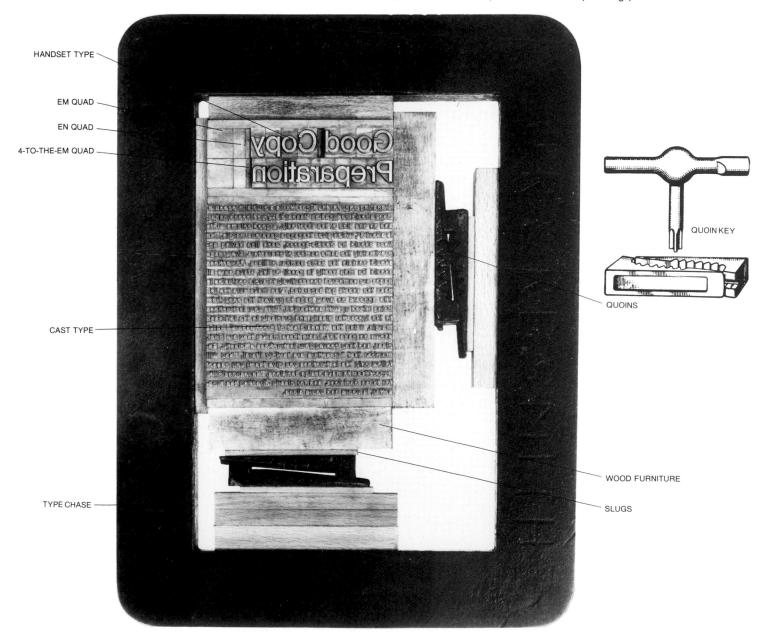

Type locked up in a chase ready for proofing.

Proofing. It should be noted that there is a difference between proofing type and actually printing it. A proofing press is a relatively small, slow-speed, hand-operated or power-operated press designed primarily for pulling a dozen or so proofs of each job. A printing press, on the other hand, is designed to operate automatically at high speeds and print large quantities of a given job.

The proofs pulled at the proofing press are called *galley proofs* or *rough proofs*. The reason for making these proofs is to allow both the typographer and the client to see that the job has been correctly set. Before the proof is sent to the client it is first proofread in the shop. Either the necessary corrections are made or it is indicated on the *reader's proof* that the errors have been noted and will be corrected. Several proofs, including the reader's proof, are then sent to the client for proofreading. These may be read by a

proofreader, author, editor, or copywriter, depending on the job.

The designer also gets a proof so that he can make sure the job has been set as specified. The corrections made on the various proofs are then transferred to a master proof. All corrections are marked either PE or AA. PE's are printer's errors and will be corrected free of charge by the typographer; AA's are the author's alterations and will be charged to the client. AA's include editor's or designer's changes.

The master proof is returned to the typographer, who makes all the corrections indicated. The corrected type is then locked up on the bed of the proofing press and a new proof called a *reproduction proof*, or *repro*, is pulled on a special coated paper. The quality of this proof is of the utmost importance, as it is used by the designer in the preparation of his mechanicals: it will be photo-

graphed and made into a printing plate for eventual reproduction.

After the job is completed, the type is cleaned and distributed; that is, put back into the type case. Great care is taken in distributing type, as letters carelessly thrown into the wrong compartments may not show up until a new job is set and proofed. Compositors are warned to "watch their p's and q's," as it is very easy to confuse certain letters, especially these. The leads, slugs, and furniture, arranged by thickness and length, are also put away for future jobs.

Despite the speed and skill of the compositor, handset type is a relatively slow, time-consuming process and is therefore too expensive for lengthy type-setting jobs. Handsetting is recommended, however, for short "takes" (small amounts of copy) of either text or display type.

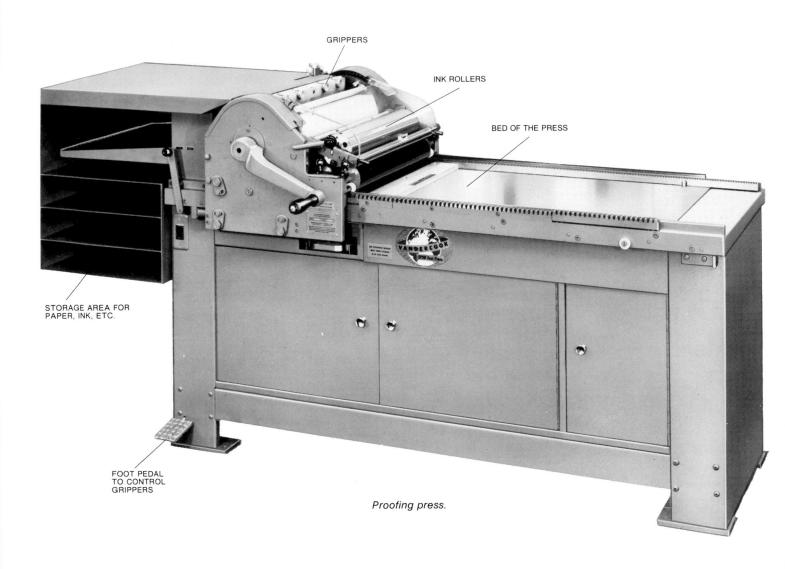

Good Copy Preparation

a

1108

Preparing copy for the typesetter is a crucial procedural. Copy should be typed on standard 8½ x 11 byond paper, and on one side of the sheet only. A good column width is about 6°, which gives the topage a generous margin. The lines should be double-spaced, each line having approximately the same number of characters. Every page should contain the same number of lines. Corrections should be mgle neatly in pencil or ink. Make sure all pages are numbered consecutively to avoid confusion in case the sheets get separated. Also make sure the jot title appears on every page to prevent the copy from being mixed up with another job, Write your instructions to the typesetter clearly and precisely in the left-hand margin, using the standard set of proofreaders' marks shown on page 154. Learn these marks; they are brief, clear, and they convey your instructions efficiently. Remember that typesetters are terribly literal. They will follow only the instructions you give them; you cannot expect them to make design decisions. The responsibility for these decisions, and for clearly directing the typesetter, is yours and yours alone.

Rough proof with corrections indicated.

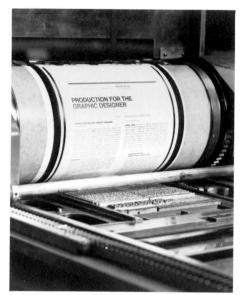

Pulling a repro proof.

Good Copy Preparation

Preparing copy for the typesetter is a crucial procedure. Copy should be typed on standard 8½ x 11 bond paper, and on one side of the sheet only. A good column width is about 6", which gives the page a generous margin. The lines should be double-spaced, each line having approximately the same number of characters. Every page should contain the same number of lines. Corrections should be made neatly in pencil or ink. Make sure all pages are numbered consecutively to avoid confusion in case the sheets get separated. Also, make sure the job title appears on every page to prevent the copy from being mixed up with another job. Write your instructions to the typesetter clearly and precisely in the left-hand margin, using the standard set of proofreaders' marks shown on page 154. Learn these marks; they are brief, clear, and they convey your instructions efficiently. Remember that typesetters are terribly literal. They will follow only the instructions you give them; you cannot expect them to make design decisions. The responsibility for making these decisions, and for clearly directing the typesetter, is yours and yours alone.

EXPLANATION	MARGINAL	ERRORS MARKED
	MARK	
Take out letter, letters, or words indicated.	5	He opened the windo ϕ w.
Insert space.	#	He opened thewindow.
Turn inverted line.	@	(He opened the window.)
Insert letter.	e	He opned the window.
Set in lowercase.	lc D	He $ ot\!\!\!/$ pened the window.
Wrong font.	wf	He opered the window.
Broken letter. Must replace.	× ital	He pened the window.
Reset in italic.		He opened the window.
Reset in roman.	ol	He opened <u>the</u> window.
Reset in bold face.	bf O	He opened the window.
Insert period.		He opened the window,
Transpose letters or words as indicated.	tr	He(the window)opened.)
Let it stand as is. Disregard all marks	stat	He opened the window.
Insert hyphen.	=/	He made the proofmark.
Equalize spacing.	eg#	He opened the window.
Move over to point indicated. [if to the left; if to the right]	ŕ	He opened the window.
Lower to point indicated.		He opened the window.
Raise to point indicated.		He opened the window.
Insert comma.	5	Yes he opened the window.
Insert apostrophe.	V	He opened the boys window.
Enclose in quotation marks.	(c) m	He opened the window.
Enclose in parenthesis.	()	He John opened it.
Enclose in brackets.		He John opened it.
Replace with capital letter.	cap	he opened the window.
Use small capitals instead of type now used	sc	He opened the <u>window</u>
Push down space.	Τ	He j opened the window.
Draw the word together.		He op ened the window.
Insert inferior figure.	12	Sulphuric Acid is HSO,.
Insert superior figure.	2/	$2a + b^2 = c_{\chi}$
Used when words left out are to be set	out, see upy	He _A window.
The diphthong is to be used.	â	Caesar opened the window.
The ligature of these two letters is to be used.	fi	He <u>fi</u> led the proof.
Spell out words marked with circle.	spell out	He opened the 2dwindow.
Start a new paragraph.	spell out	door. He opened the
Should not be a paragraph. Run in.	no #	door.
Query to author. Encircled.	(1, 7)	He opened the window.
This is the symbol used when a question	was.	The proof Λ read by.
mark is to be set.	?	Who opened the window
NOTE: A query is encircled.	_	
Out of alignment. Straighten.	=	He opened the window.
1-em dash	1/1	He opened the window
2-em dash. En dash.	1 2 1	He opened the window
Indent 1 em.	1 1	He opened the window
Indent 1 em. Indent 2 ems.		He opened the window.
Indent 3 ems.		He opened the window.
macin 5 cms.] He opened the window.

Machine Set

This method involves casting type from molten metal. For this reason, machineset type is also referred to as *hot type*. Until the arrival of phototypesetting, machine-setting was by far the most popular typesetting method. There are four major typecasting machines: Linotype, Intertype, Monotype, and Ludlow.

LINOTYPE AND INTERTYPE

Linotype was invented in 1886 by Ottmar Mergenthaler of Baltimore. Intertype, which is based on the Linotype principle, was developed in 1911. Because the Linotype and Intertype machines cast lines of type rather than individual characters, they are called *linecasting machines*. (The name Linotype is derived from the casting of a ''line-of-type.'')

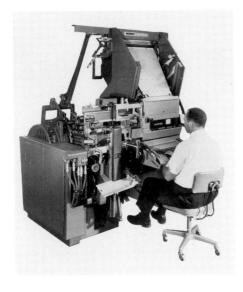

In both systems, the operator sits at a keyboard. The machine is adjusted to set type to a desired pica measure and leading. The upper front of the machine carries a magazine, a slotted, metal container that holds the matrices (more commonly called mats), or lettermolds, of the type to be set. When the operator strikes the keys, the matrices fall into position to form a line of type. The operator sets as many characters and wedgeshaped "spacebands" as possible within a given measure. The spacebands are used for wordspacing. When the operator is ready to cast the line, he pulls a lever which sets off a series of events: the line, made up of mats and spacebands, is transferred to the casting mechanism; the wedge-shaped spacebands are driven up between the words to justify the line; molten metal is forced into the mats; and the line of type, or "slug," is

ejected onto a pan. As soon as the type is cast, the mats are returned to the magazine via the distributor and the spacebands to the spaceband box, ready for the next line. All this takes about 15 seconds. After the job is set, the type is locked up on a galley and a proof is pulled. When the type is no longer required it is melted down for reuse.

The standard linecasting machine is designed to set type from one magazine at a time. This magazine contains 90 duplex (two-character) mats, capable of setting either two styles of the same typeface (for example, Garamond roman and italic) or two different typefaces (Garamond and News Gothic). There are also models that set type from two magazines at one time. This permits the mixing of four type styles, such as roman, italic, roman bold, and italic bold. It also permits the mixing of four different typefaces; however, the designer should be aware that not all typefaces align on the same baseline, and he should check with the typographer before mixing typefaces indiscriminately.

Linecasting machines are designed to set type from 5 to 18 point, in measures up to 30 picas. It is possible to set to wider measures by "butting slugs." In this case, the operator sets the line in two parts and then butts the slugs together to make one line. This slows down the operation and therefore costs money. Some machines set type up to 42 picas, however not every typographer has one.

Linecasting machines can set type and leading as one piece. For this reason, it is impossible to reduce the amount of leading once the type has been cast. Leading can be increased, however, by inserting leads between lines by hand.

Casting is less time-consuming than handsetting, therefore less expensive. The average operator should be able to set type at the rate of 3 to 4 lines per minute. (A line in this case is the industry standard: a newspaper line consisting of straight matter set in 8-point type on an 11-pica measure.) Some casting machines are designed to be driven by teletype tape, which increases the output to about 10 lines per minute.

The cost of corrections is reasonable, but remember, any change within a line means the entire line, or even all the succeeding lines in the paragraph, will have to be reset.

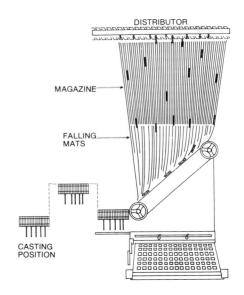

Slugs ready for printing.

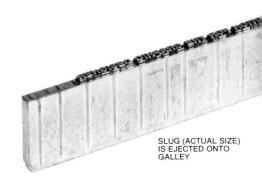

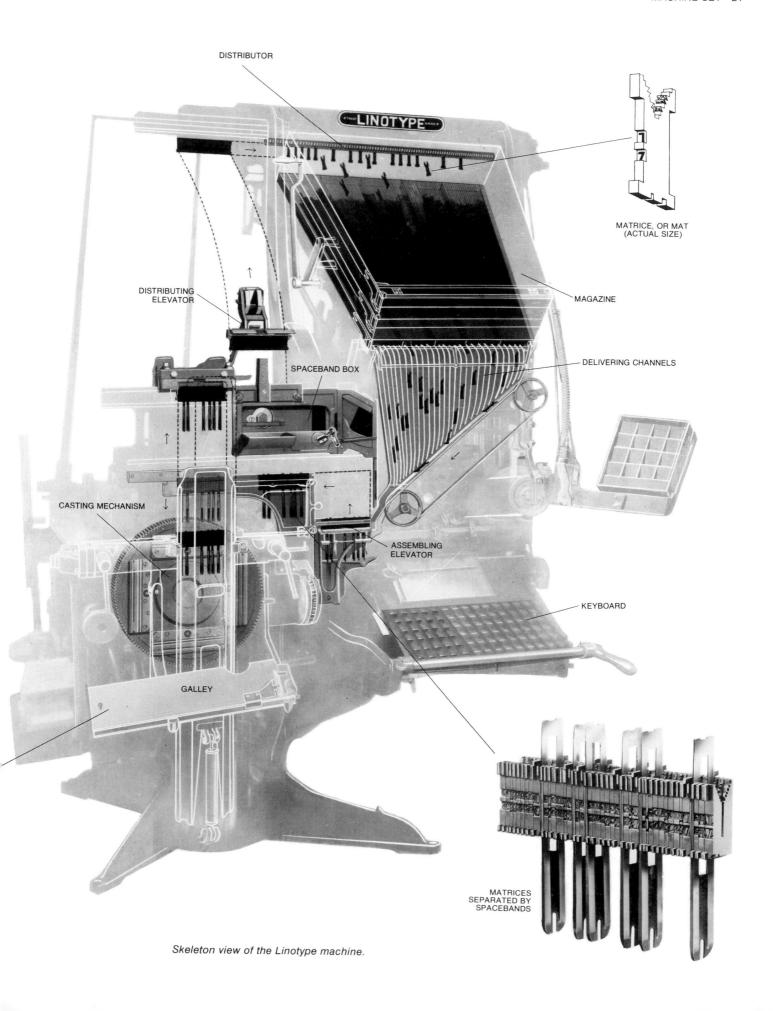

MONOTYPE

The Monotype system was invented in 1887 by Tolbert Lanston of Washington, D.C. As the name suggests, Monotype casts the characters one by one rather than as a complete line. It is a combination of two machines: a keyboard (perforator), and a typecaster.

To set type, the operator first adjusts the machine to the required pica measure and leading. As he types the copy he produces a perforated paper roll, which is used to drive the typecaster. It is the combination of the holes that dictates the letters, spaces, and punctuation marks, etc., to be set. To justify the lines of type, a counting mechanism automatically registers the set widths of characters as they are typed. (See page 15 for a detailed explanation.) When the maximum number of characters per line has been reached, a bell rings to alert the operator. He then determines how much additional space must be added to justify the line. Space can be added between words, letters, or both.

Up to this point, no type has actually been set. We merely have a perforated, or encoded, paper roll. To set the type, the roll is placed on the typecaster, where it directs the casting mechanism by means of compressed air. The air passing through the perforations brings the matrix-holder and the specific matrix, ready to be filled with molten metal, into the proper position. Once the type has been cast, it is ejected onto a galley a character at a time. When the galley is full or the job completed, a proof is pulled. After use, the type can be melted down.

Monotype can set type from 41/2 to 14 point in any measure up to 36 picas. Each matrix case holds 272 individual matrices, which makes it possible to mix roman, italic, and boldface types all in the same line. It is also easy to take out individual matrices and replace them with special characters not in the regular font called "pi characters." This makes Monotype ideal for such complex settings as tables, charts, and scientific and mathematical material. It is also widely used for textbooks. Furthermore, because each character is set separately, individual elements in a line may be corrected by using pre-cast sorts out of the typecase without having to reset the entire line. As with Linotype, Monotype can cast type and leading as one piece. So again, it is possible to increase the leading, but not to reduce it.

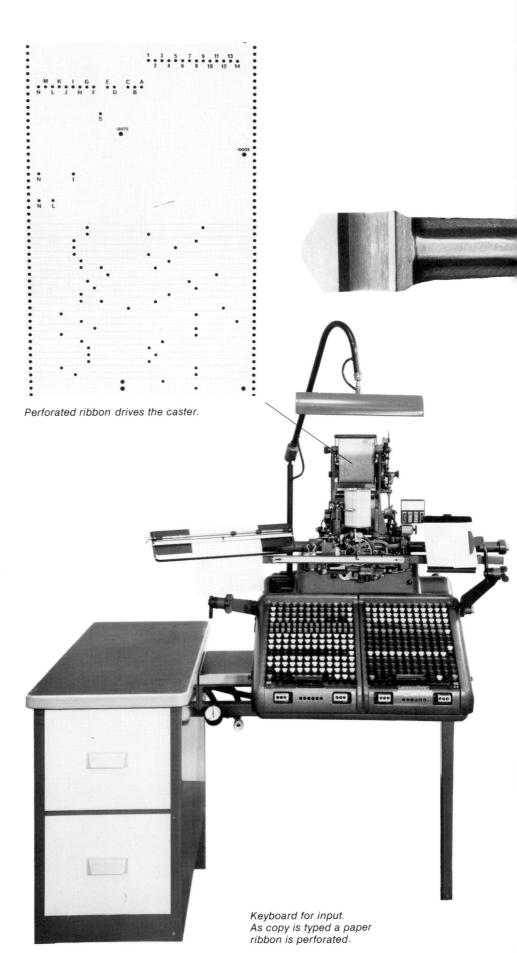

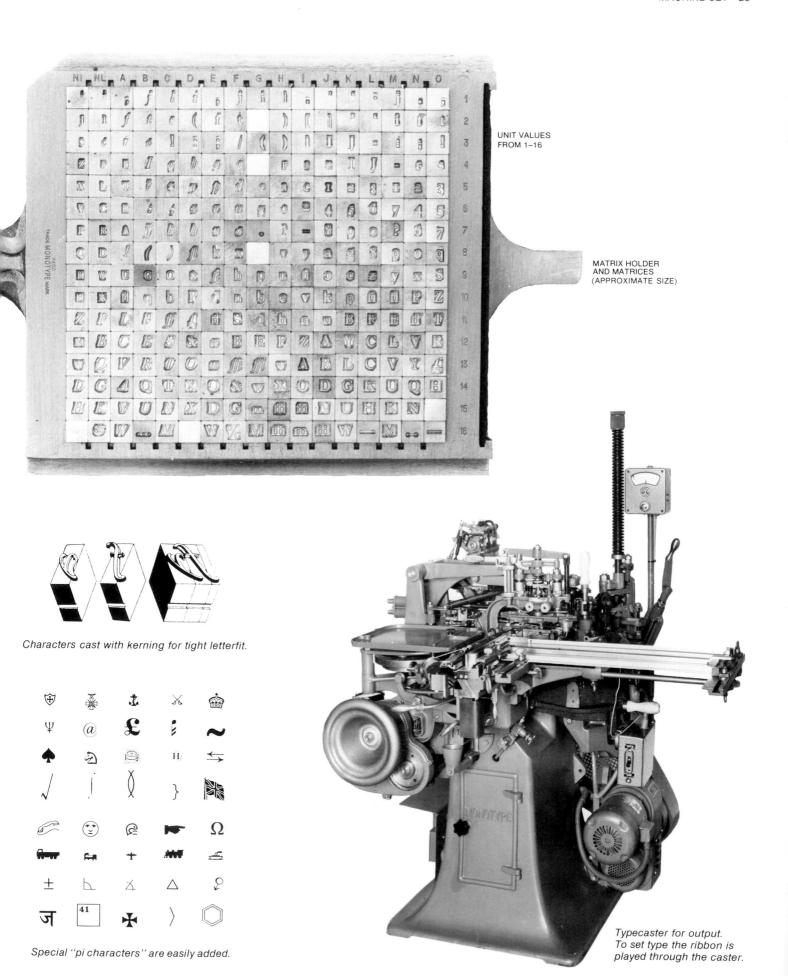

LUDLOW

The Ludlow system was suggested by Washington I. Ludlow, and perfected by A. Reade in 1906. It is a combination of handsetting and casting. Like Linotype, it produces a slug, but in a different way. The operator handsets the type matrices and leading in a composing stick. They are then locked into a casting machine where they are covered with molten lead to produce the slug. The faces of the slugs are polished and they are placed on a galley. Then a proof is pulled, after which the slug is melted down for reuse.

Ludlow was designed primarily for casting display type from 12 to 72 point. It is most used for newspaper headlines.

Handsetting type matrices with Ludlow composing stick.

Ludlow slug.

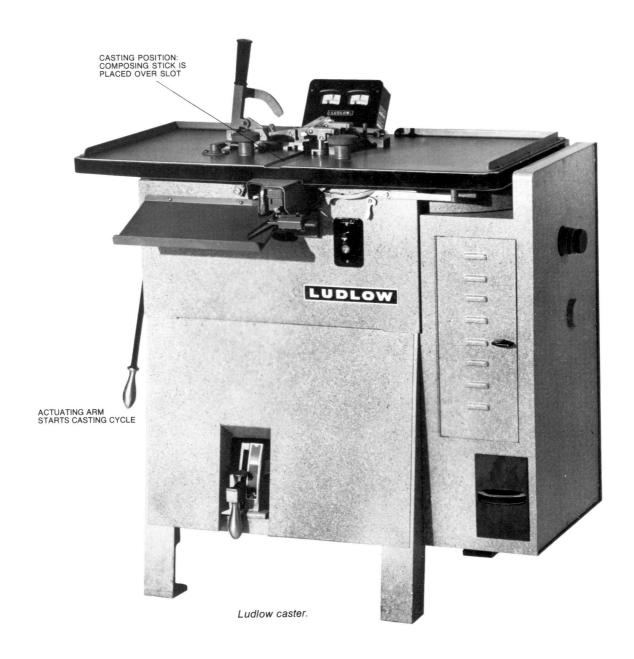

Typewriter

Typewriter composition, also known as strike-on or direct impression typography, is ideal for low-budget jobs consisting of all text type. (Display type must be set by other means.) Typewriter composition is probably the simplest of all typesetting methods: the copy is typed directly onto repro paper, either manually or automatically (tape-driven). Most systems have a good, if somewhat limited, variety of popular typefaces in a wide range of text sizes.

Most typewriter composition systems, like phototypesetting systems, are based on a unit system. (See page 15 for a detailed discussion of the unit system.) This offers a typographic advantage over a regular typewriter: because the width of each of the characters in a font varies, they can be set closer together, improving the letterfit.

Typewriter composition systems produce only one repro. If more than one is required, the job either has to be retyped or the tape has to be run through again to produce a second typing. In most cases, photocopies are supplied for proofreading and dummying purposes.

Corrections are relatively inexpensive. If few and simple, they can be typed and stripped into the original repro; if extensive, all or sections of the job should be retyped.

The majority of typewriter composition systems in use today are manufactured either by IBM or VariTyper. Other manufacturers are Redactron, Remington, and Wang.

IBM SELECTRIC

IBM Selectric is one of the more widely used typewriter composition systems in use today. There are two basic systems: manual and tape-driven. The manual system consists only of a Selectric Composer (SC); the tape-driven system is comprised of a Selectric Typewriter (MT/ST), for input, and a Selectric Composer (MT/SC), for output. The tape is magnetic. Let's study both systems.

3 Units	4 Units	5 Units	6 Units	7 Units	8 Units	9 Units
i	f	a	b P	В	w V	m
j	r	С	d S	С	A X	M
l	S	e	h *	Е	DΥ	W
	t	g	k †	F	G &	
,	I	v	n \$	L	H %	
;	:	Z	0 +	T	K @	
,)	J	p =	Z	N -	
•	(?	q]		0 3/4	
-	!	[u		Q ½	
	/		х		R 1/4	
			у		U	
			All numbers			

IBM 9-unit system.

IBM font.

Manual. The Selectric Composer is virtually a one-man composing room. Essentially, it is a sophisticated typewriter based on a 9-unit system, which permits seven different character widths. It is capable of setting type in measures up to 76 picas and can be leaded (linespaced) in 1-point increments.

The Selectric Composer is designed to use all the IBM type fonts: approximately a dozen type families, including such workhorses as Baskerville, Bodoni, Century, Press Roman (Times Roman), and Univers. Most type families consist mainly of roman, italic, and bold, although some have light, condensed, and bold italic versions as well. Type sizes range from 6 to 12 point and are set from a ball-shaped font that carries 88 characters—one size of one type style. Because the IBM Selectric holds just one font at a time, any font changes must be made manually by the operator. As this can be time-consuming, it is a good idea to limit the number of font changes when designing for this system.

Another important factor to consider when designing for the Selectric Composer is that unjustified type (ragged left or ragged right) requires only one typing, whereas justified type requires a second typing. The first typing tells the operator how much wordspacing will be required to justify each line when he types it the second time. So not only will justified type cost more, but the second typing also increases the possibility of typing errors. This problem can be avoided by using the tape-driven system.

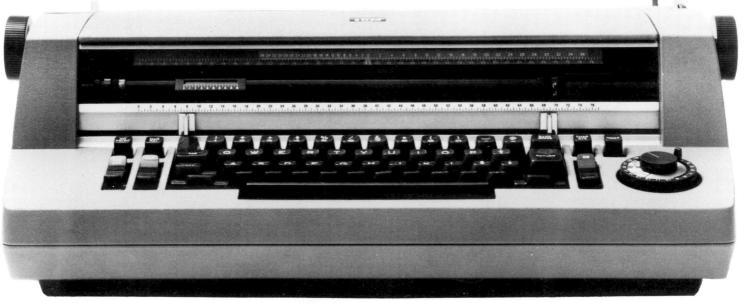

IBM Selectric Composer (SC).

Tape-Driven. The tape-driven system is made up of two units: an electric typewriter, the Magnetic Tape Selectric Typewriter (MT/ST), and a tape-driven composer, the Magnetic Tape Selectric Composer (MT/SC).

Magnetic Tape Selectric Typewriter (MT/ST). This is an electric typewriter and is used only to record input copy on a magnetic tape. As it does no typesetting (output), it has only regular typewriter fonts and is not based on a unit system. To input, the keyboard operator types the copy without regard to typeface, line length, or leading (linespace). He does, however, include instructions for changes of "mode" (center, flush left, or flush right), type styles (roman, italic, bold, etc.), and paragraph indents.

As he types the copy, it is automatically recorded on a magnetic tape. In addition to the magnetic tape, the typewriter also produces typewritten copy for proofreading. If the operator makes a mistake he simply backspaces and types in the correction. The tape erases the incorrect copy and records the correct copy. (It is also possible to find and correct mistakes that are discovered after the tape has been completed.) After the copy has been recorded it is played out (output) on the tape-driven Selectric Composer (MT/SC).

Magnetic Tape Selectric Composer (MT/SC). The MT/SC combines the Selectric Composer with a small computer, called a reader, capable of reading the magnetic tape and setting the line.

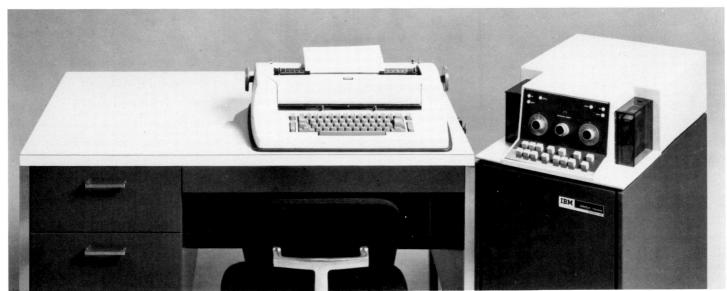

Copy is typed on a Magnetic Tape Selectric Typewriter (MT/ST) and is automatically recorded on a magnetic tape (right).

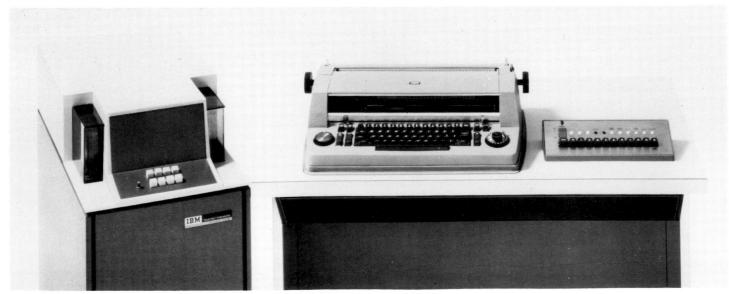

Reader (left) reads the tape and drives the Magnetic Tape Selectric Composer (MT/SC).

Although the MT/SC can set justified lines of type, it cannot hyphenate. Whenever a word needs to be hyphenated, the machine stops; this means that the operator must be on hand to make all end-ofline decisions. Once again, any change in type style, type size, or leading must be done by the operator.

To run the MT/SC, the operator adjusts the composer for the desired line length and leading, and inserts the correct type font. The tape is then run through the computer, which drives the composer at a rate of 150 words per minute. The speed of the MT/SC makes it an ideal typesetting system for high-volume requirements, and the computer's ability to justify lines eliminates the need to retype copy in order to justify (as is the case with the Manual Composer).

A useful feature of the MT/SC is that it is possible to change type specifications-typeface, measure, leading (linespace), etc.—without having to make a new tape. This is a great advantage to the designer who finds the copy to be set is running longer or shorter than expected. Also, tapes may be stored and corrected or updated at a later date without having to retype the original copy. Any new copy is simply typed onto a "correction tape," which is then merged with the original tape during the printout. This guarantees a printout free of errors and uniform in color.

Another advantage of the MT/SC is that it can also be used manually, making it possible for the operator to make corrections or add new copy even while the job is being tape-driven.

ALPHABET LENGTHS

6 point Century ABCDEFGHIJKLMNOPQRSTUVWXYZ abcdefghijklmnopqrstuvwxyz 7 point Univers ABCDEFGHIJKLMNOPQRSTUVWXYZ abcdefghijklmnopqrstuvwxyz 8 point Press Roman ABCDEFGHIJKLMNOPQRSTUVWXYZ abcdefghijklmnopgrstuvwxyz 9 point Baskerville ABCDEFGHIJKLMNOPQRSTUVWXYZ abcdefghijklmnopqrstuvwxyz 10 point Bodoni ABCDEFGHIJKLMNOPQRSTUVWXYZ abcdefghijklmnopqrstuvwxyz 11 point Journal Roman ABCDEFGHIJKLMNOPQRSTUVWXYZ abcdefghijklmnopqrstuvwxyz 12 point Aldine Roman ABCDEFGHIJKLMNOPQRSTUVWXYZ abcdefghijklmnopgrstuvwxyz

The designer should be aware that all IBM typefaces are one of three alphabet lengths. With few exceptions they fall into the following categories: 6-point, 7-point, and 8-point type are the shortest length; 9point and 10-point type are medium length; 11-point and 12-point type are the longest.

This means that in each of the three length groups, the number of characters per pica will be exactly the same. To illustrate this, we have set this copy in both 9-point and 10-point type with 2 points leading. Notice that each block of type has the same number of lines and characters per line.

The designer should remember this when he wishes to adjust the length of a setting by using a smaller or a larger type size. He may well end up resetting an entire job only to find that it sets to exactly the same number of lines.

9/11 PRESS ROMAN

The designer should be aware that all IBM typefaces are one of three alphabet lengths. With few exceptions they fall into the following categories: 6-point, 7-point, and 8-point type are the shortest length; 9point and 10-point type are medium length; 11-point and 12-point type are the longest.

This means that in each of the three length groups, the number of characters per pica will be exactly the same. To illustrate this, we have set this copy in both 9-point and 10-point type with 2 points leading. Notice that each block of type has the same number of lines and characters per line.

The designer should remember this when he wishes to adjust the length of a setting by using a smaller or a larger type size. He may well end up resetting an entire job only to find that it sets to exactly the same number of lines.

10/12 PRESS ROMAN

VARITYPER

VariTyper is the oldest manufacturer of desk-top strike-on composition equipment. Like the IBM Selectric Composer, it is manually operated and the copy must be typed twice to produce justified lines. On the first typing the VariTyper counts the number of wordspaces in each line; on the second typing it automatically adds the correct amount of extra space between the words to justify the lines.

The VariTyper has over 1,200 typefaces available, in sizes ranging from 31/2 to 13 point. It is designed to hold two type fonts at a time, each containing 99 characters, so it is possible to mix two type styles without changing fonts. Type can be set solid, or leaded in 1/2-point increis designed with an open carriage. This permits oversize sheets of paper to be used, and also means that the maximum line length that can be typed is limited only by the size of the paper. The open carriage, along with the VariTyper's ability to set horizontal and vertical rules, makes it ideal for forms and tabular material.

The VariTyper is available in two models: the 270, which is a conventional typewriter system in which all characters occupy the same amount of space, and the 1010, which is a 4-unit system.

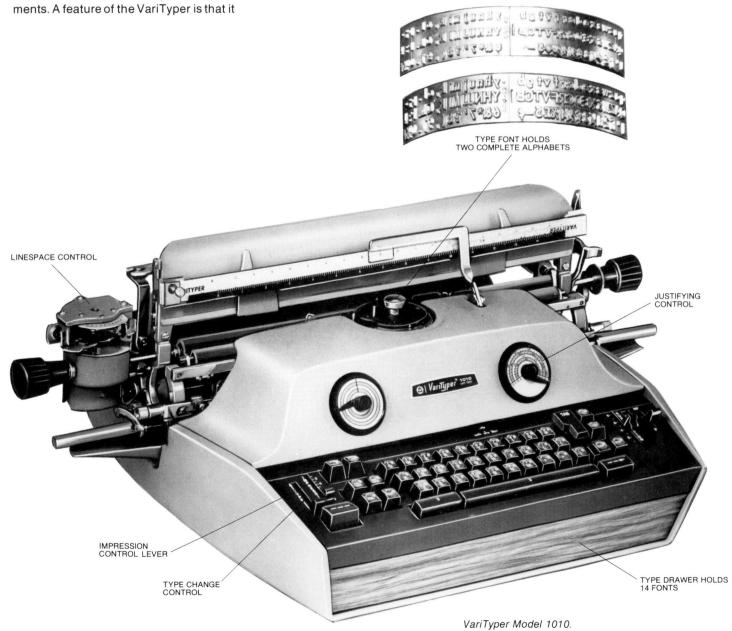

Phototypesetting

Phototypesetting, also called photocomposition, is the latest development in the typesetting industry. It provides a fast, flexible, relatively inexpensive method of setting type by photographic means. And it offers several advantages over other typesetting methods:

Type Is Sharper. In handsetting and casting, type has to be inked in order to print. The pressure of the metal type against the paper causes "ink squeeze," which tends to make the edges of the printed letterforms irregular. In phototypesetting, on the other hand, the individual letters are projected and exposed directly onto photosensitive paper or film, resulting in the sharpest possible letterforms.

Letterfit Is Better. As long as type is on a piece of metal, there is a limit to just how close the letters can be set. With phototypesetting, it is merely a question of projecting the letters where you want them. Letters can be set touching, overlapping—in fact, any way you wish. And with the use of prisms, letters can be slanted, extended, or condensed. Furthermore, changing typefaces is as simple as changing the film in a camera.

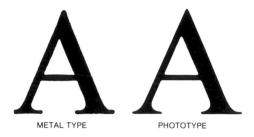

Typography Typography

ADJUSTABLE LETTERFIT

VERSATILE sets type on either paper or film

PAPER OR FILM PROOF

Sets Type on Film. Perhaps the most unique advantage of phototypesetting is that type can be set and jobs made up directly on photosensitized film or paper. This means that it is possible to go directly from film to platemaking, eliminating the need for a mechanical. Not only does this save time for the designer. but also for the printer, because there are no "out-of-process" steps such as shooting a mechanical and developing the film before he can make his printing plate. Perhaps the most important advantage of staying "in process" is that because the printer makes his plates from first-generation material rather than second or third generation, the quality of the printing plate is better.

The only inconvenience the designer may encounter is the occasional difference in terminology: quad left for flush left, quad right for flush right, and quad center for centered; interlinespacing for leading, photoproof for proof, and photoprint or photorepro for repro. Whatever slight inconvenience this may cause is far outweighed by the many advantages of phototypesetting.

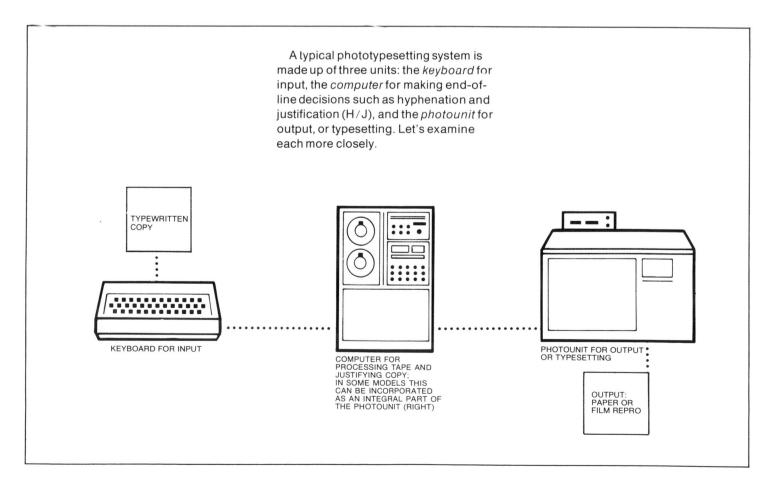

KEYBOARD

Before copy can be set it must first be typed on a special tape-producing keyboard. This keyboard is like an ordinary typewriter except that it has extra keys for special formatting functions such as font changes (typeface or type size), letterspacing, quadding, tabbing, leading, etc. As the operator types, he produces a perforated paper tape used to drive the photounit.

Not all keyboards produce perforated tapes. Many produce magnetic tapes. Others produce no tapes at all, but are hard-wired to store the information in memory on magnetic discs or drums for subsequent activation of the photo unit. There are also economy models that do not have the capacity to store information, but set type directly as the keyboard operator types it. This is called direct input. Although there are a variety of input methods, we shall concern ourselves only with the most commonly used, the perforated tape.

The perforated tape, approximately 1" wide, is very much like the old piano player roll on which the position of the holes dictates the keys to be played. For each character typed, a unique configuration of holes is punched.

In addition to producing a perforated tape, some keyboards also produce typewritten copy, called hard copy, for proofreading. Others are equipped with a visual display (a small video screen), permitting the operator to see the words as they are being typed. In this way if a mistake is made it can be corrected before the tape is punched.

There are two basic keyboard systems: counting and non-counting (also known as justifying and non-justifying).

Counting Keyboard. This is the more complex and expensive of the two keyboard systems, and it demands more skill to operate because the keyboard operator rather than the computer makes the end-of-line decisions. To do this the operator must know the typeface, point size, line length, minimum and maximum wordspacing, etc. He should also have a knowledge of typography. As he types the copy, the unit widths of the individual characters are totalled and shown on a scale in front of him. (See page 15 for a detailed discussion of the unit system.) As he nears the end of the line, he is warned by a light or audio signal that the line is ready to be justified. At this point the operator makes his end-of-line decision (see box at right). He then strikes a key that instructs the typesetting unit to expand the wordspace to fill out the line to the specified measure. The tape is punched and the operator proceeds to the next line.

The great advantage of the counting keyboard is that the operator directly controls the quality of the setting by the decisions he makes: how many words will fit on a line; whether or not to hyphenate, and if so, between which syllables; whether to use letterspacing in addition to wordspacing, etc. Because all these decisions have been made, the tape-called a justified tape-does not have to go through a computer, but goes directly to the photounit for typesetting. By the same token, because all these decisions have been made and the tape punched, there are few possibilities for change. One of the few changes that can be made on a justified tape is in the leading, which is controlled at the photounit. The type size can also be changed, but this will affect the pica measure proportionately: since the linebreaks are already determined, smaller type sizes will result in shorter lines.

Because counting keyboards are operator-controlled, they are often used for complex settings such as tabular matter, mathematical equations, scientific formulas, etc.

END-OF-LINE DECISIONS Hyphenation and Justification

The counting keyboard operator makes the end-of-line decisions when the line he is setting falls within the "justification range" near the end of the measure. It is within this range that the line can be physically justified by the phototypesetting machine. The quality of the setting will be dictated by the quality of the keyboard operator's decisions. Here are some of the questions he must ask himself when justifying a line:

- Can the next word fit on the line or can it be hyphenated, and where?
- · If not, do I add extra wordspace and letterspace. If so, where?
- · When the line is justified, will the wordspacing be objectionably loose or tight?

Warning lights indicate when line is ready to be justified or is overset.

No flash creates space the width of given character(s) without exposing them onto film.

Code delete allows operator to make corrections by deleting a character.

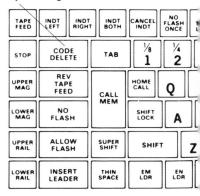

Special instruction keys for coding out the proper magazine (font), changing from roman to italic, to caps, or to boldface, etc.

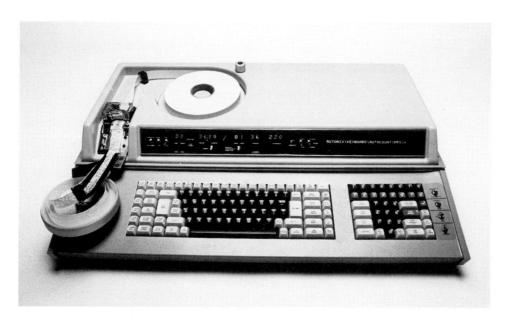

Counting keyboard with paper tape perforator on left.

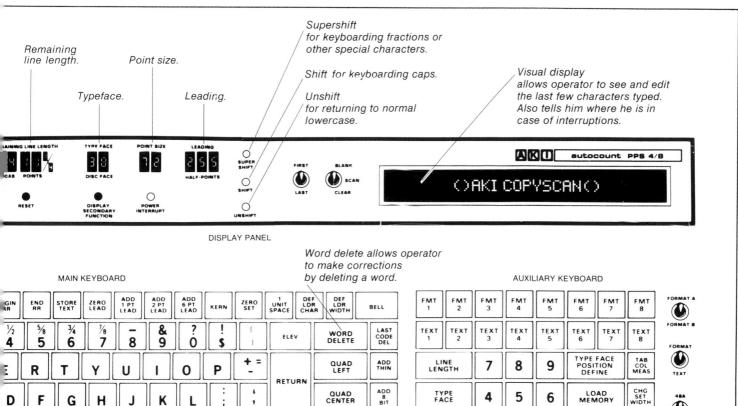

ADD 7 BIT

CALL

Regular typewriter keys.

Special instruction keys for wordspacing, letterspacing, flush left, flush right, etc.

SHIFT

SPACE

QUAD

LINE

Program formatting keys for setting pre-specified instructions stored in computer memory. For example: "Set text in font #1, 28 picas wide, indent paragraphs 1 em, and hang all end-of-line punctuation.

2

0

1

RECALL PHOTON FORMAT

LEADING

3

STORE PHOTON FORMAT

END MEM

SET

COUNTING KEYBOARD

VERT

SPACE

All end-of-line decisions are made by the computer rather than by the keyboard operator. All he is concerned with is the copy and formatting instructions such as line length, leading, type style (italic, bold, etc.), and paragraph indents. As he types the copy, the keyboard operator produces an unjustified tape, commonly referred to as an "idiot tape."

Among the advantages of the non-counting keyboard is that some of the formatting instructions such as line length and leading can be overridden at the photounit. This permits the designer to have copy keyboarded in advance of type specifications; that is, available copy can be keyboarded as it is received, and when the job is complete the designer can specify the typeface, line length, and leading. Also, if he wishes he can use the same tape to set the same job in any number of different typefaces or measures.

Perhaps the major advantage of the non-counting keyboard is speed. It is estimated that one-third of a counting keyboard operator's time is spent making end-of-line decisions. The non-counting keyboard operator, on the other hand, is free to type continuous copy at maximum speed, leaving it up to the computer to determine the hyphenation and justification.

Because of the simplicity of input there are more non-counting keyboards than counting keyboards in use today, and there is every indication that this will remain the direction in phototypesetting.

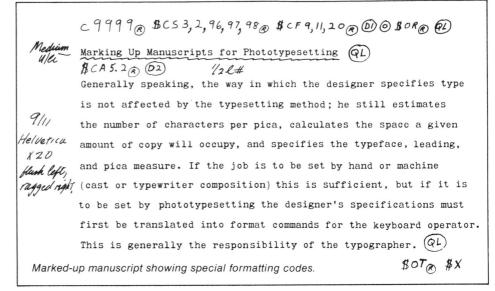

One of the advantages of the unjustified, or idiot, tape, is that copy can be keyboarded in advance of type specifications. If the type specifications are already included, they can be changed before the type is set. Furthermore, the same tape can be used to set a given job in a variety of typefaces and measures.

10/12 PALATINO

One of the advantages of the unjustified, or idiot, tape, is that copy can be keyboarded in advance of type specifications. If the type specifications are already included, they can be changed before the type is set. Furthermore, the same tape can be used to set a given job in a variety of typefaces and measures.

9/11 TIMES ROMAN

One of the advantages of the unjustified, or idiot, tape is that copy can be keyboarded in advance of type specifications. If the type specifications are already included, they can be changed before the type is set. Furthermore, the same tape can be used to set a given job in a variety of typefaces and measures.

8/10 HELVETICA

Same tape used to set three jobs.

Code delete allows operator to make corrections by deleting a character.

5.14.45.61				
REPEAT				
ADD 8 BIT	RE TA FEI			
ADD 7 BIT	TA FE			
UPPER RAIL	EL			
LOWER RAIL	TH			

Special instruction keys for wordspacifi letterspacing, etc.

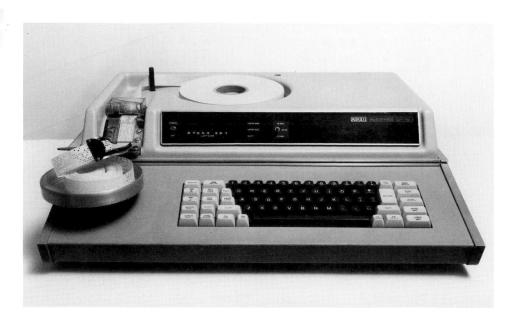

Non-counting keyboard with paper tape perforator on left.

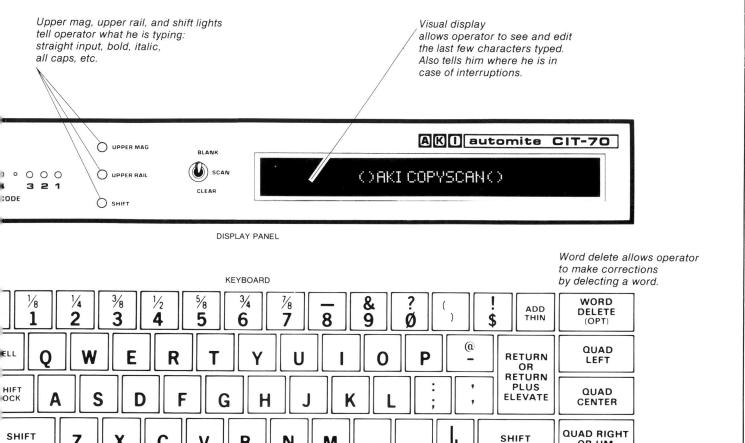

Regular typewriter keys.

Special instruction keys for wordspacing, letterspacing, flush leit, flush right, center, etc.

EM

SPACE

EN SPACE

OR UM LOWER MAG

OR PAPER FEED

NON-COUNTING KEYBOARD

EM LDR

COMPUTER UNIT

The computer is basically an adding machine with an expanded memory. Its job is to process the unjustified tapes and, among other things, to make end-of-line decisions. How well it does this is determined by the computer's programming (referred to as "software," to differentiate it from the equipment itself, which is referred to as "hardware"). The more thoroughly the computer is programmed, the better the chances of correct hyphenation, even wordspacing, and generally good typography.

In some phototypesetting systems the computer unit is an integral part of the photounit. In this case, the unjustified tape is fed directly into the photounit and a mini-computer resolves the linebreaks as the type is being set.

When the computer unit is separate from the photounit, the unjustified tape must first be converted into a justified tape. In this case, the computer reads the unjustified tape and produces a new, justified tape capable of driving the photounit.

There are four systems by which computers can be programmed to resolve linebreaks: hyphenless, discretionary, logic, and exception dictionary. However, not all computers are designed to use all four systems. If you look at the table on pages 48 through 55 you will see that many use only two or three.

Computer independent of the photounit.

When setting type hyphenless, the lines are justified by increasing or decreasing the wordspace. On some machines, letterspacing can be adjusted to help justify the line. This can be distracting and the designer should have a sample set before deciding whether he wants to use letterspacing as well as wordspacing. The disadvantage of hyphenless setting is that wordspacing can be disastrous, especially if setting type to a short measure.

If composition must be set hyphenless, it is a good idea to consider having it set flush left, ragged right. This way the wordspacing will be even and any excess space will be at the end of the lines where it is not noticeable.

Hyphenless. In this system, no words are hyphenated. The lines are justified by increasing or decreasing the wordspacing, and on some machines, the letterspacing. This can create some very poor wordspacing and letterspacing, which may require the resetting of lines to create more pleasing results.

The com-puter is basic-ally an adding machine with an ex-pand-ed memory. Its job is to process the unjust-ified tapes and, among other things, to make end--of--line decis-ions. How well it does this is deter-mined by the com-puter's pro-gramm-ing (re-ferred to as "soft-ware." to differ-entiate it from the equip-ment itself, which is re-ferred to as "hard-ware"). The more thor-oughly the com-puter is pro-grammed, the better the chances of correct hyphen-ation, even word-spacing, and gener-ally good typog-raphy.

Discretionary. Here, the computer needs a little help from the keyboard operator. As the operator types the copy, he hyphenates every word of three syllables and over. The computer, when justifying a line, uses its "discretion" to choose only the hyphenation it needs, disregarding that not needed.

TYPICAL RULES OF LOGIC

- Insert a hyphen before the suffixes ing, ed, ly, ty, day.
- Insert a hyphen after the prefixes non, pop, air, mul, gas, gar, cor, con, com, dis, ger, out, pan, psy, syn, sur, sul, suf, sub, mis, ul, un, im, il, ig, eu, es, os, and up.
- Insert a hyphen in a sequence of numbers broken up by commas after a comma
- Do not hyphenate if less than five letters in a word, or if less than two characters before or after a hyphen. For example: ring not r-ing.
- Do not insert a hyphen before the suffix ing if preceded by one of the letters d, t, or h.
- · Do not insert a hyphen before the suffix ed if preceded by one of the letters v, r, t, p, or where v is a vowel.
- · Do not insert a hyphen before the suffix ly if the word ends in bly.
- · Do not insert a hyphen before the suffix ty if the word ends in hty.

Logic. The computer is programmed with a specific set of rules of hyphenation (hyphenate between double consonants, before ing, etc.). All words covered by these rules will be hyphenated accordingly. If the rules cannot be applied, the word will not be hyphenated; instead, the line will be justified by adding wordspace and/or letterspace. As with the hyphenless system, this can result in cases of poor wordspacing, again making it necessary to reset lines.

Also, there are words that can be hyphenated according to logic, but should not be; for example, ring should not be hyphenated r-ing. There are many words like this that are exceptions to the rules of hyphenation. For this reason some computers have an exception dictionary. **CROSS-ING** not **CROS-SING**

INK-LING not **INKL-ING**

THER-APIST not THE-RAPIST

Exception Dictionary. To avoid poor hyphenation, some of the more sophisticated computers are equipped with an "exception dictionary." This dictionary covers words and proper nouns that are exceptions to the computer's rules of logic. The computer first searches the exception dictionary. If the word is listed (for example, ink-ling), the computer hyphenates accordingly. If the word is not listed, the computer tries to hyphenate it according to the rules of its logic system. If no rule is applicable, the word will not be hyphenated and wordspace will be used to justify the line. Not all exception dictionaries are the same; some contain only a small number of words while others, with expanded memory capacity, are very extensive. Some computers, with sufficient memory capacity, carry a complete dictionary plus most common proper names in memory.

Note: The computer may also have difficulty determining exactly what the author meant and this could affect the hyphenation. For example: de-sert and des-ert or mi-nute and min-ute.

Phototypesetter with computer and photounit combined.

PHOTOUNIT

It is the photounit, or phototypesetter, that actually sets the type. This output unit is so fast it would take half-a-dozen highly proficient keyboard operators to produce enough input to efficiently utilize its capacity.

The photounit is a combination of photographic, electronic, and mechanical components. The type font is carried as a negative image on an image master. Depending on the system, the image master may be a grid, disc, drum, or film strip. To set type, high-intensity light is flashed through the characters, projecting them onto photosensitive paper or film. In some systems the image master remains stationary while the light source moves, in others the image master spins or rotates while the light remains stationary.

Photounits vary greatly: method of handling the image master; number of image masters, and fonts per master, handled at one time; range of type sizes (controlled by lenses available); maximum line length; method of projecting the image onto photosensitive paper or film; speed of output; and control electronics. Also, some photounits use a different image master for each type size, while others use a single image master that can be reduced or enlarged by a lens system to produce a number of different type sizes.

These are just a few of the mechanical differences in photounits, which may or may not affect the quality of the setting. From the designer's point of view, how the type gets onto the paper or film is less important than how the type looks. To avoid any disappointment, the designer should always have a type sample set showing the specified typeface set to the correct measure with the proper amount of leading.

For a complete list of the various characteristics of the different photounits, see the table on pages 48 through 55. See also the type specimens shown on pages 56 through 63.

Mergenthaler VIP.

Harris-Intertype Fototronic TXT.

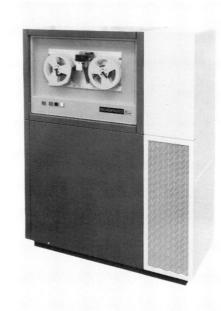

Monophoto 600.

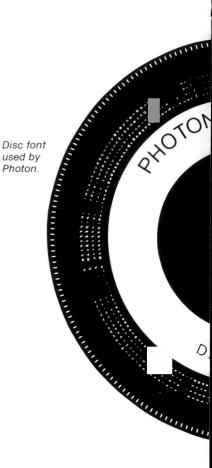

Grid font used by Alphatype.

SPINNING DISC HOLDS NEGATIVE IMAGES OF THE TYPE CHARACTERS FILM OR PAPER J **SCIENCE** FLASH LAMP MOVING PRISM ESTABLISHES TYPE POSITION LENS TURRET DICTATES TYPE SIZE °C. P. Palmer

The basic principle of phototypesetting.

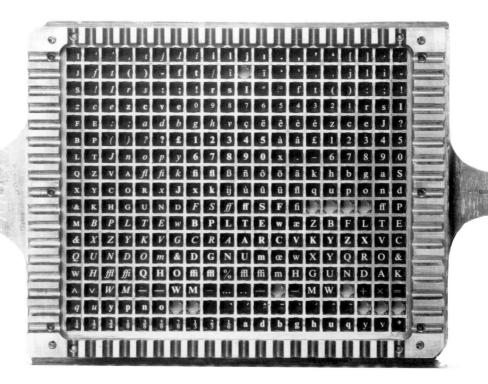

Grid font with interchangeable matrices used by Monophoto Mark IV.

Film strip font used by Mergenthaler VIP.

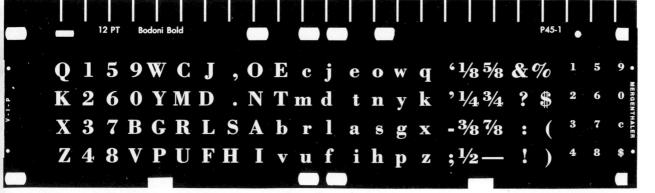

EDITING AND CORRECTING

The best way to keep mistakes from turning up in type is to give the typographer clean, error-free original copy. However, if errors do slip by or are introduced into the copy by the keyboard operator, the best and least expensive time to correct them is at the keyboard or on the tape after keyboarding but before typesetting. Once set in type, copy becomes more expensive to correct.

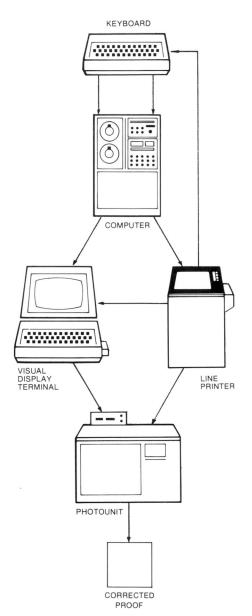

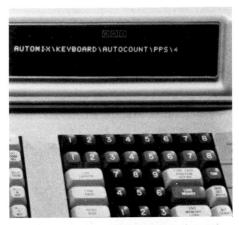

At the Keyboard. To catch errors made by the keyboard operator, some keyboards are equipped with a visual display that permits the operator to see the words as they are being typed. Other keyboards produce hard (typewritten) copy, which can be read. In both cases, if a mistake is caught it can be corrected. Not all keyboards have visual displays and produce hard copy, some just produce tapes; these are called "blind keyboards."

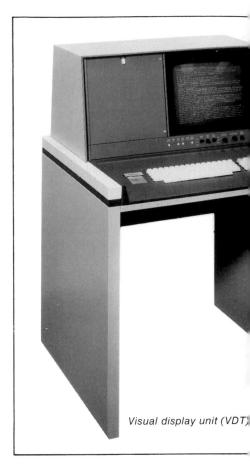

After Keyboarding. There are two methods of editing a tape after keyboarding and before typesetting: visual display terminal (VDT) or line printer.

Visual Display Terminal. By playing the tape through a visual display terminal, also called an editing and correcting terminal, the operator can get a visual readout of the copy. Depending on the system, this readout may consist of a few lines or of thousands of characters. Either way, the operator can zero in on the exact character, word, or line to be corrected. He types the correction on a keyboard that is part of the terminal and a new tape is automatically created. Some of the more sophisticated editing terminals have computers that not only make the correction but automatically rejustify any lines affected.

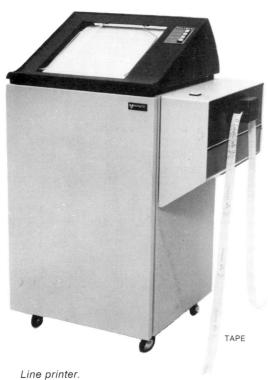

TYPICAL PROOFING COPY

2

3

4

5

6

7

9

10

11

12

13

14 15

16

17

18

19

20

21

22

23

24

25

26

abarup 10-26 adv for pms thurs oct 26 American Basketball Association Roundup< < < < < By United Press International< It was Dan Issel's birthday but he blew out the Dallas Chaps rather than candles. Issel marked his 24th birthday Wednesday night with a season-high 29 points as he led the Kentucky Colonels to a 116108 victory over the Chaps. A last period spurt sparked by Issel and Walt Simon, who finished with 21 points, 11 in the final period, put the game out of reach. Collis Jones had 31 points and 16 rebounds, both career highs, for the Chaps. In the only other American Baskeetball Association game, Joe Caldwell scored 24 points and the Carolina Cougars took advantage of 23 Denver turn-

overs to defeat the Rockets

Line Printer. This is a machine that produces a hard copy printout in typewriterlike characters. The individual lines are numbered and set in the same way that the photounit will set them, except that they are unjustified. By studying the printout it is possible to detect such things as keyboarding errors, poor hyphenation, and widows, and to determine the number of lines the typeset copy will be. Corrections are made by punching a new tape and merging this by computer with the original tape, producing a new tape to activate the photounit.

The disadvantage of the line printer printout is that the typewritten copy can be difficult to read; command and formatting codes are normally included in the copy, which can be distracting, and there is no way to distinguish between type styles (roman, italic, and boldface) or type sizes, except by reading the codes.

After Typesetting. Once the type has been set, if the corrections are extensive, it is better to reset the entire block of copy; if they are not extensive, there are three ways to make corrections: tape editing and tape merging, in which a corrected tape is produced, and patching, either by stripping film or pasting repros.

Tape Editing. The transferring of information from one tape to another. The operator locates the copy to be corrected on a visual display terminal or on a line printer printout. He types the correction on the keyboard, which simultaneously produces a corrected tape ready to activate the photounit. In addition to making typographic corrections, the operator can also delete or insert new copy.

Tape Merging. Only possible with systems that utilize an off-line computer to automatically number every line of type. The keyboard operator instructs the computer where the mistake is and how it is to be corrected—a typical correction would read as follows: "Line 88, delete comma after now; line 107, change tpye to read type." The correction is merged with the existing tape by the computer, producing a corrected tape ready to activate the photounit.

Patching. If the corrections are few and brief, the operator simply types the corrected copy on the keyboard, running the tape through the photounit to get a corrected film or paper print. The film patch is stripped into position on the original film; the paper (repro) patch is pasted into position on the repros.

OCR SYSTEMS

The input systems we have described so far are basically the same: the operator types the copy on a keyboard, which produces a punched or magnetic tape. With the OCR (optical character recognition) system, the keyboard operator is eliminated because the OCR converts original typed copy into tape. To do this, the original copy must be typed either with a specially designed alphabet or an alphabet in which each character is accompanied by a series of bar codes. The typewritten copy, including formatting codes, is then put through a scanner that reads the copy and produces a tape.

One of the major advantages of the OCR is that it does not require an operator or an expensive keyboard to produce tapes. There are presently a number of companies manufacturing OCR equipment, among them Compuscan, Datatype, Graphic Systems, Inc., Implac, Singer Friden, and VariTyper.

IBM selectric font with OCR bar code characters. Used by VariTyper.

Graphic Systems, Inc. System 1 Scanner - Editing Routines

KeyEdit:

This is an example of delete charifacter. A single symbol removes the preceding character.

This is an example of delete werd \$1 word. Two symbols remove the preceding word.

This is an ecample of JJJThis is an example of line delete. Three symbols remove the typewritten line.

OCR typewriter characters used by Graphic Systems, Inc.

Scanner reads typed copy and produces a tape.

Detail of scanning operation.

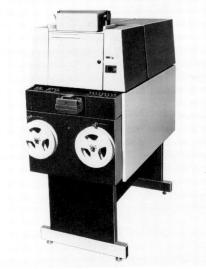

Tape is played through a phototypesetter.

PHOTOCOMPOSING SYSTEMS

Photocomposing systems, also called video layout systems or composition and makeup terminals, permit one person to prepare complete ads, based on the designer's specifications and layout, and go directly to typesetting without additional markup or pasteup. A photocomposing system is basically a sophisticated visual display terminal (VDT), consisting of a keyboard with editing and layout controls and a cathode ray tube for a video screen. Here is how it works:

The designer lavs out the ad and specifies the copy as usual. The copy is keyboarded to produce a perforated paper tape. The amount of keyboarding reguired is less than that required for conventional phototypesetting; it is for this reason that the marking up of command codes is not necessary. At this stage the tape can be edited and corrected on a VDT if necessary. If not, the tape is read into the terminal via a "reader" and the copy appears immediately on the screen of the video display terminal, ready for layout. Using a keyboard-directed cursor (usually a white mark that can be directed anywhere on the screen) and copyfitting keys, the operator positions the copy on the screen to match the designer's layout. The copy appears in the actual type size and set width of the desired type font, in the correct measure, and with correct leading and hyphenation. If necessary, the operator can change type sizes, delete or add copy. move entire blocks, and change line measures. When the operator is satisfied with the layout, he strikes a key, transmitting the ad and all the layout coding (via tape) to the typesetter for complete one-piece composition. The result is a one-piece paper positive, ready to be pasted into the mechanical or made up in positive-reading film for platemaking.

Photocomposing systems are becoming popular with newspapers for setting retail and classified ads. They are also used for composing complex straight matter, full-page composition, and for directories such as the Yellow Pages. Photocomposing systems can input from OCR-scanned copy or keyboarded copy and output from conventional phototypesetting systems or CRT systems. At present they are not widely used for advertising agency work, book publishing, or commercial work. However, it is not difficult to foresee photocomposing replacing tight layouts and comps, with designers employed by typesetters to work on and with the terminals.

Copy is keyboarded.

Detail showing cursor (white box).

Reader (left) reads tape and copy appears on screen ready for makeup.

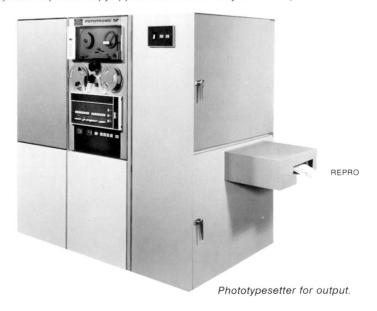

CRT SYSTEMS

The CRT (cathode ray tube) is a highspeed phototypesetting and/or photocomposing machine that uses sophisticated computer electronics and an electronic video tube as a means of character generation, or typesetting. The copy to be set is first keyboarded onto a magnetic tape that drives the CRT unit. In terms of speed, the CRT is to phototypesetting what phototypesetting is to linecasting. For example, a typical linecasting machine can set type at the approximate rate of 5 cps (characters per second), a phototypesetting unit from 30 to 100 cps, and the CRT anywhere from 1,000 to 10,000 cps. There are two basic CRT systems: formation and projection.

Formation. (Computer Logic Character Formation.) In this system, the characters to be set are stored as digital information in the computer. When the character request comes from the magnetic tape, the computer sends the configuration of the character as electronic signals to the cathode ray tube where the character is formed. A lens then focuses and projects the information needed to form each character onto photosensitive paper or film as a series of small dots or portions of closely spaced vertical lines. too small to be seen by the naked eye. Formation is the system used by the Harris-Intertype Fototronic CRT, among others.

Projection. (Character Projection.) Generally, the projection system produces a better-quality type character than the formation system. It scans the characters to be set (which are on a master grid) and translates this information by breaking it down into thousands of lines (300 to 500 per inch). These lines are then relayed to the cathode ray tube and projected onto photosensitive paper or film. Projection is the system used by Mergenthaler Linotron 505, among others.

Enlargement of f formed by dots.

Enlargement of f made up of lines.

The Intertype Fototronic-CRT phototypesett designed to give unmatched flexibility and re

The Intertype Fototronic-CRT pho grated circuit device designed to give

The Intertype Fototronic-CRT an integrated circuit device desi

The Intertype Fototronic-C tem is an integrated circuit

The Intertype Fototron ting system is an integra

The Intertype Fototronic-CRT an integrated circuit device desi

Type can be condensed, extended, or slanted.

Just as CRTs can break down line copy into lines or dots, some specially designed CRTs can also break down continuous-tone copy-photographs, drawings, paintings-into lines or dots. This permits a properly programmed CRT to do complete page makeup, with both type and illustrations. (This process is called photocomposing, not to be confused with photocomposition.) Furthermore, page makeup can be done on paper, film, microfilm, or even offset plates.

A unique feature of the CRT system is that in addition to setting type in ½-point increments, it can electronically expand or condense any typeface. This permits the designer to control, within reason, the number of characters he wishes to set in a given measure. Type can also be made bolder, or slanted. The designer

> Teletypewriter. The means of communication between the operator and the Linotron and vice-versa. Also capable of producing a printout status report on the state of the program.

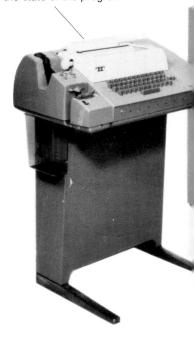

should note that slanted type in this case is not italic, but merely slanted roman type. True italics are available on most CRT machines.

The quality of the typography produced by the CRT is in direct ratio to the speed of character generation and the number of lines per inch: the faster the system, the lower the typographic quality. In many cases a reading proof will be set at 10,000 cps, with 300 scan lines per inch; when approved, the copy will be reset at 3,000 cps, with 500 scan lines per inch. Also, the distortions that produce bold, light, expanded, and obliqued type are not always esthetically pleasing.

Despite its shortcomings at this time, the CRT offers a speed and versatility that is unique in typesetting systems. CRTs are used mainly for high-volume

reproducer unit what type to use, the size, and how to set it.

typesetting requirements, such as for newspapers, timetables, inventories, records, phone directories, catalogs, and price lists.

The major reason there are not more CRT systems in use is their present high cost. A partial list of CRT systems includes Autologic APS-4, Compugraphic Videosetter I & II, Crosfield Magnaset 226, Harris Fototronic CRT, Hell Digiset, Mergenthaler Linotron 303 and 505, MGD MetroSet, SunCom, and SunSetter.

Image master used by Linotron 505.

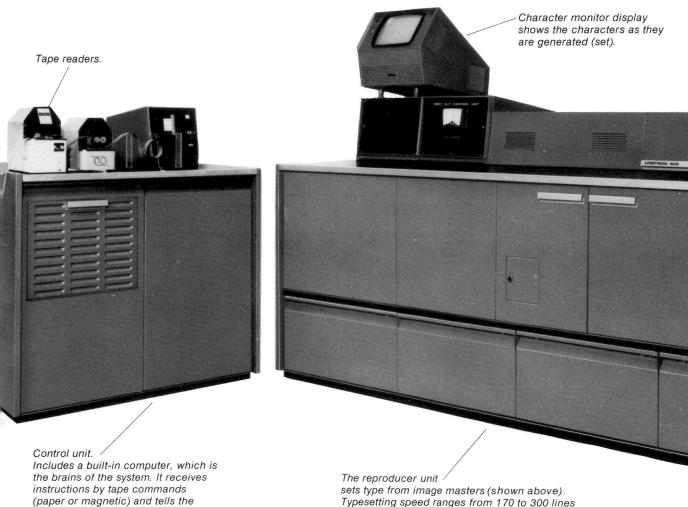

per minute depending on the typographic

quality desired.

PHOTODISPLAY UNITS

Photodisplay units specialize in setting display type at the comparatively slow rate of 20 to 30 characters per minute. These machines offer an inexpensive method of setting display type and are easy to operate.

Most of these units work on the same basic principle: the type font, carried on a disc, grid, or film strip, is placed in the machine and adjusted manually to bring the character to be set into position. A key is pressed and a light beam exposes the letter onto photosensitive paper or film. After the letter or word has been set, the paper or film is developed, fixed, and washed. This operation takes place either in the machine or in a separate unit.

There are two basic photodisplay systems: manual letterspacing and automatic letterspacing. With the manual letterspacing system, the operator can see what he is setting and is able to visually control the letterspacing. This is a great advantage if the operator is skilled-a disadvantage if he is unskilled. The opposite is generally true for automatic letterspacing. Here the operator must work "blind"; that is, he cannot see the type being set. Although the letterspacing is done mechanically, the machine can usually be adjusted to set type with normal, loose, tight, or overlapping letter-

Another factor to consider is the lighting conditions under which the operator must work. With many (but not all) of the manual letterspacing machines, the operator must work under safelight conditions to avoid exposing the photosensitive paper to light. On the other hand, the machines with automatic letterspacing are generally totally enclosed, which permits the operator to work under normal office lighting conditions.

The majority of photodisplay systems set type as a continuous strip of paper or film about 2" wide, making it impossible to set lines of type one under the other. If the type is to be set on more than one line, either the operator or the designer must cut and paste. Some machines, however, especially those that set type on sheets or rolls of paper, can set type in a number of lines.

The following are some of the more popular photodisplay units, ranging in complexity from a simple Strip Printer to keyboard-operated units such as the Compugraphic CG 7200 or the Photo Display 70.

SPACE GUIDE

TOUCHING

VERY TIGHT

ypography Typography Typography **Typography** Typography

NORMAL

TV SPACING

REPROPORTIONING GUIDE

CONDENSED 24%

CONDENSED 16%

CONDENSED 8%

EXPANDED 24%

EXPANDED 16%

EXPANDED 8%

Typography **Typography Typography** pography pography Typography *lypography*

Compugraphic CG 7200. (Compugraphic Corp.) Over 150 typefaces. A keyboard-operated unit that sets type from two film strips (two fonts per strip) in eight sizes from 14 to 72 point. All type is base-aligning. The photographic unit is totally enclosed, which permits the operator to work under normal lighting conditions. Letterspacing is automatic or manual. Also available with a Line Length Display Counter which tells the operator the exact line length in picas and points before he sets it. This avoids the time and expense involved in having to reset lines that do not set to the required measure. Used primarily by newspapers for display and headline typography.

Diatype Headliner. (Berthold Fototype.) Over 420 typefaces available. Sets type from standard Diatype disc in sizes from 17 through 129 point, inclusive, and prints out on 70mm paper or film. The Diatype Headliner operates under normal lighting conditions and is designed to permit the operator to control letterspacing manually. Special screen grids make it possible to screen type while setting. Ideally suited to fast (30 to 60 characters per minute), high-quality type production.

Filmotype. (Alphatype Sales Corp.) Over 1,000 typefaces. Sets type from a film strip. Type can then be reduced or enlarged from 12 to 144 point on a 2" strip of paper or film. Mixes up to 20 fonts, all base-aligning. Words or lines can be set to specific measure. Automatic letterspacing. Operator works under normal office lighting conditions. Film or paper is processed in a unit separate from the typesetting unit, allowing the operator to set type at good speed. Wide variety of type styles available: handlettering, formals, cursives, scripts, flat serifs, free style, outlines, novelties. Can also incorporate logotypes, trademarks, insignia in film strips.

Ministar. (Berthold Fototype.) Over 60 typefaces available. Sets type from a 35mm cassette font, each font having 140 characters. Type sizes range from 9/64" to 1%". Operator must work under safelight conditions and has direct visual control over letterspacing. Ministar is a low-cost, easy-to-operate photodisplay unit.

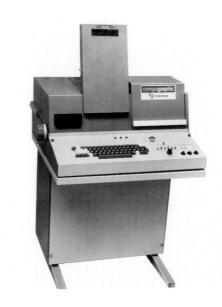

Compugraphic CG7200

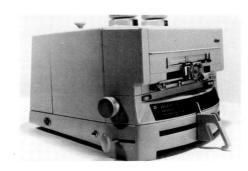

Diatype Headliner.

Filmotype.

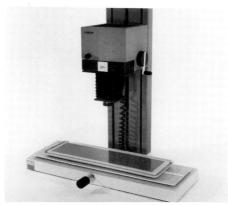

Ministar

Monotype Studio Lettering. (Distributed by American Type Founders Co.) Sets type from a single disc in sizes ranging from 1/8" to 5" at a rate of 20 characters per minute. Operator must work under safelight conditions and can control letterspacing. Type can be bounced, staggered, screened. Type can be set on paper or film in strips or sheets $(5\%'' \times 14\%'')$.

Photo Display 70. (Singer Graphic Systems.) Over 135 typefaces. A keyboardoperated unit that sets type from two film strips (two fonts per strip) in 10 type sizes from 12 to 96 point. Type is top-aligning. (If the designer is in the habit of mixing typefaces or sizes he will have to cut and paste to make the type base-aligning.) The photographic unit is totally enclosed, permitting the operator to work under normal lighting conditions. Letterspacing is automatic and can be adjusted for tighter setting or kerning. A selection of ready-made fonts is available to which special symbols or characters can be added.

Photo Typositor. (Visual Graphics Corp.) Over 1,400 typefaces and 2,800 variations in size, slant, and proportion. Sets type from film strip. Type can be reduced or enlarged from 25% to 200% (approximately 18 to 144 point). Although the Photo Typositor operates under normal lighting conditions, it is designed to permit the operator to control the letterspacing manually. With the aid of special lenses, type can be set in a variety of styles: condensed, backslanted, italicized, bounced, staggered, form-interlocking, and with drop shadows or background tints.

Staromat and Superstar. (Berthold Fototype.) Over 700 typefaces and 1,300 film strips. Type can be set from a single font from 1/8" to 51/2". Also available with a special projection mirror that allows type to be blown up to 391/2". Operator must work under safelight conditions, can control wordspacing and letterspacing manually or automatically. Ideally suited to creative, high-quality typesetting. Sets type in a number of configurations: circular, spiral, around illustrations, and on more than one line. Both can also be used as regular film enlargers (2" x 2" negatives). The major difference between the Staromat and Superstar is that the latter is designed for high speed manual typesetting.

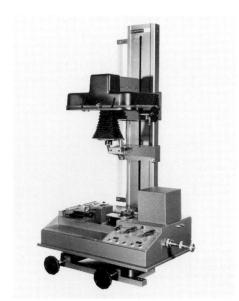

Monotype Studio Lettering.

Photodisplay 70.

Photo Typositor.

StripPrinter. (StripPrinter, Inc.) Offers 5,000 typefaces and sizes, including fancy scripts, antiques, reverses, screens, and handlettering. Sets type from 35mm film strip in sizes from 6 to 96 point, one size only per strip, since no reduction or enlargement is possible. Designed to operate under daylight conditions and to permit the operator to control letterspacing manually.

VariTyper Headliner. (VariTyper Corp. Models 80, 123, 810, 820, and 860.) Over 400 typefaces available. Sets type from plastic discs called Typemasters in sizes from 10 to 86 point. Each Typemaster contains one font and there are no reductions or enlargements possible onmachine. Normal lighting conditions. Blind setting with letterspacing done automatically by machine. Letterspacing can be adjusted manually for tighter setting. Type is set on a 35mm paper or film strip, with or without adhesive backing. The 810 operates with an 81/2" wide roll of photographic paper which can be cut to any desired length and which permits type to be set on more than one line.

Visutek 750. (Visutek Graphic Products Division.) Over 700 typefaces available, plus the capability of using film strips from other photodisplay units. Type can be set from 18 point to 41/2" with special reproportional lenses available which will slant the type and permit other optical changes. Type can also be set with screens, Bendays, drop shadows, etc. The Visutek 750 sets type on 2" strips and sheet film or on photosensitive paper. Type set on strips can be done under normal lighting conditions; type set on sheets must be done under safelight conditions. Typesetting on the Visutek 750 is a dry-process operation with all chemicals contained in a separate processing unit. A less expensive model, Visutek 725, is also available for setting type in strips only.

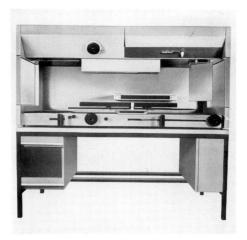

Superstar.

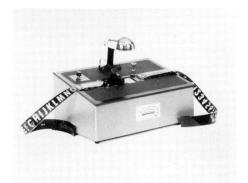

Strip Printer.

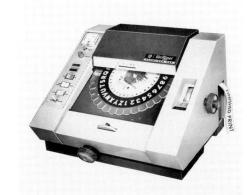

VariTyper Headliner.

Visutek 725.

Manufacturers of Phototypesetting Equipment

The following lists the major manufacturers of phototypesetting equipment.

A complete listing of all these phototypesetting machines, along with their basic characteristics, can be found on pages 51–55.

Alphatype Corp.

2 Pennsylvania Plaza New York, New York 10036

Founded in 1959. Alphatype has always followed a policy of non-obsolesence: nine improvements to the basic machine have been manufactured and all are available for installation on existing machines. Manufactures Alphasette.

H. Berthold A.G.

1000 Berlin 61

Mehringdamm 43, West Germany
Founded in Berlin in 1858 and now the
largest producer of phototypesetting
equipment in Europe. Berthold also offers a wide range of enlargers, process
cameras, miscellaneous graphic arts
equipment, and has an extensive library
of fine typefaces. Manufactures the
Diatronic, Diatronic S., Diacomp, Staromat, and Superstar. Since 1971, distribution for H. Berthold A.G. has been
handled by Berthold Fototype Co., P.O.
Box 430, Willet St., Bloomfield, New Jersey 07003.

Compugraphic Corp.

80 Industrial Way

Wilmington, Massachusetts 01887
Founded in 1961 to manufacture special-purpose typesetting computers. Has since introduced an extensive line of low-cost phototypesetting equipment and has captured a large share of the market. Presently manufactures a wide range of phototypesetting equipment, including keyboards. Manufactures the CompuWriter Junior I and II, ACM 9000, 2961 Series, 4961 Series, and Video-Setter I and II.

Graphic Systems, Inc.

217 Jackson St.

Lowell, Massachusetts 01852

Founded in 1968 to manufacture phototypesetting equipment as an OEM (original equipment manufacturer) for Singer. Has since initiated its own marketing efforts with an expanded line of equipment, including OCR, VDT, magnetic tape keyboards, and computers. Manufactures the System 1 C/A/T Typesetter.

Harris Corporation

P.O. Box 2080

Melbourne, Florida 32901

One of the major manufacturers of line-casting machines, founded in 1916. In addition to making linecasting machines, Harris Corp., formerly Harris-Intertype, is one of the largest manufacturers of phototypesetting machines, electronic editors, advertising layout terminals, and electronic word-processing systems. Harris has one of the finest libraries of typefaces. Manufactures the Fototronic 600, 1200, and TXT. (See pages 37 and 41.)

Mergenthaler Linotype Co.

A division of ELTRA Corp. Mergenthaler Drive, P.O. Box 82 Plainview, New York 11803

Founded in 1886 to manufacture the Linotype machine (first successful typesetter). Currently a worldwide operation marketing a broad range of graphic arts products, including: Linotypes, basic and computerized phototypesetters, high-speed CRT phototypesetters, input keyboards, video editing/correction terminals, and complete composition systems, including software. Also has an extensive library of fine typefaces. Manufactures the VIP Linofilm, Linotron, and Linocomp. (See pages 20, 21, and 36.)

The Monotype Corp. Ltd.

Salfords, Redhill RH1 5JP, England

A major manufacturer of metal type-setting equipment and one of the oldest. The Monotype system of casting individual pieces of type, based on a unit system, was invented in 1887 by Tolbert Lanston of Washington, D.C. The same unit system is now the basis of most phototypesetting systems. Monotype has an excellent library of fine typefaces. Manufactures the basic Monotype, Monophoto Mark III and IV, 400 and 600 Filmsetter, and Monotype Studio Lettering. (See pages 22, 23, and 36.)

Photon, Inc.

355 Middlesex Ave.

Wilmington, Massachusetts 01887
Founded in 1950. Credited with one of the first production phototypesetting units, which it marketed in 1954. Since then has manufactured a wide range of phototypesetters for newspaper and commercial markets and maintains a large library of typefaces. Manufactures the Pacesetter Mark I, Mark II, and Mark III series (See page 35.)

Singer Graphic Systems, Inc.

151 Callan Ave.

San Leandro, California 94577

Established as a separate division of The Singer Company in January 1973, to expand and continue the manufacture and marketing of the phototypesetters and paper tape perforators formerly part of the Business Machines (Friden) Division product line. Also introduced new sophisticated phototypesetters, perforators, and CRT editing terminals for the entire graphic arts industry. Manufactures the Justotext 70 and 71; Photomix 8000, 8100, 8200, and 8400.

Star Graphic Systems, Inc.

A division of Dymo Industries 240 South Main St.

South Hackensack, New Jersey 07606 Founded in 1924 to manufacture replacement parts for linecasting ma-

chines. Today Star manufactures and sells photocomposition input and output equipment and supplies, linecasting replacement parts and service, and totally automated copy-processing systems.

Manufactures CompStar 190H, 190HU 190DL, and 191.

VariTyper

A division of Addressograph - Multigraph Corp.

11 Mount Pleasant Ave.

East Hanover, New Jersey 07936

VariTyper Division became a subsidiary of Addressograph - Multigraph Corporation in 1956. Manufactures both direct impression (typewriter composition) and phototypesetting equipment, including visual display terminals (VDT), paper tape keyboards, and phototypesetters. Also markets OCR through a national sales and service organization. Manufactures the VariTyper 744 and 748. (See page 40.)

TABLE OF PHOTOTYPESETTING SYSTEMS

The comparative table on pages 51 through 55 lists the most popular phototypesetting machines in use today, along with their basic characteristics. These characteristics are listed in order of concern to the designer, starting with typefaces, type sizes, maximum measure, and leading, and working through to more technical items such as form of input, type fonts, and typesetting speeds. (Keyboards have not been listed, as they do not directly concern the designer. It is assumed that the typographer will use the right keyboard for his equipment.) The terminology has been kept in a language familiar to the designer, and new terms have been introduced only where necessary.

To help you understand and make use of the information contained in the table, read the following explanation of the entries.

- 1. Typefaces Available. The number of typefaces presently available. (This is an approximate number and in all cases will expand as new typefaces are added.) Typeface in this case means one style of type in all sizes. For example, Helvetica roman is one typeface, Helvetica italic another. From the designer's point of view, the number of typefaces is not as important as is the quality of typeface and typesetting. Although all systems have most of the popular typefaces, the designer should not expect to find any consistency of design, style, x-height, characters per pica, etc., from one manufacturer to another.
- 2. Type Size Range. The minimum and maximum point size the machine is capable of producing. Where the type size range is extreme, such as 5 to 72 point, you can assume that this involves a font change. Generally speaking, the smaller sizes are set on one font and the larger sizes on another to avoid the distortion that may occur in type and letterspacing when type is enlarged too much.

Note: many systems can also set type in ½-point sizes, usually the text type sizes of 5 through 8 point.

- 3. Maximum Line Length. The longest possible line the machine can set, shown in picas. On some machines the maximum line length will vary depending on the type size being set. For example, the maximum line for 5-point type may be 20 picas, while the maximum line for 12point type may be 30 picas.
- 4. Leading Range. (Note: in phototypesetting leading is also referred to as interlinespacing.) Maximum amount of leading possible, shown in points. (For additional leading beyond the "maximum," lines of blank space may be keyboarded on most machines.) Although not shown, many phototypesetting machines can set type with "minus leading"; that is, -1 point (10/9), -2 points (10/8), etc. This allows the designer to set lines of type as close as he wishes, which is convenient when setting caps.

- 5. Leading Increment. The smallest fraction of a point that can be used as leading. For example, if the increment is \(\frac{1}{2} \) point, the type can be leaded as follows: $\frac{1}{2}$, 1, $\frac{1}{2}$, 2, $\frac{2}{2}$, etc.
- 6. Reverse Leading. This means that the system can set type anywhere on the film, even if it means going back. For example, it can set one column of type and then return to the top of the film to set another column. This is an excellent feature for setting tabular work or positioning heads, vertical rules, complex equations, etc. In such cases, it is possible to go directly to page makeup without having to cut and paste.

Note: accuracy and amount of reverse leading possible varies with manufacturers.

- 7. Units to the Em. Although the designer works in picas and points, phototypesetting machines work in units. The unit is a variable measurement, based on the division of the em (the square of the type size). In an 18unit system each unit is 1/18 em (or 1/18 of the type size being set). Both the line length and the type being set are measurable in units as well as in picas and points. By adding up the unit value of the characters it is possible for the machine to determine when a line is ready to be justified. (See page 15 for a complete discussion of the unit system.)
- 8. Letterspacing. The minimum and maximum spacing that can be added between letters by keyboard commands. Expressed in units. A unit is the smallest amount of letterspacing possible. The following will give you an idea of how much space this represents in points: if setting 9-point type on a 18-unit system, a unit would be 1/2 point; if setting 18point type, a unit would be 1 point; if setting 36-point type, a unit would be 2 points.

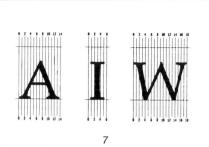

LETTERSPACE NORMAL

LETTERSPACE + 1 LINIT

LETTERSPACE + 2 UNITS

LETTERSPACE + 3 UNITS

NORMAL

Hillbilly Schoolbook

Hillbilly -1 UNIT

Schoolbook

Hillbilly -2 UNITS

Schoolbook

Hilbily -3 UNITS

Schoolbook

9

NORMAL YO, Te, LY, YA

KERNED 1 UNIT YO, Te, LY, YA

KERNED 2 UNITS YO, Te, LY, YA

Typeface mixing within a line

11

Typesize mixing within a line

Typeface and size mixing in a line

TOP ALIGNING **BOTTOM ALIGNING**

16

Name	Color	Price
Packard	Red	5,000
Edsel	Yellow	2,000
Hupmobile	Blue	3,950
Kaiser	Green	1.000
	17	

9. Minus Letterspacing. Also referred to as automatic kerning or lettertightening. The minimum and maximum amount of space that can be removed from between letters, expressed in units. This category refers to the overall minus letterspacing as compared with selective kerning (see Category 10), which involves only certain letter combinations. Minus letterspacing not only affects the number of characters that can be set to a given measure, but also the "color" of the setting: the more characters set per line the blacker, or denser, the setting will appear.

Note: when setting type with minus letterspacing, have a type specimen set that shows enough copy to enable you to properly judge the effect. You may find that the letterspacing is improved between straight letters, such as i's and I's, but that the round letters, such as o's and c's, tend to overlap. Good words to include in any sample setting are "hillbilly" and "schoolbook," because they show the effect of minus letterspacing on both straight and round letters.

- 10. Kerning. The ability to selectively reduce the letterspacing between certain letters while the rest of the setting remains the same. Shown in units. Usually used between certain letter combinations, such as Ye. Yo. Te. LY, and YA. that are generally improved by the deletion of one or two units of space. The ability to kern is particularly desirable when setting display type.
- 11. Typeface Mixing within a Line. The ability to mix a variety of typefaces in the same line. Note: this may or may not be an automatic change; that is, keyboardcommanded and tape-activated. On some machines the change is manual.
- 12. Automatic Typeface Change. Is the machine capable of changing typefaces by keyboard command (that is, tapecontrolled), or is it a manual operation? In the latter case, the machine stops, gives a visual or audible signal, and the operator changes the font by hand. This can be time-consuming and expensive; it is therefore not recommended for settings that require extensive font changes.
- 13. Type Size Mixing within a Line. The ability to mix a variety of type sizes in the same line. On some machines this change is by keyboard command, on others it is manual.

- 14. Automatic Type Size Change. Is the machine capable of changing the type size by keyboard command (tape-controlled), or is it a manual operation? If via the keyboard, it is faster, more efficient, and probably less expensive. If the type size must be changed by hand, the designer should try to limit the number of
- 15. Typeface and Type Size Mixing within a Line. The ability to mix a variety of typefaces and type sizes within the same line. Again, on some machines this change is automatic while on others it is manual.
- 16. Character Alignment. This is very important if you intend to mix typefaces, type sizes, or both. If the type is basealigning, all the characters will align along the base of the characters. If it is top-aligning or center-aligning, the type may have to be cut and pasted in mechanicals to make it base-aligning.
- 17. Tabular Facility. The ability to set columns of text or figures at predetermined locations on a given pica measure. Although not indicated, the number of tab positions available to the keyboard operator can also be important: some machines have only one, while others have as many as 300. Also important is what the system is capable of doing at each tab position; that is, can it set type flush left only, or can it also set type flush right and centered?
- 18. Pi Position Available. The designer may have occasion to set special characters that are not included in the standard font: foreign accents, characters for setting scientific formulas, mathematical equations, etc. Some machines allow blank spaces on regular fonts where pi characters can be added by the operator. These characters are either supplied by the designer or taken from the system's library of pi characters. Other systems have special pi fonts available that carry an assortment of popular pi characters. In this case, the font is added to the others in the machine by mixing.

19. Width of Paper/Film. Minimum and maximum widths only, shown in inches. Some machines are designed to use a variety of paper or film widths, permitting the use of narrower paper for jobs that are to be set in a narrow pica measure. Also, not all machines can accommodate both photosensitive paper and film; some are designed for paper only.

Note: there are three basic types of photographic materials used on phototypesetting machines: stabilization paper, photographic paper, and film. Stabilization paper is the least expensive and the most difficult to keep under control. Furthermore, if not properly fixed after processing, it will fade. Photographic paper, while more expensive, affords a higher degree of control and a higherquality image. Photographic film, which is the most expensive, produces the highest-quality results.

In all cases, the designer should be aware that failure to control exposure and development can cause perceptible variations in the weight (color) of the type, making it difficult to match corrections to the original setting.

- 20. Form of Input. The means by which the copy is recorded: paper tape (justified and unjustified), magnetic tape, direct input, computer cards, etc.
- 21. Accepts Unjustified Tapes. All systems will accept justified tapes, however not all systems will accept unjustified tapes. If the system accepts unjustified tapes it means that the linebreaks have not been resolved and that a computer unit must determine the hyphenation and justification before the type can be processed by the photo typesetting unit.
- 22. Justification. The method by which the computer makes end-of-line decisions (hyphenation and justification). (1) Hyphenless: words are not hyphenated, but extra space is added between the words, and on some machines between letters, to justify the line. (2) Discretionary: all words three syllables and over are hyphenated by the operator as he keyboards the copy. The computer uses whatever hyphenation is necessary to justify the lines of type, disregarding the other hyphenation. (3) Logic: the computer is programmed with a specific set of rules of hyphenation. All words covered by these rules will be hyphenated accordingly. If the rules cannot be applied, the word will not be hyphenated; instead, the line will be justified by add-

ing wordspace or letterspace. (4) Exception Dictionary: the computer searches a special "exception dictionary" for the word in question. If the word is there, it is hyphenated according to this dictionary; if the word is not there, it is hyphenated according to pre-programmed rules of hyphenation. (See page 34 for a complete discussion of justification.)

Five masters in one photounit.

- 23. Form of Image Master. Also referred to as the type matrix. The part of the photounit that holds the typeface fonts. Usually a disc, grid, or film strip.
- 24. Masters in Machine. The number of image masters the machine can hold at one time. Note: this number may be deceiving because some machines cannot make the change from one master to another automatically, but must depend upon an operator to make the change manually. This can affect the speed and the cost of a job.
- 25. Typefaces (Fonts) per Master. The number of typefaces (fonts) one master holds; that is, one size of one typeface, such as 10-point Helvetica roman. On some machines this one size can be reduced or enlarged to provide a range of different sizes.
- 26. Characters per Typeface (Font). The number of characters in a single typeface. Although this is usually around 90 characters, some may have as many as 190, including foreign accents, pi characters, mathematical symbols, etc.
- 27. Total Character Capacity. The total number of characters available when the machine is operating at capacity. (This figure is for one type size only; to get the total for all type sizes, this figure must be multiplied by the number of type sizes on the machine, as shown below.) The total

- character capacity for any given machine can be deceiving because all systems can make typeface and type size changes automatically; in some cases changes must be made manually. Therefore, a machine's ability to hold a large number of fonts is not to be confused with the machine's ability to set them economically.
- 28. Type Sizes on Machine. The number of type sizes the machine is capable of setting. Some systems operate on a oneto-one ratio; that is, an 8-point font sets only 8-point type. Others use a single font that can be reduced or enlarged by lenses to produce a number of different type sizes.
- 29. Lines per Minute. An industry method of measuring the typesetting speed of a machine, based on newspaper lines: straight matter in 8-point type set in 11-pica measure, or approximately 30 characters per line. Typesetting speeds are not listed for direct input keyboards, because for these the speed of setting is dictated by the speed of the keyboard operator.

Note: blank columns have been left intentionally to allow the designer to add information on any machine not listed.

	ALPHATYPE CORP.	BERTHOLD FOTOTYPE COMPANY				
	ALPHASETTE	DIATRONIC	DIATRONIC S	DIACOMP		
1. TYPEFACES AVAILABLE	200	240	240	405		
2. TYPE SIZE RANGE (POINTS)	5-18 ¹	6-20	6-20	4-51-1/2		
3. MAXIMUM LINE LENGTH (PICAS)	66	72	72	216		
4. LEADING RANGE (POINTS)	0-39	0-864	0-864	0-864		
5. LEADING INCREMENT (POINTS)	1/4	1/18	1/18	1/4		
6. REVERSE LEADING	NO ²	YES	YES	YES		
7. UNITS TO THE EM	18 ³	48	48	N.A.		
8. LETTERSPACING (UNITS)	1/2-5	1-INFINITY	1-INFINITY	1-INFINITY		
9. MINUS LETTERSPACING (UNITS)	1/2-5	1-4	1-4	1-INFINITY		
10. KERNING (UNITS)	1/2-5	1/4-INFINITY	1/4-INFINITY	1-INFINITY		
11. TYPEFACE MIXING WITHIN A LINE	YES	YES	YES	YES		
12. AUTOMATIC TYPEFACE CHANGE	YES	YES	YES	YES ⁵		
13. TYPE SIZE MIXING WITHIN A LINE	YES	YES	YES	YES		
14. AUTOMATIC TYPE SIZE CHANGE	YES	YES	YES	YES		
15. TYPEFACE AND TYPE SIZE MIXING WITHIN A LINE	YES	YES	YES	YES		
16. CHARACTER ALIGNMENT	BASELINE	BASELINE	BASELINE	BASELINE		
17. TABULAR FACILITY	YES	YES	YES	YES		
18. PI POSITIONS AVAILABLE	YES	YES	YES	YES		
19. WIDTH OF PAPER/FILM (INCHES)	12-15	12 x 12 ⁴	12 x 12 ⁴	18 x 12		
20. FORM OF INPUT	PAPER OR MAG. TAPE	DIRECT INPUT	PAPER OR MAG. TAPE	DIRECT INPUT		
21. ACCEPTS UNJUSTIFIED TAPES	YES	NO	YES	N.A.		
22. JUSTIFICATION: (1) HYPHENLESS (2) DISCRETIONARY (3) LOGIC (4) EXCEPTION DICTIONARY	1-2	N.A.	1-2-3-4	N.A.		
23. IMAGE MASTER	FILM GRID	CHROME GRID	CHROME GRID	GLASS DISC		
24. MASTERS IN MACHINE	1-5	8	8	1		
25. TYPEFACES (FONTS) PER MASTER	2	1	1	1-3		
26. CHARACTERS PER TYPEFACE (FONT)	84	126	126	195		
27. TOTAL CHARACTER CAPACITY (ONE TYPE SIZE)	840	1008	1008	195		
28. TYPE SIZES ON MACHINE	11	15	15	INFINITE 6		
29. LINES PER MINUTE (NEWSPAPER)	20	N.A.	25	N.A.	=	

		COMPUGRAF	PHIC CORP.		GRAPHIC SYSTEMS, INC.	
	COMPUWRITER	ACM 9000	2961 SERIES	4961 SERIES	SYSTEM I TYPESETTER	
1. TYPEFACES AVAILABLE	185	225	185	185	60	
2. TYPE SIZE RANGE (POINTS)	5-1/2-24	6-72	5-1/2-24	5-1/2-24	6-18	
3. MAXIMUM LINE LENGTH (PICAS)	45	45	45	45	47	
4. LEADING RANGE (POINTS)	0-31-1/2	0-99	0-31-1/2	0-31-1/2	0-1000	
5. LEADING INCREMENT (POINTS)	1/2	1/2	1/2	1/2	1/2	
6. REVERSE LEADING	NO-YES	YES	NO	NO	YES	
7. UNITS TO THE EM	18	54	18	18	36	
8. LETTERSPACING (UNITS)	1-3	1-3	1-3	1-3	1-36	
9. MINUS LETTERSPACING (UNITS)	1-INFINITY	1-INFINITY	1-INFINITY	1-INFINITY	1-36	
10. KERNING (UNITS)	1-INFINITY	1-INFINITY	1-INFINITY	1-INFINITY	1-36	
11. TYPEFACE MIXING WITHIN A LINE	YES	YES	YES	YES	YES	
12. AUTOMATIC TYPEFACE CHANGE	NO-YES	YES	YES	YES	YES	
13. TYPE SIZE MIXING WITHIN A LINE	YES	YES	NO	NO	YES	
14. AUTOMATIC TYPE SIZE CHANGE	YES	YES	NO	YES	YES	
15. TYPEFACE AND TYPE SIZE MIXING WITHIN A LINE	YES	YES	NO	NO	YES	
16. CHARACTER ALIGNMENT	BASELINE	BASELINE	BASELINE	BASELINE	BASELINE	
17. TABULAR FACILITY	YES	YES	NO	YES	YES	
18. PI POSITIONS AVAILABLE	NO ⁷	NO ⁷	NO ⁷	NO ⁷	YES	
19. WIDTH OF PAPER/FILM (INCHES)	3-8	3-8	3-8	3-8	2-8	
20. FORM OF INPUT	DIRECT INPUT	PAPER TAPE DIRECT INPUT	PAPER TAPE	PAPER TAPE	PAPER MAG. TAPE or CASSETTE	
21. ACCEPTS UNJUSTIFIED TAPES	NO	YES	YES	YES	YES	
22. JUSTIFICATION: (1) HYPHENLESS (2) DISCRETIONARY (3) LOGIC (4) EXCEPTION DICTIONARY	1-2	1-2-3	1-2-3	1-2-3	1-2-3-4	
23. IMAGE MASTER	FILM STRIP	FILM STRIP	FILM STRIP	FILM STRIP	FILM STRIP	
24. MASTERS IN MACHINE	1	2	1	1	4	
25. TYPEFACES (FONTS) PER MASTER	2-4	4	2	4	1	
26. CHARACTERS PER TYPEFACE (FONT)	96	102	96	96	102	
27. TOTAL CHARACTER CAPACITY (ONE TYPE SIZE)	192-384	816	192	384	408	
28. TYPE SIZES ON MACHINE	1-2	12	1	2	15	
29. LINES PER MINUTE (NEWSPAPER)	N.A.	25	60	25	50	

							Г			
HARRIS CORP.			MERGENTHALER LINOTYPE CO.		MONOTY	PE CORP.	PHOTON INC.			
FOTOTRONIC 600	FOTOTRONIC TXT	FOTOTRONIC 1200	LINOCOMP	VIP	600	400 FILMSETTER	PACESETTER MARK I	PACESETTER MARK II	PACESETTER MARK III	
1500	1500	1500	1000	1000	300	300	700	700	700	
5-24	5-72	5-72	6-36	6-72	6-28	5-24	5-72	5-72	5-72	
42	42	51	45	45	52	54	45	45	45	
0-42	0-99.9	0-63-3/4	0-63-1/2	0-99-1/29	0-99-1/2	0-31-1/2	0-127-1/2	0-127-1/2	0-127-1/2	
1/2	1/10	1/4	1/2	1/2	1/2	1/2	1/2	1/2	1/2	
NO	YES	YES	YES	NO	YES	YES	NO	NO	NO	
32	32	32	18	18	18	18	36	36	36	
1-INFINITY ⁸	1-INFINITY ⁸	1-INFINITY ⁸	1-9	1-9	1-INFINITY	1-INFINITY	1/2-INFINITY	1/2-INFINITY	1/2-INFINITY	
1-INFINITY	1-INFINITY	1-INFINITY	1-9	1-9	1-INFINITY	1-INFINITY	1/2-INFINITY	1/2-INFINITY	1/2-INFINITY	
NO	1-INFINITY	1-INFINITY	1-9	1-9	1-INFINITY	1-INFINITY	1/2-INFINITY	1/2-INFINITY	1/2-INFINITY	
YES	YES	YES	YES	YES	YES	YES	YES	YES	YES	
YES	YES	YES	NO	YES	YES	NO	YES	YES	YES	
YES	YES	YES	YES	YES	YES	YES	YES	YES	YES	
YES	YES	YES	NO	YES	YES	NO	YES	YES	YES	
YES	YES	YES	NO	YES	YES	YES	YES	YES	YES	
BASELINE	BASELINE	BASELINE	BASELINE	BASELINE ¹⁰ AND CENTER	BASELINE	BASELINE	BASELINE	BASELINE BASELINE		
YES	YES	YES	YES	YES	YES	YES	YES	YES	YES	
YES	NO	YES	YES	YES	YES	YES	NO	NO	NO	
3-3/4 - 7-3/4	3-3/4 - 7-3/4	3-3/4 - 9-1/4	3-8	3-8	6-10	6-10	3-10	3-10	3-10	
PAPER TAPE	PAPER OR MAG. TAPE	PAPER TAPE	DIRECT INPUT	PAPER OR MAG. TAPE	PAPER OR MAG. TAPE	PAPER TAPE	PAPER OR MAG. TAPE	PAPER OR MAG. TAPE	PAPER OR MAG. TAPE	
YES	YES	NO	NO	YES	NO	NO	YES	YES	YES	
2-3	2-3	-	1-2	1-2-3	-	_	1-2-3	1-2-3	1-2-3-4	
PLASTIC DISC	GLASS DISC	GLASS DISC	FILM STRIP	FILM STRIP	FILM DISC	FILM DISC	GLASS DISC	GLASS DISC	GLASS DISC	
1	5	5	4	6-12-18	4 11	1	1	1	1	
6	2	2	4	1	VARIABLE ¹¹	VARIABLE	4-8	2-4 4-8	8-16	
120	120	120	104	96	VARIABLE ¹¹	VARIABLE	112	112	112	
720	1200	1200	420	576-1152-1728	397	400	448-896	224-448 448-896	896-1792	
6	12	19	2	22	14	28	4-16	4-16	4-16	
50	90-150	30	N.A.	50	70	25	50	90-150	90-150	

	SING	ER GRAPHIC SYS	TEMS	STAR GRAPH	IIC SYSTEMS	
	JUXTOTEXT 70-71 ¹²	PHOTOMIX 8000, 8100, 8200	PHOTOMIX 8400	COMPSTAR 190 SERIES ¹⁶	191	
1. TYPEFACES AVAILABLE	60	100	100	50	50	
2. TYPE SIZE RANGE (POINTS)	5-12	5-18 ¹⁴	6-36	5-1/2-24	5-1/2-48	
3. MAXIMUM LINE LENGTH (PICAS)	36	47	47	33	45	
4. LEADING RANGE (POINTS)	0-31-1/2	U-31-1/2 ¹⁵	0-1000	0-31-1/2	0-99-1/2	
5. LEADING INCREMENT (POINTS)	1/2	1/2	1/2	1/2	1/2	
6. REVERSE LEADING	NO	NO	YES	NO	NO	
7. UNITS TO THE EM	5	36	36	18	.001"	
8. LETTERSPACING (UNITS)	1-3	1-INFINITY	1-INFINITY	1-1.8	.001"-INFINITY	
9. MINUS LETTERSPACING (UNITS)	NO	1-INFINITY	1-INFINITY	NO	.001"-INFINITY	
10. KERNING (UNITS)	NO	1-INFINITY	1-INFINITY	NO	.001"-INFINITY	
11. TYPEFACE MIXING WITHIN A LINE	YES	YES	YES	YES	YES	
12. AUTOMATIC TYPEFACE CHANGE	YES	YES	YES	YES	YES	
13. TYPE SIZE MIXING WITHIN A LINE	NO	YES	YES	NO	YES	
14. AUTOMATIC TYPE SIZE CHANGE	NO	YES	YES	YES	YES	
15. TYPEFACE AND TYPE SIZE MIXING WITHIN A LINE	NO	YES	YES	NO	YES	
16. CHARACTER ALIGNMENT	BASELINE	BASELINE	BASELINE	BASELINE	BASELINE	
17. TABULAR FACILITY	NO	YES	YES	YES ¹⁷	YES	
18. PI POSITIONS AVAILABLE	YES ¹³	YES ¹³	YES ¹³	YES	YES	
19. WIDTH OF PAPER/FILM (INCHES)	2-6	2-8	2-8	3-8	3-8	
20. FORM OF INPUT	PAPER TAPE	PAPER TAPE	PAPER TAPE	PAPER OR MAG. TAPE	PAPER OR MAG. TAPE	
21. ACCEPTS UNJUSTIFIED TAPES	YES	YES	YES	YES	YES	
22. JUSTIFICATION: (1) HYPHENLESS (2) DISCRETIONARY (3) LOGIC (4) EXCEPTION DICTIONARY	1-3	1-2-3	1-2-3-4	1-2-3	1-2-3	
23. IMAGE MASTER	FILM STRIP	FILMSTRIP	FILMSTRIP	FILMSTRIP	FILMSTRIP	
24. MASTERS IN MACHINE	1	4	4	1	1	
25. TYPEFACES (FONTS) PER MASTER	2	1	1	2	6-8	
26. CHARACTERS PER TYPEFACE (FONT)	90	102	102	120	110	
27. TOTAL CHARACTER CAPACITY (ONE TYPE SIZE)	180	408	408	240	660-880	
28. TYPE SIZES ON MACHINE	1	9-10	15	2	16	
29. LINES PER MINUTE (NEWSPAPER)	30	30	45	150	150	

_	T	· · · · · · · · · · · · · · · · · · ·	т		
_	VARI	TYPER			
	744	748			
	40	40			
	5-18 ¹⁸	5-72			
	20-33	20-45			
	0-49-1/2	0-99-1/2			
	1/2	1/2			
	NO	NO			
	18	18			
	1-6	1-6			
	1-6	1-6			
	1-6	1-6			
	YES	YES			
	YES	YES			
	NO	YES			
	YES ¹⁹	YES			
	NO	YES			
	BASELINE	BASELINE			
	YES	YES			
	YES	YES			
	4-8	4-8			
	PAPER TAPE	PAPER OR MAG. TAPE			
	YES	YES			
	1-2-3-4	1-2-3-4			
	DISC	DISC			
	1	1			
	4	4			
	112	112			
	448	448			
	4 20	8			
	30	50			

NOTES

- N.A. Not applicable.
- 1. For larger sizes—20 through 96 point—a special enlarger font is used. The copy is keyboarded onmachine, but must be enlarged in a separate off-machine unit.
- 2. Optional.
- 3. Can be modified to 36 unit. Op-
- 4. Rolls available 54" wide by 12" high.
- 5. Can mix only two typefaces automatically.
- 6. Capable of setting type in increments of 1 point.
- 7. Pi film strips can be factory ordered.
- 8. Fixed spaces also available in the following pica measurements: 1/64, 1/32, 1/16, 1/8, 1/4, 1/2, and 1.
- 9. Also available with a leading range of 0 through 631/2 points.
- 10. On some models 6-point through 24-point type is base-aligning while 12-point through 48-point type is center-aligning. Other models are all base-aligning.
- 11. Besides holding 4 film discs, the 600 can also accommodate 100 35mm slides holding additional characters.
- 12. Justotext 70 and 71 are basically the same except for the following: Justotext 70 requires a counting keyboard and does not accept unjustified tapes; Justotext 70 has a leading range from 0-31 in 1-point increments.
- 13. Pi fonts are available, or individual characters can be added at the factory.
- 14.8200 can set type from 6 through 36 point.
- 15. 8100 and 8200 have a leading range from 0 through $127\frac{1}{2}$ point.
- 16. Available in three models: 190H. 190HU, and 190DL. 190H has option of automatic hyphenation; 190HU adds unitization (capability of setting typefaces based on 18-unit system); and 190DL has a dual lens for setting display and text or two different point sizes at one time.
- 17. Single tab position only.
- 18. Under 8 point, sets to shorter measure; over 8 point, sets to larger measure.
- 19. For two sizes only.
- 20. Although the machine can set 10 sizes, it can only accomodate two lenses and therefore can set only two sizes at a time.

Type Specimens

To enable the designer to see the enormous difference in the various typesetting systems, we asked 12 major manufacturers of machine composition (casting), typewriter composition, and phototypesetting systems to set specimens of the same five widely used and familiar typefaces: Baskerville, Bodoni, Century Expanded, Garamond, and Helvetica. (In several cases the exact typeface was not available, so a sample of a similar typeface was used instead.) All specimens are set in 10-point type with 2 points leading. They are shown in alphabetical order and are identified both by their original names (as above) and by the manufacturer's special names. The designer should note that not only is the type design from one system to another different, but the number of characters per pica (set width) varies as well.

The systems represented are: Alphatype Corp./photo Berthold Fototype Co./photo Compugraphic Corp./photo Graphic Systems, Inc./photo Harris Corp. / photo IBM/typewriter Mergenthaler Linotype/cast and photo Monotype Corp. Ltd./cast and photo Photon, Inc./photo Singer Graphic Systems/photo Star Graphics Systems/photo VariTyper/typewriter and photo

ALPHATYPE

I am the voice of today, the herald of tomorrow. I am type! Of my earliest ancestry neither history nor relics remain. The wedge-shaped symbols impressed in plastic clay in the dim past by Babylonian builders foreshadowed me: from them, on through the hieroglyphs of the ancient Egyptians, down to the beautiful manuscript letters of the medieval scribes, I was in the making. Johann Gutenberg was the first to cast me in metal. From his chance thought straying through an idle reverie—a dream most golden—the profound art of printing with mov-GARAMOND

I am the voice of today, the herald of tomorrow. I am type! Of my earliest ancestry neither history nor relics remain. The wedge-shaped symbols impressed in plastic clay in the dim past by Babylonian builders foreshadowed me: from them, on through the hieroglyphs of the ancient Egyptians, down to the beautiful manuscript letters of the medieval scribes, I was in the making. Johann Gutenberg was the first to cast me in metal. From his chance thought straying through an idle reverie-a dream most golden-the profound BASKERLINE (BASKERVILLE)

I am the voice of today, the herald of tomorrow. I am type! Of my earliest ancestry neither history nor relics remain. The wedge-shaped symbols impressed in plastic clay in the dim past by Babylonian builders foreshadowed me: from them, on through the hieroglyphs of the ancient Egyptians, down to the beautiful manuscript letters of the medieval scribes, I was in the making. Johann Gutenberg was the first to cast me in metal. From his chance thought straying through and idle reverie-a dream most golden BODONI

I am the voice of today, the herald of tomorrow. I am type! Of my earliest ancestry neither history nor relics remain. The wedge-shaped symbols impressed in plastic clay in the dim past by Babylonian builders foreshadowed me: from them, on through the hieroglyphs of the ancient Egyptians down to the beautiful manuscript letters of the medieval scribes, I was in the making. Johann Gutenberg was the first to cast me in metal. From his chance thought straying through

CENTURY EXPANDED

I am the voice of today, the herald of tomorrow. I am type! Of my earliest ancestry neither history nor relics remain. The wedge-shaped symbols impressed in plastics clay in the dim past by Babylonian builders foreshadowed me: from them, on through the hieroglyphs of the ancient Egyptians, down to the beautiful manuscript letters of the medieval scribes, I was in the making. Johann Gutenberg was the first to cast me in metal. From his chance thought stray-

CLARO (HELVETICA)

BERTHOLD FOTOTYPE

I am the voice of today, the herald of tomorrow. I am type! Of my earliest ancestry neither history nor relics remain. The wedge-shaped symbols impressed in plastic clay in the dim past by Babylonian builders foreshadowed me: from them, on through the hieroglyphs of the ancient Egyptians, down to the beautiful manuscript letters of the medieval scribes, I was in the making. Johann Gutenberg was the first to cast me in metal. From his chance thought straying through an idle reserie-a dream most golden-the profound art of printing with movable types was born. Cold GARAMOND

I am the voice of today, the herald of tomorrow. I am type! Of my earliest ancestry neither history nor relics remain. The wedge-shaped symbols impressed in plastic clay in the dim past by Babylonian builders foreshadowed me: from them, on through the hieroglyphs of the ancient Egyptians, down to the beautiful manuscript letters of the medieval scribes, I was in the making. Johann Gutenberg was the first to cast me in metal. From his chance thought straying through idle reverie-a dream most golden-the profound art of printing with BASKERVILLE

I am the voice of today, the herald of tomorrow. I am type. Of my earliest ancestry neither history nor relics remain. The wedge-shaped symbols impressed in plastic clay in the dim past by Babylonian builders foreshadowed me: from them, on through the hieroglyphs of the ancient Egyptians, down to the beautiful manuscript letters of the medieval scribes, I was in the making. Johann Gutenberg was the first to cast me in metal. From his chance thought straying through an idle reverie-a dream most golden-the profound art of BODONI

I am the voice of today, the herald of tomorrow. I am type! Of my earliest ancestry neither history nor relics remain. The wedge-shaped symbols impressed in plastic clay in the dim past by Babylonian builders foreshadowed me: from them, on through the hieroglyphs of the ancient Egyptians, down to the beautiful manuscript letters of the medieval scribes, I was in the making. Johann Gutenberg was the first to cast me in metal. From his chance thought straying through idle reverie-a dream most golden-the CENTURY EXPANDED

I am the voice of today, the herald of tomorrow. I am type! Of my earliest ancestry neither history nor relics remain. The wedge-shaped symbols impressed in plastic clay in the dim past by Babylonian builders foreshadowed me: from them, on through the hieroglyphs of the ancient Egyptians, down to the beautiful manuscript letters of the medieval scribes, I was in the making. Johann Gutenberg was the first to cast me in metal. From his chance thought straying through idle reverie-a dream most golden-HELVETICA

COMPUGRAPHIC

I am the voice of today, the herald of tomorrow. I am type! Of my earliest ancestry neither history nor relics remain. The wedge-shaped symbols impressed in plastic clay in the dim past by Babylonian builders foreshadowed me: from them, on through the hieroglyphs of the ancient Egyptians, down to the beautiful manuscript letters of the medieval scribes, I was in the making. Johann Gutenberg was the first to cast me in metal. From this chance thought straying through an idle reverie —a golden dream—the profound art of printing with movable GARAMOND

I am the voice of today, the herald of tomorrow. I am type! Of my earliest ancestry neither history nor relics remain. The wedge-shaped symbols impressed in plastic clay in the dim past by Babylonian builders foreshadowed me: from them, on through the hieroglyphs of the ancient Egyptians, down to the beautiful manuscript letters of the medieval scribes, I was in the making. JOHANN GUTENBERG was the first to cast me in metal. From his chance thought straying through an idle reverie—a dream most golden—the pro-BASKERVILLE

I am the voice of today, the herald of tomorrow. I am type! Of my earliest ancestry neither history nor relics remain. The wedge-shaped symbols impressed in plastic clay in the dim past by Babylonian builders foreshadowed me: from them, on through the hieroglyphs of the ancient Egyptians, down to the beautiful manuscript letters of the medieval scribes, I was in the making. Johann Gutenberg was the first to cast me in metal. From his chance thought straying through an idle reverie—a dream most golden— BODONI

I am the voice of today, the herald of tomorrow. I am type! Of my earliest ancestry neither history nor relics remain. The wedge-shaped symbols impressed in plastic clay in the dim past by Babylonian builders foreshadowed me: from them, on through the hieroglyphs of the ancient Egyptians, down to the beautiful manuscript letters of the medieval scribes, I was in the making. Johann Gutenberg was the first to cast me in metal. From his chance thought straying through an CENTURY TEXTBOOK (CENTURY SCHOOLBOOK)

I am the voice of today, the herald of tomorrow. I am type! Of my earliest ancestry neither history nor relics remain. The wedge-shaped symbols impressed in plastic clay in the dim past by Babylonian builders foreshadowed me: from them, on through the hieroglyphs of the ancient Egyptians, down to the beautiful manuscript letters on the medieval scribes, I was in the making. Johannn Gutenberg was the first to cast me in metal. From his chance

HELIOS (HELVETICA)

GRAPHIC SYSTEMS

I am the voice of today, the herald of tomorrow. I am type! Of my earliest ancestry neither history nor relics remain. The wedge-shaped symbols impressed in plastic clay in the dim past by Babylonian builders foreshadowed me: from them, on through the hieroglyphs of the ancient Egyptians, down to the beautiful manuscript letters of the medieval scribes, I was in the making. JOHANN GUTENBERG was the first to cast me in metal. From his change thought straying through an idle GARAMOND

I am the voice of today, the herald of tomorrow. I am type! Of my earliest ancestry neither history nor relics remain. The wedge-shaped symbols impressed in plastic clay in the dim past by Babylonian builders foreshadowed me: from them, on through the hieroglyphs of the ancient Egyptians, down to the beautiful manuscript letters of the medieval scribes, I was in the making. Johann Gutenberg was the first to cast me in metal. From his change thought straying through an idle BASKERVILLE

I am the voice of today, the herald of tomorrow. I am type! Of my earliest ancestry neither history nor relics remain. The wedge-shaped symbols impressed in plastic clay in the dim past by Babylonian builders foreshadowed me: from them, on through the hieroglyphs of the ancient Egyptians, down to the beautiful manuscript letters of the medieval scribes, I was in the making. Johann Gutenberg was the first to cast me in metal. From his change thought straying through EDINBURGH (CALEDONIA)

I am the voice of today, the herald of tomorrow. I am type! Of my earliest ancestry neither history nor relics remain. The wedge-shaped symbols impressed in plastic clay in the dim past by Babylonian builders foreshadowed me: from them, on through the hieroglyphs of the ancient Egyptians, down to the beautiful manuscript letters of the medieval scribes, I was in the making. Johann Gutenberg was the first to cast me in metal. From his change thought straying through an CENTURY EXPANDED

I am the voice of today, the herald of tomorrow. I am type! Of my earliest ancestry neither history nor relics remain. The wedge-shaped symbols impressed in plastic clay in the dim past by Babylonian builders foreshadowed me: from them, on through the hieroglyphs of the ancient Egyptians, down to the beautiful manuscript letters of the medieval scribes, I was in the making. JOHANN GUTENBERG was the first to cast me in metal. From GENEVA

IBM (TYPEWRITER)

I am the voice of today, the herald of tomorrow. I am type! Of my earliest ancestry neither history nor relics remain. The wedge-shaped symbols impressed in plastic clay in the dim past by Babylonian builders foreshadowed me from them on through the hieroglyphs of the ancient Egyptians, down to the beautiful manuscript letters of the medieval scribes. I was in the making. Johann Gutenberg was the first to cast me in precious stores of knowledge and wisdom long hidden in the grave of ignorance; I coin for you the enchanting tale, the PRESS ROMAN (TIMES ROMAN)

I am the voice of today, the herald of tomorrow. I am type! Of my earliest ancestry neither history nor relics remain. The wedge-shaped symbols impressed in plastic clay in the dim past by Babylonian builders foreshadowed me from them on through the hieroglyphs of the ancient Egyptians, down to the beautiful manuscript letters of the medieval scribes. I was in the making. Johann Gutenberg was the first to cast me in precious stores of knowledge and wisdom long hidden in the grave of ignorance; I coin for you the enchanting tale, the BASKERVILLE

I am the voice of today, the herald of tomorrow. I am type! Of my earliest ancestry neither history nor relics remain. The wedge-shaped symbols impressed in plastic clay in the dim past by Babylonian builders foreshadowed me from them on through the hieroglyphs of the ancient Egyptians, down to the beautiful manuscript letters of the medieval scribes. I was in the making. Johann Gutenberg was the first to cast me in precious stores of knowledge and wisdom long hidden in the grave of ignorance; I coin for you the enchanting tale, the BODONI

I am the voice of today, the herald of tomorrow. I am type! Of my earliest ancestry neither history nor relics remain. The wedge-shaped symbols impressed in plastic clay in the dim past by Babylonian builders foreshadowed me from them on through the hieroglyphs of the ancient Egyptians, down to the beautiful manuscript letters of the medieval scribes. I was precious stores of knowledge and wisdom long hidden in the grave of ignorance; I coin for you the CENTURY EXPANDED

I am the voice of today, the herald of tomorrow. I am type! Of my earliest ancestry neither history nor relics remain. The wedge-shaped symbols impressed in plastic clay in the dim past by Babylonian builders foreshadowed me from them on through the hieroglyphs of the ancient Egyptians, down to the beautiful manuscript letters of the medieval scribes. I was in the making. Johann Gutenberg was the first to cast me in precious stores of knowledge and wisdom long hidden in the grave of ignorance; I coin for you the enchanting tale, the UNIVERS

HARRIS FOTOTRONIC (PHOTO)

I am the voice of today, the herald of tomorrow. I am type! Of my earliest ancestry neither history nor relics remain. The wedge-shaped symbols impressed in plastic clay in the dim past by Babylonian builders foreshadowed me: from them, on through the hieroglyphs of the ancient Egyptians, down to the beautiful manuscript letters of the medieval scribes, I was in the making. JOHANN GUTENBERG was the first to cast me in metal. From his chance thought straying through an idle reverie-a dream most golden-the profound art of printing with movable types was GARAMOND

I am the voice of today, the herald of tomorrow. I am type! Of my earliest ancestry neither history nor relics remain. The wedge-shaped symbols impressed in plastic clay in the dim past by Babylonian builders foreshadowed me: from them, on through the hieroglyphs of the ancient Egyptians, down to the beautiful manuscript letters of the medieval scribes, I was in the making. Jo-HANN GUTENBERG was the first to cast me in metal. From his chance thought straying through an idle reverie-a dream most BASKERVILLE

I am the voice of today, the herald of tomorrow. I am type! Of my earliest ancestry neither history nor relics remain. The wedge-shaped symbols impressed in plastic clay in the dim past by Babylonian builders foreshadowed me: from them, on through the hieroglyphs of the ancient Egyptians, down to the beautiful manuscript letters of the medieval scribes, I was in the making. Johann Gutenberg was the first to cast me in metal. From his chance thought straying through an idle reverie-a dream most golden-the pro-BODONI

I am the voice of today, the herald of tomorrow. I am type! Of my earliest ancestry neither history nor relics remain. The wedge-shaped symbols impressed in plastic clay in the dim past by Babylonian builders foreshadowed me: from them, on through the hieroglyphs of the ancient Egyptians, down to the beautiful manuscript letters of the medieval scribes, I was in the making. Johann Gutenberg was the first to cast me in metal. From his chance thought straying CENTURY EXPANDED

I am the voice of today, the herald of tomorrow. I am type! Of my earliest ancestry neither history nor relics remain. The wedge-shaped symbols impressed in plastic clay in the dim past by Babylonian builders foreshadowed me: from them, on through the hieroglyphs of the ancient Egyptians, down to the beautiful manuscript letters of the medieval scribes, I was in the making. JOHANN GUTENBERG was the first to cast me in metal. From his chance VEGA (HELVETICA)

MERGENTHALER LINOTYPE (CAST)

I am the voice of today, the herald of tomorrow. I am type! Of my earliest ancestry neither history nor relics remain. The wedge-shaped symbols impressed in plastic clay in the dim past by Babylonian builders foreshadowed me: from them, on through the hieroglyphs of the ancient Egyptians, down to the beautiful manuscript letters of the medieval scribes, I was in the making. JOHANN GUTENBERG was the first to cast me in metal. From his chance thought straying through an idle reverie—a dream most golden—the profound art of printing GARAMOND #3

I am the voice of today, the herald of tomorrow. I am type! Of my earliest ancestry neither history nor relics remain. The wedge-shaped symbols impressed in plastic clay in the dim past by Babylonian builders foreshadowed me: from them, on through the hieroglyphs of the ancient Egyptians, down to the beautiful manuscipt letters of the medieval scribes, I was in the making. Johann GUTENBERG was the first to cast me in metal. From his chance thought straying through an idle reverie—a BASKERVILLE

I am the voice of today, the herald of tomorrow. I am type! Of my earliest ancestry neither history nor relics remain. The wedge-shaped symbols impressed in plastic clay in the dim past by Babylonian builders foreshadowed me: from them, on through the hieroglyphs of the ancient Egyptians, down to the beautiful manuscript letters of the medieval scribes, I was in the making. Johann Gutenberg was the first to cast me in metal. From his chance thought straying through an idle BODONI

I am the voice of today, the herald of tomorrow. I am type! Of my earliest ancestry neither history nor relics remain. The wedge-shaped symbols impressed in plastic clay in the dim past by Babylonian builders foreshadowed me: from them, on through the hieroglyphs of the ancient Egyptians, down to the beautiful manuscript letters of the medieval scribes, I was in the making, Johann Gutenberg was the first to cast me in metal. From his chance CENTURY EXPANDED

I am the voice of today, the herald of tomorrow. I am type! Of my earliest ancestry neither history nor relics remain. The wedge-shaped symbols impressed in plastic clay in the dim past by Babylonian builders foreshadowed me: from them, on through the hieroglyphs of the ancient Egyptians, down to the beautiful manuscript letters of the medieval scribes, I was in the making. Johann Gutenberg was the first to cast me in metal. From his chance thought straying HELVETICA

MERGENTHALER VIP (PHOTO)

I am the voice of today, the herald of tomorrow. I am type! Of my earliest ancestry neither history nor relics remain. The wedge-shaped symbols impressed in plastic clay in the dim past by Babylonian builders foreshadowed me: from them, on through the hieroglyphs of the ancient Egyptians, down to the beautiful manuscript letters of the medieval scribes, I was in the making. Johann Gutenberg was the first to cast me in metal. From his chance thought straying through an idle reverie-a dream most golden—the profound art of printing with movable types was born. GARAMOND #3

I am the voice of today, the herald of tomorrow. I am type! Of my earliest ancestry neither history nor relics remain. The wedge-shaped symbols impressed in plastic clay in the dim past by Babylonian builders foreshadowed me: from them, on through the hieroglyphs of the ancient Egyptians, down to the beautiful manuscript letters of the medieval scribes, I was in the making. Johann Gutenberg was the first to cast me in metal. From his chance thought straying through an idle reverie—a BASKERVILLE

I am the voice of today, the herald of tomorrow. I am type! Of my earliest ancestry neither history nor relics remain. The wedge-shaped symbols impressed in plastic clay in the dim past by Babylonian builders foreshadowed me: from them, on through the hieroglyphs of the ancient Egyptians, down to the beautiful manuscript letters of the medieval scribes, I was in the making. Johann Gutenberg was the first to cast me in metal. From his chance thought straying through an idle reverie—a dream most golden BODONI

I am the voice of today, the herald of tomorrow. I am type! Of my earliest ancestry neither history nor relics remain. The wedge-shaped symbols impressed in plastic clay in the dim past by Babylonian builders foreshadowed me: from them, on through the hieroglyphs of the ancient Egyptians, down to the beautiful manuscript letters of the medieval scribes, I was in the making. Johann Gutenberg was the first to cast me in metal. From his chance thought straying through an CENTURY EXPANDED

I am the voice of today, the herald of tomorrow. I am type! Of my earliest ancestry neither history nor relics remain. The wedge-shaped symbols impressed in plastic clay in the dim past by Babylonian builders foreshadowed me: from them, on through the hieroglyphs of the ancient Egyptians, down to the beautiful manuscript letters of the medieval scribes, I was in the making. Johann Gutenberg was the first to cast me in metal. From his chance thought straying through an HELVETICA

MONOTYPE (CAST)

I am the voice of today, the herald of tomorrow. I am type! Of my earliest ancestry neither history nor relics remain. The wedge-shaped symbols impressed in plastic clay in the dim past by Babylonian builders foreshadowed me: from them, on through the hieroglyphs of the ancient Egyptians, down to the beautiful manuscript letters of the medieval scribes, I was in the making. Johann Gutenberg was the first to cast me in metal. From his chance thought straying through an idle reverie – a dream most golden – the profound art of printing GARAMOND

I am the voice of today, the herald of tomorrow. I am type! Of my earliest ancestry neither history nor relics remain. The wedge-shaped symbols impressed in plastic clay in the dim past by Babylonian builders foreshadowed me: from them, on through the hieroglyphs of the ancient Egyptians, down to the beautiful manuscript letters of the medieval scribes, I was in the making. Johann Gutenberg was the first to cast me in metal. From his chance thought straying through an idle reverie - a dream most golden - the profound art BASKERVILLE

I am the voice of today, the herald of tomorrow. I am type! Of my earliest ancestry neither history nor relics remain. The wedge-shaped symbols impressed in plastic clay in the dim past by Babylonian builders foreshadowed me: from them, on through the hieroglyphs of the ancient Egyptians, down to the beautiful manuscript letters of the medieval scribes, I was in the making. Johann Gutenberg was the first to cast me in metal. From his chance thought straying through an idle reverie - a dream most golden - the profound BODONI

I am the voice of today, the herald of tomorrow. I am type! Of my earliest ancestry neither history nor relics remain. The wedge-shaped symbols impressed in plastic clay in the dim past by Babylonian builders foreshadowed me: from them, on through the hieroglyphs of the ancient Egyptians, down to the beautiful manuscript letters of the medieval scribes, I was in the making. Johann Gutenberg was the first to cast me in metal. From his chance thought straying CENTURY EXPANDED

I am the voice of today, the herald of tomorrow. I am type! Of my earliest ancestry neither history nor relics remain. The wedge-shaped symbols impressed in plastic clay in the dim past by Babylonian builders foreshadowed me: from them, on through the hieroglyphs of the ancient Egyptians, down to the beautiful manuscript letters of the medieval scribes, I was in the making. Johann Gutenberg was the first to cast me in metal. From his chance thought straying through an idle HELVETICA

MONOTYPE (PHOTO)

I am the voice of today, the herald of tomorrow. I am type! Of my earliest ancestry neither history nor relics remain. The wedge-shaped symbols impressed in plastic clay in the dim past by Babylonian builders foreshadowed me: from them, on through the hieroglyphs of the ancient Egyptians, down to the beautiful manuscript letters of the medieval scribes, I was in the making. JOHANN GUTENBERG was the first to cast me in metal. From his chance thought straying through an idle reverie – a dream most golden – the profound art of printing GARAMOND

I am the voice of today, the herald of tomorrow. I am type! Of my earliest ancestry neither history nor relics remain. The wedge-shaped symbols impressed in plastic clay in the dim past by Babylonian builders foreshadowed me: from them, on through the hieroglyphs of the ancient Egyptians, down to the beautiful manuscript letters of the medieval scribes, I was in the making. Johann Gutenberg was the first to cast me in metal. From his chance thought straying through an idle reverie - a dream most golden - the profound art BASKERVILLE

I am the voice of today, the herald of tomorrow. I am type! Of my earliest ancestry neither history nor relics remain. The wedge-shaped symbols impressed in plastic clay in the dim past by Babylonian builders foreshadowed me: from them, on through the hieroglyphs of the ancient Egyptians, down to the beautiful manuscript letters of the medieval scribes, I was in the making. Johann Gutenberg was the first to cast me in metal. From his chance thought straying through an idle reverie - a dream most golden - the profound BODONI

I am the voice of today, the herald of tomorrow. I am type! Of my earliest ancestry neither history nor relics remain. The wedge-shaped symbols impressed in plastic clay in the dim past by Babylonian builders foreshadowed me: from them, on through the hieroglyphs of the ancient Egyptians, down to the beautiful manuscript letters of the medieval scribes, I was in the making. Johann Gutenberg was the first to cast me in metal. From his chance thought straying CENTURY EXPANDED

I am the voice of today, the herald of tomorrow. I am type! Of my earliest ancestry neither history nor relics remain. The wedge-shaped symbols impressed in plastic clay in the dim past by Babylonian builders foreshadowed me: from them, on through the hieroglyphs of the ancient Egyptians, down to the beautiful manuscript letters of the medieval scribes, I was in the making. Johann Gutenberg was the first to cast me in metal. From his chance thought straying through HELVETICA

PHOTON

I am the voice of today, the herald of tommorrow. I am type! Of my earliest ancestry neither history nor relics remain. The wedgeshaped symbols impressed in plastic clay in the dim past by Babylonian builders foreshadowed me: from them, on through the hieroglyphs of the ancient Egyptians, down to the beautiful manuscript letters of the medieval scribes, I was in the making. Johann Gutenberg was the first to cast me in metal. From his chance thought straying through an idle reverie—a dream most golden—the profound art of printing with movable types was GARAMOND

I am the voice of today, the herald of tommorrow. I am type! Of my earliest ancestry neither history nor relics remain. The wedge-shaped symbols impressed in plastic clay in the dim past by Babylonian builders foreshadowed me: from them, on through the hieroglyphs of the ancient Egyptians, down to the beautiful manuscript letters of the medieval scribes, I was in the making. Johann Gutenberg was the first to cast me in metal. From his chance thought straying through an idle reverie - a dream most though BASKERVILLE

I am the voice of today, the herald of tommorrow. I am type! Of my earliest ancestry neither history nor relics remain. The wedge-shaped symbols impressed in plastic clay in the dim past by Babylonian builders foreshadowed me: from them, on through the hieroglyphs of the ancient Egyptians, down to the beautiful manuscript letters of the medieval scribes, I was in the making. Johann Gutenberg was the first to cast me in metal. From his chance thought straying through an idle reverie - a dream straying thro BODONI

I am the voice of today, the herald of tomorrow. I am type! Of my earliest ancestry neither history nor relics remain. The wedge-shaped symbols impressed in plastic clay in the dim past by Babylonian builders foreshadowed me: from them, on through the hieroglyphs of the ancient Egyptians, down to the beautiful manuscript letters of the medieval scribes, I was in the making. Johann Gutenberg was the first to cast me in metal. From his chance thought straying CENTURY SCHOOLBOOK 455

I am the voice of today, the herald of tomorrow. I am type! Of my earliest ancestry neither history nor relics remain. The wedge-shaped symbols impressed in plastic clay in the dim past by Babylonian builders foreshadowed me: from them, on through the hieroglyphs of the ancient Egyptians, down to the beautiful manuscript letters of the medieval scribes, I was in the making. Johann Gutenberg was the first to cast me in metal. From his chance thought straying

NEWTON MEDIUM 597

SINGER

I am the voice of today, the hearld of tomorrow. I am type! Of my earliest ancestry neither history nor relics remain. The wedge-shaped symbols impressed in plastic clay in the dim past by Babylonian builders foreshadowed me: from them, on through the hieroglyphs of the ancient Egyptians, down to the beautiful manuscript letters of the medieval scribes, I was in the making. JOHANN GUTENBERG was the first to cast me in metal. From his chance thought straying through an idle reverie—a dream most gold-GRENADA

I am the voice of today, the hearld of tomorrow. I am type! Of my earliest ancestry neither history nor relics remain. The wedge-shaped symbols impressed in plastic clay in the dim past by Babylonian builders foreshadowed me: from them, on through the hieroglyphs of the ancient Egyptians, down to the beautiful manuscript letters of the medieval scribes, I was in the making. JOHANN GUTENBERG was the first to cast me in metal. From his chance thought straying through an idle reverie—a dream most golden—the profound art of print-BEAUMONT

I am the voice of today, the hearld of tomorrow. I am type! Of my earliest ancestry neither history nor relics remain. The wedge-shaped symbols impressed in plastic clay in the dim past by Babylonian builders foreshadowed me: from them, on through the hieroglyphs of the ancient Egyptians, down to the beautiful manuscript letters of the medieval scribes, I was in the making. JOHANN GUTENBERG was the first to cast me in metal. From his chance thought straying through an idle reverie—a dream most BRUNSWICK

I am the voice of today, the hearld of tomorrow. I am type! Of my earliest ancestry neither history nor relics remain. The wedge-shaped symbols impressed in plastic clay in the dim past by Babylonian builders foreshadowed me: from them, on through the hieroglyphs of the ancient Egyptians, down to the beautiful manuscript letters of the medieval scribes, I was in the making. Johann Gutenberg was the first to cast me in metal. From his chance thought stray-CAMBRIDGE EXP.

I am the voice of today, the hearld of tomorrow. I am type! Of my earliest ancestry neither history nor relics remain. The wedge-shaped symbols impressed in plastic clay in the dim past by Babylonian builders foreshadowed me: from them, on through the hieroglyphs of the ancient Egyptians, down to the beautiful manuscript letters of the medieval scribes, I was in the making. JOHANN GUTENBERG was the first to cast me in metal. From his chance thought straying through an

STAR GRAPHICS

I am the voice of today, the herald of tomorrow. I am type! Of my earliest ancestry neither history nor relics remain. The wedge-shaped symbols impressed in plastic clay in the dim past by Babylonian builders foreshadowed me: from them, on through the hieroglyphs of the ancient Egyptians, down to the beautiful manuscript letters of the medieval scribes, I was in the making. Johann Gutenberg was the first to cast me in metal. From his chance thought straying through an idle reverie - a dream most golden - the profound art of printing GARASTAR

I am the voice of today, the herald of tomorrow. I am type! Of my earliest ancestry neither history nor relics remain. The wedge-shaped symbols impressed in plastic clay in the dim past by Babylonian builders foreshadowed me: from them, on through the hieroglyphs of the ancient Egyptians, down to the beautiful manuscript letters of the medieval scribes, I was in the making. Johann Gutenberg was the first to cast me in metal. From his chance thought straying through an BASKERSTAR

I am the voice of today, the herald of tomorrow. I am type! Of my earliest ancestry neither history nor relics remain. The wedge-shaped symbols impressed in plastic clay in the dim past by Babylonian builders foreshadowed me: from them, on through the hieroglyphs of the ancient Egyptians, down to the beautiful manuscript letters of the medieval scribes, I was in the making. Johann Gutenberg was the first to cast me in metal. From his chance BONDONISTAR

I am the voice of today, the herald of tomorrow. I am type! Of my earliest ancestry neither history The wedgeshaped symbols nor relics remain. impressed in plastic clay in the dim past by Babylonian builders foreshadowed me: from them, on down to the beautiful manuscript letters of the medieval scribes, I was in the making. Johann was in the making. Johann Gutenberg was the first to cast me in metal. From his chance thought CENTSTAR EXPANDED

I am the voice of today, the herald of tomorrow. I am type! Of my earliest ancestry neither history nor relics remain. The wedge-shaped impressed in plastic clay in the dim past by Babylonian builders foreshadowed me: from them, on through the hieroglyphs of the ancient Egyptians, down to the beautiful manuscript letters of the medieval scribes, I was in the making. Johann Gutenberg was the first to cast me in

HELVETSTAR

VARITYPER (PHOTO)

I am the voice of today, the herald of tomorrow. I am type! Of my earliest ancestry neither history nor relics remain. The wedge-shaped symbols impressed in plastic clay in the dim past by Babylonian builders foreshadowed me: from them, on through the hieroglyphs of the ancient Egyptians, down to the beautiful manuscript letters of the medieval scribes, I was in the making. Johann Gutenberg was the first to cast me in metal. From his chance thought straying through an idle reverie—a dream most GARAMOND

I am the voice of today, the herald of tomorrow. I am type! Of my earliest ancestry neither history nor relics remain. The wedge-shaped symbols impressed in plastic clay in the dim past by Babylonian builders foreshadowed me: from them, on through the hieroglyphs of the ancient Egyptians, down to the beautiful manuscript letters of the medieval scribes, I was in the making. Johann Gutenberg was the first to cast me in metal. From his chance thought straying BASKERVILLE

I am the voice of today, the herald of tomorrow. I am type! Of my earliest ancestry neither history nor relics remain. The wedge-shaped symbols impressed in plastic clay in the dim past by Babylonian builders foreshadowed me: from them, on through the hieroglyphs of the ancient Egyptians, down to the beautiful manuscript letters of the medieval scribes, I was in the making. Johann Gutenberg was the first to cast me in metal. From his chance thought straying RODONI

I am the voice of today, the herald of tomorrow. I am type! Of my earliest ancestry neither history nor relics remain. The wedge-shaped symbols impressed in plastic clay in the dim past by Babylonian builders foreshadowed me: from them, on through the hieroglyphs of the ancient Egyptians, down to the beautiful manuscript letters of the medieval scribes, I was in the making. Johann Gutenberg was the first to cast me in metal. From SCHOOLBOOK

I am the voice of today, the herald of tomorrow. I am type! Of my earliest ancestry neither history nor relics remain. The wedge-shaped symbols impressed in plastic clay in the dim past by Baby-Ionian builders foreshadowed me: from them, on through the hieroglyphs of the ancient Egyptians, down to the beautiful manuscript letters of the medieval scribes, I was in the making. Johann Gutenberg was the first to cast me in metal. From his MEGARON MEDIUM

VARITYPER (TYPEWRITER)

I am the voice of today, the herald of tomorrow. I am type! Of my earliest ancestry neither history nor relics remain. The wedge-shaped symbols impressed in plastic clay in the dim past by Babylonian builders foreshadowed me: from them, on through the hieroglyphs of the ancient Egyptians, down to the beautiful manuscript letters of the medieval scribes, I was in the making. Johann Guttenberg was the first to cast me in metal. From his chance thought straying through an idle rev-GARAMOND

I am the voice of today, the herald of tomorrow. I am type! Of my earliest ancestry neither history nor relics remain. The wedge-shaped symbols impressed in plastic clay in the dim past by Babylonian builders foreshadowed me: from them, on through the hieroglyphs of the ancient Egyptians, down to the beautiful manuscript letters of the medieval scribes, I was in the making. Johann Guttenberg was the first to cast me in metal. From his chance thought straying through an idle rev-BASKERVILLE

I am the voice of today, the herald of tomorrow. I am type! Of my earliest ancestry neither history nor relics remain. The wedge-shaped symbols impressed in plastic clay in the dim past by Babylonian builders foreshadowed me: from them, on through the hieroglyphs of the ancient Egyptians, down to the beautiful manuscript letters of the medieval scribes, I was in the making. Johann Guttenberg was the first to cast me in metal. From his chance thought straying through an idle rev-RODONI

I am the voice of today, the herald of tomorrow. I am type! Of my earliest ancestry neither history nor relics remain. The wedge-shaped symbols impressed in plastic clay in the dim past by Babylonian builders foreshadowed me: from them, on through the hieroglyphs of the ancient Egyptians, down to the beautiful manuscript letters of the medieval scribes, I was in the making. Johann Guttenberg was the first to cast me in metal. From his chance thought straying through an idle rev-SCHOOLBOOK

I am the voice of today, the herald of tomorrow. I am type! Of my earliest ancestry neither history nor relics remain. The wedge-shaped symbols impressed in plastic clay in the dim past by Babylonian builders foreshadowed me: from them, on through the hieroglyphs of the ancient Egyptians. down to the beautiful manuscript letters of the medieval scribes, I was in the making. Johann Guttenberg was the first to cast me in metal. From his

MEGARON MEDIUM

Cross Reference Chart

COMMERCIAL TYPEFACES	ALPHATYPE	BERTHOLD FOTOTYPE	COMPU- GRAPHIC	GRAPHIC SYSTEMS	HARRIS	MERGEN- THALER LINOTYPE	MONOTYPE	PHOTON	SINGER GRAPHICS	STAR GRAPHICS	VARITYPER
BASKERVILLE	BASKERLINE	BASKERVILLE		BEAUMONT	BASKERVILLE	BASKERVILLE	BASKERVILLE	BASKERVILLE	BEAUMONT	BASKERSTAR	BASKERVILLE
BODONI	BODONI	BODONI	BODONI	BRUNSWICK	BODONI	BODONI	BODONI	BODONI	BRUNSWICK	BODONISTAR	BODONI
CALEDONIA	CALEDO		CALIFORNIA*	EDINBURGH*	LAUREL	CALEDONIA	CALEDONIA	HIGHLAND		CALEDONSTAR	HIGHLAND
CASLON				CASLON*	CASLON	CASLON	CASLON	CASLON		CASLOSTAR	
CENTURY EXPANDED	CENTURY X	CENTURY EXP.		CAMBRIDGE	CENTURY EXP.	CENTURY EXP.	CENTURY EXP.	CENTURY EXP.	CAMBRIDGE EXP.	CENSTAR EXP.	
CENTURY SCHOOLBOOK	CENTURY TEXT	CENTURY SCHOOL BOOK	CENTURY TEXTBOOK	CAMBRIDGE LIGHT	CENTURY SCHOOLBOOK	CENTURY SCHOOLBOOK	CENTURY SCHOOLBOOK	CENTURY SCHOOLBOOK	CAMBRIDGE	CENSTAR SCHOOL	SCHOOLBOOK
CLARENDON	CLARENDON	CLARENDON		CLARENDON	CLARIQUE	CLARENDON	CLARENDON	CLARENDON		CLARENDO- STAR	CLARENDON
COPPER- PLATE	COPPERPLATE GOTHIC	COPPERPLATE		COPPERPLATE*	GOTHIC No. 31	COPPERPLATE	COPPERPLATE GOTHIC	COPPERPLATE GOTHIC			COPPERPLATE
FUTURA BOOK	FUTURA BOOK	FUTURABOOK	FUTURABOOK	UTICABOOK	FUTURA BOOK	SPARTAN BOOK		PHOTURA BOOK	UTICABOOK	FUTURSTAR BOOK	
FUTURALIGHT	FUTURA LIGHT	FUTURA LIGHT		UTICALIGHT	FUTURA LIGHT	SPARTAN LIGHT	20th CENTURY LIGHT	TECHNO LIGHT	UTICA	FUTURSTAR LIGHT	
FUTURA MEDIUM	FUTURA MEDIUM	FUTURA MEDIUM	FUTURA MEDIUM	UTICA MEDIUM	FUTURA MEDIUM	SPARTAN MEDIUM	20th CENTURY MEDIUM	TECHNO MED.		FUTURSTAR MEDIUM	TECHNO MED
FUTURABOLD	FUTURA BOLD	FUTURA BOLD	FUTURA BOLD	UTICA HEAVY	FUTURA BOLD	SPARTAN BLACK	20th CENTURY BOLD	TECHNO BOLD	UTICAHEAVY	FUTURSTAR BOLD	TECHNO BOLD
GARAMOND	GARAMOND	GARAMOND	GARAMOND	GRENADA	GARAMOND	GARAMOND	GARAMOND	GARAMOND	GRENADA	GARASTAR	GARAMOND
HELVETICA	CLARO	AG BOOK	HELIOS	GENEVA	VEGA	HELVETICA	HELVETICA	NEWTON	GENEVA	HELVETSTAR	MEGARON
MELIOR	URANUS	MELIOR	MALLARD	VENTURA	MEDALLION	MELIOR	MELIOR	BALLARDVALE	VENTURA	MELIOSTAR	HANOVER
NEWS GOTHIC	NEWS GOTHIC	NEWS GOTHIC	NEWS GOTHIC	NEWS GOTHIC	NEWS GOTHIC	TRADE GOTHIC	NEWS GOTHIC	NEWS GOTHIC	TOLEDO	GOTHSTAR TRADE	NEWS GOTHIC
ОРТІМА	MUSICA	ОРТІМА	ORACLE	ORLEANS	ZENITH	ОРТІМА	ОРТІМА	CHELMSFORD	ORLEANS	OPTISTAR	CHELMSFORD
PALATINO	PATINA	PALATINO	PALLADIUM*	PONTIAC*	ELEGANTE	PALATINO		ANDOVER	PONTIAC	PALASTAR	ANDOVER
STYMIE	STYMIE	ROCKWELL	STYMIE	STYMIE	CAIRO	MEMPHIS	STYMIE 3	STYMIE	ALEXANDRIA		
TIMES ROMAN	ENGLISH	TIMES ROMAN	ENGLISH	LONDON ROMAN	TIMES ROMAN	TIMES ROMAN	TIMES NEW ROMAN	TIMES NEW ROMAN	LONDON ROMAN	TIMES STAR	TIMES ROMAN
UNIVERS 55,56	VERSATILE	UNIVERS 55,56	UNIVERS 55,56	BOSTON	GALAXY MEDIUM	UNIVERS	UNIVERS	UNIVERS MED.	BOSTON	UNISTAR	UNIVERS MED
UNIVERS 65,66	VERSATILE	UNIVERS 65,66	UNIVERS 65,66	BOSTON DEMI	GALAXY DEMI	UNIVERS	UNIVERSBOLD	UNIVERSBOLD	BOSTON DEMI	UNISTAR	UNIVERSBOLE

NEWSPAPER TYPEFACES

IEWSPAPER TYP	EFACES										
AURORA		A.G.	NEWS NO. 2		REGAL	AURORA		GROTESQUE COND.		AURORSTAR	
CORONA	KORONNA	A.G.	NEWS NO. 3	QUINCY	ROYAL	CORONA		CROWN	QUINCY	CORONSTAR	CROWN
IMPERIAL		A.G.	NEWS NO. 2		IMPERIAL			BEDFORD		IMPERISTAR	
REGAL					REGAL			EMPIRA		REGALSTAR	EMPIRA
ROYAL					ROYAL					ROYAL STAR	
EXCELSIOR	LEAGUE TEXT				REGAL BERLIN	EXCELLSIOR		EXCELLA			CAMELOT
IONIC	NEWS TEXT MEDIUM			IONIC	IONIC NO. 5	IONIC No. 5	IONIC	DORIC			
REX		BODONI BOLD	NEWS NO. 10		REX			ZAH			
SPARTAN BOOK/AGATE		FUTURA COND.	SANS NO. 2	UTICA BOOK	FUTURA	SPARTAN BOOK		ТЕСНИО ВООК	UTICA BOOK	SPARSTAR	
BODONI BOLD		BODONI BOLD	BODONI BOLD	BRUNSWICK BOLD	BODONI BOLD	BODONIBOLD		BODONI BOLD	BRUNSWICK BOLD	BODONI STAR	BODONI BOLD
FUTURA CONDENSED		FUTURA COND. BOOK	FUTURA COND.	FUTURA HEAVY COND.	FUTURA COND. BOOK DEMI MED.	SPARTAN BOOK COND.		TECHNO MED COND.		FUTURSTAR	TECHNO MED COND.

Choosing the Right System

The "right" typesetting system for your job is not necessarily the one that produces the highest quality typography: sometimes speed is the most important consideration; and there are jobs in which cost is a more important consideration than excellence of typography.

As a start, however, let's examine the advantages and disadvantages of each typesetting system.

Not only is it necessary to find the right system, but it is also desirable to find the right typographer. Keep in mind that just as a good book designer is not necessarily a good advertising designer, a good publisher's typographer is not necessarily a good advertising typographer. Also, the difference in what these people charge may be considerable; advertising typographers, whose work is more demanding, are more expensive than publisher's typographers who schedule work far in advance and take weeks or months to produce a job.

Good typography can be negated by carelessly produced reproduction proofs. In metal typography, all type forms should be meticulously squared up, made ready, and inked. The designer should inspect all repros, including correction patches, to be sure the color (inking) of all the proofs is identical. Photorepros should likewise be carefully inspected for squareness, density, and evenness of development. If you are not completely satisfied with the quality of the proofs, reject them. Remember: you deserve what you accept.

Handset. Hand composition is slow and time-consuming compared with machine composition; it is therefore expensive. Although out of the question for extensive text setting, hand composition can be ideal for setting one or a few lines of text or display type. Corrections or changes in leading are simple to make and relatively inexpensive.

There is a wide range of typefaces available and in most cases their design is excellent.

Handset display type can be made up on more than one line. This is not possible with most photodisplay units, which because they set type on film strips produce only single lines of type.

An advantage of handset type is the ability to pull multiple repros while the type is locked up on the proofing press. Also, when printed by letterpress, handset type, which is type-high, can go directly to press; no printing plate is required. It can also be mixed with cast type, which is also type-high. Handset type, unlike phototype, does not enlarge well. Enlargements of more than 10% tend to accentuate the rough-printed edge of the type caused by ink squeeze. Generally speaking, it is always better to set type a size larger and reduce it than to set it a size smaller and enlarge it.

A disadvantage for those who like tight letterspacing is that because of the metal surrounding the individual characters, the type cannot be set with the letters close together. The designer must do any subtle closing up of letters by cutting and pasting the repros.

Unlike the typesetting methods which have unlimited type, with handset type there is always the possibility of running out of certain letters, especially if setting lengthy copy. If this happens, part of the job must be set, proofed, and then broken down to set the rest of the job.

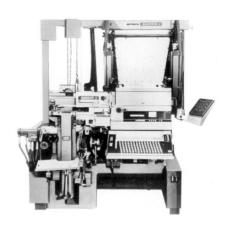

Machine Set. Although more and more typographers are switching to phototypesetting, there is still a great deal of type being set by Linotype, Intertype, and Monotype. One of the great advantages of cast type is familiarity. Most designers who have been in the field more than five years know the popular typefaces, and in many cases the number of characters per pica. The typefaces themselves are the original designs and are excellent. The designer knows the limitations of the casting machines and can work successfully within them. Furthermore, as all the machines are keyboard-operated, with the operator making all end-of-line decisions, the designer can depend on a certain quality of setting.

Although for setting a large amount of type casting may not be as fast as phototypesetting, for short jobs it is usually faster. Corrections are much simpler to make in cast type than phototype and are often less expensive; the corrected word or line is reset, dropped in place, and a new proof is pulled. This may be particularly helpful in jobs where extensive changes are anticipated, such as in a prospectus or annual report.

As with handset type, multiple repros can be pulled while the type is on the proofing press. Also, when printing by letterpress, cast type, like handset type, can be locked up on the press, inked, and printed.

Most linecasting machines are designed to set type to a maximum measure of 30 picas, which may in some cases be a restricting factor. Wider measures can be set on special machines, or as butted slugs, but this generally costs more.

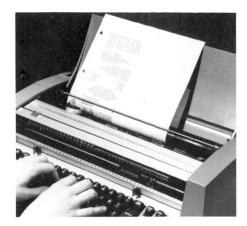

Typewriter. One of the major advantages of typewriter composition is its low cost, especially for setting straight copy. Font changes must be done manually and should be kept to a minimum. Display type must be set by other means and then stripped into the job. This could reduce or eliminate some of the savings realized by using typewriter composition in the first place.

A certain amount of page makeup can be done at the keyboard, thereby reducing or eliminating extra cutting and paste-up time for the designer.

The quality of the setting can vary greatly, depending on the system and on the operator's experience. However, although the quality is generally not as high as that of hand composition, machine composition, or phototypesetting, it is more than adequate for many jobs. Typewriter composition produces only one repro, which may or may not present a problem. Note: typewriter repros tend to smudge easily and should be lightly sprayed before use.

Whereas most casting machines set to a maximum measure of 30 picas, typewriters are capable of setting type up to 76 picas or longer, depending on the particular system. This, along with the system's ability to set both vertical and horizontal rules (although generally not of high quality), makes typewriter composition ideal for setting tabular material.

Phototypesetting. The major advantages of phototypesetting are perfect images, unlimited type per font, speed, versatility, and low cost.

In phototypesetting the individual letters are projected onto photosensitive paper or film resulting in the sharpest possible letter forms. The setting can be controlled to produce tight, loose, or overlapping letterspace. Also, unlike handset type where there is a limit to the number of characters available, phototypesetting has unlimited type: the negative images on the type font are used over and over again.

In terms of speed and cost, phototypesetting is generally faster and less expensive than machine composition, especially where extensive composition is involved. Low equipment costs, low operating costs, and the ability to makeup quickly all mean potential savings.

Compared with machine composition, phototypesetting offers a great savings in operating space not only in terms of equipment and working space, but also in terms of space required to store jobs. (Compare storing galleys of cast type for a job the size of a telephone book with storing it on film or better yet on a couple of reels of magnetic tape!)

One of the major advantages of phototypesetting is that type can be set and makeup done directly on film, making it possible to go directly from film to platemaking without having to prepare a mechanical. This saves time for both designer and printer and produces a better printing plate.

When the job is set directly on photosensitive paper only one photoprint (photorepro) is produced. For proofreading and dummying purposes, the designer usually works from an inexpensive photographic copy of the photoprint. However, if the job is set on film,

any number of duplicate photoprints, called diazos, can be made.

Beyond this, however, it is difficult to generalize further. Phototypesetting equipment is produced by a large number of manufacturers, each offering a wide variety of keyboards and output units. Some systems are designed for high-speed composition of straight, uncomplicated copy such as newspapers; others can produce more complex work such as charts, tabular material, catalog pages, and textbooks. Also, the degree of sophistication in computer programming varies greatly from one typographer to another.

The problem facing the designer is to match the equipment to the job. He should acquaint himself with the different phototypesetting systems available. It is an excellent idea, if possible, to visit the typographer's shop or the manufacturer's showroom to see the actual equipment and study its capabilities. Also, before setting a job, always get a type sample—not just a line sample, but a block of type that displays the quality of the type, color, format, leading, etc.

Choosing a Typographer. The designer should also be aware that many phototypesetting shops today are run by people who do not always have a strong typographic background; their prices can be very attractive, but the errors they make due to their unfamiliarity with typography may more than eat up the

Another factor in choosing a typographer, which is very subtle but which has a direct bearing on the quality and cost of the setting, is how familiar the typographer is with his phototypesetting equipment. Most typographers have spent their lives setting type either by hand or machine; they know typography. Some phototypographers need a period of orientation; it takes time for the metal or strike-on typographer to become familiar with phototypography and its potential. The simplest job may become a disaster, with wasted time and aggravation for the designer and a less than perfect job for the client.

Phototypesetting and the Designer. The designer, too, must adjust to using phototypography. Like the typographer who has previously worked only with linecasting machines, the designer may know all the metal typefaces intimately: their availability, the number of characters per pica, the maximum measure,

and other bits of accumulated wisdom that help make his life easier and hold down the cost of a job. He must now adjust to a whole new set of rules: the names of the typefaces, characters per pica, maximum measure, etc. Not only will these be different from metal type, but they will also vary from machine to machine and shop to shop. Even the copy the designer carefully specs must be properly formatted (coded) by the compositor for the particular system.

There are some factors the designer should be aware of when working with his phototypographer:

Matching Type. The design and X-height of a particular typeface will vary from manufacturer to manufacturer. Therefore it is impossible to match typefaces and type sizes from one system to another. The same applies when setting patches. Make sure the type for your patches is set on the same equipment as the original text. Also, make sure that the typographer uses the same font (that is, the same grid, lens, and type size) for patches that he used for the original setting. If he enlarges an 8-point font to 10 point, the size will be different than if he reduces a 12-point font to 10 point.

Another factor to consider when matching type is density control. Failure to control density in the exposure and development of photographic material (film or paper) may cause perceptible variations in the weight (color) of the type. Furthermore, when output is in film, care should be exercised to obtain emulsion-to-emulsion contact at every phase of the work. Shooting through the base of the film will spread (heavy up) the typeface. To ensure the highest quality, the designer should carefully examine all photorepros to make sure they are consistent in density and color. Usually, any difference is obvious to the naked eye. However, if you are uncertain, an optical comparator can be used to measure the thickness of the individual type characters. This is a precision magnifying glass with a reticle (fine lines etched on the lens), which permits measurements to the thousandths-of-an-inch.

Enlarging Type. Some phototypesetting systems use a separate font for each type size. Others have master fonts that are enlarged (or reduced) to set a number of different size types. On some equipment, when type is enlarged too much it may become fuzzy if not properly exposed.

Mixing Typefaces. Just because a phototypesetting machine holds 10 different typefaces does not mean that it is practical to mix them. Not all typeface or type size changes are automated (set up at the keyboard and controlled by the tape). Font changes often require monitoring by the operator, who must make the changes manually. Even at the keyboard stage some phototypesetting machines require over 10 keyboard commands to make type changes. This is not only time-consuming, but costly.

Phototypesetting is not the answer to all our typographic problems. It is another approach to these problems, with its own advantages and disadvantages. The designer should become as familiar as possible with as many methods of setting type as possible and compare the results in terms of quality, service, and cost. Only then can he decide which method is best suited to his needs.

Transfer Type. Although not "composition" in the mechanical sense of the word, transfer type is yet another means of setting type. If cost is a factor and the amount of type to be set is small, you may find that no typesetting method, photo or

otherwise, is inexpensive. At times like this you might consider transfer type. The type, both text and display, is carried on sheets approximately 10" x 14". In many cases, type is available not only in black, but also in white and a range of colors. This can be a great asset in preparing finished comps. In addition to alphabets, sheets with borders, rules, symbols, ornaments, drawings, screens, etc., are also available.

The two most common ways of transferring type are pressure-sensitive lettering and cut-out lettering. Both do the same job and both are easy to use.

Pressure-sensitive Lettering. (Letraset, Prestype, etc.) Remove the protective backing tissue and position the sheet on the working surface. Press the letter gently with your finger to make sure it is lying flat. To transfer the letter, burnish it gently with a ballpoint pen or pencil, using sweeping strokes. These strokes do not affect the actual letter on the underside of the sheet. After the letter has been burnished, gently lift the sheet. The letter will remain on the working surface. Then place the next letter in position, using the system of lines or bars on the sheet to ensure correct alignment and letterspacing. After the entire word has been transferred, place the backing sheet over the word and burnish firmly.

Cut-out Lettering. (Artype, Formatt, Zipa-Tone, etc.) Using a razor blade or Xacto knife, lightly cut around the desired letter, including any guidelines that may be necessary for proper positioning of the letter. As you cut, be careful not to cut through the protective backing sheet. Insert the tip of the razor blade under the letter and lift it away. Position the letter directly on the art and burnish it lightly, preferably with a wooden stylus. When you are satisfied that it is properly positioned, burnish firmly and trim away any unwanted guidelines.

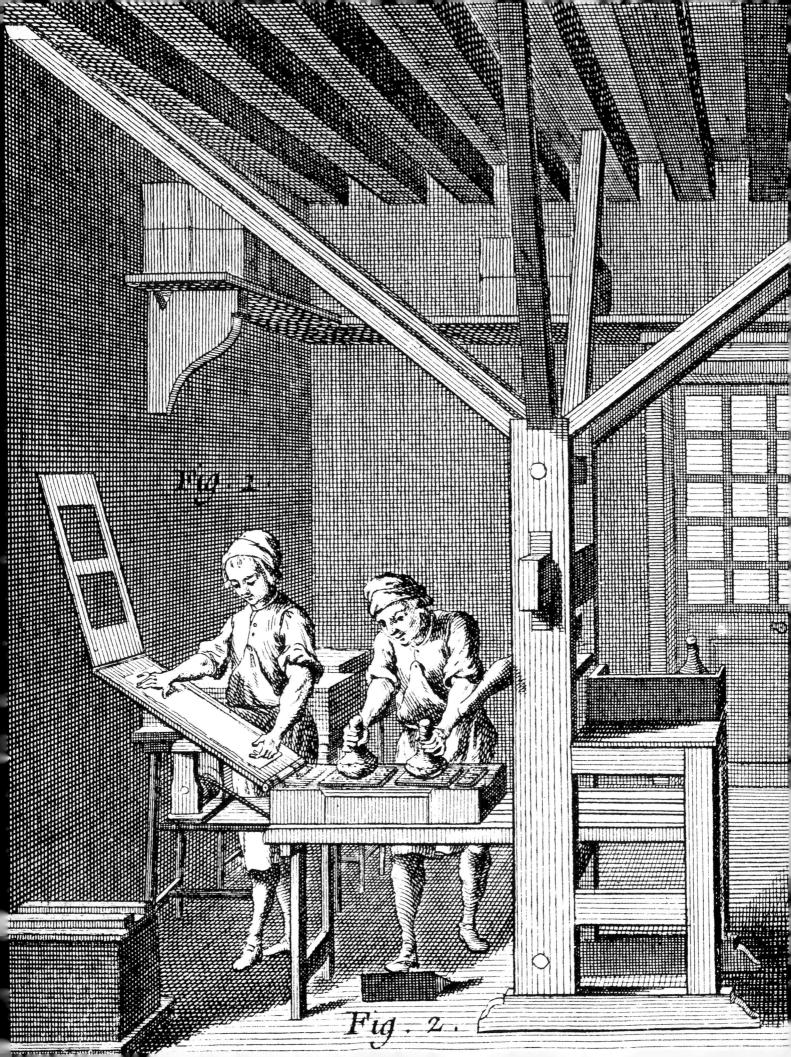

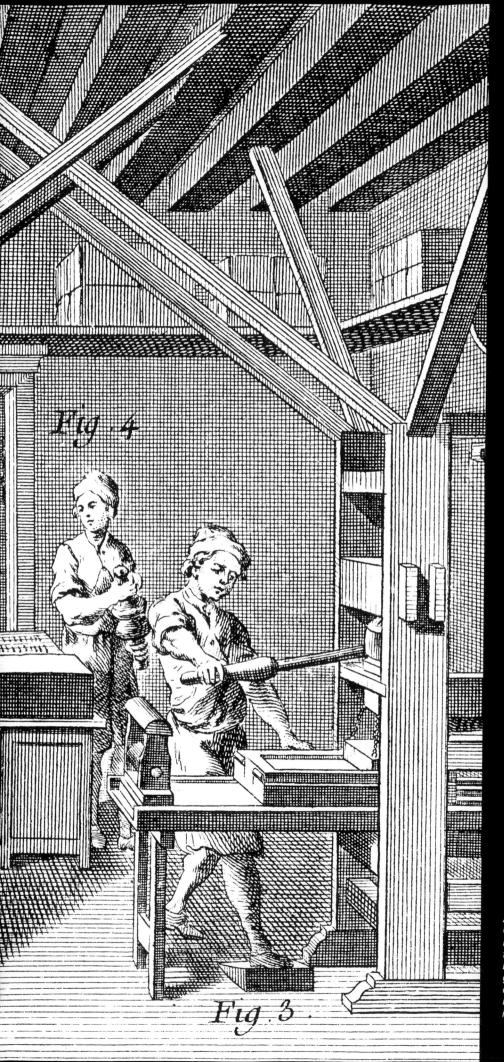

Printing

The designer works out his ideas on paper; the printer carries them out in metal. The process by which a design becomes a printed page may be of little concern to the average reader, but to the graphic designer it is crucial: it is the printing process that to a large extent dictates the designer's choice of type, illustrations, and paper, and even his preparation of mechanicals. In short, the more the designer knows about printing, the better he can control the quality and cost of a job.

In this section we shall deal only with black and white printing. Color printing, which is more complex, will be dealt with separately in the next section, Color Printing.

An 18th century printing shop. On the left, the press is made ready and the type is inked ready for printing. On the right, type is being printed. In the background, the printed sheets are checked by the same man who is responsible for preparing the ink balls.

Copy

To the designer, copy usually means typewritten copy that is to be spec'd and set in type. To the printer or platemaker, copy means anything that is to be printed: type, photographs, illustrations, etc. All copy can be divided into two categories: line copy and continuous-tone copy.

Line Copy. Line copy is any image that is made up of solid black, with no gradation of tone: lines, dots, rules, solid masses, etc. The type you are now reading is line copy, as are the illustrations below. Line copy is shot with a high-contrast film that reduces everything to either black or white. The film is then developed, producing a line negative from which the printing plate is made.

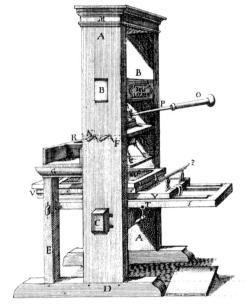

Continuous-tone Copy. Continuous-tone copy is any image that has a full range of tones from white to black. Photographs, paintings, and charcoal or pencil drawings are all continuous-tone copy. If you look closely at an original photograph (not a reproduction in a book, magazine, or newspaper), you will notice that the tones vary and seem to melt into one another, resulting in a range of gray tones.

It is impossible to reproduce these tones exactly as you see them. A printing press cannot print grays, it can only print solid tones; in this case, black.

Therefore, before it can be printed, continuous-tone copy must first be converted to line copy. This is done by photographing the copy through a screen.

Unfortunately, continuous-tone copy cannot be reproduced by any of the major printing processes without first being converted to line.

Process Camera

The first step in making a printing plate is to photograph the copy. This is usually done by the platemaker or engraver, using a special camera, called a process camera, also referred to as a copy camera or a graphic arts camera.

It is possible to shoot the same photograph in a number of ways to get a variety of effects. The result you get depends on the clarity of your instructions and on how well the cameraman does his job.

When shooting continuous-tone copy, the cameraman uses a densitometer to make a reading of the density of the black and white or color copy in order to determine the

correct exposure.

Amount of enlargement or reduction is controlled by moving both the lens and the copyboard.

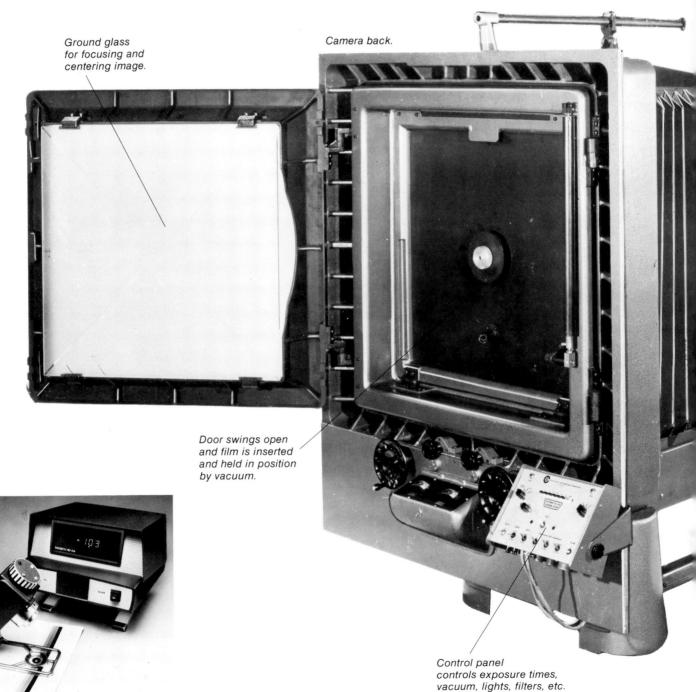

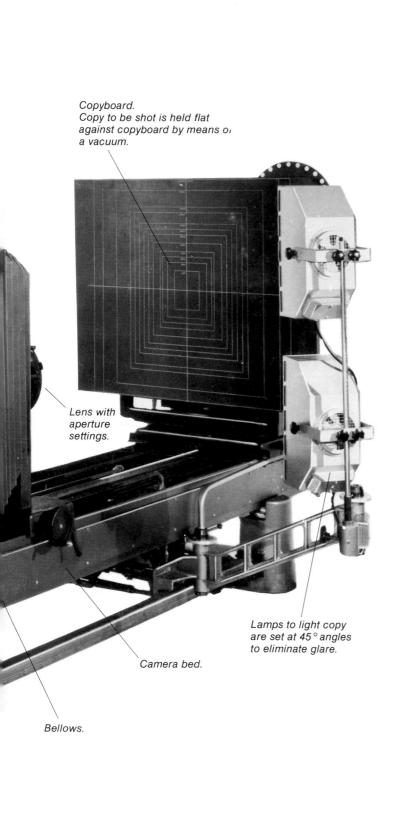

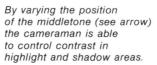

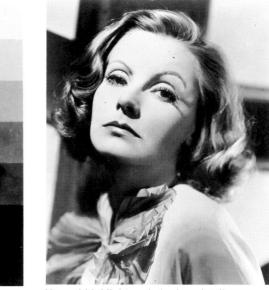

Normal highlight and shadow detail.

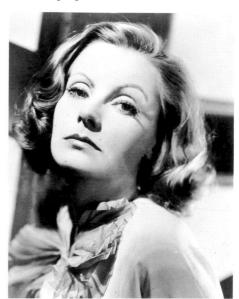

Highlight detail lost; shadow detail gained.

Highlight detail gained; shadow detail lost.

Halftone Screens

There are two kinds of screens: glass screens and contact screens. The glass screen consists of a finely ruled grid pattern and is placed between the camera's lens and the film. The contact screen consists of a pattern of vignetted dots and is placed in direct contact with the unexposed film. Both produce the same results: they reduce continuous-tone copy to thousands of tiny dots (like copy), varying in size, shape, and number. When printed, these dots give the illusion of the original tones.

After the continuous-tone copy is screened, the film is developed, producing a halftone negative. The printed image is called a halftone. (The term "halftone" comes from the idea that the screening eliminates half the original image, which could be considered a "fulltone," and that only half of this full tone remains.)

Screens are measured by the number of lines per inch. The most commonly used are 55, 65, 85, 100, 120, 133, and 150. The more lines per inch a screen has, the finer the dot pattern and the higher quality halftone it will produce. For example, a 55-line screen has 3,025 dots per square inch, while a 150-line screen has 225,000. The 150-line halftone will look more like the original continuous-tone copy than the 55-line halftone because the dots will be more numerous, finer, and closer together.

The screen used is determined by the surface of the paper, the type of printing plate, and the quality of the printing press and the printing inks. Newspapers, for example, use rather rough paper, stereotype printing plates, presses not designed for fine reproduction, and inks of watery consistency. Therefore, newspapers require a coarse, 85-line screen. If a finer screen were used, the paper would be unable to hold the detail and the spaces between the dots would fill in. Magazines, on the other hand, use a smoother paper and are able to use finer screens, normally up to 150-line, and thus obtain finer, more detailed halftones. Obviously, it is important to match the screen to the paper and the printing conditions.

(For a discussion of special line screens used to create special effects, see *Line Conversions*, page 164.)

Enlarged glass screen.

Enlarged contact screen.

65-line screen.

85-line screen. (See detail.)

110-line screen.

120-line screen.

A magnifying glass is an invaluable tool for examining the quality of halftone dots.

100-line screen.

133-line screen.

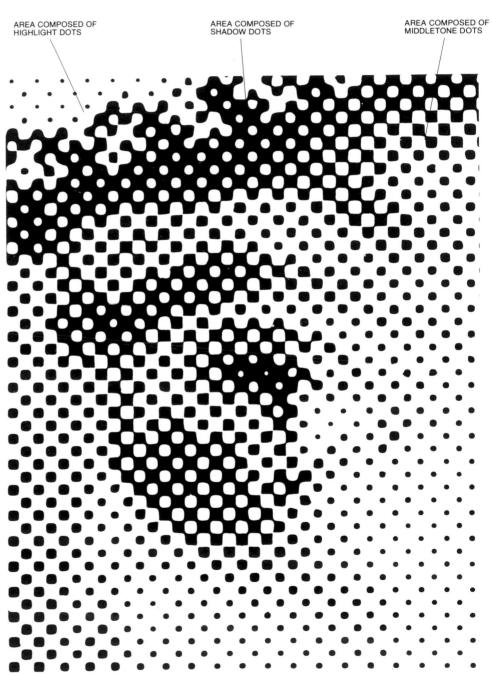

Detail of 85-line halftone.

Halftones

Design would indeed be monotonous if all continuous-tone copy had to be reproduced in exactly the same manner. Fortunately, there are a number of things the designer can do with the conventional halftone. The particular approach is usually dictated by both esthetic and practical considerations. Here are some of the more popular kinds of halftone reproduction.

Square. A halftone that has been squared up. That is, all the corners are right angles. Although called a "square" halftone, it does not necessarily have to be square; it is in fact more often rectangular. Although there are also round and oval halftones, square halftones are the most widely used.

Silhouette. Also called an *outline halftone*. A halftone showing only the important area. The printer removes all the halftone dots from the background by opaquing the negative with paint or by covering it with a mask. There is also a *modified silhouette*, in which only a portion of the halftone is silhouetted and the remaining portions are the square sides of the halftone. Silhouette halftones are usually opaqued by hand and can be expensive.

Dropout. Also called a highlight halftone. A halftone in which certain areas have been highlighted by dropping out (eliminating) the screened dots, so that all that remains in the actual printing is the white of the paper. The dots are removed from the negative by opaquing them with paint, or by a special camera technique.

Vignette. A halftone in which the image fades almost imperceptibly into the white of the paper. Vignetting is done by an artist who creates the blend by airbrushing directly on the original art or photograph. This can also be expensive.

Combination Line and Halftone. As the name implies, part of the art is line and part is halftone. The line copy, in this case Babe Ruth's signature, is shot as line and the continuous-tone is shot as halftone, then the two are combined for reproduction. In this way the strength of the black in the line copy is held. (If line copy were to be shot as continuous-tone copy it would break up into dots, which when reproduced would appear slightly gray rather than black.)

Platemaking

After the copy has been shot and the film developed, you get a film negative. It is from this film negative that the printing plate is made. (Although printing plates can also be made from film positives we shall base our discussions only on those made with film negatives.)

All printing plates have one thing in common: the area to be printed must stand apart from the non-printing area. There are three basic ways to separate the printing area from the non-printing area: (1) raise the printing area, (2) lower the printing area, or (3) leave both areas on the same level and treat the plate chemically so that the printing area accepts ink while the non-printing area rejects it. These three ways form the bases of our three major printing processes: letterpress, gravure, and offset lithography.

Although there is a great deal of difference between letterpress, gravure, and offset plates, they are made in much the same way. In all cases the plates are made photographically by using a film negative, a light-sensitive metal plate, and chemicals.

Let's look at the platemaking process in conjunction with each of the printing processes.

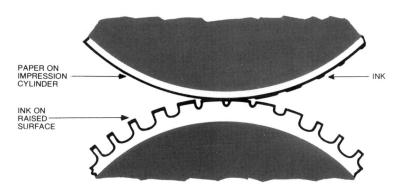

Letterpress.

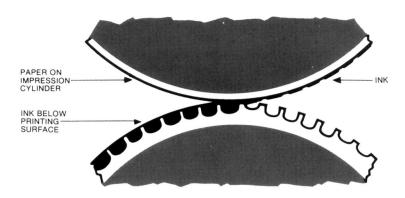

Gravure.

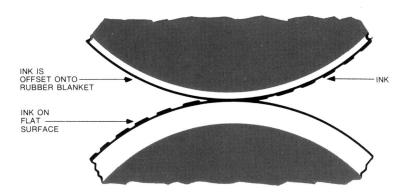

Offset lithography

Letterpress

Letterpress, also known as *relief printing*, is the oldest of the printing methods and probably the easiest to understand. When we print a woodblock or use a rubber stamp, we are printing by letterpress. The area to be printed is raised; when the surface is inked, the surrounding area, being lower, receives no ink and therefore does not print. The ink is transferred from the printing plate directly to the paper by means of pressure.

Because letterpress plates involve photography and engraving, they are called *photoengraved printing plates* (more often referred to as *engravings*, *cuts*, or *zincs*), and the platemaker is called an engraver. Letterpress plates are usually made of zinc, magnesium, or

copper. Zinc is primarily used for line copy and coarse screen work, while magnesium is used where detail and wearability are important. Copper, which is easier to etch and work, is used for high-quality line work.

Printing shop "dance of death" by Mathais Huss, Lyons, 1499. This woodcut is one of the oldest illustrations depicting a printing shop. Note the letterpress in the center.

To make a letterpress plate, a photographic negative is brought into contact with a light-sensitive metal plate. The plate and negative are exposed to a light that passes through the clear part of the negative and strikes the plate. The exposed areas are light-hardened. The plate is then dipped into an acid bath. The hardened image area of the plate is impervious to the acid, while the remaining areas are etched to the desired depth. This leaves the image area raised and ready to be inked.

The plate is then "blocked"; that is, mounted on a piece of wood or metal to make it type-high (.918"). After the plate is blocked, it is inked and a proof is pulled. A copy of the proof is sent to the client and the plate is sent to the printer.

Not all letterpress printing requires a printing plate: type that is handset or cast can simply be inked and printed. If an illustration or halftone is to be combined with the type, then an engraving is made for that piece of art only. Most letterpress jobs are an assortment of type and engravings all "locked up" together on the press. An advantage of this system is that elements can be changed without the expense of having to make an entirely new plate.

There are times when the printer may wish to convert from one printing method to another. This is particularly common in cases where a job that was originally printed by letterpress is to be printed by offset lithography. In this case, the printing plates are converted to film from which a new plate is made. Three conversion systems are Brightype, Cronapress, and Scotchprint. (See Glossary.)

In recent years a great number of jobs. especially newspapers, have been converted from letterpress to offset. This is not because of a lack of quality in letterpress printing but because of the time involved in plate-engraving. To counteract the flow of business away from letterpress to offset, the letterpress industry has developed the photopolymer direct relief (PPDR) printing plate. This is a photosensitive plastic plate which when mounted on metal can be used as a regular letterpress plate. The photopolymer plate drastically reduces the time required to make a letterpress plate, which is one of the major advantages of offset printing, while at the same time retaining the letterpress advantages of being able to use cheaper paper and ink.

Original line copy to be shot.

Negative and plate exposed to light.

Plate is blocked to make it type-high.

Line negative.

Plate is developed and etched in acid.

Printed image.

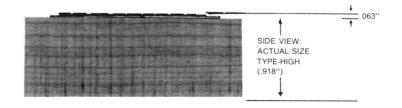

CHARACTERISTICS OF **LETTERPRESS**

- · Capable of high-speed, high-quality printing of jobs of a variety of sizes in black and white and in color.
- · Consistent quality throughout run.
- · Printing plates are generally more expensive than offset, but considerably less expensive than gravure.
- · Capable of printing from handset or machine-set type as well as from original or duplicate printing plates.
- · Duplicate plates are relatively expensive. The most commonly used duplicate plates are electrotypes, plastic plates, rubber plates, and stereotypes.
- Prints best on book papers. If halftones are to be printed, the paper must be calendered or coated. Also, accepts papers of any thickness, from the very thinnest to cardboard, depending on the type of press.
- · When printing from original metal type or engravings, any part of the job can be changed without the expense of having to make entirely new plates. This does not apply when printing from one-piece duplicate plates or from curved plates (rotary).
- Among the uses of letterpress are short-run printing from type and engravings; jobs requiring numbering (tickets, forms, etc.); and imprinting, imprint changes, on-press die-cutting, slotting, perforating, embossing, debossing, etc. Also used for fine long-run publication work where the cost of the press plates can be economically amortized over a number of printings.
- · Proofing is relatively inexpensive.
- Lays down an ink film thicker than offset but not as thick as gravure.
- Requires a lot of makeready time to compensate for the varying thicknesses of materials used: type, plates, engravings, etc.

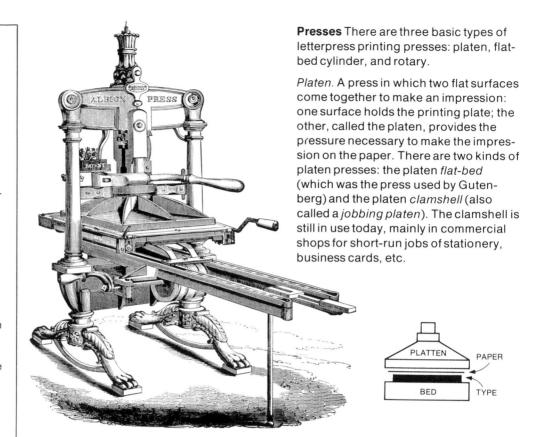

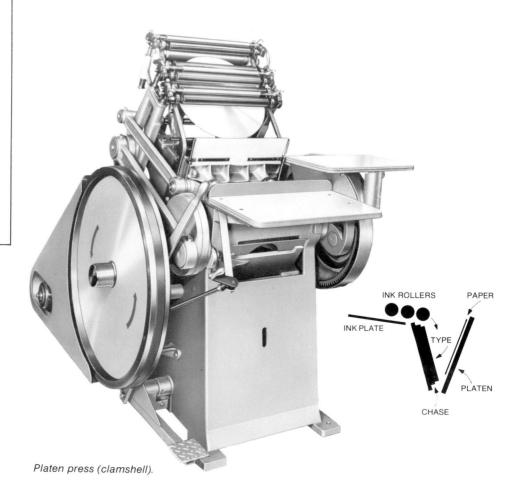

Flat-bed Cylinder. As the name implies, this press consists of a flat bed, which supports the printing plate or type form, and a cylinder which replaces the platen in providing the necessary pressure. These presses are usually larger and faster than platen presses. Excellent for booklets, catalogs, etc.

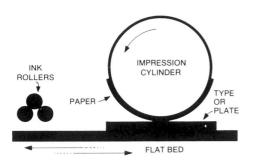

Flat-bed cylinder press.

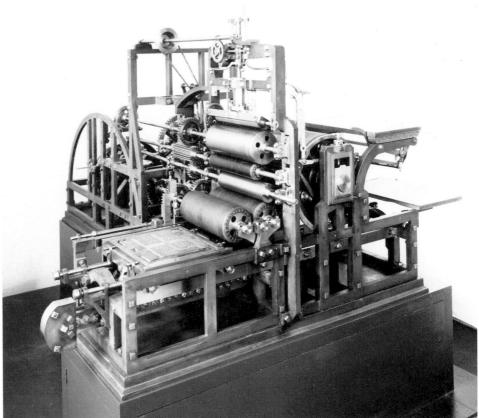

First cylinder press manufactured by Friedrich Koenig, 1811.

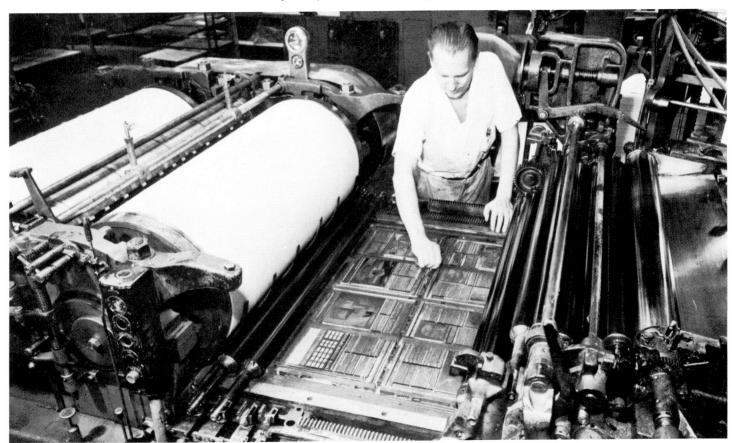

Type and engravings locked up in a type form ready to be printed.

Rotary. Unlike the platen and the flat-bed cylinder presses, in which the type or engravings to be printed are flat, the rotary press has a curved printing plate that either fits on a cylinder or wraps completely around it. This permits printing at high speeds and is ideally suited to long runs of high-quality work. A rotary press can print from individual sheets of paper (sheet-fed) or from a continuous roll (web-fed). Other rotary presses, called perfecting presses, can print both sides of the paper at the same time.

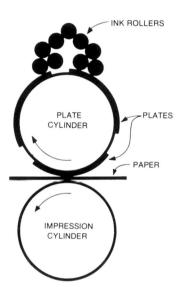

Rotary press.

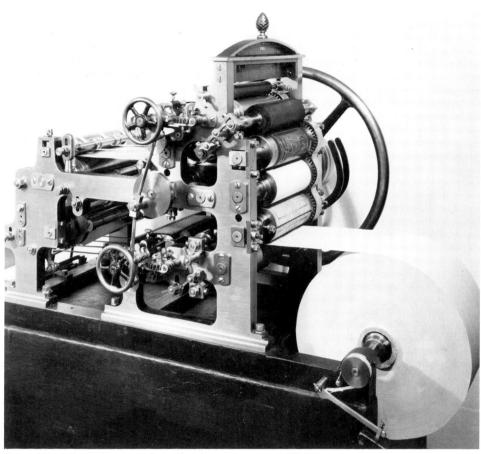

An early web-fed rotary press from Augsburg, Germany, 1883.

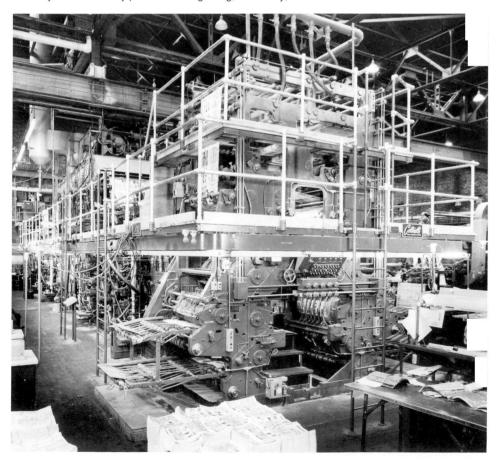

Huge web-fed rotary press capable of printing 40 pages on each side of the sheet in five colors.

Gravure

Gravure is the commercial form of *intaglio* printing. Intaglio is the second oldest printing process, dating back to 15th century Germany. The original process is very simple: the image to be printed is cut or etched into the surface of the plate; the plate is then inked and wiped clean, leaving ink only in the incised areas. When printed under pressure, the paper draws the ink out of the etched areas, transferring the image onto the paper.

Gravure is printed from either curved plates, designed to wrap around a plate cylinder, or directly from etched cylinders. Like letterpress plates, gravure plates are photoengraved; however, unlike letterpress plates, the area to be printed is lowered, not raised. To print, the entire surface of the plate is inked and then wiped clean with a flexible steel scraper called a ''doctor blade,'' leaving ink only in the etched areas.

The unique aspect of gravure printing is that all copy, continuous-tone and line, must be screened. This includes type. The screening process is much more complicated than that used for either letterpress or offset lithography. However, the purpose is the same: to break the image up into thousands of microscopic dots which when etched in acid become tiny cells, varying in depth and diameter. The tonal gradations of the printed image are determined by the depth of the cells: the deep cells hold more ink and therefore print darker tones: the shallow cells hold less ink and print lighter tones.

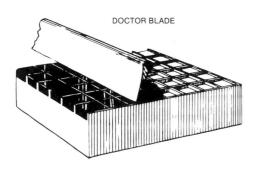

Presses. Gravure printing is done on a rotary press that is either sheet-fed or web-fed (rotogravure). Sheet-fed gravure is used most often for short runs and to reproduce works of art. The rotogravure press is designed to run at tremendous speeds and is ideally suited to long-run jobs such as mass-circulation catalogs, newspaper inserts, cigarette packages, postage stamps, etc.

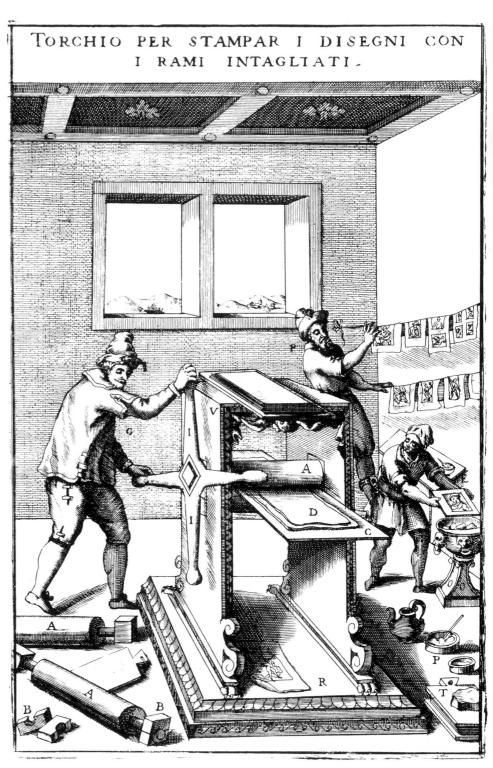

This 17th century engraving clearly shows the process of intaglio printing by hand.

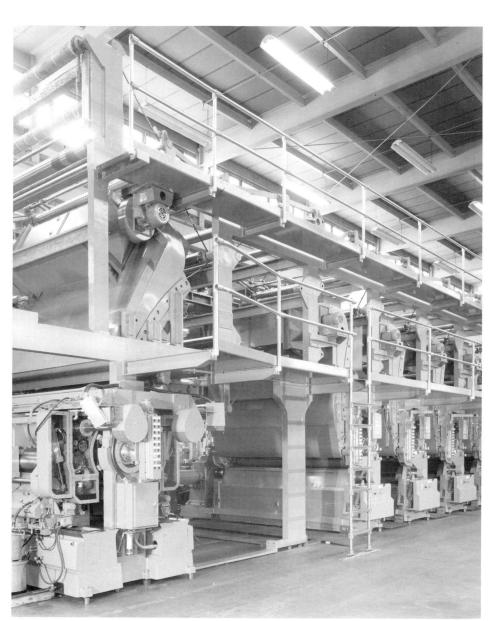

Web-fed gravure press.

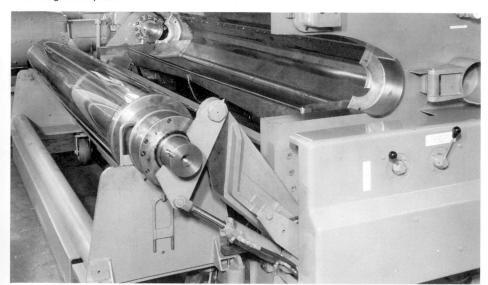

Gravure printing cylinder.

CHARACTERISTICS OF GRAVURE

- High-quality, high-speed printing of black and white and of color.
- · Consistent quality throughout run.
- Richest blacks and widest tonal range of all the printing processes.
- Most economical for long runs at high speed (web-fed). However, with careful preparation and attention to detail, short-run jobs can be printed at a cost competitive with that of quality letterpress or offset.
- Plates or cylinders are more expensive than either letterpress or offset plates, but they last longer.
- Duplicate plates or cylinders are expensive.
- Capable of printing on a wide range of surfaces. Although the highest quality is attained on smooth or coated stock, gravure can also produce high-quality work on inexpensive uncoated papers. An example of this is the Sunday supplements printed by rotogravure (web-fed gravure).
- Corrections are expensive because a new printing plate must be made.
- Proofing is much more expensive than for either letterpress or offset.
- Gravure printing is recognizable by the fact that the entire image area is screened, including the type. For this reason, gravure printing is better suited to reproducing continuoustone images than to reproducing type (especially type with fine serifs or strokes and in sizes of less than 8 point).
- Able to most closely simulate the continuous-tone effect.

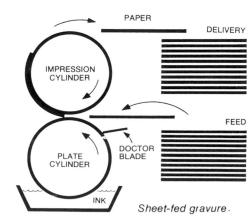

Offset Lithography

Of the three major printing processes, offset lithography is the most recent. It is a highly refined form of lithography invented in 1799 by a German named Aloys Senefelder. Lithography, which means "stone-writing," is based on the principle that water and grease do not mix. The image to be printed is drawn with a special grease crayon on a slab of highly polished limestone. The stone is then sponged with a solution of water, gum arabic, and acid. This solution is rejected by the greasy image area and absorbed by the non-image area. When the stone is inked, the opposite happens: the ink, which is greasy, is accepted by the image area and rejected by the non-image area. To print the image, a sheet of paper is placed over the stone, pressure is applied, and the image is transferred to the paper. Properly prepared, a lithograph stone can produce hundreds of high-quality prints.

Portrait of Aloys Senefelder. Lithograph.

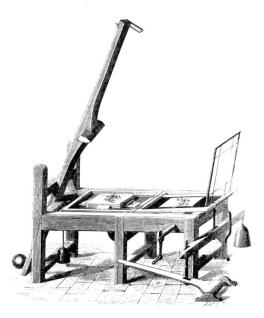

Jane Avril. Lithograph by Henri de Toulouse-Lautrec, 1899, 22" x 14". Collection, Museum of Modern Art, New York. Gift of Abby Aldrich Rockefeller.

The commercial form of lithography is offset lithography, more commonly known simply as "offset." (Offset refers to the method of transferring the image from the plate to the paper, which we will discuss later.) In offset lithography the flat stone is replaced by a thin, flexible metal printing plate designed to wrap around a printing cylinder.

The first step in making an offset plate is to "strip" both the line and halftone film negatives into their proper positions according to the mechanical. This makes up what is called a "flat." Before the actual offset plates are made, a photographic paper proof is made from the flat that shows the client the exact position of the elements. These proofs are called by various names, reflecting their general color: Van Dykes, browns, silvers, blues, or salts. After the proof has been approved, the plate is made and the job printed.

Offset plates are made photographically. The plate, which may be aluminum, stainless steel, or a specially processed paper, is coated with a lightsensitive chemical similar to that used on photographic paper. The flat is brought into contact with the plate and exposed to a high-intensity light. The plate is then either processed by hand or put through an automatic processor where it is developed and made press-ready (That is, the plate is chemically treated so that the image area will reject the water solution and accept ink and the non-image area will accept the water and reject ink.)

As the platemaking process for offset is much simpler than for either gravure or letterpress, the printer will very often make his own plates rather than depend on the services of an outside platemaker or engraver.

Flat in vacuum frame for exposure to light.

Removing coating not exposed to light.

Washing plate.

Applying gum arabic solution to plate to inhibit oxydizing before printing

CHARACTERISTICS OF OFFSET

- Capable of printing jobs of a variety sizes in black and white and in color at a relatively low cost.
- Requires more attention than letterpress or gravure to maintain image consistency throughout run.
- · Printing plates are relatively inexpensive and require only a short time to make as compared with letterpress and gravure plates.
- · Duplicate plates are inexpensive.
- · Printing plates can be either negativeworking or positive-working (deep etch); that is, made from either film positives or film negatives.
- · Although the quality is highest on smooth or coated papers, offset can print effectively on rough-surface papers as well.
- · Corrections require making a new plate, but plates are inexpensive.
- · Proofing can be done either on the production press or special proofing presses. Proofing on the production press is expensive. Pre-press proofs made from the film are usually furnished in the form of blueprints, Cromalin proofs (if process color), or by overlay systems such as the 3M system of color proofs.
- Offers the designer great creative freedom: a great variety of substrates and finishes can be printed; vignette halftones are easy to produce; soft and subtle tones are easily reproduced.

Automatic film processor eliminates the need for hand processing and affords better quality control.

Presses. There is a wide variety of offset presses available, ranging in size from small office duplicators to huge web-fed perfecting presses capable of printing an entire book in a single run.

All offset presses are of the rotary type and have three cylinders: a plate cylinder, around which the printing plate is wrapped; a blanket cylinder, onto which the image is offset; and an impression cylinder, which presses the paper against the blanket cylinder.

In operation, the printing plate first comes into contact with dampening rollers. These wet the plate with a solution of water, gum arabic, and acid. This water solution is accepted by the non-image area and rejected by the image area. Next, the plate is inked. The ink, repelled by the water solution in the non-image area, is accepted only by the image area. The inked image is then transferred, or "offset," onto the blanket cylinder, which in turn transfers the image to the paper.

The reason the image is offset onto the rubber blanket rather than printed directly on the paper is because the offset plate is very delicate and the abrasiveness of the paper's surface would cause damage. In addition to extending the life of the plate, the rubber blanket, because it is compressible and conforms to the slightest degree of texture on the paper's surface, makes it possible to print on rough papers.

Multilith 1250. 11"x14", 1/C.

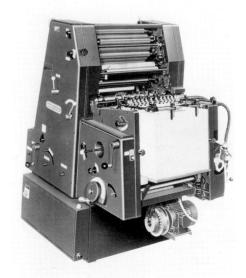

Heidelberg GTO. 13"x18", 1/C.

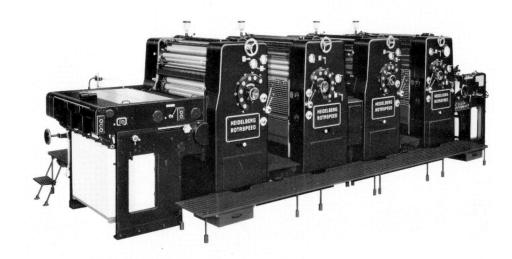

Heidelberg RVO. 28"x401/2", 4/C.

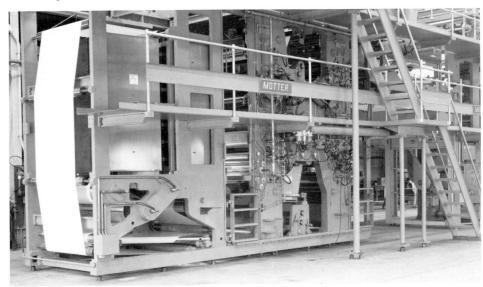

Motter 51" web-fed 4/C. Prints 2/C on full web or 4/C on half web.

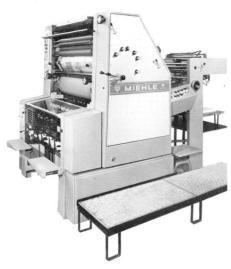

Miehle 29. 25"x29", 1/C.

Heidelberg. 251/4"x36", 2/C.

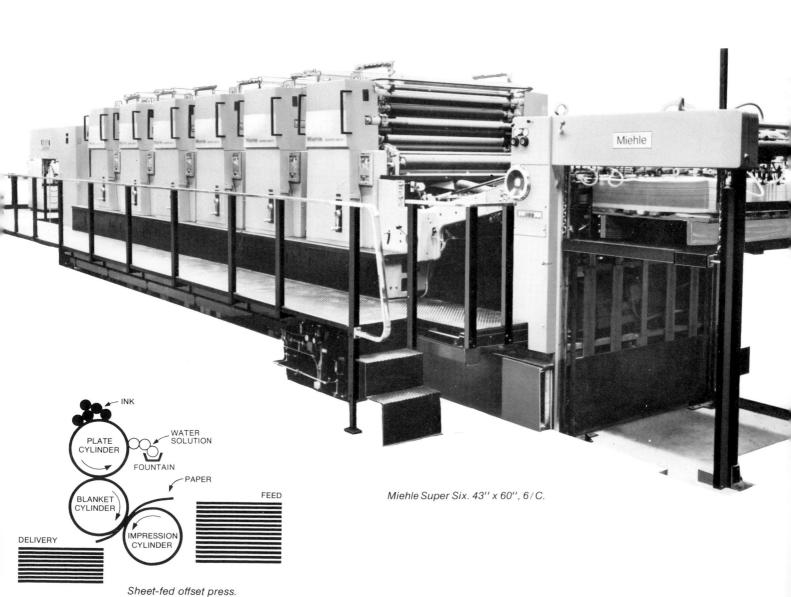

Other Printing Processes

Not all our printing demands are met by the three major printing process. Today, our printing needs are highly diversified; printing is no longer restricted to ink on paper, but can be found on a wide range of materials such as glass, plastics, and metals, to name just a few. To satisfy this demand, printing methods have been diversified and specialized. Here are a few of the more popular printing processes with which the designer should be familiar.

Screen Printing. Screen printing, also known as *silkscreen printing*, is a stencil process. The stencils are either cut by hand or photographically prepared. They are bonded for support to a screen (silk, nylon, Dacron, or fine metal mesh) and stretched over a wooden frame to create a smooth flat surface. A squeegee is then used to force the ink through the open (image) area of the screen onto the surface to be printed.

Because the inking in screen printing is heavier than in other printing processes, it produces excellent results on a variety of smooth and rough surfaces: metal, glass, ceramic, wood, plastic, fabric, cardboard, and of course, paper. This makes screen printing ideal for a great many commercial projects, such as street signs, posters, and wallpapers.

A major advantage of screen printing is that because of the opaque quality of the ink, white or any light color can be printed on a dark surface in one application. And there are a great variety of inks available, including metallic inks and fluorescent colors. There is even a special ink that is used for screen printing electronic circuits.

Although the speed of screen printing does not compare favorably with that of the three major printing processes, it has attained an important place in the printing industry because of its versatility and unique advantages.

Flexography is a form of relief printing in which a rubber or soft plastic printing plate, made from a mold of a letterpress plate, is used with fast-drying ink (usually aniline). The printing process is similar to that of rotary letterpress: the rubber plate is mounted on a printing cylinder and generally prints onto roll stock (web-fed).

Flexography is a versatile printing process, printing from one to six colors using webs up to 100" wide. It can be used to print on paper, cellophane, foil, or plastic and is used for printing such diverse items as bubblegum and bread wrappers, wallpaper, paperback books, and shower curtains. Flexography is particularly popular with the packaging industry.

Because the printing plate used in flexography is flexible it can be easily mounted onto the plate cylinders with tape. Magnetic rubber is also used for plates. Changes can be inserted directly into the rubber plate by simply cutting out the old copy and replacing it with a patch. This operation is much easier than making a new plate. Printing cylinders are interchangeable, making it possible to change jobs quickly and easily.

Flexography does have its limitations, however. The ink has a tendency to spread, making it difficult to print a clean, sharp halftone. For this reason it is not unusual to use gravure cylinders on the press to print halftones and use flexography for the line work only. Also for this reason, small type sizes (6 point and smaller) should be avoided, and if the type is to be reversed, it should be bold enough so that it will not fill in.

UNFORTUNATELY IT IS IMPOSSIBLE TO SHOW AN ILLUSTRATION OF COLLOTYPE PRINTING AS IT IS A SCREENLESS PRINTING PROCESS THIS BOOK IS PRINTED BY OFFSET LITHOGRAPHY WHICH REQUIRES THAT ALL CONTINUOUS-TONE COPY BE SCREENED BEFORE PRINTING

Letterset. In letterset, also known as indirect letterpress, the image, carried on a one-piece, low relief, wrap-around printing plate, is first offset onto a rubber blanket and then transferred from the blanket to the paper.

The purpose of letterset is to combine the quality of letterpress with the convenience of offset. Letterset printing is ideal for printing on metal or plastic (cans, labels, cartons) and offers consistency of printing quality and color.

The purpose of letterset is to combine the quality of letterpress with the convenience of offset. Furthermore, it is possible for a printer with an offset press to modify it for letterset work. One of the advantages of this arrangement is that it allows the printer to lay down a heavier deposit of ink than would otherwise be possible with his offset press. Letterset printing is used mainly in the packaging industry.

Collotype. Also called photogelatin. The only process in which continuoustone copy can be reproduced without the use of a screen. The basic concept is similar to that of offset lithography, in which water and ink do not mix. In collotype, moisture and ink do not mix. The printing plates are aluminum and are coated with a gelatin solution. The relative softness or hardness of the gelatin dictates the continuous-tone values: the soft areas accept more water and less ink; the hard areas accept less water and more ink. However, unlike offset lithography, in which the image is first offset, in collotype the image is transferred directly from plate to paper. Collotype is a short-run process, which is used extensively for one-sheet, two-sheet, and three-sheet posters; point-of-purchase displays; and printed transparencies used in back-lighted displays. Runs are limited by plate life.

Thermography. Although thermography is a finishing process rather than a printing process, the designer should be familiar with it. Thermography is an inexpensive way to achieve an engraved look and feel and is frequently used to print business cards, invitations, decorative papers, and greeting cards. To produce this engraved look, the image is printed with a slow-drying ink and then dusted with powdered rosin. When heated, the powder and the ink fuse to give the type a raised, or engraved look. Thermography can be done in a number of colors, including gold, silver, and copper. The fin ish may be either dull or glossy.

Printing Terms and Techniques

When discussing printing with a printer you will find that he has his own language; the better you understand it, the easier communication will be. Let's examine some of the terms:

Backing-up. Printing the reverse side of an already printed sheet.

Form. In letterpress, type and other printing matter locked up in a chase ready for printing. In offset, refers to the printing plate. Can also refer to one side of a printed sheet.

Gang Printing. Also called *ganging up*. Printing a variety of different jobs on the same sheet of paper. After printing, the sheet is cut into the individual jobs.

Gripper Edge. The leading edge of a sheet of paper held by the grippers as it passes through the printing press. Paper allowance must be made at the gripper edge of from $\frac{1}{4}$ " to $\frac{1}{2}$ ", depending on the kind of printing press used.

Grippers. Metal fingers that hold the paper onto the impression cylinder of the press.

Imposition. The arrangement of pages in a form so they will be in the correct order when the sheet is printed, folded, and trimmed.

Makeready. The complete process involved in getting the presses ready to run after plates have been mounted: register, building up the form so all areas print evenly, ink control, feeder control, etc.

One-up, Two-up, Etc. When printing small units it is often more practical and economical to repeat the image many times (two-up, three-up, etc.), using duplicate plates on a larger sheet of paper, than to print it singly (one-up) on a small sheet of paper. The advantage is that the cost of duplicate plates is generally less than the cost of the additional press time that is required to print a single image on each pass through the press. This is especially true in offset lithography, for which duplicate plates are particularly inexpensive to make. Also, because the press plate is a given size on any press (that is, a smaller plate cannot be substituted just because your job is small), it is economical to make sure that the plate is covered with the greatest possible number of images.

Preparation. Also called *prep work*. All the work necessary in getting a job ready for printing: camera, stripping, platemaking, proofing, etc.

Sheetwise. A printing procedure in which one side of the sheet is printed with one form, the reverse side with another, and in both passes through the press, the gripper and guide sides remain the same.

Work and Tumble. A printing procedure that allows the printer to "back up" a sheet without having to change printing plates. The plates for both sides of the sheet are contained in a single form; on the first pass through the press half the sheet receives the impression of Side A and the other half of the sheet receives the impression of Side B. The sheet is then tumbled; that is, turned over from front (gripper edge) to back, so that a new edge meets the gripper. With the same printing plate, Side A is backed up with Side B and Side B is backed up with Side A. Because changing the gripper edge means that adjustments must be made on press before printing the second side of the sheet, work and tumble is seldom used where close register is important. Also, because both ends of the sheet are used as gripper edges, extra paper must be allowed for margins.

Work and Turn. A printing procedure similar to work and tumble except that the second side of the sheet is printed by turning it over from left to right, so that the same gripper edge is used for both sides. Not having to change the gripper edge makes it much easier for the printer to hold proper register. For this reason, work and turn is more widely used than work and tumble.

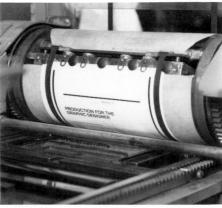

Grippers and gripper edge.

Two-up.

Work and tumble.

Work and turn.

Printing Problems

Although printing problems are not the designer's responsibility, he is of course affected by any imperfections in the printed piece resulting from a problem on press.

Printing problems are usually caused by the paper, the press, the printing plate, or the ink. If the problem is serious, the press may have to be stopped until a correction is made, and someone—the printer, the client, or the paper merchant—will have to pay for the delay.

The following are some of the more common printing problems that may arise:

Chalking. Also called *Powdering*. A condition that occurs when the printing ink is not properly bound to the paper and can be easily rubbed off as a powder. This condition is never noticed until the ink has had time to dry, and by that time it is too late to correct the factors that caused it. However, the job can be saved by using the same printing plate to print a transparent size over the entire job.

Crawling. This printer's term is so ambiguous that the same word can have opposite meanings within one plant. To some printers, crawling means the contraction of ink film on a surface that the ink has not wet completely; to others, it means the expansion of ink, such as might occur when a "soupy" ink overprints a wet ink film.

Crystallization. (Not to be confused with the same term, meaning the formation of crystals, used in chemistry.) A dried ink film repels a second ink that must be printed on top of it. For example, when a four-color job is printed on a two-color press, the first and second colors are printed on the first pass through the press; the third and fourth colors are printed in a subsequent pass, allowing enough time between passes to avoid smudging. It is during this time that crystallization can occur-the inks may dry too hard or some of the ink's components may rise to the surface and cause poor trapping (which see). Crystallization can be avoided by using an ink formulated to dry properly on the specific paper used and by paying attention to the time intervals between subsequent printings.

Doubling. As the name suggests, doubling is two impressions of each dot, which causes the printed image to appear heavier, or fuller, than it should. Doubling occurs in wet multicolor printing when the first color printed is picked up on the blanket of the second cylinder, which in turn, prints it back onto the next sheet. If it is in exact register this second imprint will not be seen, but if it is slightly off-register it will print as a light "ghost" dot next to the original dot, thus causing variations in tone and color values.

Drying, Poor. When ink requires an unreasonable amount of time to dry after printing. Poor drying can be caused by the kind and amount of dryers in the ink, dryer dissipation, too much moisture in the paper, too much humidity in the printing plant, too much water being run, or too acid a fountain solution.

Emulsification. In offset printing, the dispersion of the fountain solution (acid, gum arabic, and water) in the ink. Emulsification affects the color strength of the ink and its ability to dry with a gloss, resulting in a washed-out appearance.

Flocculation. Also called *orange peeling*. Clumps of pigment particles are surrounded by clear vehicle, which causes the solid areas to resemble an orange peel. The condition can be caused by improper handling of the press, but it is generally regarded as an ink defect.

Ghosting. The printed image appears faint where not intended. This is caused by an abrupt change in ink take-off on the rollers. This may occur when a border is involved, for example: because the vertical sides strip off more ink than the horizontal, a solid printed behind will be starved for ink and print lighter in that area. Ghosting is one of the few printing problems that the designer should be able to foresee and control. One solution is to have the solid areas well distributed thereby giving the ink a chance to build up again on the rollers. Also, avoid running light tints of color: choose a lighter color and run more of it.

Halation. Although not a press problem, halation may be mistaken for one. It appears in halftones (black and white or color) as a light, halo-like area around a very dark area. Halation is caused by improper automatic photographic developing, and new plates must be made to correct it.

Chalking.

Doubling.

Ghosting.

Ink hickies.

Moiré caused by rescreening a halftone.

Hickies, Ink and Paper. This is probably the one printing problem with which most designers are familiar. Hickies may be caused by foreign matter in the ink or by loose paper fibers. Ink hickies are identifiable as small doughnuts (ink spots with white rings around them), while paper hickies appear as clean white specks.

Ink hickies occur when dirt or solids in the ink adhere to the blanket: ink is transferred from the particle to the paper, with the edge of the particle leaving a small uninked ring. Ink hickies continue to appear in the same place from sheet to sheet, and the only way to eliminate them is to do a complete wash-up and replace the ink in the fountain.

Paper hickies, on the other hand, are caused by clumps of paper fiber or dust adhering to the blanket (see *Picking*). As they absorb water they tend to repel the ink, becoming whiter as they repeat. The only way to eliminate paper hickies is to find out where they come from and remove them at the source. Otherwise, frequent press wash-ups will be necessary.

Moiré. A moiré (pronounced moh-ray) is an undesirable pattern created by the optical meshing of screen dots when screens are superimposed on one another. This can happen whenever two or more screens are used. A common cause of moiré is when a printed halftone is rescreened for subsequent reproduction. For example, if you wished to reproduce the halftones on this page, and you shot the already screened halftone through a second screen, the result would be a combination of the two screens. This could cause a moiré. To avoid a moiré, the second screen must be set at a different angle from the first so that the angles of the two screens are about 30° apart.

There is another way to reproduce a previously printed halftone that will avoid creating a moiré. Because the halftone already has dots, it can be photographed as line art. This is a good solution if the dots are sharp and if the halftone does not have to be enlarged or reduced too much; overly enlarged dots become coarse, and if reduced too much the dots may be so close together that the halftone will fill in.

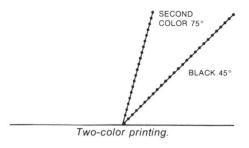

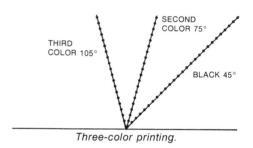

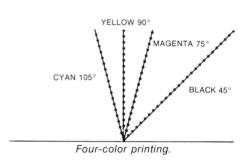

Screens angled at 45° are the least visible and are generally used for dark colors, such as black, while screens angled at 90° are the most visible and are reserved for the lightest colors, such as yellow.

Moiré produced by incorrect screen angles.

Mottle. An uneven or speckled appearance caused by the ink's inability to form a smooth, uniform film. Some forms of mottle are noticeable while the ink is wet: others become noticeable as the ink dries. Mottle can be caused by a number of factors: ink not properly adjusted to stock; stock not receptive to ink; uncoated stock with wild formation; coated stock with nonuniform ink absorbency; running too much ink on hard-surface. nonabsorbent stock; and too much dampening water. In some cases, mottle can be reduced or overcome by modifying the ink or keeping the dampening water to a minimum.

Off Color. When the job appears to be a different color from that specified. This can be the result of many things, the most obvious of which is a poor color match by the pressman or ink manufacturer. This in turn could be caused by an inadequate color specimen, an incorrect paper sample, or insufficient information regarding the type of press, job, or form. Other factors that can affect color are the thickness of the ink film -the thicker the film, the darker the color will appear; whether or not the press rollers, fountain; and printing plates are properly cleaned; in offset, if too much water gets in the ink; and the color of the paper. Also, colors, especially tints and pastel shades, may darken or fade after printing.

Paper Curling. In offset, this can be caused by too much fountain water, which causes the sheets to curl up. (This is especially common in one-side printing such as labels.) In other cases, when the printing ink is too tacky, the back edge of the printed sheet has a tendency to curl down if heavy ink coverage extends too close to the back edge of the sheet (tail-end hook). Extremes of humidity in the printing plant can also cause paper to curl, especially along the edges.

Picking. When the pull of the ink (the tack) is too strong for the paper, the surface of the paper is ruptured, or "picked." Picking may appear as small white specks in the solid printed areas of a paper's surface. It is caused by inks that are too tacky or papers that are too weak. Picking can often be corrected by adding a solvent or compounds to reduce the ink's tack, by slowing the press, or by changing to a paper with a higher pick strength. A lot of trouble can be avoided if paper is tested for pick strength before going to press.

Piling, Ink. Ink must transfer uniformly at each point in the printing system. If it does not, an accumulation of ink gradually builds up on the press rollers, making continued printing impossible. Among the causes of piling are inks that are not properly ground, and too much moisture on press which causes the paper coating to become tacky.

Piling, Paper. A problem in offset printing, where coated papers come in contact with moisture on the blanket. The coating is loosened and particles adhere to the blanket, causing halftones to become sandy and highlight dots to be lost. To avoid piling, the fountain solution may have to be modified or the paper changed.

Registration, Poor. In printing, the accurate positioning of one printing plate over another is extremely important. When plates are printed off-register, the printed image is fuzzy. The two most common of the many reasons for poor registration are poor platemaking and paper that is not stable (has a tendency to stretch). Also, the more colors used, the more chances there are for poor registration. Perhaps the most difficult job to control would be a job requiring tight registration, printed by a high-speed web press on cheap paper.

Scuffing. If an ink contains too much non-drying oil or varnish it rubs, or scuffs, easily even when dry. This is a particularly disastrous problem in packaging, where printed cartons or labels tend to rub against one another. Scuffing is also common in printing done on highly absorbent coatings such as Kromecote. Scuffing can be minimized by using a scuffproof ink, or by varnishing after printing, which is usually done on press.

Picking.

Scumming. In offset printing, the adherence of ink to the non-image area. Scumming occurs only in lithography because the image and non-image areas of the printing plate are on the same plane. When the non-image area loses its ability to repel ink, the ink will be accepted and then transferred to the nonimage area of the print. This may be uniform over the sheet, but it is more likely to occur in the form of blotches at the ends and sides of the sheet.

Although scumming used to be a common problem, advances in lithographic plates have now made it a rarity.

Set-off. (Formerly called offset, a term now reserved for offset lithography printing.) Set-off occurs when the ink on a printed sheet fails to set in time and transfers to the underside of the next sheet. This can be brought about by any combination of many factors that inhibit ink from setting.

Show-through. When the low opacity of a paper permits the printing to be seen from the other side of the sheet. Showthrough can be avoided by printing on a more opaque sheet.

Slurring. The filling in of halftones and of reverse lettering, a common problem in offset printing, especially when printing on coated stock. Slurring is caused by too much ink or by slippage between the paper and either the printing plate or the blanket. Slur, or "drag," is most apt to happen when printing solids or halftones on a smooth-coated paper because the ink acts as a lubricant, aggravating the slippage. Usually, slurred type gains weight in only one direction.

Snowflaking. The failure of a printed ink to form a continuous film. Snowflaking is visible in the form of small holes, or voids, in the printed area. It is caused by water droplets in the ink which prevent the uniform transfer of a solid to the paper, or in gravure by too light a pressure setting between the cylinders, which prevents the paper from making contact with one or more gravure cells. Extremely rough stock will also cause snowflaking problems due to failure of the ink to make contact with the paper's surface.

Spreading. A thickening, or enlarging, of the printed image. This may be due to a number of things: a poorly made plate, running too much ink, excessive plateblanket squeeze, etc.

Sticking. Also called blocking. Set-off (which see) carried to a point where the sheets actually stick together.

Strike-through. When the vehicle of the ink penetrates through the sheet so that it is visible from the opposite side. Strikethrough is more apt to occur on an absorbent stock than on a nonabsorbent stock. A possible solution is to change the stock or print with an ink that has a higher hold-out formula.

Tinting. Found only in offset printing; occurs when pigment particles migrate to the fountain solution, producing a uniform discoloration of the background. Tinting differs from scumming (which see) in that it usually shows up over the entire plate rather than in streaks. When washed from the plate, the tinting instantly reappears.

Trapping, Poor. Trapping is the ability of an ink film to properly accept a subsequent ink film. To ensure good trapping in wet printing, the colors first printed must be tackier than subsequent colors; in this way, the first ink down helps pull the subsequent ink off the plate or blanket. If the ink manufacturer knows how a multi color job is to be run, he can adjust the ink tack to minimize the likelihood of poor trapping.

Another form of trapping that is of concern to the designer is where two color areas meet. To avoid a white line between these two areas, a slight trapping, or overlapping, of the two colors is necessary.

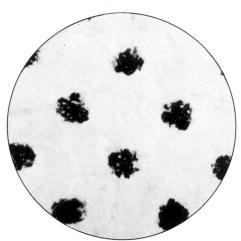

Normal halftone dot enlarged.

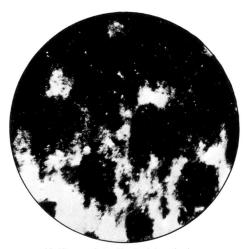

Halftone dot affected by sluring.

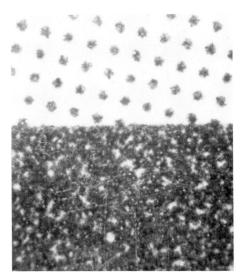

Enlarged detail of halftone dots and solid area shows the effect of snowflaking.

Quality Control

Every designer wants the highest possible quality in his printed job. And most clients would add: at the lowest possible cost. It is the designer's responsibility to try to satisfy both demands. There are several areas in which the designer can influence both the quality and the cost of the job:

Design. Design is crucial to the quality of a job; it also has an enormous influence on the cost of a job. For example, the least expensive job to print is all line art, printed black. Adding a halftone means that original continuous-tone copy will have to be screened and stripped into position. This will add to your cost. And if you use a colored ink instead of black, expect to pay more. Not only do colored inks generally cost more, but since most printing plants are always running black ink, the press must be cleaned before printing another color. And after the job is printed, the press must be cleaned again before going back to black. By the same token, two-color jobs are more expensive than one-color jobs, and fullcolor printing is the most expensive.

Original Art. The quality of the printing plate is dictated by the quality of the original copy, so make sure all copy is of the highest possible quality. If the art is not perfect, have it retouched or crop the areas that will not reproduce well (make sure you consult with the client before cropping!). If the art cannot be improved, show the problem to the printer; a certain amount of correction is possible in the shooting, platemaking, and printing processes.

Paper. Find out enough about paper so that you will be able to make intelligent decisions. The best printing press and the best presswork are useless if the job is printed on the wrong paper. Paper must be suited not only to the printing process but also to the copy to be printed. For example, the selection of paper is far more critical for printing color and halftones than it is for printing type or line illustrations. The smoothness of the paper's surface directly affects the quality of the printed piece: a smooth paper permits each dot to print accurately; a rough paper tends to break up the dot patterns, creating a printed image that lacks strength and detail. In short, the more you know about paper, the better the chances that the job will be properly printed. (See Paper, page 121.)

Proofs. Check proofs carefully. If the job is printed by letterpress or gravure, you will receive an engraver's proof. In this case, the printing plate has already been made and what you see is exactly what will appear when the job is printed. If the plate is correct, it is sent by the engraver directly to the printer. Corrections or changes at this stage are expensive and may require handwork, or making a completely new plate. Whenever possible, an engraver's proof should be pulled on the same paper on which the job is to be printed.

If the job is to be printed by offset, you will receive a photographic proof. In this case, the printing plate has not been made, and what you see will not help you determine the quality of the printed job so much as reassure you that all the elements are correct and in their proper positions. Check the proofs carefully with the client to be certain there are no mistakes. Mark the corrections directly on the proof and return it to the platemaker or printer along with any new copy to be shot. Unless you ask for a corrected proof, the next time you see the job it will be printed.

Printer. In many cases, the printer can be more important than the printing process. A good printer can control the quality of a job by applying his knowledge of the press, paper, and ink; a poor printer may destroy the job. The printer you choose may be someone you know by

reputation or someone recommended to you. Ask the printer to discuss the job with you and perhaps show you similar jobs printed on the kind of paper you intend to use. It won't do you any good if he shows you a great letterpress job on smooth paper when you intend to print offset on rough paper!

At times the designer may have to work closely with the printer to determine imposition, sheet size, and press size. The size of the printing press is designated by the size of the sheet the press is designed to handle—for example, 22" x 29", 25" x 38", or 52" x 76". (In some cases there may be an inch or two difference between the official size and the sheet size because some presses are capable of taking a sheet size slightly larger than standard.) If the job is being printed by web, the press is measured by the width of the roll (web width) and the minimum and maximum cutoff of the roll.

Scheduling. Keep in mind scheduling requirements, allowing the proper amount of time for each of the trades to do its job. The typographer, the platemaker, and the printer must all be included in the schedule. And remember that it takes time to ship paper to the printer and the printed piece to the client. Also, do not overlook vacation schedules. These can involve closing entire plants for two weeks during the summer, and sometimes for the week between Christmas and New Year.

It is impossible to anticipate everything that can go wrong with a job; there are just too many people involved. All you can do is plan well enough in advance so that if things do go wrong there will still be plenty of time to rectify them. Otherwise, you will find yourself making a compromise between what you want and what is available. In the end, lack of planning means more work for the designer, as well as a less than successful job.

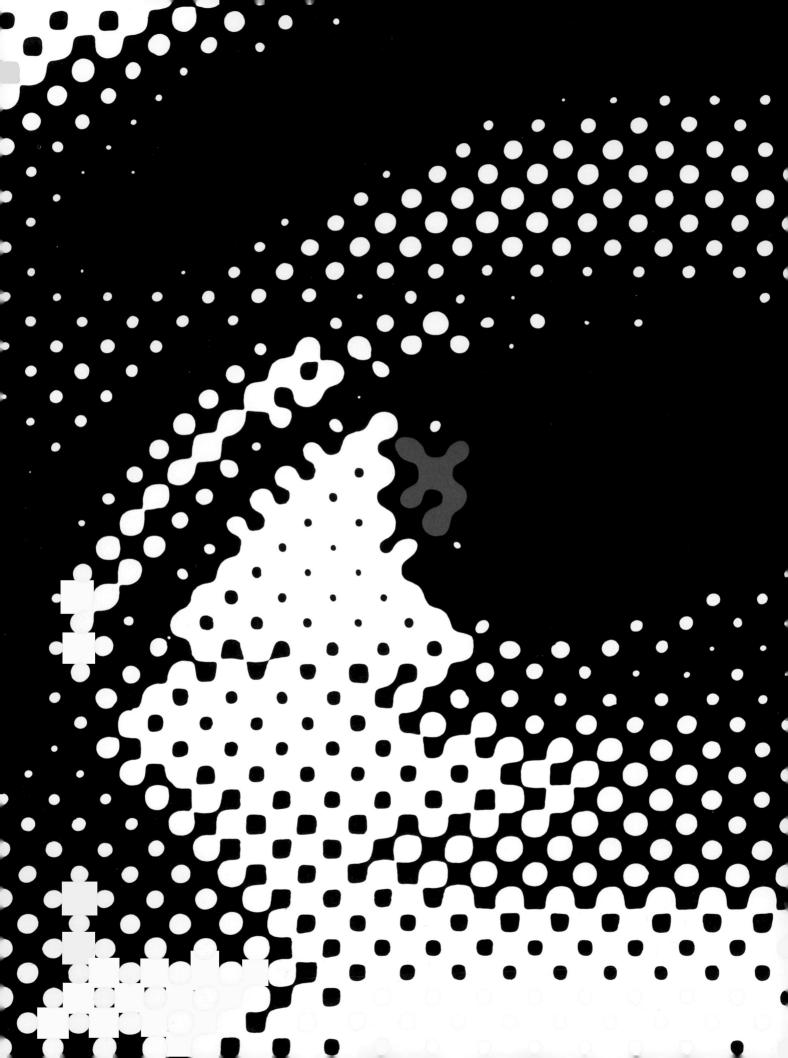

Color Printing

Today, more and more printing is being done in color. Used properly, color can be very effective: it can attract attention, create sales appeal, clarify complex design, highlight specific points, or add a decorative touch. In short, color can be one of the designer's most important tools.

Color printing can be divided into two basic categories: flat (or match) color and four-color process. Let's examine each of these color printing methods more closely.

Enlarged detail of eye showing dot formation. The dots forming the highlight have been printed in a second color, orange.

Flat Color

Flat color, also referred to as *match color*, is any color the designer chooses and asks the printer to match. Flat color is used for the color reproduction of any black and white copy, line or continuous tone.

Flat-color printing is designated by the number of colors used: one-color, two-color, three-color, four-color (1/C, 2/C, 3/C, 4/C), etc. Because each color requires a separate printing plate and a separate run on the press, the more colors used, the more expensive the job. Most flat-color jobs use from one to four colors, with two colors being by far the most common.

ONE-COLOR

A one-color job means just that: it is printed in one color, whether red, blue, green, or black (in the printing industry black counts as a color).

It is possible to achieve a wide variety of effects working with only one color. For example, type can be printed solid (100% value), screened (producing tints of from 5% to 95%), surprinted (printed solid over a tint) or reversed (dropped out of a solid-color background).

When screening or reversing type, make sure the type you use is large or bold enough not to be adversely affected by these techniques. For example, if the type is too small or the serifs too fine, screening may result in broken type, and reversing the type may cause it to fill in.

Color is also a consideration: make sure the color you choose is dark enough so that the type is legible and comfortable to read. The same consideration should be given to the reproduction of halftones: the color should be dark enough so that the halftone will not appear washed out.

Surprint
Surprint
Surprint
Surprint
Surprint

Surprint
Surprint
Surprint
Surprint
Reverse
Reverse
Reverse
Reverse

Surprint

Surprint

Surprint

Surprint

Surprint
Surprint
Surprint
Surprint
Reverse
Reverse
Reverse
Reverse

Surprint
Surprint
Surprint
Surprint
Surprint
Reverse
Reverse
Reverse
Reverse

.

Tint blocks from 10% to 100% (133-line screen) with type surprinted and reversed.

Surprint
Surprint
Surprint
Surprint

Reverse Reverse Reverse Reverse 20%

Surprint
Surprint
Surprint
Surprint
Surprint
Reverse
Reverse
Reverse
Reverse

Surprint
Surprint
Surprint
Surprint
Reverse
Reverse
Reverse
Reverse

The color you choose should be dark enough to make the type legible and the halftones strong.

The color you choose should be dark enough to make the type legible and the halftones strong.

The color you choose should be dark enough to make the type legible and the halftones strong.

Surprint
Surprint
Surprint
Surprint
Reverse
Reverse
Reverse
Reverse

50%

The color you choose should be dark enough to make the type legible and the halftones strong.

The color you choose should be dark enough to make the type legible and the halftones strong.

The color you choose should be dark enough to make the type legible and the halftones strong.

MULTICOLOR

Multicolor printing is printing in more than one color: two, three, four, etc.

The addition of a second color provides a variety of design possibilites: not only can the two colors be used separately, but they can also be combined as solids and screened tints to produce a wide range of colors.

Although it is possible to use any two colors, one of the most common combinations is black and a second color. This allows halftones and text type to be printed in black, while the second color can be used in a more decorative manner.

The addition of a third or fourth color extends the color possibilities. While technically everything that has been said

about one-color and two-color printing applies to three-color and four-color printing, there are a few factors to keep in mind when designing three-color and four-color jobs.

In many cases the designer may find that a three-color job costs as much as a four-color job. The reason for this is that most printers use either one-color, two-color, or four-color presses. To do a three-color job the printer has to either make multiple passes on his one-color or two-color press or use a four-color press for only three colors. Ideally, one pass through the press is preferable; it is less expensive and it offers the printer an opportunity to correct or balance the color while the job is running.

Although it is possible to print an un-

Screened tints, using one color (C) plus black (K).

Full-range black and white halftone.

20% tint of second color.

Flat-tint halftone.

(Right) Duotones produced by shooting the black plate for contrast (upper left) and then surprinting it with a second color plate (orange) shot for overall detail. By varying the tonal value of the color plate it is possible to produce a wide range of effects.

limited number of colors, four is generally the maximum. One reason for this is that a four-color press is an industry standard. Also, from the designer's point of view, four colors plus tints and combinations will give him as much color as he needs for all but the most unusual jobs. (Examples of three-color and four-color printing can be seen on page 112.)

Flat-tint Halftone. The flat-tint halftone provides an inexpensive way of introducing color into a halftone. The black and white halftone is printed (surprinted) over a flat background tint of a second color. The designer should keep in mind that the darker the tint the darker the highlights will be, hence the flatter the halftone will appear.

Duotone. A duotone is a two-color half-tone made from a regular black and white photograph. To make a duotone, the photograph is shot twice (at different screen angles), once for the black plate and once for the color plate. The black plate is shot for contrast to hold the dark, or shadow tones; the color plate is shot for the middle tones. When printed, the halftone dots from these two plates produce a complete range of tones.

For the best duotone results, use a photograph that has a full range of tones from black to white. And remember that the second color should not be so strong or dark that it will overpower the black; the best second color for duotones is gray or pastel in tone.

It is also possible to print a duotone us-

ing black for both the first and the second color. This is called a double-black duotone. Double-black printing represents an effort to overcome the limitations of the printing process. Using a single plate, it is impossible for a printing ink to match the rich, solid blacks of a glossy photograph. To compensate, the printer adds a second black plate for the shadow areas. When printed, these two plates combine to produce a rich, dense, black and white image with excellent contrast.

If you work with duotones, it is wise to ask the printer for a sample of his duotone printing; there are a number of ways to achieve a duotone effect and you may not always get the result you anticipate.

Black halftone shot for contrast.

20% value orange halftone over black.

40% value orange halftone over black.

60% value orange halftone over black.

80% value orange halftone over black.

Full value orange halftone over black.

SPECIFYING FLAT COLOR

There are two ways to specify flat color: by asking the printer to mix a color that is part of a color-matching system or by asking him to match a color that is not part of a system (such as a piece of colored paper or a part of a painting). The first method is the most practical because it provides the printer with inkmixing instructions for every color; the second method is more hit-or-miss, very much like mixing housepaints. There are many color-matching systems in use today, the most widely used by the designer being the Pantone Matching System.

Pantone Matching System. This sytem is based on 10 Pantone Colors (8 basic colors, plus black and transparent white) which mixed in varying amounts produce a total of 500 different colors. These colors are numbered and arranged in a "swatchbook" available from art supply stores in a designer's edition as well as in a printer's edition that includes ink-mixing instructions.

To specify a color, the designer looks through the swatchbook, chooses the color he wants, and indicates its number on his mechanical. It is also a good idea to attach a sample of the color, at least $\frac{1}{2}$ " x $\frac{1}{2}$ ", to avoid any possibility of error. The Pantone Color Specifier contains sheets of numbered tear-out samples for this purpose.

PANTONE PANTONE PANTONE 428 428 428 **PANTONE** PANTONE PANTONE 429 429 429 PANTONE PANTONE PANTONE 430 430 430 PANTONE PANTONE PANTONE 431 431 431

Swatchbooks are usually divided into two sections, one showing the colors printed on a coated stock, the other showing them on an uncoated stock. It is important to see both, because the paper's finish will have a definite effect on how the color will look when printed: if the paper is coated, the colors will appear brilliant; if the paper is uncoated, the colors will appear soft or flat.

The color of the paper will also affect the appearance of any color that is printed on it. In standard Pantone swatchbooks the colors are printed on white stock, but there are swatchbooks available, mostly through paper companies, that show standard-color inks printed on a variety of colored papers.

Pantone swatchbooks are also available that show colors printed on newsprint and kraft paper, as well as how the colors look when printed by every major printing process. If a job is to be printed by an unusual process or on an unusual surface (acetate, foil, metal, etc.), the designer should contact the printer for more information.

Although there are other color-matching systems, Pantone offers the designer the widest range of worldwide services. In addition to Pantone Color inks, Pantone Colors are available in a number of related products—self-adhesive overlays, colored papers, and color markers—to help the designer control the color throughout a job.

Four-Color Process

Four-color process printing is the method used to reproduce full-color continuous-tone copy, such as transparencies, color prints, and paintings. Four-color process printing should not be confused with four-color printing, discussed earlier in this section. Whereas four-color printing can be done with any four flat colors, four-color process printing uses four specific colors, called process colors, which consist of the three primary colors—yellow, magenta (process red), cyan (process blue)—and black. Note: although most printers refer to the process colors simply as yellow, red, blue, and black, we shall use the correct terminology, yellow, magenta, cyan, and black, so as not to confuse the reader when discussing separations.

When printed, the four process colors appear as dots of solid color which combined in various sizes and patterns duplicate the full range of colors found in the original image. It is interesting to note that the colors are created not by a physical mixing of the inks, but by the optical mixing of the four original colors by the viewer's eye (similar to the principle of the pointillist technique developed by impressionist painter Georges Seurat).

Magenta (process red)

Black

Enlarged detail of flower showing dot formation.

Bedroom Painting #7 by Tom Wesselmann, oil on canvas, 78" x 87". Collection Philadelphia Museum of Art. Courtesy Sidney Janis Gallery.

COLOR SEPARATION

The first step in reproducing full-color continuous-tone copy is to make color separations. As the name suggests, color separation is the breaking down of the original copy into the four process colors: yellow, magenta, cyan, and black. There are two ways to do this, photographically and electronically.

Photographic Separation. Photographic separations can be made by process camera, enlarger, or by contact printing. To make color separations, the original copy is photographed four times through special filters. (For a full explanation of the color concept behind fourcolor process printing, please refer to pages 108 and 109.) This results in four separation negatives, each carrying a record of the amount and distribution of one of the process colors found in the original copy.

Because process printing is halftone printing, the separations must be screened before the printing plates can be made. To do this, each separation is photographed through a screen that breaks the image down into thousands of tiny dots. To ensure that these dots will fall in correct relation to one another (to avoid a moiré), each screen is set at a different angle. (See Moiré, page 94.)

Separating and screening can take place as a single operation, in the direct method, or as two independent operations, in the indirect method.

Direct Method. The copy is separated, screened, and scaled in the same operation, resulting in four screened separation negatives. This method is fast and efficient, but it does have one disadvantage: if there is any change in the size of the reproduction after the separations have been made, the original copy has to be reseparated and rescreened. This is because reducing or enlarging screened negatives produces an undesirable effect on the dot size.

Indirect Method. The copy is only separated, resulting in four continuous-tone (unscreened) separation negatives. One of the major advantages of this method is that because the separation negatives are unscreened, they can be enlarged or reduced to make any number of reproductions without having to go back to the original copy. Another advantage is that color can be corrected by masking or retouching the film. After scaling and color correction, the negatives are screened.

Electronic Separation. Although most color separation is still being done photographically, more and more is being done by electronic scanners. The electronic scanner "reads" the colors in the original copy and produces screened or unscreened positive or negative separations. Some scanners not only make separations, but can also strip in background tints at the same time. One of the major advantages of the electronic scanner is that it allows for methods of color correcting to be built right into the system, eliminating much of the handwork involved in conventional color correcting.

The electronic scanner has one restriction, however: it can only separate copy that is flexible enough to be wrapped around a scanner drum. This limits acceptable copy to transparent copy (copy viewed by transmitted light, such as transparencies) and unmounted type C or type R prints. Photographic separations, on the other hand, can be made from either transparent copy or reflection copy (copy viewed by reflected light, such as paintings and photographs).

Color Correcting Separations. The best time to adjust color is before the separations have been made. By telling the printer in advance what you want, he can make adjustments while separating; he can modify individual colors, change the overall tone from warm to cool, or increase or decrease contrast.

Once the copy has been separated, it is still possible to do a certain amount of color correcting on the unscreened separations. This is done either on the positives or the negatives, usually by masking or retouching. After the separations have been screened all that can be done to correct color is dot-etching, which chemically alters the size of the halftone dots.

> This page shows a photographic separation using the direct method: the copy is separated and screened in one step.

Screened separation negative: yellow printer.

Yellow proof.

(ABOVE) SEPARATIONS; (BELOW) PROGRESSIVE PROOF

Screened separation negative: cyan printer.

Screened separation negative: black printer.

Magenta proof.

Cyan proof.

Black proof.

Yellow plus magenta.

Yellow, magenta plus cyan.

Yellow, magenta, and cyan plus black.

Process printing is an attempt to reproduce all the colors of the spectrum with just three colors plus black. To understand why we use the specific colors we do in four-color process printing, it is important to understand the nature of light and color.

Light and Color. Light contains all the colors of the spectrum. This can be demonstrated by directing a beam of light through a prism. Although the spectrum contains all possible colors, it can be broken down into three color regions-red, green, blue-each representing a third of the visible spectrum.

As it is possible to break light down into three colors, conversely these same three colors when projected on top of one another create white light. Whereas all three colors overlapping produce white, if one is removed, leaving only two overlapping colors, a totally different color is created: red and green, with the blue removed, produce yellow; red and blue, with the green removed, produce magenta; green and blue, with red removed, produce cyan.

Because the red, green, and blue combine to produce white light, they are called additive primaries. Because the yellow, magenta, and cyan are formed by taking away one of the three additive primaries, they are called subtractive primaries.

How We See Light and Color. Because light contains all colors, it is light that gives color to everything we see. When we see color, we are really seeing light.

There are three ways we see light: as direct, reflected, or transmitted. Direct light, as the name suggests, is from a light source, such as the sun, a candle, or a lightbulb. Reflected light is reflected off some opaque surface, such as that of a photograph, painting, or drawing. Transmitted light is passed through a transparent material, such as a photographic transparency, piece of colored glass, or filter.

As designers, we are mainly concerned with the last two kinds of light: reflected and transmitted. Let's look at a simple example of both:

First, let's examine what happens when light strikes a red apple. We have already established that light is made up of red, green, and blue. When this light strikes the apple, every color is absorbed by the apple except the color it is-red. The red is reflected off its surface, so the color that we see is the reflected color red.

Now let's take a piece of red glass. Once again, all the colors of light, except the color of the object, are absorbed. But in this case the red passes through the object rather than reflecting off its surface. You might say that the red glass has filtered out the green and blue, allowing only the red to pass through. As with the apple, the color we see is red, but it is a transmitted color red, not a reflected color.

Now let's apply this principle to separating color for process printing.

Separating Color. All colors are made up of varying amounts of the three additive primaries: red, green, and blue. Therefore it should follow that if we can separate a full-color image into these three colors, we should be able to recreate it by using the same three colors in printing inks. Unfortunately, we cannot. The problem is that there is a limit to the number of colors that can be created using these three particular colors. For example, although red and green light produce yellow light, red and green inks produce a brown/black color. Therefore, not only would it be impossible to create yellow, but any color brighter than the original colors. The solution to the problem lies in the subtractive primaries: vellow, magenta, and cvan. Using inks in these three colors it is possible to re-create all the colors of the spectrum.

To separate the full-color image into yellow, magenta, and cyan, it is necessary to photograph the copy three times, through filters which are the same color as the additive primaries: red, green, and blue. When the copy is photographed through the red filter, the green and blue is absorbed and the red passes through, producing a negative with a record of the red. By making a positive of this negative we will obtain a record of everything that is not red, or more specifically, a record of the green and blue. The green and blue, as we have seen earlier, combine to produce cyan; therefore, we have a record of the cyan. The same process is repeated for the magenta, using a green filter, and for the yellow, using a blue filter. As each filter covers one-third of the spectrum, we now have a record of all the colors found in the original copy. When combined and printed with the correct colors-yellow, magenta, and cyanwe should be able to reproduce all the colors of the original.

In theory, this is correct. Unfortunately, printing inks are not "pure"; they absorb colors that they would not absorb if they were pure. For this rea-

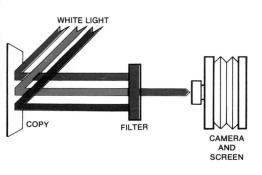

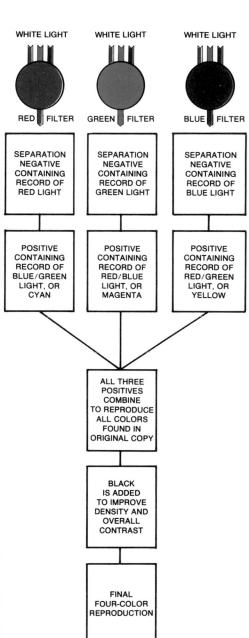

son, the printed image will appear dirty or muddied unless color corrections are made on the separations to compensate for these ink deficiencies. Another problem is a lack of density in the shadow areas. To overcome this, a black separation is made by using a yellow filter or a combination of all three filters. The addition of black improves shadow density and overall contrast.

Reproducing the Image. The four separations are screened at different angles, and from these screened separations the printing plates are made. When printed, the image is reproduced as thousands of tiny dots laid down in thin layers of color. The particular color is dictated by the size of the dots, the manner in which they overlap, and their relation to one another. Therefore the colors are produced not in the physical mixing of the inks, but in the optical mixing of individual colors by the viewer's eye.

Ink and Paper. The paper used has a major influence on the quality of the color printed on it. Because process inks are transparent, it is the light reflected from the paper's surface that supplies the light to the ink. For example, let's look at some cyan printed on a sheet of paper. The light passes through the transparent cyan ink as through a glass filter. The cyan absorbs the color it is not-red-and allows the color it is-blue and green-to pass through. These two colors reflect off the paper and back up through the ink. What we see is a blue and green color, or cyan. It is the quality and quantity of the reflected light that dictates the quality of the color. For this reason, the paper must be bright if it is to reflect maximum light. Also, because a rough surface will scatter the light and distort the color, the paper should be smooth so the ink will lie flat and filter properly.

White paper reflects all colors.

Yellow absorbs blue, reflects red and green.

Magenta absorbs green, reflects red and blue.

Cyan absorbs red, reflects green and blue.

Black absorbs all colors.

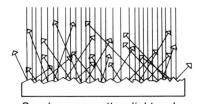

Rough paper scatters light and distorts color.

Smooth paper reflects light evenly.

PROOFS

Before the job is printed, the designer receives a sample of the printed piece, called a proof. From this, he checks the color, the size of the reproduction, and whether or not the overall quality is acceptable. Proofs can be made from the screened separations (pre-press proofs), or from the printing plates (press proofs).

Pre-press Proofs. Pre-press proofs are made directly from the film separations before the printing plates are made. These proofs can be made by an overlay system (3M Color-Key, GAF Chromatic Color System) or by a transfer system (Du Pont Cromalin, 3M Transfer-Key, Agfa Gevaert Gevaproof).

The overlay system consists of four sheets of acetate, one for each color, which when overlayed create the final proof. These are fine for approximating the final color, but are not accurate enough to be used for color correcting.

The transfer system represents an improvement over the overlay system in that it is able to produce a highquality four-color proof on a single sheet of coated paper. The color is accurate and can be used as a guide for color correcting. (Note: some printers have difficulty matching the proofs produced by the transfer system because the dots are sharper than those produced by the press.)

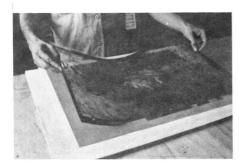

Transfer-Key process. (Top) Negative is positioned over a sheet (Transfer-Key) of one of the process colors and exposed to ultraviolet light. (Bottom) Color is transferred to a single sheet of paper by rubbing. This is repeated for all four process colors.

Because of the low cost compared with press proofing, pre-press proofing may well become the standard proofing method. And because the printing plates have not been made, corrections are relatively inexpensive. (Once plates have been made, corrections are not only more expensive, but there is little the printer can do to adjust the color.)

Press Proofs. These are made directly from the printing plates, using the same ink and paper that will be used for the final printing. Although press proofs can be pulled on the production press, they are more often pulled on a small fourcolor proofing press.

Along with press proofs, the designer will often receive progressive proofs, more commonly called progs. Progs consist of a number of sheets, each showing a process color by itself and in combination with the others. The sequence follows the proper printing rotation: yellow, magenta, cyan, black. The first sheet shows the yellow plate, the second shows the magenta plate, and third sheet shows the two combined; this is followed by the cyan plate, then a combination of the cyan, yellow, and magenta; and finally the black plate, followed by all four combined.

Learning to read these progressive proofs will help the designer in making color corrections. Before correcting color, however, the accuracy and quality of the progressive proofs should be established by checking the color bar.

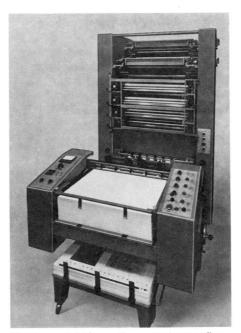

Vandercook 4/C proofing press for proofing with offset printing plates.

Color Bar. Most proofs carry a color bar, made up of the four process colors and usually including tints, overprints, slur bars, star targets, etc. Although not of much concern to the designer, to the printer the color bar represents a simple and accurate means of controlling the quality of a job. At a glance he can tell if the colors are accurate and if the proper amount of ink is being carried on each plate. If necessary, he can measure the color strength with a densitometer. Any variation in the color strength will affect the printed piece. The color bar also shows such printing problems as poor trapping and dot gain. Perhaps most important for the printer is the fact that the color bar is independent of the copy being reproduced and therefore represents a consistent guide from job to job.

> QC (quality control) strip. Used in areas where space does not permit the use of the full color bar-trim areas, for example. Solid bar at top should be clearly distinguishable from the screened area below.

10% tints of solid colors. 40% tints of solid colors.

Star targets. Same as those on the color bar except not squared off.

Correcting Proofs. Color corrections may be necessary, although adequate instructions at the outset will reduce or negate the need for such correcting. Color proofs should be checked for such obvious things as correct size, imperfections in the printing plates such as spots or scratches, and-most important-for accuracy of color.

Unless you are very familiar with the four-color process it is often difficult to say specifically what is wrong with a color. For example, the fact that something appears too blue does not necessarily mean the printer used too much blue; it could mean that one of the other colors is not printing properly, making the blue appear too strong. Fortunately, it is not the designer's job to tell the printer how to correct the color, but simply to tell him what is wrong with it.

An important factor in color correcting is the light under which the job is viewed. Most printers use a standard light source (5,000 Kelvins) for both the transparency viewer (light box) and the overall lighting. This means that everyone in the printing plant views the color under the same conditions. Ideally, the designer, or whoever corrects the color, should view the printed image under the same lighting conditions; many large agencies and studios have areas set aside that are specially lighted and painted a neutral color (Munsell gray) for viewing proofs. The reason for the neutral gray is to reduce the effect reflected light might have on one's color judgment.

Although a number of people may wish to see the proofs, only one person should have the responsibility for correcting them. Each person sees color differently, and it could confuse the printer if each corrected the proofs.

Corrections should be written clearly on the proof, and they should be specific. This marked proof becomes the printer's working guide. Also, give the printer ample time to make corrections: remember, extensive corrections might involve making new separations.

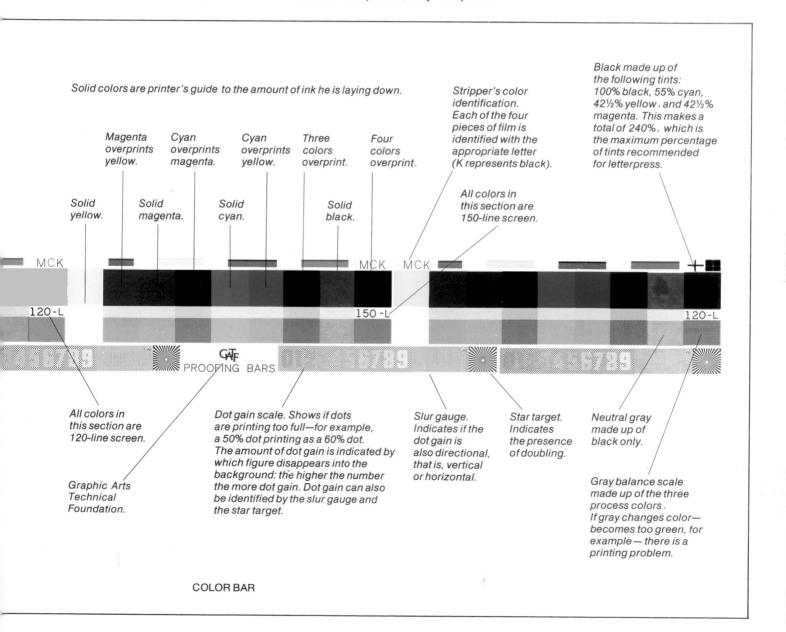

PROCESS COLOR AS FLAT COLOR

Although process color is used primarily for the reproduction of full-color continuous-tone images, it can also be used to reproduce black and white line copy in color. This is possible because any flat color can be approximated by combining various tints of the four process colors. This technique is commonly used for jobs such as ads, posters, magazines, and book covers.

Note: when combining process-color tints, keep in mind that the more ink applied to the paper's surface, the muddier the colors become. The total percentage of tints should not exceed 240%. For example, 100% yellow, 100% magenta, and 40% cyan would be acceptable, whereas 100% yellow, 100% magenta, and 100% cyan would not be.

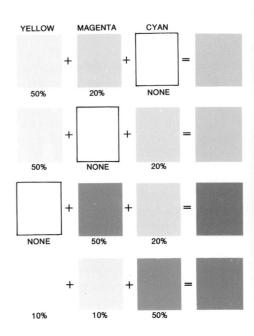

TIPS AND SUGGESTIONS

Fine color printing is an art that calls on the skills of the photographer, the platemaker, and the printer. The designer, too, can contribute a great deal to the success of a job.

One way to help achieve high-quality color printing is to start with the best original copy possible, whether reflective copy or transparent copy. Given a choice between reflective copy and transparent copy, most printers would rather work from transparencies. They are easy to handle, can be separated either photographically or electronically. and because they are small, they can easily be ganged-up to reduce costs.

When working with color transparencies it is advisable to use the larger sizes. Although it is possible to get good reproductions from some 35mm transparencies, the results are generally much sharper with 4" x 5" or 8" x 10" transparencies. This is because the emulsion in the 35mm transparency can appear grainy when enlarged too much or the photo is out of focus.

To get a good transparency you must work with a good photographer; the best

and least expensive time to control the color, the lighting, and overall quality is during the shooting. Ask the photographer to bracket the shots (shoot at different exposures), then choose the best. If you have a choice between a light transparency and a darker one, choose the darker. Generally speaking, the darker, or fuller, transparency will produce better results than the lighter transparency, which could appear washed out. If you are not satisfied with any of the transparencies, reshoot the job. The cost of reshooting will probably be less than the cost of extensive color correcting.

Before releasing transparencies for separation, check them carefully for imperfections such as scratches. Highquality originals not only reduce or eliminate the need for corrections, but they also save time and money for the client.

If you have a transparency with imperfections, do not retouch it; the retouching will show on the separation, which in turn will have to be retouched before printing. The most direct way to overcome a poor transparency is—if possible -to reshoot the original art. Another way is to send the transparency to the engraver, along with a black and white print (or stat) on which the desired corrections are indicated. The engraver will then make the continuous-tone separations and retouch them following your instructions. A third way, which is more expensive, is to make a full-color print (a dye transfer, C-print, or Cibachrome), retouch that, and send it to the engraver for separation.

When comparing a transparency to the printed image, or proof, don't expect the printed image to match the brilliance of the transparency. Allowances must be made for the fact that the transparency is viewed by light passing through it, which gives the color a brilliance that could never be matched by ink on paper. On the other hand, when comparing a color print or painting against a proof, the proof should be a close match because both are reflective copy.

At times you may find it wise to accept the color, if it is well balanced, even if it doesn't match the transparency exactly, rather than incur the time and expense of color correcting. This is especially true in cases where it is impossible to check the transparency against the original subject.

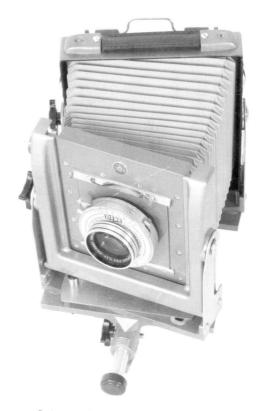

Calumet 4" x 5" view camera.

Tints used for illustrations on the opposite page.

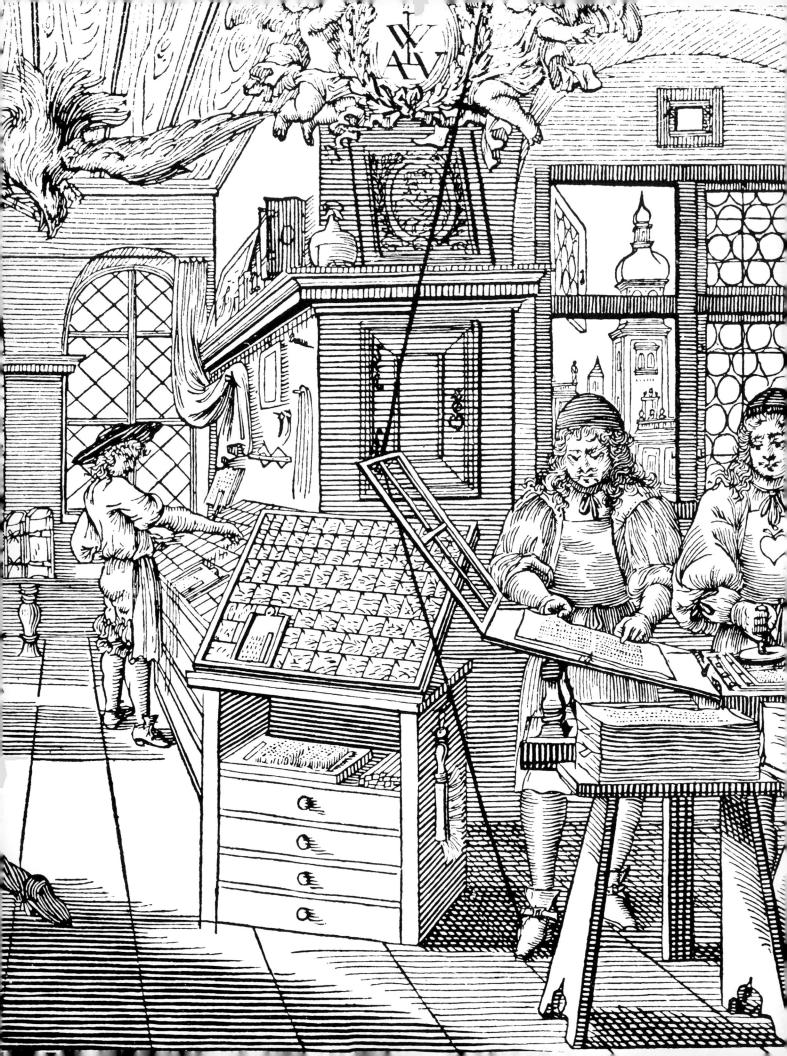

Inks

Inks must serve a wide range of printing needs: letterpress, gravure, offset lithography, flexography, and screen printing, to name just a few. Inks must also be capable of printing on a variety of surfaces, such as paper, cardboard, plastic, foil, glass, textile, and metal. Although the designer is not responsible for the preparation of printing inks, it does help if he understands what they are made of, the different ink-drying processes, and how ink behaves when used with different printing processes and printing surfaces.

Basic Ingredients of Ink

Printing inks, in one form or another, have been around since long before Johann Gutenberg invented printing with movable type. Three hundred years before Christ, the Chinese were using inks to print with wooden blocks. One of the earliest ink formulas included lampblack, glue, and water. This was later improved somewhat by the addition of linseed oil, but it was not until the late 19th century, with the introduction of synthetic oils and man-made resins, that the quality of printing inks was greatly improved.

A series of woodcuts showing the early Chinese ink-making process.

1. Manufacturing lampblack.

2. Straining the glue.

3. Pounding the ink.

The specific ingredients used in the manufacture of printing inks are dictated by many factors—the printing process, the ink-drying system, the surface to be printed, etc.—however they can be broken down into three categories: pigment, vehicle, and miscellaneous ingredients (mainly driers and compounds).

Pigment. The fine, solid particles that give printing ink its color. In addition to determining color, pigment contributes to the ink's opacity and permanence. It is also the pigment that determines whether the printed page will bleed if wet. Pigments can be mineral, organic, or dyes.

Vehicle. The liquid ingredient into which the pigment and other ingredients are mixed. The function of the vehicle is to act as a carrier for the pigment, and as a binder to affix the pigment to the printed surface. It is also mainly responsible for the gloss and hardness of the dried ink film. To a great extent the vehicle determines the "body" of the ink; that is, the viscosity, consistency, and flow characteristics (fluidity) of an ink. Inks with rapid flow characteristics are called "long"; those with slow flow characteristics are called "short." The type of printing process and drying system determines the type of vehicle used. Some of the more popular vehicles are linseed oil, petroleum oils, resin oils, and alcohol.

Miscellaneous Ingredients. One of the most important ingredients that all oxidizing inks must have is a drier. (The process of drying ink by oxidation will be discussed on page 117.) This is usually made from oil, a metallic salt, or a mineral compound and is added to the ink to help it dry more rapidly.

Waxes and compounds are added to prevent set-off and sheet sticking, and to improve scuff resistance. Greases, lubricants, reducing oils, and solvents are used to reduce tackiness and aid penetration and rapid setting. Body gums and binding varnishes help inks print more sharply, improve drying, and prevent chalking. Antiskinning agents reduce excessive drying and skinning on press and in storage. Cornstarch adds body to the ink and prevents set-off.

Because every pigment-vehicle combination behaves differently, the addition of these ingredients is carefully controlled; what is effective in one case may be harmful in another.

Ink-Drying Processes

Before inks dry they "set." Setting is the initial stage of the drying process in which the printed sheets, though not fully dry, can be handled without smudging. The ink is considered dry when the ink film is converted to a solid state and is absolutely dry to the touch.

Perhaps the best way to understand the ink-drying process is to think of the ink as a fresh coat of paint on a board. Part of the paint is absorbed into the wood, part of it gels (polymerization), and the rest dries by evaporation.

Drying is brought about by any one or more usually by a combination—of the following: absorption, evaporation, oxidation/polymerization, and precipitation.

Absorption. Also called *penetration*. The ink used is usually quite thin, and the vehicle, which is non-drying, is absorbed by the inner fibers of the paper, where it stays damp for some time. Meanwhile, the pigment remains on the surface. This is the ink-drying process used by most newspapers, which explains why one's fingers are always so dirty after reading a newspaper.

Evaporation. Also called *volatization*. Used in gravure and flexography: the ink is dried principally by the evaporation of the vehicle from the ink, leaving behind a solid film of pigment. The evaporation drying process is used with or without heat. Screen printing and die stamping inks, as well as heat-set ink, (a specialty ink discussed on page 119), are also dried by evaporation.

Oxidation/Polymerization. A two-step ink-drying method used for most offset and letterpress inks. Oxygen is absorbed by the drying, oil, portion of the vehicle (oxidation), followed by a cross-linking of molecules (polymerization), causing the ink film to gel and then harden.

Precipitation. A drying method in which the printed piece is subjected to water in the form of steam, a fine mist, or merely the moisture in the atmosphere. The water moisture causes the binder to be thrown out of the solution (precipitated), binding the pigment firmly to the paper. Commonly used for steam-set and waxset inks.

PIGMENT AND VEHICLE

Before setting, the pigment and vehicle rest on the paper's surface.

PIGMENT VEHICLE

After setting, the vehicle seeps into the paper, leaving the pigment on the surface.

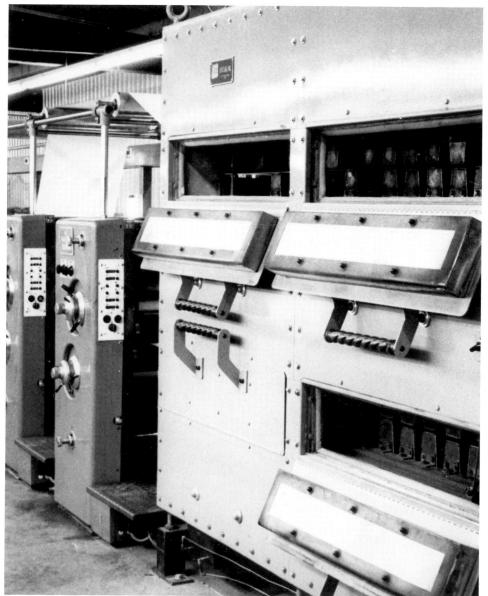

Web dryer used to speed the ink-drying process. After the web (upper left) leaves the press, it passes through a web dryer riding on a cushion of heated air.

Ink and the Printing Process

Each printing process requires an ink with different characteristics. The ink used is also determined by the kind and speed of the press, the surface to be printed, and the end use of the printed piece. Let's examine some of the inks used for the more common printing processes, and the specific properties of each.

Enlargement of an early Chinese signature hand stamp.

Letterpress Inks. Designed to print from a raised surface. Letterpress inks must be tacky and viscous enough to hold to the surface of the plate until printed. In addition to this, each type of letterpress printing press requires an ink with a different combination of ingredients. The platen press uses an ink that does not flow freely and is very tacky; cylinder press inks flow more freely and are less tacky; rotary press inks are the least tacky. Another reason for using longer inks on the rotary press is its high speed; the higher the speed of the press the thinner the inks must be. Letterpress inks can be dried by absorption, evaporation, or oxidation/polymerization.

Gravure Inks. Designed to print from a depressed surface. Gravure inks must be very fluid to fill the thousands of tiny wells, and at the same time have enough body and adhesion to be pulled from the wells onto the paper. Gravure inks should be totally free of hard particles that might scratch the engraved cylinder or plate. The consistency of the ink must be maintained to permit the doctor blade to properly clean the plate and ensure a proper transfer of the printed image to the paper. Gravure inks are quick-drying and are usually dried by evaporation. (They can also be dried by absorption or oxidation.) Because of the highly volatile solvents used in gravure inks, they must be handled with care.

Offset Lithography Inks. Designed to print from a flat surface. "Litho" inks are usually longer and more viscous and heavy bodied than letterpress inks. Offset inks must be resistant to the dampening action of the water used in offset printing. They must also be non-bleeding. Because the film of ink deposited on the surface of the paper is about half as thick as that of letterpress, the inks must be strong in color to compensate. To supply the proper ink for offset, the inkmaker must know if it is to be used on a one-color, two-color, or four-color press, and also the order in which the colors are to be printed. Offset inks are usually dried by evaporation, oxidation/ polymerization, or penetration.

Screen Printing Inks. Designed to be forced through a mesh screen onto a wide range of surfaces such as paper, cardboard, metal, ceramic, and glass. Screen printing inks are short and buttery. To ensure good adhesion, the binder must be changed to suit the surface being printed. The thickness of the ink film is controlled by the mesh size. To avoid clogging the screen, it is important that the solvents used in the ink do not evaporate too rapidly.

Flexography Inks. Another form of letterpress printing which employs rubber plates and aniline inks designed to print on a wide range of surfaces, including paper, cellophane, plastic, and metal foil. Flexography ("flexo") is extremely popular in the packaging industry; the ink colors are bright, strong, opaque, and can be made resistant to light and abrasion. Flexography inks are very fluid and fast-drying and can therefore be printed at high speeds. Most flexography inks have an alcohol base and are dried by evaporation; others have a water base and are dried by either absorption or evaporation.

Letterset Inks. Just as letterset is a combination of letterpress and offset lithography, letterset inks are a combination of letterpress and offset inks. Letterset inks are transferred from printing plate to blanket to paper on a special offset press that does not require the use of a fountain. Because no fountain solution is used, there is more latitude in the vehicle that can be used in the making of the ink. The thickness of the ink film is similar to that used in regular offset printing. Letterset inks are dried in the same way as letterpress and offset inks.

Specialty Inks

Specialty inks are the result of the everincreasing demand for brighter colors, higher speeds, and new printing techniques. The following are some of the more commonly used specialty inks. Cold Set. Unlike all other inks, cold-set inks are solid at room temperature, but melt at 150° to 200°. The printing plate and the press must first be heated to melt the ink. When printed on the relatively cold paper, the ink immediately reverts to its solid state. There is no smudging, no set-off and the printing is almost tack-free. Cold-set inks produce sharp printing results, however they require a complicated heating and cooling system.

Fluorescent. Available in a rather limited range of a few reds, yellows, blues, and greens. Fluorescent inks are bright and vibrant, but they require two passes to achieve full color. Day-Glo is the brand of fluorescent pigment whose formula is the most widely used today. Fluorescent inks are most widely used for screen printing signs.

Heat Set. A fast-drying ink that permits large, high-speed, high-quality runs. To use heat-set inks, the press must be equipped with a heating unit, cooling rolls, and an exhaust system. As the printed sheet passes over the heating unit the solvent is evaporated, leaving only an ink film, which dries almost immediately. Used for printing almost any job involving long runs.

High Gloss. Made possible by the development of a vehicle that permits only a minimal penetration of the paper's surface and ensures a maximum gloss. For the best results and highest possible gloss, the paper used should be coated or cast-coated stock with a surface resistant to the penetration of the vehicle. The drying of high-gloss inks should be done with the least amount of heat in order not to reduce the gloss. Available for both letterpress and offset.

Magnetic. These inks are made with special pigments which can be magnetized after printing. The printed characters can then be recognized by electronic reading equipment. In order to be successful, the printing must be of high enough quality to meet the rigid requirements of the equipment. Magnetic inks are used a great deal for such jobs as bank checks and business forms.

Metallic. Metallic powders such as bronze, gold, aluminum, and copper are suspended in the vehicle, which also serves to bind the powders to the surface of the paper. When preparing gold inks (the pigment is actually bronze powder), the bronze powder and vehicle must be

mixed just before printing because the bronze has a tendency to tarnish rapidly once the ink is mixed. Metallic inks are also available in a metallic paste, which makes far less of a mess.

Moisture Set. These inks are created in such a way that when the printed surface is subjected to water, usually in the form of steam or a fine spray, the binder is thrown out of the solution (precipitated), binding the pigment to the paper. Moisture-set inks are relatively odor free and are popular with the food-packaging industry for such things as bread wrappers, milk containers, and paper cups. Moisture-set inks dry principally by precipitation.

News. Generally used on web presses for printing newspapers, these inks have a fluid consistency that must be adjusted to the type of press, press speed, and stock. News inks are made of inexpensive raw materials (mineral oils and carbon blacks) and are generally dried by absorption. As newspaper is uncoated and has a rough surface, it permits the ink to penetrate readily.

Quick Setting. Primarily designed to prevent set-off. After the ink has been printed the vehicle rapidly penetrates the paper, leaving a film of ink that dries almost immedately on the surface. This permits printing at high speeds and also reduces the time required before printing the reverse side of the printing surface. Quick-setting inks, which have a high gloss, are most effective when printed on enamel or cast-coated stocks, and they may be used for both letter-press and offset.

Scuffproof or Rubproof. Hard-drying inks made particularly for labels, cartons, box wraps, or any printed pieces that can be marred by rubbing against one another or against the sides of a shipping container.

Watercolor. Generally used to print wall-paper, greeting cards, and novelties. The vehicle permits the use of pigments or dyes in the preparation of this type of ink. Watercolor inks require special rollers on press and can be washed with water after printing.

Wax Set. A specially prepared vehicle permits this ink to set and dry immediately when immersed in a bath of molten wax. It was developed to fulfill the need for faster printing and handling of bread wrappers and other wax papers.

Numbers printed by magnetic inks can be read by electronic reading equipment.

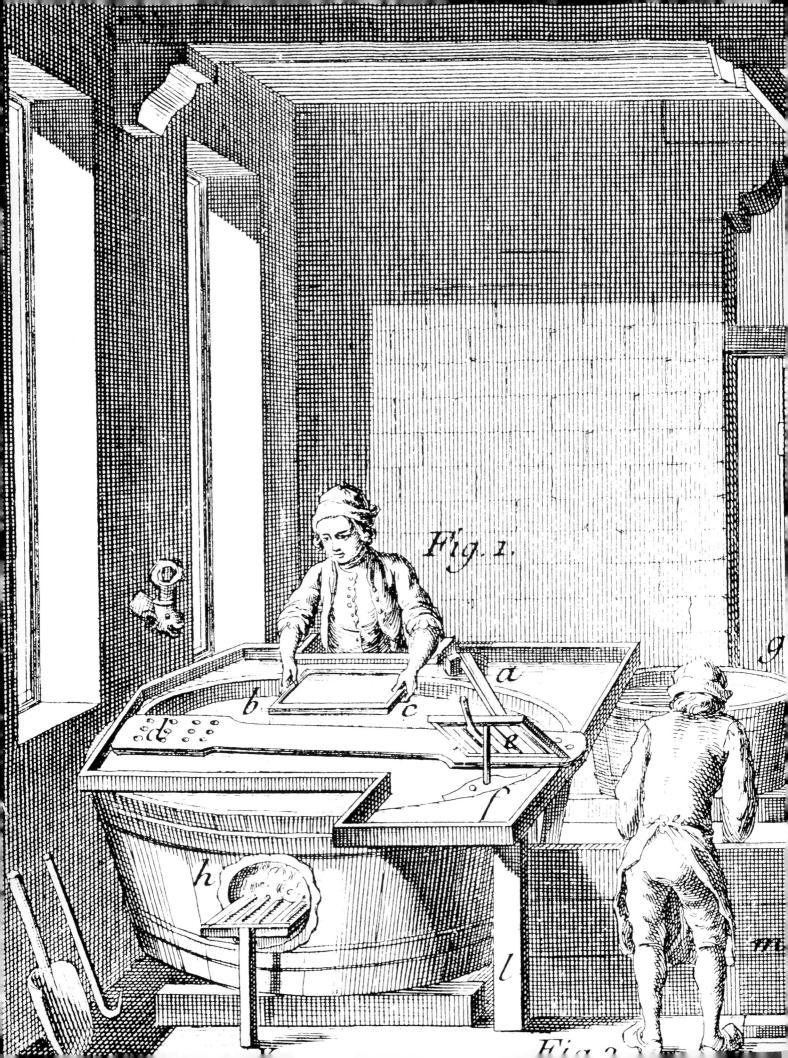

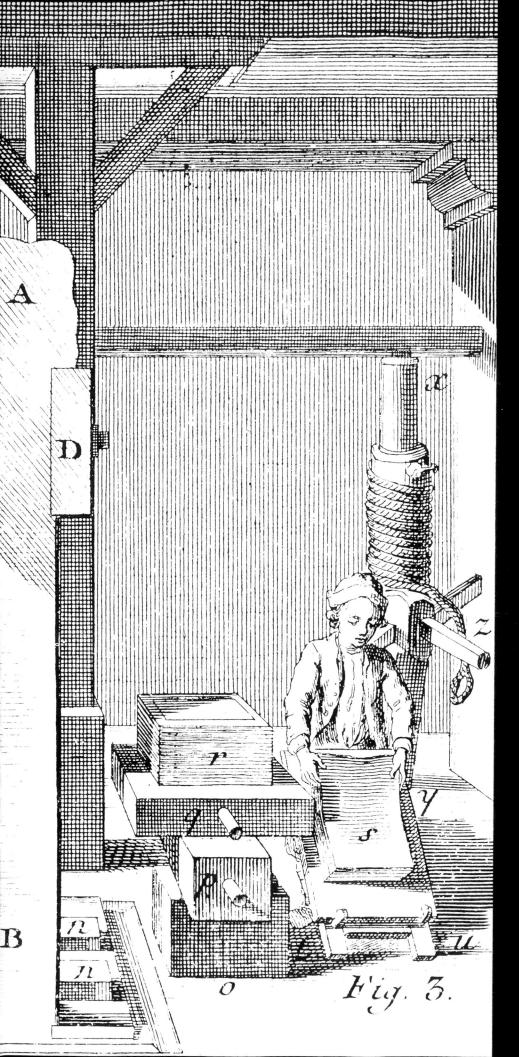

Paper

Paper is one of the designer's main considerations, and he will be expected to choose the "right" one from an enormous range of available papers. This choice will be easier if the designer understands the properties and characteristics of paper: what it is made from, how it is made, and the processes which make one paper different from another.

An 18th century French papermill. The vatman (Figure 1) forms the sheet of paper in the mold, from which it passes to the coucher (Figure 2), who places the sheet between felts to absorb excess water. The sheets are then squeezed in a large press, after which the layer (Figure 3) separates them from the felts.

History of Paper

The word ''paper'' is derived from the Greek word *papyrus*, meaning reed. The predecessor of true paper was developed by the Egyptians around 300 B.C. It was made by weaving reeds together, soaking them in water, and pounding them to the desired smoothness and thickness.

The invention of paper as we know it has been credited to Ts'ai Lun, in China, in the year 105 A.D. In Chinese papermaking, tree bark, rags, or other fibrous materials were beaten until they formed a pulpy substance. This was mixed with water in a large vat. Then a shallow, porous mold was dipped into the pulp; as the mold was lifted up, the water drained away through the sievelike bottom, leaving behind a mat of fibers. When removed from the mold and dried, this mat of fibers became a sheet of paper.

The papermaking craft passed from the Chinese to the Arabs in the 8th century, and from the Arabs to the Spanish in the 12th century. Other countries were slow to follow: papermaking arrived in Italy in the 13th century, in France in the early 14th century, and in Germany in the late 14th century. It was 1495 before papermaking was established in England, and 1690 before the first American paper mill went into operation.

Papermaking has come a long way since Ts'ai Lun. Although some papers are still handmade, most are made on enormous papermaking machines. These machines are several hundred feet long and produce a continuous sheet of paper called a "web."

In spite of its progress, the papermaking process still consists of removing the water from a mixture of fibers and water to form a fibrous mat.

1. Cutting branches.

6. Drying inner bark.

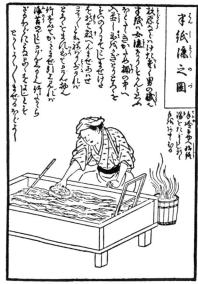

11. Diluting pulp.

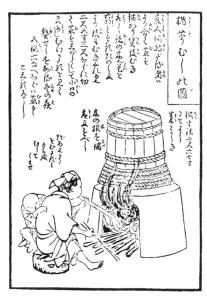

2. Boiling bark.

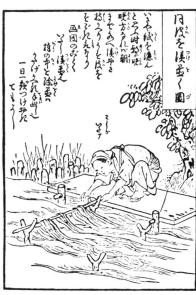

7. Washing bark.

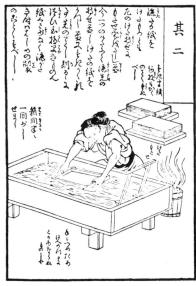

12. Making a sheet of paper.

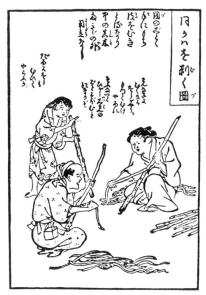

3. Peeling bark.

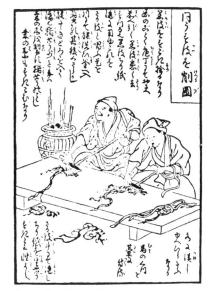

4. Peeling inner skin.

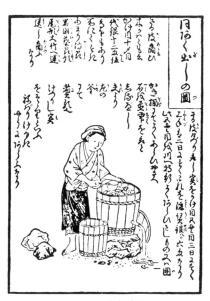

5. Soaking inner bark in lye.

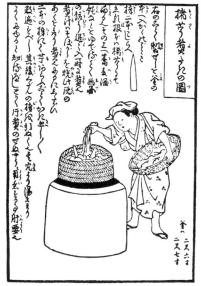

8. Boiling bark in Iye.

9. Washing bark again.

10. Beating bark to pulp.

13. Applying sheet to drying board.

14. Trimming sheets.

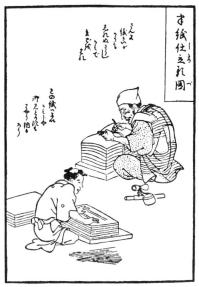

15. Packing finished paper.

Papermaking

Three ingredients are required to produce paper: water, power, and cellulose fibers. Cellulose fibers are found in trees, grass, cotton, bamboo, sugar cane, etc. At one time or another paper has been made from all of these. Today, the most common sources of cellulose fibers are wood, rag (including raw cotton fibers), and old paper.

The choice of fibers determines much of the paper's basic characteristics. For example, pulp from softwood trees has long fibers, which gives paper strength; pulp from hardwood trees has short fibers, which gives paper bulk and body. Rag pulp, on the other hand, contains fibers that are not only longer and stronger than wood fibers, but which are also freer of impurities, resulting in a stronger, whiter paper.

Most papers are made from a blend of various wood fibers and occasionally a mixture of rag and wood fibers. And with today's emphasis on conservation and ecology, there is an increasing demand for recycled paper. Once treated to remove impurities such as inks and dyes, old pulp paper can be made into excellent "new" paper.

Other sources notwithstanding, trees are by far the most common source of cellulose fibers. There are two basic processes by which trees are reduced to pulp. One is a mechanical process, the other a chemical process.

Hardwood:	leaf bearing	short fiber	even formation	less strength	greater bulk
Softwood:	needle bearing	long fiber	coarse formation	greater strength	less bulk

Hardwood (partial listing): birch, beech, maple, elm, ash and some oak.

Softwood (partial listing): white pine, hemlock, spruce, and fir.

MECHANICAL PROCESS

This is the simplest and most economical way to reduce trees to pulp. Pulp made by the mechanical process is called mechanical or groundwood pulp. The tree is cut into logs four feet long and the logs are tumbled against one another in huge drums to remove the bark. Any remaining scraps of bark are blasted away by high-pressure jets of water. The logs are then ground into tiny particles by a huge grindstone.

Because the grinding action reduces the fiber length, groundwood pulp does not produce a strong paper. Also, because the entire log is used, groundwood pulp contains undesirable elements such as resins, lignins, and gums, which cause the paper to yellow and become brittle with age. But because the entire log is converted into pulp, the mechanical process is a low-cost, highyield method of producing paper. And although groundwood pulp lacks strength and permanence it does have good absorbency, bulk, and opacity. The largest users of groundwood pulp are newspapers, for whom the low quality and short life of the paper are not drawbacks.

Tree reduced to logs.

De-barked logs ready for the grinder.

Old grindstones.

Cross-section of a tree.

CHEMICAL PROCESS

As the name implies, the chemical process involves the use of chemicals and produces what is called chemical pulp. As in the mechanical process, the tree is cut into logs and stripped of its bark. This time, instead of being ground into tiny particles, the logs are reduced to small chips by powerful rotating knives. The chips are then fed into a huge silolike "digester" where they are pressurecooked in chemicals (sulfite, sulfate, and soda). This chemical action reduces the chips to a mass of individual fibers by dissolving the lignin that holds the fibers together.

Chemical pulp produces a stronger, brighter, more permanent paper than groundwood pulp and is used in the majority of high-quality papers. Unfortu-

nately, compared with the mechanical process the chemical process yields much less pulp from the same amount of wood. This in part explains the high cost of fine papers compared with that of newsprint.

Washing, Screening, and Bleaching. After the wood has been reduced to pulp, it is washed, screened, and bleached to remove any remaining impurities that may produce undesirable qualities in the paper. Impurities can cause paper to discolor, affect its permanence, and even affect its performance on the printing press. Without being washed, screened, and bleached, the pulp at this stage could not be made into a white enough printing paper for the majority of our needs.

Beating. The pulp, or blend of pulps, is now ready for the beating process, also called refining or stock preparation. Beating accomplishes two things: it roughens, or frays, the fibers to give them a greater surface attraction, and it extracts a gelatinous substance from the fibers that helps bond them together when the paper is made. It is also at this stage that the basic nature of the paper is determined: if the duration of the beating is short, the paper will be soft, bulky, and opaque (similar to blotting paper); if the beating duration is long, the paper will be hard, thin, smooth, and less opaque.

Stock Preparation. Although the pulp at this stage is highly refined, it is still not ready to be made into paper. To give the paper smoothness, opacity, and resist-

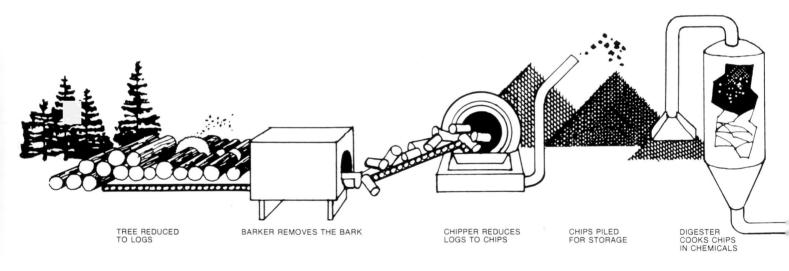

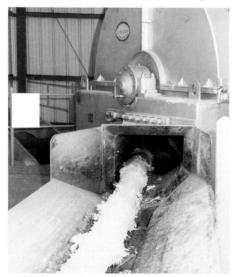

De-barked log.

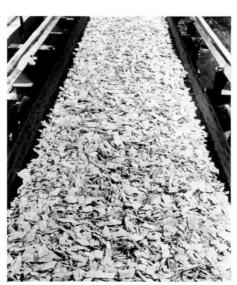

Chips.

Digesters.

ance to moisture, "additives" such as fillers, sizing, and coloring (dyes) are added. As we shall see, making paper is like making a cake, with each grade of paper having its own recipe. It is what goes into the batter that dictates the end product:

Fillers. Also called loading agents, these are fine mineral pigments that fill in the spaces between the fibers to create a smoother, more uniform surface. They also increase opacity and improve printing qualities. The most common filler is clay, which is naturally white. Other fillers are calcium carbonate and titanium dioxide.

Sizing. Also called size, this is an essential ingredient in most printing papers. The size holds the fibers together and

makes the paper resistant to the penetration of water and ink, so that the ink will not run when we write or print on paper. The most common sizing is rosin, which is usually added during the beating process.

Another form of sizing, called *surface* sizing, is applied to the surface of the paper while it is still on the papermaking machine. Surface sizing is frequently starch, and its function is to bind down the fibers of the paper to produce a smoother printing surface.

Sizing is particularly important when printing by offset lithography because it prevents fibers from sticking to the blanket and interfering with the printing.

After the additives have been added, the pulp is mixed with huge quantities of water—approximately 1% pulp to 99%

water-to form a milklike suspension called "furnish." The furnish is held in a large container called a "head box," which is situated at the head of the papermaking machine. From here the journey begins through the next four stages of the papermaking process: forming, pressing, drying, and calendering.

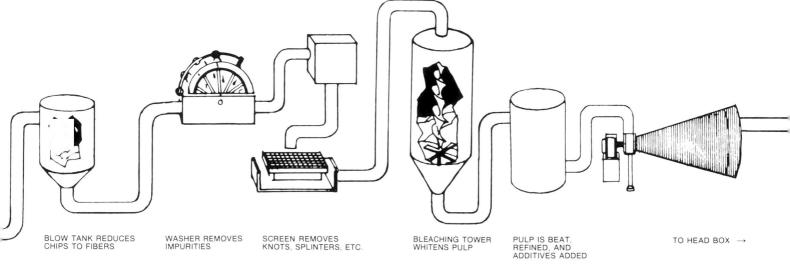

Refiners.

Stock preparation.

The furnish is released from the head box onto the wire. As the wire moves forward it vibrates from side to side. The vibration and the suction from beneath the wire drain off excess water and cause the fibers to interweave, forming a continuous web, or sheet, of paper. The amount of furnish released from the head box, together with the speed of the wire, dictate the weight of the paper: the

more furnish and the slower the wire, the heavier the paper will be.

As the sheet is being formed, the underside (the wire side) takes on the texture of the wire: if the wire is coarse, the texture will be coarse; if smooth, the texture will be smooth. To make the top of the sheet (or felt side) match the underside, a huge cylinder called a "dandy roll" is used. The dandy roll, which is the width of the wire, is covered with a woven mesh similar to the wire. As the sheet travels along the wire it passes under the dandy, which levels the fibers and imparts its texture to the paper. Papers formed with this type of dandy are known as wove papers.

Another type of dandy imparts a grid pattern of horizontal and vertical lines onto the paper. Papers made with this

type of dandy are known as *laid* papers and are an imitation of the first handmade papers.

The dandy roll is also used to create watermarks. This is done by adding a raised wire watermark design to the dandy roll. When the pattern comes into contact with the paper it presses down the fibers, making the area it touches thinner and therefore more transparent. Watermarks and laid marks are actually planned imperfections in the papermaking process.

Pressing. After forming on the wire, the sheet is still 80% water. To reduce the water content, the sheet, supported by a felt belt, is fed through a series of three presses. Each press consists of two rollers, one directly above the other. As the

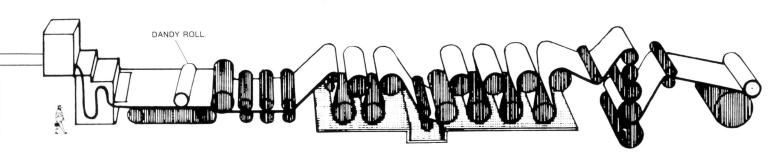

HEAD BOX STORES AND METERS PULP ONTO WIRE FOURDRINIER, WHERE PAPER IS FORMED PRESS SECTION REMOVES EXCESS WATER ON-MACHINE COATING OR SIZING DRYING SECTION DRIES THE SHEET CALENDER STACK SMOOTHS PAPER'S SURFACE

Head box.

Fourdrinier, or wire.

Press section and drying section.

Calender stack.

paper is pressed between the rollers, the water is squeezed out of it. It is also during the pressing stage that specially woven felt belts can be used to give the paper a "felt finish."

Drying. The sheet, which is still 70% water, is fed directly from the presses to the dryer. The dryer consists of a series of steam-heated cylinders approximately four feet in diameter. These are mounted in two rows, one above the other, but staggered so that no cylinder is directly above another. The paper is carried by an asbestos felt belt which is threaded in such a way as to permit both sides of the paper to come in contact with the heated cylinders. After leaving the dryer, the paper contains from 4% to 6% water. This amount of water in the paper is necessary to ensure good printing and folding characteristics and to keep the paper in balance with the relative humidity of the atmosphere.

Calendering. From the dryer, the paper is passed, under pressure, through a vertical stack of highly polished cast-iron rolls, called calenders. The function of the calenders is to increase the smoothness and gloss of the surface of the paper, an operation not unlike ironing a freshly laundered shirt. The degree of smoothness is dictated by the number of calenders (or "nips") the paper is run through. The more calenders, the smoother the surface of the paper and the higher the gloss.

It is interesting to note that from the time the pulp is poured from the head box until it becomes a finished sheet of paper, often less than two minutes have elapsed.

Slitting and Sheeting. After calendering. the web is wound into large rolls. These rolls are then slit as they are rewound. At this point, these smaller rolls can be shipped out for web printing or they can be transferred to the sheeting department of the mill to be cut into sheets for use on sheet-fed presses.

Special Finishes. Not all papers are finished on the papermaking machine; some require further finishing off-machine, such as additional coating, supercalendering, and embossing. These finishes are discussed later in this section.

PAPER IS WOUND INTO LARGE ROLLS

SLITTER SLITS LARGE ROLLS INTO SMALLER ROLLS

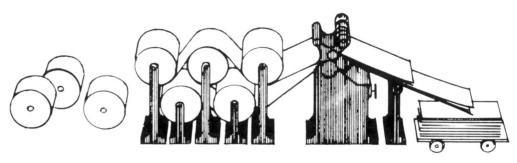

SHEET CUTTER CUTS ROLLS INTO SHEETS

Slitter.

Slit rolls.

Inspection of sheets.

Characteristics of Paper

All papers have characteristics in common, which when understood should help the designer choose the right paper for the job. The six basic characteristics of paper are grain, weight, bulk, opacity, color, and finish.

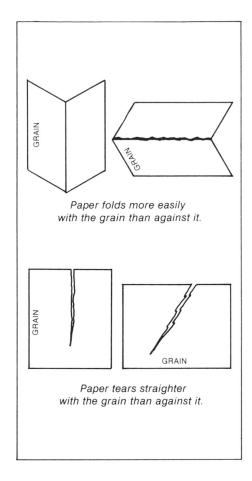

EQUIVALENT WEIGHTS						
(basic weights in bold type)						
(Da	sic weig	Jiilo III L	ioid typ	e)		
				12		
		2	H 9	INDEX 25½ x 30½		
	X X	N ×	× 2	»×		
	BOOK 25 x 38	BOND 17 x 22	COVER 20 x 26	INDEX 25½ x (
BOOK	30	12	16	25		
	40	16	22	33		
	45	18	25	37		
	50	20	27	41		
	60	24	33	49		
	70	28	38	57		
	80 90	31	44	65		
	100	35	49	74		
	120	39 47	55 66	82		
	120	47	99	98		
BOND	33	13	18	27		
	41	16	22	33		
	51	20	28	42		
	61	24	33	50		
	71	28	39	58		
	81	32	45	67		
	91	36	50	75		
	102	40	56	83		
COVER	91	36	50	75		
	110	43	60	90		
	119	47	65	97		
	146	58	80	120		
	164	65	90	135		
	183	72	100	150		
INDEX	110	43	60	90		
	135	53	74	110		
	170	67	93	140		
	208	82	114	170		

Grain. The grain of the paper is the direction in which the fibers line up when the sheet is made; it is in this direction that the paper folds and tears most easily. If the grain runs lengthwise the paper is called "grain-long"; if it runs across the width, the paper is called "grain-short." The direction of the grain is a most important consideration when ordering paper, because it affects foldability and printability. The grain on the page you are now reading runs parallel to the binding—that is, grain-long—which enables the pages to be turned easily.

There are a number of ways to determine the direction of the grain in a piece of paper. One is to simply tear a sheet of paper across and then down; it will tear most easily, and straighter, with the grain. Another test, which works well for uncoated papers, is to tear off a corner and lick it; after a few seconds it will curl in the direction of the grain.

Weight. Known as basis weight. This is the weight in pounds of 500 sheets of standard-size paper. The size of the sheets weighed is determined by the type of paper. For example, the standard size of bond paper is 17" x 22"; of newsprint, 24" x 36"; of book papers, 25" x 38"; of cover stock, 20" x 26". Typical weights of book papers are as follows: 30, 40, 45, 50, 60, 70, 80, 90, 100, and 120 lbs. The book you are now reading is printed on 80-lb. paper (500 sheets of 25" x 38" book paper weighs 80 lbs.).

If you were designing a job and wished to use another grade of paper than that used in this book, but one of the equivilant weight, you would refer to the above table under 80-lb. book paper. You will see that a 31-lb. bond, a 44-lb. cover, and a 65-lb. index are all approximately the same weight.

BULK FOR 70-LB. UNCOATED

Finish	PPI	Caliper
Antique	274	29.2
Eggshell	318	25.2
Machine Finish	412	19.2
English Finish	474	16.9

BULK FOR 80-LB. UNCOATED

Finish	PPI	Caliper
Antique	240	33.3
Eggshell	278	28.2
Machine Finish	360	22.2
English Finish	416	19.2

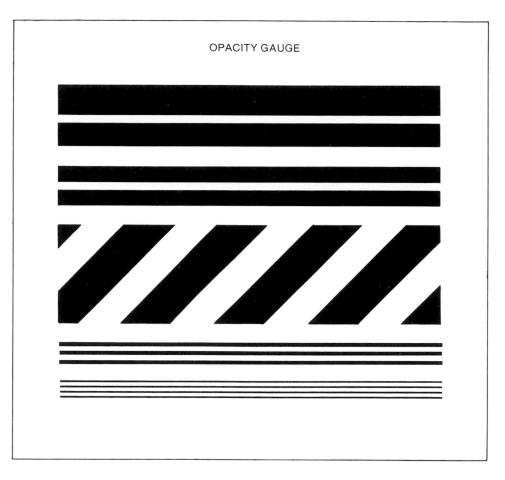

Bulk. A term used to describe the thickness of paper. Generally speaking, the rougher the paper, the higher the bulk. There are two ways to measure bulk. The first is to measure the thickness of four sheets of paper (eight pages) with a micrometer. This measurement, called a four-sheet caliper, is given in thousandths-of-an-inch and is referred to as mils or points. A four-sheet caliper of the paper in this book measures 17.2 mils, or 17.2 points. However, the more common way to measure bulk, especially in book publishing, is to quote the "pages per inch" (PPI). The page you are now reading bulks at 390 PPI.

It is the bulk that determines the thickness of a book. There are two ways in which a designer can increase bulk: he can choose a heavier paper-replace a 60-lb. paper with a similar 80-lb. paper, for example—or he can choose a paper of the same weight with a bulkier finish.

Opacity. The capability of a paper to take ink on one side without it showing through on the other. From the designer's point of view, this means that if the paper is not sufficiently opaque, the reader will be distracted by the printed material showing through from the other side, a condition called "showthrough."

Opacity is affected by the paper's weight and bulk. The heavier and more bulky the paper, the more fibers there are to retard the passage of light and therefore the more opaque the paper is.

There are two kinds of opacity that can be measured: visual, which is the opacity of the unprinted sheet; and printed, which is the opacity of the printed sheet.

Visual opacity can be accurately measured by an opacimeter and is expressed in terms of percentage, 100% being totally opaque. No printing paper has 100% opacity, but some come closer than others. The visual opacity of this page is 97%.

Printed opacity presents a different problem. Because some papers absorb more ink than others (resulting in the ink being absorbed by the paper to the extent that it shows through on the other

side in a condition known as "strikethrough"), it is possible to have two papers with the same visual opacity but with different printed opacities. Printed opacity is affected by the paper's ink holdout; that is, the paper's capacity to hold ink on the surface rather than absorbing it. The greater a paper's ink holdout, the higher its printed opacity. Printed opacity cannot be measured in terms of percentages, only by the degree to which strike-through is present in a printed sheet. Printed opacity is generally referred to as being high, medium, or low. If you examine this page, you will see that in addition to its high percentage of visual opacity it also has a high degree of printed opacity.

The designer can also get a general idea of the opacity of paper by using an opacity gauge (shown above). The gauge is placed under the sheet of paper: the more difficult it is to see the gauge, the more opaque the paper. An opacity gauge is particularly handy when comparing unprinted papers.

LIMITS OF CONTRAST

PAPER=WHITE

INK=BLACK

You cannot have a highlight brighter than the paper nor a shadow deeper (darker) than the ink.

Color. Printing papers are available in a wide range of colors and also in a wide range of whites. The "whiteness" of paper is controlled by the addition of bleaches, fluorescent dyes, pigments, and other additives. Whiteness ranges from cream-white to blue-white and encompasses every imaginable white in between. The color of the paper you choose will affect everything printed on it: an image printed on a cream-white sheet will look quite different from the same image printed on a blue-white sheet. Remember, the whiteness of the paper controls the whitest highlight of your reproduction; in other words, you cannot have a highlight brighter than the color of the paper.

HOW FINISH AFFECTS THE BULK (PAGES PER INCH)

Finish	50 lb.	60 lb.	70 lb.	80 lb.
UNCOATED				
Antique	350-380	290-320	250-270	210-230
Eggshell	420-470	350-390	310-330	260-290
Machine Finish	520-580	440-480	380-410	330-360
English Finish	620-660	520-570	450-480	390-420
COATED				
Pigmented or Film-coated	590-610	430-450	400-420	370-390
Blade-coated	690-710	500-520	430-450	370-390
Conversion-coated (gloss)	*	*	560-580	470-490

Finish. Refers to the way in which the surface of the paper has been treated. For example, we have already seen how wove and laid finishes are applied by the dandy while the paper is forming on the papermaking machine. The felt finish, which is a rather toothy finish, is applied during the pressing stage. Uncoated papers are also finished on the papermaking machine during the calendering process. Coated papers are finished either on or off the papermaking machine. The more specialized finishes, such as pebble, ripple, and stucco, are done off the papermaking machine by special embossing rollers that emboss the finish on the paper.

The particular finish given to a sheet of paper affects its bulk: the more a paper is pressed and calendered the thinner it becomes, and therefore the less it bulks and the lower its opacity.

The finish is an important consideration for the designer. If the job to be printed involves small type, type with fine serifs, or fine halftone reproductions, a

paper with a smooth finish is a good choice. If, on the other hand, the job to be printed is a book that is all text, and comfort of reading is the most important consideration, then a rougher stock may be the most appropriate. The same principle applies when choosing between a dull and a glossy finish: it is much more comfortable to read type on a dull finish than on a glossy finish; however color or halftones will appear more brilliant on a glossy stock than on most dull-coated stocks.

^{*}Not available: paper too light to support coating

Printing Papers

CATEGORIES OF PRINTING PAPERS

Newsprint

Writing Papers

Bond

Ledger

Business papers

Cover Papers

Book Papers

UNCOATED

Antique

Eggshell

Machine Finish (MF)

English Finish (EF)

COATED

Pigmented or Film-coated

Blade-coated

Conversion-coated

Cast-coated

Not all papers are used for printing; they are also used for wrapping papers, tissue papers, and paper bags, among other things. As designers, however, our main interest is in printing papers. These can be divided into four categories: newsprint, writing papers, cover papers, and book papers.

Rather than use the paper manufacturers' trade names, which are so numerous that they would confuse the reader, we shall use only generic names to describe the different papers in this chapter. Once the broad categories are understood, it is a simple matter for the designer to communicate his needs to the paper manufacturer or merchant.

NEWSPRINT

Newsprint is one of the lowest grades of printing paper. It is made primarily from groundwood pulp with about 30% chemical wood pulp added for strength and color. Because the entire log is used to make the pulp, newsprint is a low-cost paper with good bulk and opacity. However, because of impurities in the paper, it has low brightness and a tendency to yellow and become brittle with age.

Newsprint is the least expensive of all the printing papers and is often used when permanence is not important. It lacks strength, has limited printing qualities, and tends to discolor. Newsprint is therefore generally used for newspapers, and mass market paperbacks.

WRITING PAPERS

Writing papers can be categorized as follows: bond, ledger, and various grades of business papers used for duplicating purposes. They are available in a wide assortment of colors and finishes.

Bond. This term was originally applied to papers of high strength and durability, such as those used for government bonds, stock certificates, and legal papers. Today, bond paper has a wide variety of uses, perhaps the most common of which is for writing paper. Among the essential qualities of good bond paper is an ability to take ink well and easily erased.

Bond papers run from 100% rag content to no rag content at all. The usual rag fiber content is 25%, 50%, or 75%. The highest-quality bond papers are made of 100% rag fiber. Cotton fibers alone make an extremely strong, white paper, and when mixed with linen fibers they produce a paper of the highest quality. In fact, banknotes are printed on paper made from a mixture of cotton and linen fibers. Bond papers are available in a variety of colors,

Ledger. This paper frequently has a high rag content. It is a strong paper made to withstand a great deal of handling and folding, and is used for ledgers and records.

Business Papers. It is the rare business today that does not have some form of duplicating machine: Xerox, mimeograph machine, spirit duplicator, Multilith, electrostatic duplicator, etc. Most business papers are made to order for the equipment manufacturer; the designer has very little to do with this segment of the paper industry.

COVER PAPERS

Cover stock is stiff, heavyweight paper, and as the name suggests it is used primarily for magazines, paperbacks, catalogs, etc. It is available in a wide range of colors, weights, and finishes. The standard size of cover papers for determining the basis weight is 20" x 26". The basis weights usually available in cover papers are 65, 80, and 100 lbs.

BOOK PAPERS

Book papers encompass the widest range of printing papers and are therefore of particular interest to the designer. Although called book papers, they are used not only for book work, but for practically everything we read, with the exception of newspapers. Book papers can be divided into two major categories: coated and uncoated. The standard size of book papers used to determine the basis weight is 25" x 38". The basis weights usually available in book papers are 40, 45, 50, 60, 70, and 80 lbs.

Uncoated Papers. Uncoated paper is the most basic, least sophisticated type of sheet. It is produced on the papermaking machine without any special coating operations. It is categorized according to its bulk and the relative smoothness of its surface:

Antique. Of all the uncoated papers, antique has the roughest surface and highest bulk. Its relatively toothy surface makes it an excellent paper for bulking up a book. Although not recommended for the reproduction of fine halftones, it is an excellent choice for books containing line illustrations and type. (Antiquefinish paper is also referred to as "vellum," especially by people who do commercial jobs as opposed to book work.)

Eggshell. A smoother version of antique. Its texture, as the name implies, is like that of an eggshell. Because eggshell paper is pressed more than antique, it is smoother and less bulky.

Machine Finish (MF). A smoother version of eggshell. Having been calendered, it bulks less. Ideal for lengthy books—400 to 600 pages—consisting mainly of type. A variety of bulks is available in machine-finish papers, usually referred to as regular, medium, and plate finish.

English Finish (EF). A smoother, lower bulking version of machine-finish paper, originally manufactured for letterpress printing of halftones. Special fillers such as clay are added to the pulp that permit the calenders to give the paper a very smooth finish. (The filler originally used was English clay, which is why the paper is called English finish.) Today, due to the availability of moderately priced coated papers that are capable of even better halftone printing, there is no longer a great demand for English-finish paper.

Coated Papers. These papers have a special clay coating which when supercalendered gives the paper an extremely glossy finish. The purpose of this coating is to bury the fibers so that the printing ink does not come into contact with them at all. This means that the ink, rather than being absorbed into the paper, rests on the surface, giving coated papers excellent ink holdout. The higher the ink holdout, the more brilliant the printed image will appear.

Coating can be applied either while the paper is on machine (machinecoated) or off machine (off-machinecoated or conversion-coated). Generally speaking, papers coated off machine are of a higher quality and more expensive than papers coated on machine; the coatings applied are thicker and the operation is more time-consuming. This does not mean however that all off-machine-coated papers are better than all on-machine-coated papers. With so many variations of paper-coating techniques it is impossible to make such a broad statement; in the final analysis, each paper must be judged on its own merits.

The finish of a coated paper may be dull or glossy. The higher the gloss, the more brilliant the reproduction of halftones or color. However, high-gloss papers are not recommended as background for type matter because the surface may interfere with the readability of the type. The following are some of the more popular coated papers:

Pigmented or Film-coated. These are the least expensive machine-coated papers and are basically the same. The pigment is applied to both sides of the paper after the first drying stage by the original onmachine method of using rollers to coat the paper. This wash coating is transferred from the roller to the paper's surface and quickly dried. The finish makes an excellent paper for jobs containing two-color images, halftones, or type; its low cost makes it ideal for textbooks.

Conversion-coated. A wash coating is applied on the papermaking machine. The rolls of paper are then transported to an off-machine coating unit in the coating department of the mill. Here the sheet receives a highly viscous coating of high-quality pigments applied slowly by rollers. The sheet is dried by hot air, then finishing operations such as glosscalendering, embossing, or dull-finishing are performed. Conversion-coated papers are ideal for four-color work and prestige publications such as art books and annual reports.

Not all conversion-coated papers are of the same high grade. Because the offmachine coating can be done in a number of ways-roll, airbrush, air knife, or blade—the quality of the paper will vary.

Blade-coated. An on-machine operation that produces a range of high-quality papers at moderately high speeds. After a pre-coating of pigments, an excess of a more viscous coating is applied to the paper and smoothed by a flexible blade to control the amount of coating. Bladecoating produces what is called a matte surface, which in appearance is similar to a dull-coated sheet. Blade-coated papers are ideal for jobs containing fourcolor reproductions, text matter, and halftones. This book is printed on a blade-coated paper, S.D. Warren's Patina Coated Matte.

Cast-coated. The highest possible gloss is obtained in cast-coated paper, which has a finish similar to that of a glossy photograph. Cast-coating is a special off-machine process in which the paper is given a special coating and then pressed against a large, highly polished chromium drum. Because of the difficulty of manufacture, cast-coated sheets, unlike other papers, are sold on a per-sheet basis and not by weight. Castcoated papers are the most expensive to make, and so are used selectively; for example, as covers for annual reports.

Conversion-coater (roll application).

Blade-coater (blade not shown).

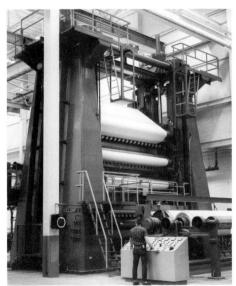

Supercalenders.

Choosing the Right Paper

Choosing the right paper is a combination of personal preference and common sense. The paper must satisfy the demands of the printing process as well as meet design and economic requirements.

Printing Process. Your first consideration when choosing paper is how the job is to be printed. As letterpress, gravure, and offset lithography are three basically different printing processes, they each require papers with different characteristics:

Letterpress. Letterpress prints by direct impression; that is, the raised metal printing plate comes into direct contact with the paper. In the early days of letterpress printing, jobs consisted mainly of type and an occasional decorative border or line illustration. The papers used were generally rough and bulky. These papers had to be dampened before printing to allow the type to "snuggle down" into them, ensuring a good impression. If the paper was too dry or if too much pressure was applied in printing, the sharp edges of the type might emboss the page or cut through the paper and ruin the opposite side for printing.

Today, letterpress printing is no longer limited to type and line illustrations; it also includes halftones. Furthermore, the paper is no longer dampened before printing, so letterpress paper must be smooth enough to ensure a uniform ink transfer yet strong enough to accept pressure without tearing.

Gravure. Like letterpress, gravure printing is also by direct impression. However, unlike letterpress, the printing plate is relatively smooth and the ink is carried in well-like cells rather than on a raised surface. For these reasons, gravure papers should be smooth and have a certain amount of absorbency: smooth so that the surface will come into close contact with the printing plate; absorbent so they will draw the ink from the cells. Although the finest gravure printing is done on high-quality coated and uncoated papers, newsprint also makes a good printing surface for gravure.

Offset Lithography. Unlike letterpress or gravure, offset is not a direct-impression process; the inked image is first transferred from the printing plate to a rubber blanket and then to the paper. The rubber blanket is compressible, conforming to the surface variations of the paper. This permits offset to print on both smooth and relatively rough surfaces. Offset papers must be properly sized to resist the moisture that is always present in offset printing. Furthermore, as offset inks are more tacky than either letterpress or gravure inks, the paper must have good surface strength to avoid "picking" (the removal of bits of the surface of the paper during printing that occurs when the pulling force, or tack, of the ink is greater than the surface strength of the paper).

Design Considerations. As a designer, you have a mental image of how the printed piece should look; the results will depend a great deal on your choice of paper. Apart from choosing a paper you like, you should also consider its printability. Printability is dicated by a paper's absorbency and smoothness of surface. Good printability is especially crucial when printing color or black and white halftones because the quality of the image will depend entirely on how accurately each dot prints.

Absorbency. Uncoated papers tend to absorb ink, causing halftone dots to be feathery and lacking in definition. Coated papers, on the other hand, have better ink holdout, resulting in sharper halftone dots and a sharper image.

Surface. If the surface of the paper is smooth, the ink transfer will be uniform and accurate, resulting in a printed image with good detail, contrast, and color. If, on the other hand, the surface is rough, the dots will not print accurately and the printed image will lack strength and detail.

Economic Considerations. Quality in paper, as in everything else, is reflected in cost. Perhaps the best way to control cost is to choose the right paper for the job. If in doubt as to your choice of paper, contact the printer or paper merchant. Not only are they capable of discussing the specific problem, but they can show you printed samples that will give you a good indication of just what you can expect from any given paper.

Note: See the cutting chart on page 145 for determining correct sheet size.

Uncoated papers tend to absorb ink.

Coated papers hold the ink on the paper's surface, resulting in more accurate color.

Rough paper breaks up halftone dots.

Smooth paper permits dots to print accurately.

		<u> </u>	
FOLD	Type or particular to the part	A company of many of m	and can be in executed by decreased and according to the control of the control o
	Conductable is well a planting designation of the conductable is well as the conductable of the conductable	BLANK	Market State Control of
TRIM	Company 17th National American Company 17th National American Proportional of American Propor	The control of the co	Extension for page disconnection Contract of the page disconnection for page of the page disconnection for page of the page disconnection for page of the page of
FOLD	This live is special with the special wi	The control of the co	And the second of the control of the
			<u> </u>

Imposition

Imposition is the arrangement of pages on a printed sheet in such a way that they will be in correct order when the sheet is folded and trimmed. A full sheet will normally print in units of 4, 8, 16, and 32 pages. When folded, these units are called *signatures*.

FOLD

TRIM

FOLD

Actual imposition used in this book showing pages on one side of a printed sheet.

Basic Impositions

The best way to understand imposition is to actually take a sheet of paper, fold it, number the pages, and make up the signatures described in this chapter. You will notice that the odd-number pages are always on the right, the even-number pages always on the left. This is standard procedure in all publications.

Let's look at some basic impositions, for a 4-page, 8-page, and 16-page signature:

Four Page Signature. The smallest signature possible. Take a sheet of paper and fold it once. Beginning with the outside page facing you, number the 1 through 4. Now open the sheet and lay it flat. This is exactly how the pages would have to be imposed in order to print four consecutive pages: on one side of the sheet are pages 1 and 4, on the other side pages 2 and 3.

Eight Page Signature. Take another sheet of paper and fold it twice. Number the pages consecutively 1 through 8. Open it up and lay it flat; this is the imposition for an 8-page signature. Notice that the pages are not in order, and that some are actually upside down on the sheet. Naturally, when folded and cut, the pages will all be rightside up and in their proper order. Also notice that an 8-page signature is folded at the head and in addition at the spine or binding edge. You can see how important trimming is in this case to permit the pages to be opened.

Sixteen Page Signature. Now take a sheet and fold it three times. Number the pages consecutively 1 through 16. (Underline the figure 9 so as not to confuse it with the figure 6.) Open it up and lay it flat; this is the imposition for a 16-page signature. It is possible by following the same procedure to make 32-page and 64-page signatures. By changing the folds it is also possible to make 12-page, 24-page, and 48-page signatures.

If you examine this book you will see that it is made up of thirteen 16-page signatures, twelve of which are printed in black and white and one in color.

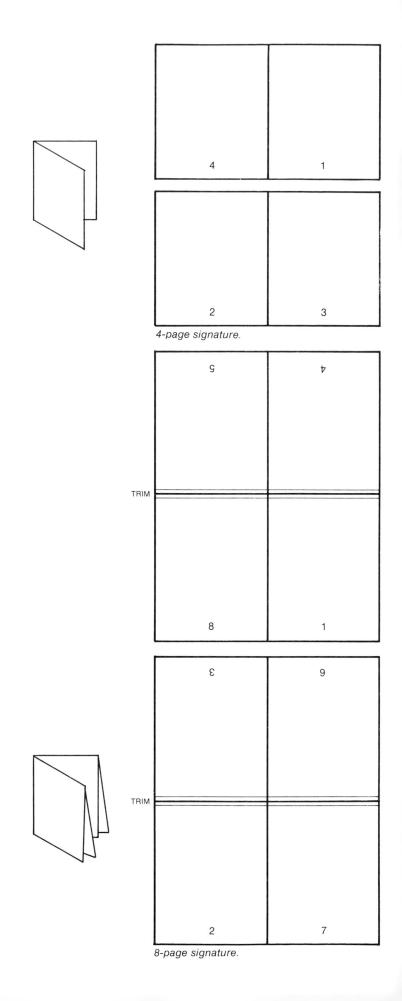

Imposition is not determined by the designer, but by the binder and the printer: the binder, because only he knows how the pages should be positioned to be handled most efficiently on his equipment; the printer, because he has to take the imposition supplied by the binder and make it work.

One factor both the printer and the binder consider when figuring the imposition is an extra paper allowance of 1/8" to 1/4" on all outside margins. This will be trimmed, or cut off, when the sheets are squared up.

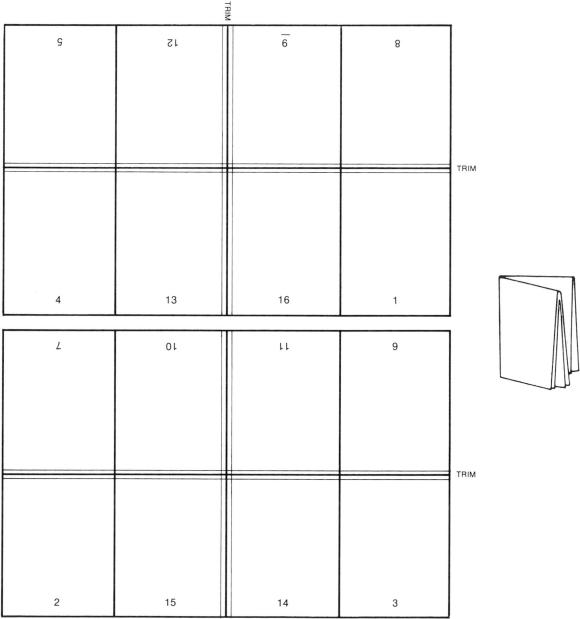

16-page signature.

Imposition and Color

By printing one color on the first side of a sheet and two colors on the second side, it is possible to give the impression that two colors were used throughout. For example, let's imagine an 8-page signature in which, for reasons of economy, a second color is to printed on only one side of the sheet. By referring to the illustration of the 8-page signature you will see that one side of the sheet prints pages 1, 4, 5, and 8; the other side prints pages 2, 3, 6, and 7. Therefore the designer can choose either of these page sequences for his second color. This will give the impression of two-color printing throughout the signature even though it is really only on one side of the sheet.

Another way to introduce even more color on the second side of the sheet is the split-fountain technique. Instead of running a single second color, the ink fountain is divided in half, with the right side printing one color and the left side another. If the two colors are allowed to meet, the inks blend to form a range of colors.

This side prints in two colors.

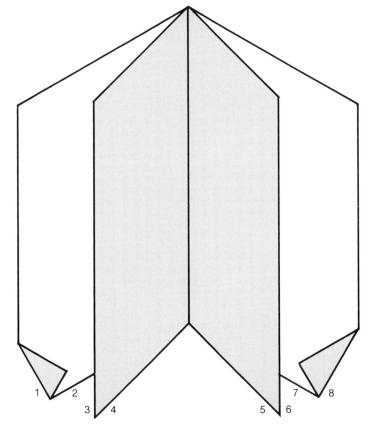

8-page signature with a second color printed on one side only.

Imposition and Gang-ups

Until now we have discussed imposition in situations where all the pages are the same size. But there is also a problem of imposition when a variety of different-size jobs are printed on a single sheet (ganged-up).

For example, a letterhead, a memo, and an invoice all to be printed on the same paper with the same color ink can be ganged up on a single sheet. In figuring the imposition, the printer must know the quantities involved. If they are all the same (1,000 of each, for example), the sheet must be divided so that one impression of each job is printed on every pass through the press. If the quantities vary, the sheet must be divided in such a way as to print some items once (one-up) and others more than once (two-up, three-up, etc.).

COMBINATION LAYOUT

- A TWO-UP
- B FOUR-UP
- C THREE-UP
- D ONE-UP
- E ONE-UP

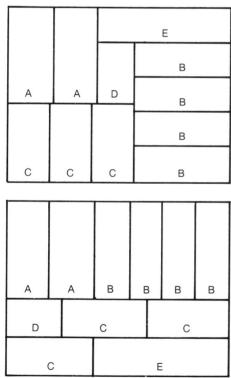

Poor impositions, requiring too many cuts.

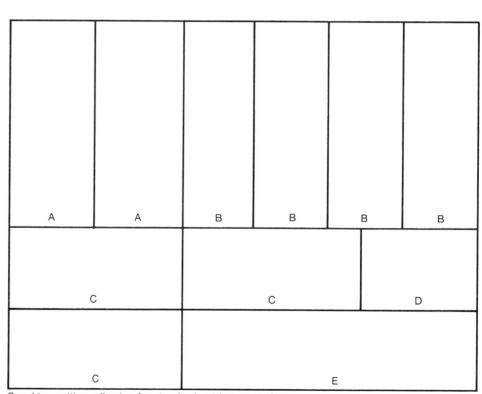

Good imposition, allowing for standard cutting operations.

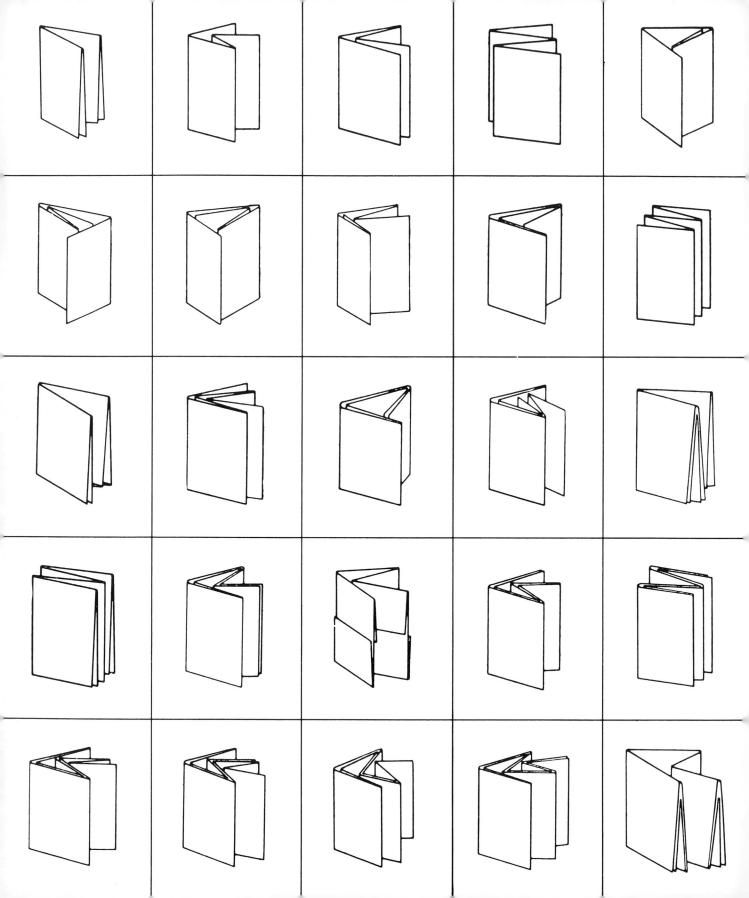

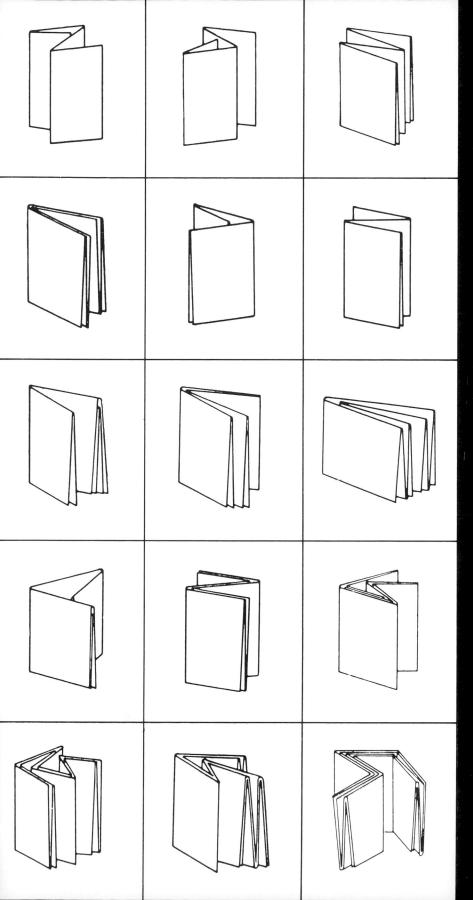

After the sheet has been printed it is folded. This is usu ally done automatically on a folding machine capable of making single or multiple folds. In addition to folding, some machines are also equipped to handle a number of other services such as pasting, perforating, scoring, slitting, and trimming.

Some sheets become fold-

Some sheets become folders, others become books. In this section we will discuss only folders; books will be discussed in the next section, *Binding*.

A variety of folders ranging from 8 pages through 80 pages

Folds and Folders

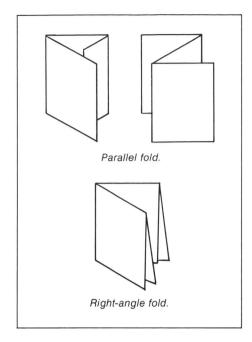

There are two basic ways to fold a sheet of paper: parallel and right angle. A parallel fold, as the name implies, is one that runs parallel to a previous fold. Parallel folds are made in business letters when they are folded twice in the same direction to fit their envelopes. A right-angle fold is one that is at a right angle to a previous fold. A familiar example of this is the "French fold" used in formal invitations. By using these two folds it is possible to produce a wide range of folders.

There are many names used to describe folders: bulletins, circulars, flyers, pamphlets, etc. These names tell us very little about how the folder was folded, or even about its general characteristicsin fact, in many cases the names are totally interchangeable. Rather than try to understand what is intended by these different names, let's compare folders in terms of the number of folds, the type of folds, and the number of pages created by these folds. Once again, it would be a good idea to take a sheet of paper and copy some of the folders discussed-you will find that each has a very distinct personality.

Four Page. The simplest folder possible: one fold, four pages. The sheet can be folded either on the short or the long side. Used for envelope enclosures, bill stuffers, price lists, etc.

Six Page. Two parallel folds, six pages. The folds can be either regular or accordion. Used for much the same purposes as the 4-page folder, except that it has an extra two pages.

Eight Page. By folding once and then folding again at a right angle to the first fold, we get what is commonly called a French fold. The advantage of this particular fold is that although the sheet can be printed economically on only one side of the sheet, the printing will still appear on both the inside and the outside of the folder. An 8-page folder can also be produced by making two parallel folds or three parallel accordion folds. These are particularly suitable if you wish to print on both sides of the sheet. They also have the advantage of being very easy to open.

Twelve Page. By combining the first fold with two right-angle folds, we make a 12-page folder. The folds can be either regular or accordion.

Sixteen Page. Again, with the first fold combined with two right-angle folds it is possible to make a 16-page folder. It is also possible to make a 16-page folder using three parallel folds. These folders are particularly suitable for transportation schedules.

Before designing a folder, check the printer or binder to learn which folder can best be accommodated by his press and folded most economically on his equipment. Keep in mind that the more folds, the more expensive the job will be. Also, remember that paper comes in standard-size sheets, so plan the job to keep waste to a minimum. Refer to the cutting chart on page 145 that shows the standard paper sheet sizes and the number of pages attainable from each.

Another factor to consider when designing folders is the paper. The grain of the paper you use is particularly important because it affects foldability; paper always folds and tears more easily in the direction of the grain (see page 130). The weight of the paper is also important. If the paper is too heavy, such as card or bristol stock, it will have to be scored before folding to ensure an even fold (see page 155).

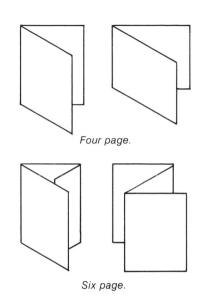

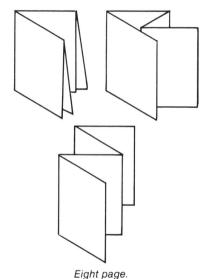

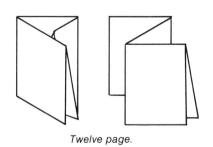

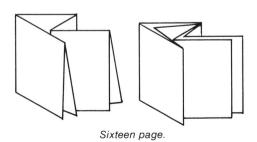

Cutting Chart

Envelopes

Paper is often made in standard sizes based on standard press sizes, therefore a paper of a given size will yield a given number of pages. Odd-size pages reduce the number of pages available from the sheet, create waste, and increase the cost of the job.

Here is a chart that shows the recommended trimmed page size and number of pages per sheet. The sizes shown have allowed for trim on top, bottom, and sides, but do not allow for bleeds. If the designer plans to have a halftone or color bleeding off any side, an extra 1/8 "must be allowed.

Not all folders require an envelope; some are planned as self-mailing folders. In this case, the front of the folder is designed to allow space for address and stamp, and the folder is fastened with a seal. Before designing self-mailing folders it is a good idea to check with the post office to make sure the size you are planning is acceptable: there are minimum sizes the post office will accept. Also, if it is a turn-around mailing—that is, a business-reply card (BRC) which is to be returned to the sender—there is a minimum weight that the post office will accept.

When designing a folder, or any mailing piece for that matter, to fit into an envelope, the size of the folder will dictate the size of the envelope. If a special-size envelope has to be made, it can be very

expensive and time-consuming. Try to plan the job so that one of the standard envelopes can be used.

When estimating the size of the envelope, allow at least 1/4" clearance on all sides of the largest insert. If inserts are thick and bulky, extra allowance should be made. This is extremely important, because most envelopes are stuffed mechanically (by machine). If anything goes wrong, the envelopes will have to be stuffed manually, and this will run up the cost.

CUTTING CHART							
Trimmed Page Size	Number of Printed Pages	Number From Sheet	Standard Paper Size	Trimmed Page Size	Number of Printed Pages	Number From Sheet	Standard Paper Size
3½ x 6¼	4	24	28 x 44	5½ x 8½	4	16	35 x 45
	8	12	28 x 44	372 X 072	8	8	35 x 45
	12	8	28 x 44		16	4	35 x 45
	16	6	28 x 44		32	2	35 x 45
	24	4	28 x 44		02	2	33 X 43
				6 x 9	4	8	25 x 38
4 x 9	4	12	25 x 38		8	4	25 x 38
	8	12	38 x 50		16	2	25 x 38
	12	4	25 x 38		32	2	38 x 50
	16	6	38 x 50				
	24	2	25 x 38	01.1			
4½ × 5¾	4	20		Oblong 7 x 5½	4	8	23 x 29
	4 8	32 16	35 x 45	/ X 5 ½	8 16	4	23 x 29
	16	8	35 x 45 35 x 45		16	2	23 x 29
	32	4	35 x 45 35 x 45	8½ x 11	4	4	23 x 35
	02	4	35 X 45	0/2 / 11	8	2	23 x 35
4½ x 6	4	16	25 x 38		16	2	35 x 45
	8	8	25 x 38			_	00 A 40
	16	4	25 x 38	8¾ x 11½	4	8	36 x 48
	32	2	25 x 38		8	4	36 x 48
					16	2	36 x 48
5¼ x 7%	4	16	32 x 44				
	8	8	32 x 44	9 x 12	4	4	25 x 38
	16	4	32 x 44		8	2	25×38
	32	2	32 x 44		16	2	38×50

Binding

Binding is the fastening together of printed sheets, in the form of signatures, into books, booklets, magazines, etc. The choice of one particular binding over another is based on a variety of factors: practicality, permanence, and perhaps most important, cost. To this list the designer may wish to add, esthetics.

The bookbinder in his studio (Frankfurt, 1568) In the background, the signatures are gathered and sewn; in the foreground, the bound books are blocked.

Binding Methods

The first step in binding is to fold the printed sheets into signatures. Next, the signatures are gathered and collated; that is, put in the order in which they will appear in the bound book or magazine. These operations are usually done by machine unless the job is small enough to be done by hand. After the signatures are gathered they are bound.

There are four basic binding methods: wire stitching, mechanical, perfect, and edition. Let's examine each.

Saddle-wire stitching.

Side-wire stitching

WIRE STITCHING

There are two methods of wire stitching: saddle-wire stitching and side-wire stitching. The particular method used is determined by the bulk of the paper and the number of pages to be bound. Thin books, such as pamphlets, catalogs, and bulletins, can be saddle-stitched; thicker books must be side-stitched.

Saddle-wire Stitching This is the most common method of pamphlet or booklet binding; it is also the simplest and least expensive. The pamphlet is opened, hung on a "saddle," and wires are inserted through the backbone into the center spread. The booklet is then trimmed on three sides: top, bottom, and right. This can be done one side at a time with a guillotine-style paper cutter, or with a special three-knife trimmer which trims all three sides at once. A great advantage of saddle-wire stitching is that it allows the pages to open fully and the book to lie flat for easy reading.

Saddle-stitched books can be bound with a self-cover (a cover made from the same paper as the text pages and cut from the same signature) or a separate cover, which is usually heavier-weight paper.

Side-wire Stitching. Books or magazines that are too thick for saddle-wire stitching must be bound with side-wire stitching. In this case the wires are inserted 1/4" from the binding edge, passing through from the front page to the back page, where they are clinched. One disadvantage of this particular binding is that the wires prevent the pages from opening flat. Books bound in this manner usually have glued-on covers of heavy stock, which are added after the binding and before trimming.

Note: when designing a book that is to be side-stitched, make sure that the inside margin (the gutter) is wide enough to compensate for the extra space required by the wire.

Although side-wire stitching is still widely used, it is slowly giving way to perfect-binding methods (see page 150), especially in magazines.

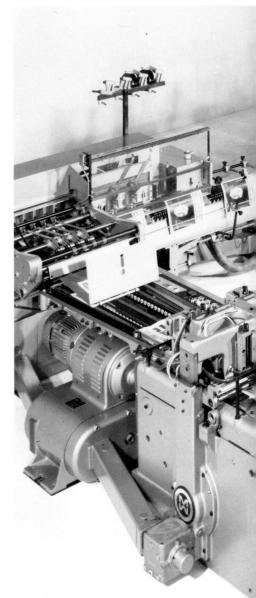

Muller Martinin Saddle-Stitcher.

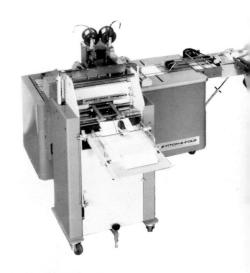

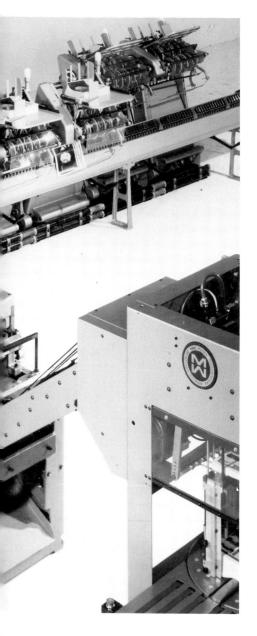

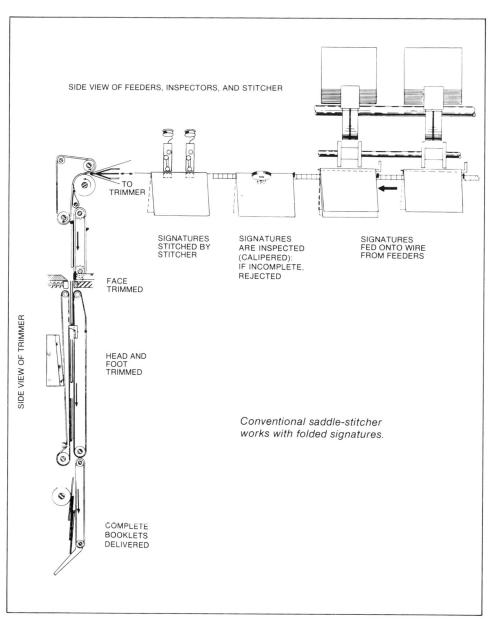

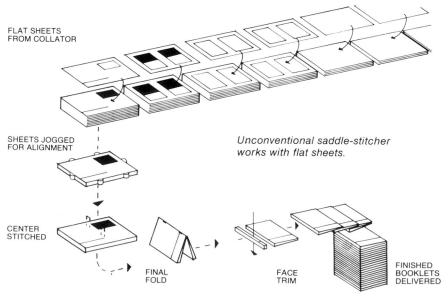

MECHANICAL BINDING

Mechanical binding is a method of binding in which the pages and cover are held together by mechanical means, usually by metal or plastic coils. A looseleaf notebook, in which the rings open to allow for the addition or removal of pages, is also a form of mechnical binding.

After the signatures have been gathered and collated they are trimmed on all four sides. A series of slotted or round holes are then drilled in the binding edge by a drilling machine. The cover, which is usually cardboard, is drilled with identical holes. The cover and pages are then bound together by wire or plastic coils inserted into the holes. Metal and plastic binding wires are available in a variety of sizes, shapes, and colors.

Some of the more popular mechnical bindings are Cerlox, Mult-O, Spiral, Sure-lox, Tally-ho, and Wire-O. Among the advantages of mechanical binding is that the book lies absolutely flat when open, making it ideal for such uses as textbooks and cookbooks.

Note: when designing for mechnical binding be sure to allow extra space at the autter not only for trimming the signatures, but also for punching the holes. The exact amount of space will depend on the particular binding.

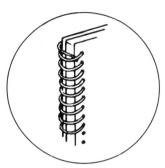

Spiral.

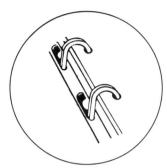

Tally-ho.

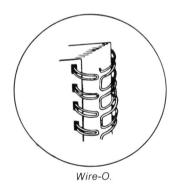

PERFECT BINDING

Perfect binding represents the fastest growing segment of the binding industry. It is a method of binding in which the pages are held together and fixed to the cover by means of adhesive. After the signatures have been gathered, the backs are ground off, leaving a rough surface onto which the adhesive is applied. If added strength is required, a strip of gauze called "super" or "crash," which is a kind of cheesecloth, is glued over the spine.

Next, the cover is added: this can be either a soft cover or a hard cover. The soft cover, which is the least expensive, is made from a cover stock that is heavier than the text stock. The cover is glued to the spine and the book and cover are trimmed as a unit. The hard cover is more expensive and sturdier. It consists of a binding material such as cloth or paper pasted on binding boards. In hardcover binding, the book is trimmed first and the cover added later. This method of binding is similar to edition binding.

Perfect binding is relatively inexpensive and is widely used for paperbacks, manuals, and textbooks. Perhaps the most familiar example of perfect binding is the telephone book.

Note: when designing for perfectbound books, leave an extra $\frac{1}{8}$ " at the gutter to allow for the 1/8" that is ground off in the binding process.

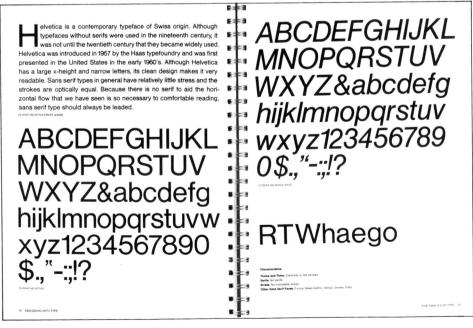

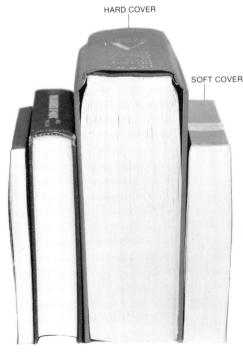

Perfect-bound books with soft and hard covers.

EDITION BINDING

Edition binding, more commonly known as hardcover or casebound, is the conventional way of binding a book. It is also the most permanent and most expensive. This book is an example of edition binding.

After the printed sheets are folded and gathered, they are sewn together in one of two ways: Smyth-sewn, in which the thread passes through the gutter of each signature; or side-sewn, in which the thread passes through the entire book 1/8" from the gutter. Four-page endpapers are then pasted to the gutter edge of the first and last signatures. Because their function is to attach the book to its cover, these endpapers are usually a heavier stock than the text papers.

The book is then trimmed on three sides and glue is added to the spine to reinforce the stitching. Next, the spine is given either a round or flat contour, depending on the designer's choice (this book, for example, has a flat spine). A strip of "super" or "crash" is then glued

along the length of the spine for reinforcement.

While the signatures are being bound in one part of the plant, the covers, or cases, are being prepared in another. These covers are nothing more than two pieces of cardboard, called binding boards, covered with a binding cloth or paper. These are stamped or printed to show the name of the book, the author, and the publisher. This is usually done by "hot stamping" with a metallic foil. The book is then inserted into its case and the endpapers are pasted to the insides of both covers. This process is called casing in. The cased-in book is put in a special hydraulic press for drying. When dry, the book is inspected. wrapped in a dust jacket, and packed for shipping.

Note: some books after being sewn are given a soft cover (usually paper) rather than a hard cover. Only the hardcover. or casebound, is considered edition binding.

Endpapers pasted to first and last signatures along binding edge.

Signatures sewn together.

One-piece case made from a single piece of binding material.

Three-piece case made from three pieces of binding material

A strip of crash is placed over glued back. Headbands added.

Case is added.

Book-Covering Materials

It is the designer's job to specify the book-covering material. Today, books are bound in a wide variety of materials, ranging from traditional coverings such as paper and cloth to more exotic coverings such as silk, velvet, burlap, and even metal. If the designer is to choose the right material he must consider not only the esthetic aspects, such as color and texture, but also how the material is finished. It is the finish that gives the material body, strength, durability, and printability.

Some covering materials are embossed to create special textures. This is particularly common with paper and plastic, which can be embossed to look like linen, buckram, or leather, or to display decorative patterns.

Other covering materials lend themselves to being pre-printed before binding. In this case, multiple images are printed on a large sheet of specially treated book cloth or paper. The sheet is then cut and trimmed into individual covers.

Book-covering materials are available in rolls, sheets, or special slit rolls designed to fit case-making machines. The most popular sizes are 38" and 42", with other sizes available if the order is large enough to warrant special manufacture. The width of the binding material is dictated by the size of the book to be bound; the object is to have as little waste as possible while still allowing enough material for board thickness, hinge, and turn-in on three sides. Generally speaking, the wider the roll the more economical the use of materials and machine time, and therefore the lower the cost per cover.

Book-covering materials can be broken down into two major categories: woven, which includes all cloths, and non-woven, which includes paper and synthetics.

WOVEN

The basic cloth for almost all woven bindings is cotton. This base cloth, called *greige* (pronounced *gray*) goods, is woven in a variety of weights. In order to produce a high-quality white book cloth, the greige goods must first be bleached to remove impurities and make the cloth absorbent. The cloth is then finished by being impregnated, or filled, with starch or pyroxylin to which color has been added.

Starch-filled cloth is a popular, lowcost binding material. The starch, similar to that used in doing the laundry, is forced into the cloth to give it body. Unfortunately, starch-filled cloth is easily stained by water and has a tendency to pick up moisture from the hands. The starch is also considered a delicacy by vermin such as cockroaches and mice. For a stronger, more durable, verminand moisture-resistant cloth, pyroxylin is used. Pyroxylin is a liquid plastic which can either be forced into the cloth to make it pyroxylin impregnated or applied in coats to make it pyroxylin coated, the latter being the strongest and most expensive.

Besides the addition of starch or pyroxylin for strength and durability, the cloth can be finished in a number of ways to give it a specific appearance. Here are three of the more popular finishes:

Linen. Starch or pyroxylin is applied to the surface of the bleached cloth, then scraped so that some of the white threads show through, giving the cloth a linen look. Linen-finish cloth is further recognizable by the fact that the reverse side of the cloth shows little color and remains practically white.

Vellum. For a vellum finish, the bleached cloth is first dyed to the approximate color of the starch or pyroxylin, before it is applied. When scraped, the threads, being the same color as the finish, do not show as they do with the linen finish. This gives the cloth the appearance of having a solid-color finish. Vellum-finish cloths are also recognizable by the fact that the color of the reverse side is similar to the color of the surface.

Natural. Once again the bleached cloth is dyed to the approximate color of the finish. This time, however, the starch or pyroxylin is applied only to the reverse side of the cloth, and the cloth is not calendered, so that the surface will retain as much of its original rough, "natural" texture as possible.

Not only is it possible to produce linen, vellum, and natural finishes on cloth, but many of the cloths, especially those treated with pyroxylin, can also be embossed to look like linen, buckram, leather, and other materials. Fortunately, manufacturers make up very complete sample books showing a wide variety of cloths in various grades, finishes, and colors. (It should be noted that while most companies manufacture similar products they use different trade names not only for each grade of cloth, but also for each finish. This can be very confusing when trying to make comparisons.)

Many book-covering cloths are manufactured to school and library specifications as laid down by NASTA (National Association of State Textbook Administrators) and LBI (Library Binding Institute). These organizations specify the weight and number of threads per inch, the tear and break strength, abrasion resistance, and so on, that the cloths must have. All cloths made to these specifications are then classified into the following grades: A, B, C, C1, D, E, and F. Cloths in F grade are the heaviest and most expensive. Note: the grade of a cloth does not imply a specific finish; any grade can be starch filled or pyroxylin coated, any can have a linen or vellum finish, and most can have a natural finish.

Not all book cloths fall into one of these grades; there are cloths which for one reason or another do not satisfy the school or library specifications, but which do have desirable qualities of their own. These are usually referred to as "non-specification" book cloths.

Some of the better-known manufacturers of book-covering cloths are Columbia Mills, Holliston Mills, and Joanna Western.

Linen finish.

Vellum finish.

Natural finish.

COMPARATIVE TABLE OF BOOK CLOTHS

GRADE	JOANNA	COLUMBIA	HOLLISTON			
	Starch Filled (Linen and Vel	lum Finish)			
Α	Eton	Minerva	Novelex			
В	Oxford	Title	Rex & Sharor			
C	Linen Finish	_	_			
D	Buckram	Sampson	Record			
101	Devon	Baltic	Crown			
*	-	Atlantic	Kingston			
	Starch Filled (Natural Finish)					
z/c	_	Lamique	Kingston			
300	Kennett	Fictionette	Payko			
2/2	Lynnene	_	Novelex			
ata	_	_	Zeppelin			
4.	Buckram	Bolton	_			
	Buckram	Bolton	_ _			

Bayside

Milbank

Riverside

Colonial

Bradford

Oneida

Royal

Roxite A

Roxite B

Roxite C

Roxite C-1

Roxite Record

Roxite Caxton Roxite Library

NON-WOVEN

The non-woven category of book covering materials includes both paper and synthetic covers. It represents the fastest growing segment of the book-covering industry, and the major reason is cost: it is less expensive to bind a book with paper or a synthetic than with cloth. Furthermore, softcover books and paperbacks do not require dust jackets, as the jacket art is printed directly on the cover.

We have broken down the non-woven materials into three categories based on NASTA specifications: Type 1, paper; Type 2, reinforced paper; and Type 3, synthetic fiber. Let's examine each:

Type 1: Paper. This is the least expensive of all covering materials, but it is also the weakest. Type 1 paper is basically a heavy-duty kraft paper which has been bleached and / or dved. However, like cloth, it can be finished to increase strength and durability by coating the sheet with acrylic, vinyl, or pyroxylin. Finishing not only strengthens the sheet, but improves ink holdout, and therefore printability. To add variety, papers can be overprinted with patterns or embossed to resemble linen, buckram, leather, or a wide range of decorative textures. Type 1 papers are most widely used for paperback and casebound

Binding papers are measured by thickness, measured in points (a point is 1/1000"), or basic weight, measured in pounds. The most commonly used paper for paperbacks is 8 and 10 point; for casebound (over boards) books, 65 pound.

Type 2: Reinforced Paper. In this case the base paper, or substrate, has been reinforced by adding polymers or resins to the pulp while the paper is being made. As with Type 1, the sheet can be further strengthened by coating it with acrylic, vinyl, or pyroxylin. It can also be embossed or overprinted. Type 2 reinforced paper is widely used for both softcover (self-supporting) and casebound (over boards) books. The most commonly used reinforced papers for softcover books are 14, 17, 20, 22, and 25 point; for casebound, 8, 9, and 10 point.

Type 3: Synthetic Fiber. These covering materials are neither cloth nor paper, but are made from synthetic fibers. At present there is only one substrate in this category: DuPont's Tyvek. This is one of the strongest and most durable of all covering materials. The synthetic fibers are spun into a sheet then bonded together by heat and pressure. The result is a tough, hardwearing, stain-resistant sheet, which because of its spun fibers and lack of grain is extremely difficult to tear. And because of its whiteness and ink holdout it is very well suited to fullcolor printing providing the sheet is properly coated. Tyvek can be printed by either letterpress, gravure, offset lithography, screen printing, or flexography. However, special inks must be used for printing on Tyvek; those commonly used in printing contain solvents that can have an adverse effect.

Tyvek is available in number of styles, colors, overprint patterns, and embossing textures; it comes coated or uncoated. However, all Tyvek used for book covering is coated—at least on one

An exception to the above categories are supported and unsupported vinyls, whose use is generally limited to looseleaf bindings.

Among the companies specializing in non-woven covering materials are: Appleton Paper, Canfield Paper, Columbia Mills, Holliston Mills, Permalin Products, Payne-Jones, Process Materials Corp., Scott Graphic, Philip G. Whitman, and Wyomissing Corp. (Paper Division).

Arrestox A

Arrestox B

Arrestox C

Arrestox S Arrestox Buch.

Arrestox E

Arrestox F

В

C

D Ε

Other Binding Materials

In addition to deciding on the covering material, the designer will most likely have to make decisions concerning endpapers, stamping, binding boards (in some cases), and headbands.

Binding Boards. There are two basic binding boards: a pasted chipboard, called pasteboard, and a heavier, stiffer board called binder board. Pasteboard is made from layers of thin chipboard pasted together with an adhesive which is much stronger than even the chipboard. Binder board is a high-quality, single-ply, solid pulp board made to the full thickness in one operation. Binder board is about 50% denser than pasteboard. Most books are bound with pasteboard, which is more than adequate for books that receive normal handling. Textbooks, which receive a greater amount of handling, require the added strength of binder boards.

Binding boards are measured by points (a point is 1/1000"). The more popular sizes of pasteboards are 70, 85, and 95 points. There is an accepted tolerance of 5 points over or under any given size. For binder boards, the sizes are 70, 80, 88, and 98, with an acceptable tolerance of 2 points. There are heavier boards available, but these are seldom used.

For thinner, more flexible binding boards there is a felted product called red flexible board available in point sizes of 24, 30, 35, and 50. This is a popular binding board for handbooks such as diaries, calendars, and yearbooks.

Endpapers. Endpapers, also called end-leafs, book linings, and flyleafs, are found at the beginning and end of casebound books. Their main function is to hold the book in its case. (The casing-in process is described on page 151.) Endpapers are normally heavier than the text pages as they must hold the book together. Typical endpapers are 80 lb. and are made from special fibers chosen for their strength. A secondary function of endpapers is esthetic; they can be very attractive. For this reason they are available in a wide range of colors and finishes. Endpapers can also be pre-printed.

Foils and Pigments. After the boards have been covered and before the book is cased in, the cases are usually stamped with the title of the book and the name of the author and publisher. The most common method of accomplishing this is hot-stamping the case with metallic foil or pigment, available in silver, gold, copper, aluminum, and a wide range of both matte and glossy colors.

When selecting colors for stamping, the designer should be aware that the color will appear different, depending on the color of the binding material. Also, some foils stamp better than others, depending on the kind of binding material. For example, some foils are specially formulated for stamping on plastics. To avoid errors, the designer should have a sample case made up showing the specified binding material and stamping foil.

Headbands. These are tiny strips of cloth that protrude slightly from the head and foot of the inside of the spine. Their function is mainly esthetic; when a book is casebound, the head and foot of the spine can have an unfinished look where the signatures are bound and pasted together. The headbands, which are very colorful, tend to dress up this area.

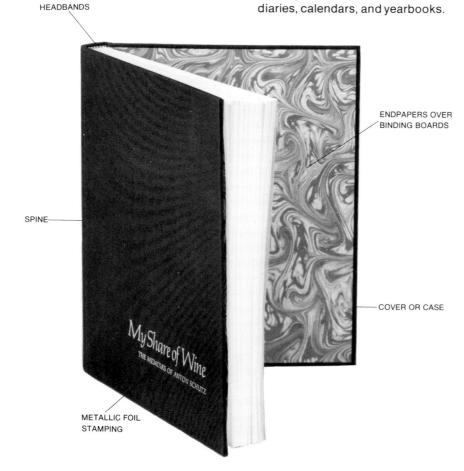

Bindery Facilities

Although we tend to think of the binder in terms of simply binding books, there are many other services available. These are referred to as finishing operations and include blind stamping, die-cutting, drilling, edge-gilding, embossing, eyeletting, indexing, laminating, padding, perforating, punching, round-cornering, scoring, tabbing, tipping and varnishing. Some of these, such as laminating, perforating, and varnishing, can also be done by the printer. It is a good policy when the job is being designed to consult the printer and binder to be sure they will be able to carry out your plans. They can make suggestions for improvements or modifications to fit existing equipment and materials. In the long run this will enable you to save time and obtain a better, less expensive job.

Let's examine some of the more common finishing operations.

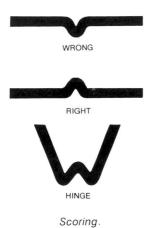

Die-cutting. The cutting of paper or cardboard with steel dies to remove a part or to leave a part attached so that it can be folded away from the rest of the sheet. Die-cutting is commonly used for mailing pieces, greeting cards, and point-of-purchase displays. The most common method of die-cutting is with steel rule dies made from thin steel blades bent into the desired form. not unlike a cookie cutter, and mounted onto 34" plywood. The die is mounted on a platen or letterpress, similar to the way in which a type form is mounted. The sheets are then die-cut individually or in groups, depending on the thickness of the paper.

Embossing. A finishing process that produces a raised image on the surface. Embossing is done directly on a letterpress or on a special embossing press. For heavy embossing, heat must be added. It is possible to emboss either a relief image or a bas-relief image. When no ink is used on the latter, it is called blind embossing. In addition to printer's inks, metallic foils can also be used in embossing.

Scoring. Making a crease in heavy-weight paper, such as cover stock, to facilitate folding. When not scored, heavy-weight papers have a lendency to fold unevenly and buckle, especially when they are folded across the grain. Scoring is usually done with a round-face scoring rule locked into a form on a platen or cylinder press. Scoring rules vary in thickness; the thicker the paper the thicker the rule must be to ensure a wide crease and a clean fold.

Stamping. Imprinting the case for casebound books. First, a die is made of the copy to be stamped (from a mechanical supplied by the designer). If it is a short run, say 1,000, the dye can be made of magnesium or zinc; if longer, then the die is made of either copper or brass, both of which are harder, more durable metals. The metallic foil is then placed over the raised letters and transferred to the case by a combination of heat, pressure, and dwell-time (duration of heat and pressure application).

Blind stamping is done in the same way except that no foil is used; the die leaves only the impression of the letters in the binding material.

Die-cutting

Embossing

Stamping.

Blind stamping.

Mechanicals

The mechanical, also called a paste-up or keyline, is the master from which the printing plate is made. It contains all the design elements pasted in position on a piece of artboard and ready for the camera. It is important that the mechanical be accurate; if elements are not properly aligned, or if type is broken, these imperfections will be photographed and become part of the printing plate.

Some of the basic tools required to prepare a mechanical.

Scaling Art

Before the designer makes his mechanical he usually has to reduce or enlarge the original art to fit his design. There are two practical methods by which the designer can scale art: the diagonal line and the proportional scale.

Diagonal Line. Place a sheet of tracing paper over the artwork and draw a rectangle around it. Now draw a diagonal line from the lower left corner to the upper right corner (if the artwork is going to be enlarged, your line should extend well beyond the corner). Measure off the new width along the bottom line of the rectangle. From this point draw a vertical line upward until it intersects the diagonal. The point of intersection establishes the new height of the reproduction. The diagonal-line method can also be used to find out the new width if the new height is known. Following the same procedure, you would measure the new height along one of the vertical sides of the rectangle and then draw a horizontal line until it intersected the diagonal.

Scaling art using a diagonal line.

Proportional Scale. The quickest and most common method of scaling art is to use a proportional scale. This low-cost instrument simplifies scaling and is easy to use; it's simply a matter of aligning two figures. For example, let's say you know the new width and wish to determine the new height. Align the actual width with the new width, then read the figure opposite the actual height. This will be your new height. The same principle applies when you know the new height and wish to determine the new width. (See the proportional scale shown below: it is set for the photograph at left.)

In addition to being very easy to use, proportional scales also show the percentage of the enlargement or reduction. This comes in handy when ordering photostats.

Align actual width with desired width.

New height appears opposite actual height.

The new art is 210% of the original art.

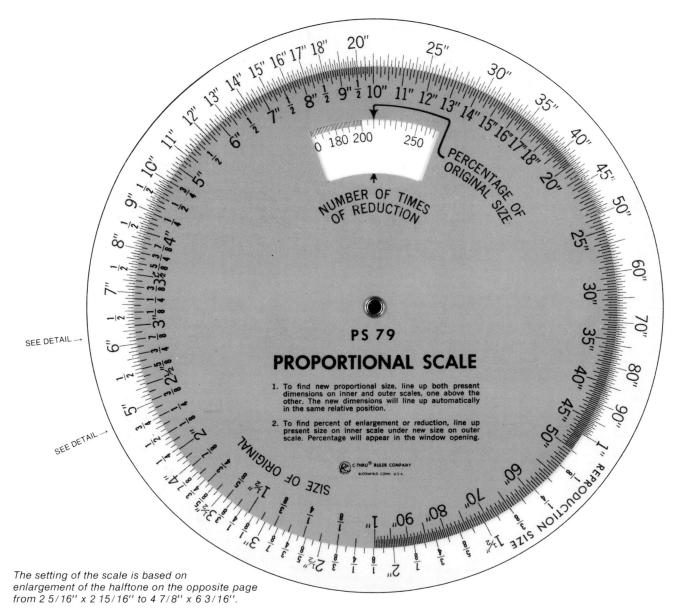

Photostats

Photostats, more commonly referred to as *stats*, are inexpensive photographic prints used to reduce or enlarge copy and are indispensable to the designer when preparing mechanicals.

Photostats can be either positive or negative. A positive stat is the same as the original copy; a negative stat is the opposite. For example, a positive stat of this page would have black type on a white background; a negative stat would have the values reversed, white type on a black background. To make a positive stat a negative stat must first be made. All stats, positives and negatives, are "right-reading"; that is, the type can be read normally from left to right.

Photostats can have either a glossy or a matte surface. Glossy stats tend to polarize all tones to either black or white. Because of their sharpness and their solid blacks, glossy stats are used for reducing or enlarging line copy, such as type or line illustrations. Glossy stats can be pasted directly on the mechanical and used as shooting copy. Matte stats, on the other hand, hold a wide range of tones and are used for shooting continuous-tone copy such as photographs, paintings, and illustrations. Matte stats are not of high enough quality to be used as shooting copy and are therefore used

Original line copy.

Negative stat.

Positive stat.

mainly to show the size and position of halftones in mechanicals.

At times, when ordering stats the designer may find the terms "positive" and "negative" confusing, especially when working with negative stats. This can be avoided by using the term "first print" and "second print." A first print will be the opposite of what you have: a first print of a positive stat will be negative; a first print of a negative stat will be positive. A second print will be the same as what you have.

Also available from some stathouses are ''direct positive'' stats. As the name suggests, the process goes from positive to positive; no negative stat is made. The quality is high, and direct positive stats are slightly less expensive. However, you won't receive a negative, and negatives can be very useful, especially if you wish to reverse type. Two examples of this trend toward direct positive stats are Visual Graphic Corp.'s Pos One System and Kodak's PMT (Photomechanical Transfer) materials (see Glossary).

When ordering stats it is important to state (1) the desired size, shown in inches or as a percentage of the original artwork; (2) the kind of paper, glossy or matte; and (3) whether the stat is to be positive or negative.

Negative stat made to same size as original.

Negative stat shows reduction.

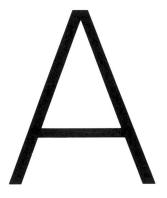

Positive made from negative stat.

Positive enlargement made from negative stat.

The same image flopped.

Veloxes

A velox is a screened photoprint of continuous-tone copy that can be pasted directly in the mechanical and shot with other line copy. To make a velox, the continuous-tone copy must be photographed through a conventional halftone screen, which transforms the image into a series of dots; that is, into line copy. From the negative, a positive photographic paper print, or velox, is made. One advantage of veloxes is that they can be pasted directly into the mechanical by the designer and shot with the line art, thus saving the expense of having the printer strip in halftones. This permits the designer to see the job, with the velox "halftone" in position, exactly as it will appear when printed. Also, the designer can work directly on a velox with opaque white paint to create highlights or with black to add lines or create solid black areas.

Veloxes, like halftones, are available in a wide range of screens—55, 60, 65, 85, 100, 110, and 120—and can be printed as dropouts, silhouettes, etc. (See page 74 for a complete discussion of screening and halftones.)

65-line screen.

85-line screen.

100-line screen.

110-line screen.

120-line screen.

Line Conversions

Line conversions use special line screens to convert continuous-tone copy to line copy. Unlike conventional halftone screens, special line screens are used to create a wide range of special effects, such as circular, mezzotint, pebble, random, steel engraving, straight line (vertical and horizontal), and wavy line, to name a few.

It is also possible for the designer to increase the degree of coarseness of any given screen simply by reducing the copy before screening and then enlarging to the final size after screening. By reversing this process it is possible to reduce the coarseness of the screen.

Line conversions can be pasted directly into the mechanical. When used with imagination and good judgment, they can create dramatic effects.

Square halftone.

Horizontal wavyline.

Steel etch.

Line resolution.

Circleline.

Steel engraving.

This series of line resolutions shows the wide range of effects made possible by varying the screens.

Toneline.

Horizontal round dot.

Woodgrain walnut.

Mezzotint.

Weave.

Fibril.

Vertical straightline.

Crosshatch.

Preparing Mechanicals

Perhaps the best way to understand mechanicals is to actually do one. In this way you can see the various steps involved and understand the reasons for them

When preparing a mechanical, the first thing to do is organize your materials: T-square, triangles, illustration board (or artboard), repros, photostats, masking tape, rubber cement, scissors, tweezers, and single-edge razor blades. You will also need a pasting and cutting board. This can be a spare piece of illustration board large enough to allow you to cut and paste freely.

Let's follow the preparation of a simple mechanical that combines type (line copy) and a photograph (continuoustone copy) and is printed in one color, black.

Check the repros carefully; if there are any imperfections such as broken letters, try to retouch them with your crowquill pen. If your efforts to patch things up fail, get corrected repros.

Most type repros, with the exception of phototype, have a tendency to smudge and should be sprayed lightly with a fixative. Even after being sprayed, however, repros should be treated with the utmost respect.

After the repro has been sprayed, cut out the individual elements to be pasted down. To do this, tape the repro securely to your cutting board, and using a metal T-square, a cutting triangle, and a sharp single-edge razor blade, cut at parallel and right angles to the lines of type. Sloppy cutting can cause optical illusions, making the type appear to be running up or downhill. Avoid cutting too close to the actual type, or you may accidentally slip and cut into the type.

The final printed piece.

Drawing Guidelines. Square up the illustration board and tape it securely to the drafting table with masking tape. Using your T-square, triangle, and light blue (nonreproducible) pencil, indicate the outside dimensions of the printing area, allowing a margin of a few inches all around. Whenever possible, mechanicals should be the same size as the printed piece.

Next, indicate the position of the type and art. These lines will serve as guidelines when pasting down type and ruling in the box that surrounds it. Light blue lines do not reproduce when the art is shot and may therefore be drawn in generously. They should be long enough so that they are not completely covered by the art you are pasting down.

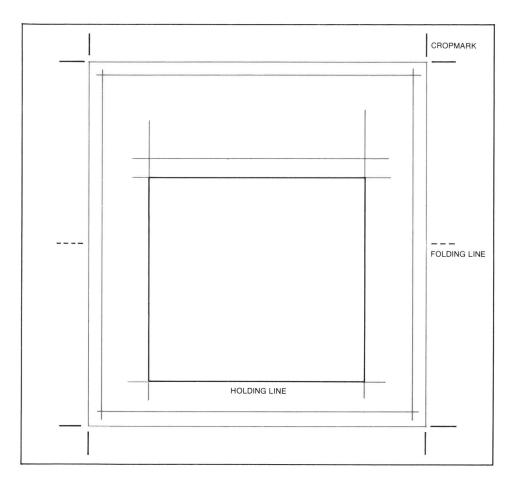

Cropmarks, Folding Lines, and Holding Lines. There are certain lines that provide information to the printer and must appear in the negative: cropmarks, folding lines, and holding lines for halftones, color, or tint areas. These occur outside the actual printing area or will subsequently be covered with printing matter and must be drawn with a red or black pen.

Cropmarks are drawn at all four corners and indicate the outside perimeter of the mechanical. They also tell the printer where the job is to be trimmed in order to make the printed piece the correct size. Folding lines, which indicate where the printed piece is to be folded, are indicated by a broken line drawn outside the trim area. Holding lines indicate the exact area that is to be occupied by a halftone, color, tint, etc.

Drawing Rules. Next, rule in the box surrounding the art with a ruling pen, Rapidograph, or good ballpoint pen. The reason for starting with the ruling-in of the box is that if you make a mistake you can simply start over with no great waste of time, whereas if the rest of the mechanical is finished and you make a mistake you either have to start over or patch it up the best you can. If you are uncertain about your ability to use a ruling pen, draw the rules separately on smooth paper or vellum, cut them out, and paste them down on your mechanical. The same method can be used to correct faulty lines that are already ruled.

Pasting Down Line Copy. Line copy, in this case consisting only of a glossy stat, is shooting copy and should be in perfect condition. Although we are beginning with line copy in this case, there is no specific order in which to paste down the various elements in your mechanical. Usually, the first element is the largest, or key, element to which the others will relate. Always try to start at the top and work down-in this way your triangle and T-square will be free to move down the mechanical without catching on elements that you have just pasted in position. Also, by working in this manner you will never cover your work with your tools; you will be able to see the elements and how they relate to one another at all times.

Using the tweezers, pick up the type and place it face down on the pasting board. Cover the entire area with onecoat rubber cement; be especially careful to cover the corners, as they have a habit of popping up and catching the T-square. (If you are not comfortable working with one-coat rubber cement, it is also possible to work with two-coat. In this case, both the art to be pasted down and the board are given a coat and allowed to dry. A slip sheet is placed over the board and the art is positioned over the slip sheet. Once the art is in the proper position the slip sheet is slowly removed. One advantage of this system is that it makes a very permanent bond.)

Once the art is covered with rubber cement, you have about 20 seconds to position it correctly on the mechanical. Because the rubber cement is wet, you can slide the art into position while checking it with your T-square and triangle to be certain it is properly aligned. Do not hold the art in the air while trying to find the exact position; this allows the cement to dry too quickly and does not give you enough time to check the alignment.

Also avoid picking the art up and putting it down again; this leaves a thin coat of cement on the art and on the board. Both coats will dry very quickly and when these two surfaces make contact they will bond immediately. If you have not properly positioned your art you will have to use rubber-cement thinner in order to lift it up. Then you will have to clean both surfaces and start over.

After the art is in position, place a clean sheet of tracing paper over it and press firmly to be sure all areas are securely pasted down. If an area has been missed, raise the edge gently, apply a little more cement, and press again.

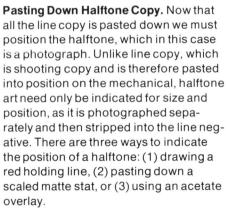

In the first method, draw a red holding line, accurately indicating the size and position of the halftone. (When photographed, the film used is designed to shoot red as black; when developed, the red line will appear as white on the negative. It is into this area that the halftone will be stripped.) You may also wish to paste a matte stat inside the holding lines to indicate the piece of art to be used, and how much of it. Be careful not to cover the holding lines; leave about 1/16" between the edge of the stat and all holding lines. Stats representing halftones are not shooting copy and so should be crossed out and keyed to the corresponding shooting copy. Write your instructions directly on each stat: "For position only; strip in halftone; see art A."

In the second method, trim a stat to the exact size of the halftone and paste it into position without using a holding line. This will work when the stat is dark enough so that a definite edge is visible on the negative, but not when the stat is so light that the printer cannot see the edge.

The third method involves the use of red acetate (Zip-a-Tone, Rubylith, etc.). Draw the holding line in light (nonreproducible) blue. Then cut a piece of red acetate slightly larger than the desired halftone and place it over the halftone area, being careful to cover all the holding lines. Because the acetate has

METHOD 2

METHOD 3

an adhesive back, it will stick immediately. Trim the acetate to size along the holding lines, using a triangle, T-square, and razor blade. (Red rather than black acetate is used because the red is transparent enough that the designer can see his holding lines in order to cut accurately.) When the mechanical is photographed this red area will appear as a clear area in the negative. It is into this clear area, or "window," that the halftone will be stripped.

Adding an Overlay. At this point the mechanical is essentially finished. Cut a sheet of tracing paper or vellum the size of the board and attach it to the upper edge with masking tape. This covering, called an overlay, protects the art and at the same time allows you to write your instructions to the printer: ink color, tint percentages, etc. Instructions should be written clearly and precisely; if there are any questions, consult the printer. For added protection, as well as a better appearance, a second sheet, or "flap," of heavy paper can be attached over the tracing paper.

Mounting Shooting Copy. It is always a good idea to mount shooting copy such as photographs or original art on a piece of artboard, with an overlay for protection. The key number, the type of shot required, and the percentage of reduction should be marked clearly on the board or tag attached to the board; for example, "Art A; square halftone; shoot at 40% of art." Cropmarks indicating how the photograph is to be cropped should be drawn on all four margins of the photograph or board. Where possible, use a grease crayon for marking photographs; it is not only less likely to destroy the surface, but its marks can be easily removed, returning the photograph to its original state.

Checking the Mechanical. Before releasing the mechanical, inspect it carefully to be certain that everything is in order. Make sure that it is clean, especially along the edges of the type; rubber cement has a bad habit of collecting dust which the camera will record.

To get an idea of how the printed piece will appear, look at the mechanical through a sheet of tracing paper or vellum. This will obscure the distracting cut marks, allowing you to see the elements of your design as a whole. Another fast, inexpensive, and effective way of checking the design is to make a Xerox of the mechanical, or, if time permits, a stat. Either way, this allows the designer or client an opportunity to make corrections while changes are still relatively inexpensive; it is easier for the designer to cut and paste with paper than it is for the printer to work with film.

When the printer receives the mechanical he checks it to make certain that everything he needs is included and that the instructions are clear. Anything missing or incorrect means lost time, which can be serious if you are working against a tight deadline.

Handling Copy. It is important that copy, photographs, illustrations, or repros, be handled with the utmost care and respect. Apart from the obvious reason that all original artwork should be returned to the client in the same condition as it was received, there is also the consideration that the better the condition of the copy, the better the printed piece will appear. Although most of the following suggestions deal specifically with photographs, most can be applied to any type of artwork:

Writing on Photographs. Do not write on a photograph—front or back—or on an overlay that comes in contact with the photograph. The pressure of the pen or pencil will cause the writing impression to show on the surface of the photograph and be picked up in the printed piece. If photographs must be identified on the reverse side, use a grease crayon and press gently. A better solution is to use tags which can be taped to the back of the photograph and then removed after use.

Paperclips. Do not use paperclips on photographs as they too will leave an impression on the surface of the photograph that might appear in the printed piece. If you do use paperclips, insert a cardboard "padding" between the paperclip and the photograph (an index card folded over the photograph to protect it front and back will do).

Folding and Rolling. Never fold or roll a photograph. This will cause cracks in the emulsion which will appear in the printed piece. It can also destroy the photograph for future use. Damage caused in this way can be retouched if not too extensive. However, this can be an expensive operation.

Trimming. Never trim a photograph to its final size. This not only spoils the photograph for future use, but also limits the possibilities of correcting any error in cropping.

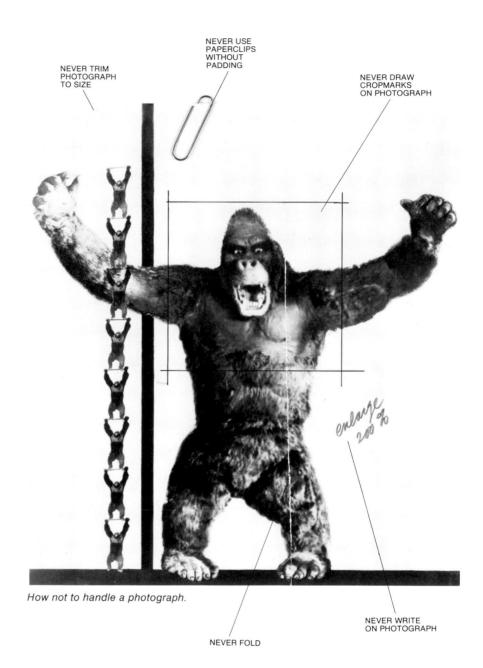

COLOR MECHANICALS

There are two basic methods for printing color: flat (or match) color and process color. (See Color Printing, page 99.) How the designer prepares his mechanical is dictated by which of these two printing methods he uses.

Flat Color Mechanicals. In flat-color printing, the designer chooses one or more colors, and for each color the printer makes a printing plate. To prepare a mechanical for flat color, the designer makes the color separations himself; that is, he indicates which elements are to be printed in which colors. The black (or major color) copy is pasted on the artboard while the copy for each additional color is pasted on acetate overlays, each one representing a color. (All

copy pasted down is black and white; it is the printing ink that dictates the final color.) Each overlay is attached to the top of the board with masking tape.

When working with overlays, it is very important that all the elements be kept in alignment. For this reason, the acetate should have sufficient body to resist warping or shrinking. It is equally important that the printer maintain this registration if the job is to be printed properly. To ensure this, registration marks are used. These are fine crosses which can be drawn by hand or bought in rolls of selfadhesive transparent tape. Registration marks are placed in at least three positions on the board outside the print area and in precisely the same position on each overlay. The reason that such precision is essential is that the board and

overlays are photographed separately and must register precisely when the printing plates are made in order to ensure proper color registration.

Some printers prefer register marks pasted only on the artboard. They then cut holes in the overlays and shoot all overlays using only these three register marks. This ensures perfect registration.

After the mechanical is finished, a color swatch at least 1" square showing the desired color is added to each overlay along with printing instructions.

There are times when overlays are not necessary. For example, in cases where colors do not overlap the color separation can be indicated on a single tissue flap. The printer will shoot the mechanical once for each color and then opaque elements not required on each negative.

Yellow plate.

Cyan plate.

Black plate.

Mechanical for illustration on page 112.

Process Color Mechanicals. Process-color printing, also referred to as full-color printing, is the method used to reproduce an image that has a full range of color, such as a transparency, painting, or color print. To prepare a mechanical for process color, all the designer has to do is paste a photostat of the original art in position and indicate that it is to be printed in process color. The printer then takes the original copy and photographically separates it into the four basic printing colors: yellow, magenta (process red), cyan (process blue), and black.

If there is line art, such as type, to be printed in color along with the full-color image, the designer must specify the color he wishes. He can do this in one of two ways. If he has a color chart he can specify the percentages of the process colors he wishes to print. For example, 100% yellow, 50% magenta, and 50% cyan. Or he can give the printer a color and ask him to match it. This way it will be the printer's responsibility to determine the correct percentages of each color.

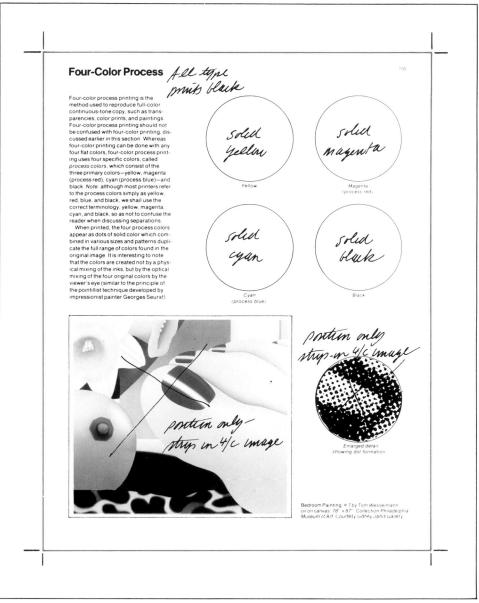

Mechanical for page 105. All instructions would be written on an overlay.

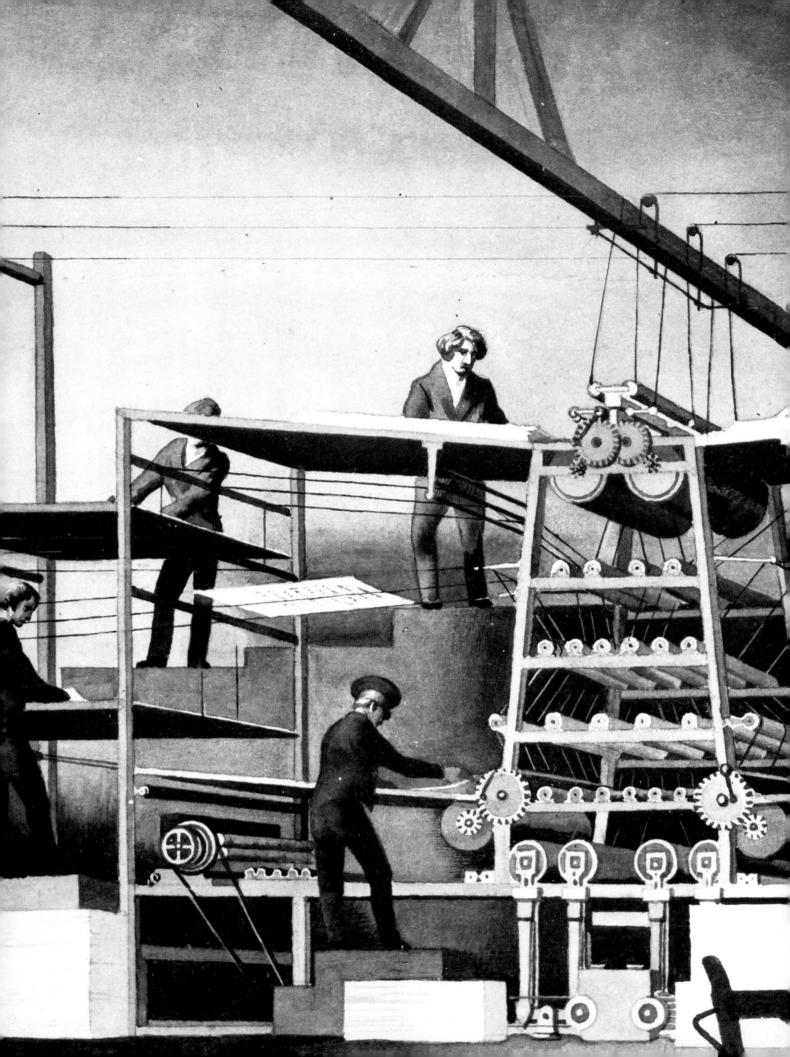

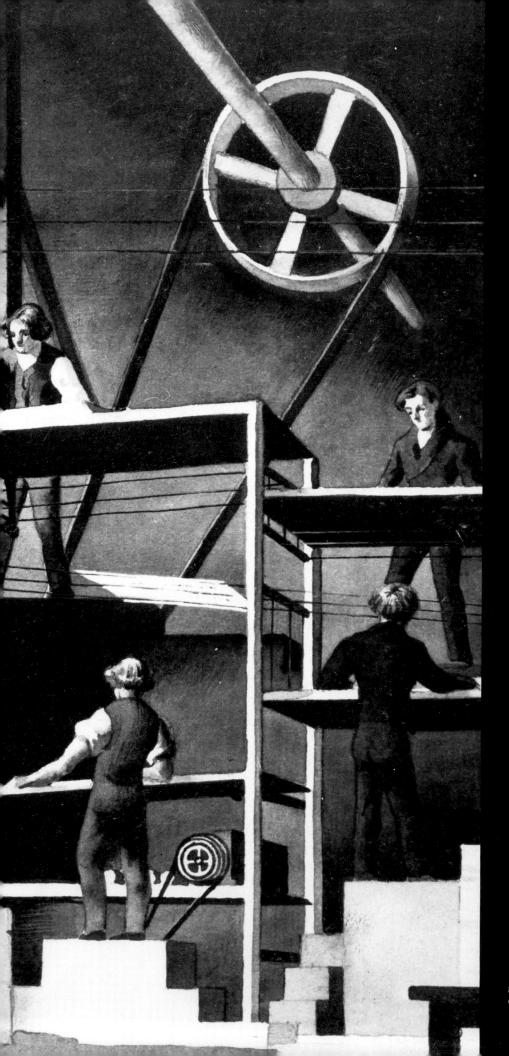

Appendix

Glossary Credits Bibliography Index

This early printing press used by the London Times in 1827 was capable of printing 4,000 sheets per hour.

Glossary

AA. Author's alteration, or any alteration in text or illustrative matter which is not a PE (printer's error).

Abrasion resistance. Ability of ink or paper to withstand rubbing and scuffing.

Accordion fold. Series of parallel folds in paper in which each fold opens in the opposite direction from the previous fold—like an accordion.

Acetate. Transparent cellulose acetate sheet placed over mechanical on which color separation can be indicated or directions to platemaker given.

Acetate proof. See Color overleaf proof.

Acetone. Volatile, fast-drying solvent.

Adhesive binding. See Perfect binding.

Against the grain. Folding paper at right angles to the grain.

Agate. Unit of measurement used in newspapers to calculate column space: 14 agate lines equal 1 inch. (Agate was originally the name of a 5½-point type.)

Airbrush. Small pressure gun, shaped like a fountain pen, that sprays paint by means of compressed air. Used to create effects of gradated tone; ideal for retouching photographs.

Albumin plate. A standard albumin-coated offset press plate made from negatives. *See also* Deep-etch plate *and* Pre-sensitized plate.

Alcohols. Solvents used in flexographic and gravure inks.

Align. To line up, or place letters or words on the same horizontal or vertical line.

Alignment. Arrangement of type in straight lines so different sizes justify at the bottom (base-aligning) and ends of lines appear even on the page.

Alphanumeric. Refers to any system of letters and numbers (alphabet plus numerals). An example of an alphanumeric designation is "AB 220."

Alphasette. Phototypesetting system manufactured by Alphatype Corporation.

Amberlith. Also known as camera amber. Brand name for a red- or orange-coated acetate sheet used on a mechanical or on artwork as marking material to position halftones, areas of color, and tints. The coating is "strippable"; that is, it can be selectively cut and peeled away to create outlines and silhouettes.

Analogue computer. A type of computer that represents numerical quantities as electrical or physical variables, used in the industry to turn valves or machinery off and on. Such computers are not used in phototypesetting. See Digital computer.

Aniline dye. A synthetic organic dye, used in flexographic printing inks.

Aniline printing. Old term for flexography (which see).

Antique finish. Soft, bulky paper with a relatively rough surface, similar to the old handmade papers.

Aquatone. Printing method combining finescreen gelatin plates and offset lithography.

Arc lamp. Lamp that produces light by a current arcing across two electrodes, usually of carbon (thus, carbon arcs). Used as a light source in photography or platemaking.

Art. All original copy, whether prepared by an artist, camera, or other mechanical means. Loosely speaking, any copy to be reproduced.

Artype. A brand name for self-adhering type printed on transparent sheets that can be cut out and placed on artwork. Available in a wide range of type styles and sizes.

Ascender. That part of the lowercase letter that rises above the body of the letter, as in b, d, f, h, k, l, and t.

Asymmetrical type. Lines of type set with no predictable pattern in terms of placement.

Author's alteration. See AA.

Backbone. Also called *spine*. In binding, that part of a book binding that connects the front and back covers.

Backing. A metal backing soldered to duplicate printing plates to make them 11 points (0.1524") thick for use on patent blocks or printing bed bases.

Backing-up. In presswork, printing the reverse side of a sheet.

Back lining. Paper or fabric that adheres to the backbone, or spine, of a hardcover book.

Bad break. In composition, when the first line of a page is hyphenated. Also, incorrect end-of-line hyphenation.

Bag paper. Usually kraft paper (*which see*), used for making bags. Paper weight varies depending on bag size.

Bank. Cabinet or bench on which type is made up or stored in readiness for makeup.

Baronial envelope. Square type of envelope used for announcements, formal correspondence, and many kinds of greeting cards.

Base. See Patent base.

Baseline. Horizontal line upon which all the characters in a given line stand.

Basis weight. Weight in pounds of 500 sheets (a ream) of paper cut to a given standard size (this size is called the *basis*

size and varies depending on the grade of paper).

Bastard progressives or progs. Also called Hollywood progs. A set of progressive proofs showing every possible color combination of the four process colors. The exact and specific effect of any two or three colors can be determined and intelligent comments formualted for correction by the platemaker. Sequence of a normal set of bastard progs is: yellow, red, yellow-red, blue, yellow-blue, red-blue, yellow-black, red-black, blue-black, yellow-red-black, yellow-black, red-blue-black, red-blue-black, and yellow-red-blue-black.

Bastard size. A non-standard size of any material used in the graphic arts.

Bearers. In composition, strips of type-high metal placed around the type form to protect the printing surface when the form is to be electrotyped. In photoengraving, the excess, or "dead" metal left on the printing plate to protect the live matter from excess pressure when molding for electroplating. On printing presses, metal rims beside the gears on which the printing cylinder rides. In reproduction proofing, strips of type-high metal placed outside the live matter of the form to even up the printing pressure and prevent the ink rollers from slurring the form.

Bed. In letterpress printing, the flat part of the press that holds the type form during printing: a job that is ready for the press is ready to be "put to bed."

Benday process. Application of dot or line patterns to line plates in order to create the effect of flat tones or shadings. Named after the man who developed the process, Ben Day. Now an obsolete process, superseded by laying photographic screen tints.

Bevel. Sloping edge around the outside of an engraving or electrotype that permits it to be locked with hooks onto a patent base (which see).

BF. Boldface (which see).

Bible paper. A thin, opaque, high-tensilestrength book paper used where low bulk is essential: for bibles, insurance rate books, encyclopedias, etc. Basis weights normally range from 14 to 30 pounds.

Binary. In computer system, a base-2 numbering system using the digits 0 and 1.

Binary code. In computer systems, a code that makes use of two distinct characters, usually 0 and 1.

Binder. Person who does bindery work. Also, a device equipped with metal rings for holding looseleaf sheets.

Binder board. High-quality, single-ply, solid pulp binding board.

Bindery. An establishment that binds books, pamphlets, etc.

Binding. The fastening together of printed sheets in the form of signatures into books, booklets, magazines, etc. Also, the covers and backing of a book.

Binding board. Paper board, either binder board or pasteboard, used in bookbinding for the covers of casebound (hardcover) books

Bit. In computer systems, the smallest unit of information representing one binary digit, 0 or 1. The word is derived from the first two letter of binary and the last letter of digit.

Bite. In photoengraving, the time required when etching with acid to produce a given depth: the depth of the etch increases with each "bite."

Black letter. Also known as gothic. A style of handwriting popular in the fifteenth century. Also, the name of a type style based on this handwriting.

Blanket. In offset lithography, the rubbersurfaced sheet clamped around the cylinder which transfers the image from plate to paper.

Bleed. Area of plate or print that extends ("bleeds" off) beyond the edge to be trimmed. Applies mostly to photographs or areas of color. When a design involves a bleed image, the designer must allow from 1/8" to 1/4" beyond the trim page size for trimming. Also, the printer must use a slightly larger sheet to accommodate bleeds.

Blind embossing. A bas-relief impression made with a regular stamping die (which see), except that no ink or foil is used.

Blind keyboard. In photocomposition, a tape-producing keyboard which has no visual display and which produces no hard CODV.

Block. In computer systems, a group of words, characters, or digits held in one section of an input/output medium and handled as a unit

Blocking. In letterpress, mounting an engraving on a block of wood or metal to make it type-high, permitting it to be locked up in a form to be printed. Also, the sticking together of printed sheets when piled too high before the ink has dried.

Blow-up. An enlargement of copy: photograph, artwork, or type.

Blueprints. Also called blues. Blue contact photoprints made on paper, usually used as a guide for negative assembly, preparing layouts, or as a preliminary proof for checking purposes.

Blurb. Summary of contents of a book presented as jacket copy. Also, a short commentary, such as a caption or the text in comic strip balloons.

Boards. See Binder board.

Board stock. See Paperboard.

Body. In composition, the metal block of a piece of type that carries the printing surface. It is the depth of the body that gives the type its point size. In printing, a term that refers to the viscosity, consistency, and flow of a vehicle or ink.

Body matter. Aslo called body copy. Regular reading matter, or text, as contrasted with display lines.

Body size. The depth of the body of a piece of type measured in points.

Body type. Also called text type. Type, from 6 point to 14 point, generally used for body matter

Boldface. A heavier version of a regular typeface. Indicated as BF.

Bond paper. A grade of writing and printing paper with a surface treated to take pen and ink well and have good erasure qualities. Cheaper grades of bond paper are made from all wood fiber; the better grades are made from rag fiber (25%, 50%, or 100% rag content). Used where strength, durability, and permanence are required.

Booklet. A small book, commonly bound in paper covers. Generally used for advertising or promotional purposes.

Book paper. A category or group of printing papers that have certain physical characteristics in common which make them suitable for the graphic arts. Used for books, magazines, and just about everything we read, with the exception of newspapers and pulp novels.

Books. Generally applies to printed, bound works. Books published as textbooks are called school books; those published for sale by bookstores are called trade books. Books printed and bound with paper covers are called paperbacks.

Borders. Decorative lines or designs available in type, used to surround a type form or page.

Brackets. Pair of marks ([]) used to set off matter extraneous or incidental to the con-

Brayer. Hand roller used to apply ink to type or printing plates when rough proofs are desired.

Break for color. To separate, color by color, the parts of a job to be printed in different colors.

Brightype. Trade name for a machine for converting letterpress type or engravings into a photographic image that can be used for offset lithography or gravure printing. The metal type form is sprayed with a black lacquer which is then selectively removed by rubbing the printing surface, making the surface reflective and the background light-absorbent. The form is then photographed in shadowless lighting as if it were line copy, resulting in a photographic film negative. Manufactured by Ludlow Typograph Company. See also Cronapress and Scotchprint.

Bristol board. Also called Bristol. A good grade of thin cardboard or pasteboard with a smooth surface. Available in a variety of finishes and colors; ideal for drawing, writing, and printing. Used for cards, posters, displays, announcements, or for any job where stiffness is required. Bristol boards are sometimes filled, but usually pasted or

Broadside. Large printed sheet folded for mailing.

Bourges. (Pronounced burgess.) Trade name for a thin, color-coated acetate overlay sheet keyed to standard printing inks. Used to produce color separations in art. Also comes in degrees of whites and grays for modifying photo backgrounds. The coating is removed either by a fluid or by scratching.

Brochure. Pamphlet bound in the form of a booklet, usually consisting of eight or more pages.

Broken package. A quantity of paper less than a standard wrapped amount (usually less than a ream). When ordered, broken packages carry a penalty charge.

Bronzing. Applying bronze or metallic powder over printed sizing ink while it is still wet to produce a metallic luster.

Brownprint. Also called a brownline or Van Dyke. A photoprint made from a negative and used as a proof to check the position of the elements before the printing plate is made.

Buckram. Sized, heavy-weave cotton cloth used for binding books.

Buffer. In computer systems, a data-storage area situated between computer units. It may be a piece of hardware, an area of memory, a disc, or a tape.

Built-up letter. A letter in which the outline is drawn first and then filled in.

Bulk. The thickness of paper, measured by the caliper of pages per inch (PPI).

Bullet. Large dot used as ornamental device.

Bulletin. Loosely used to describe several forms of printing, however it generally refers to one of a sequence of factual reports issued at irregular intervals. There is no particular form for a bulletin; it can be a single leaf, a folder, or a booklet.

Burin. In engraving, a pointed steel cutting

Burnish. In photoengraving, to darken local areas of a printing plate by rubbing down the lines and dots, thus increasing their printing surfaces. Also, a general term

for smoothing down self-adhering letters and shading sheets.

Burr. Rough edge or curl of metal left on a photoengraving as the result of burnishing, routing, or cutting.

Butted lines. Two or more linecast slugs placed side by side to produce a single line of type.

Byte. In computer systems, a group of adjacent bits (*which see*) operated on as a unit and usually shorter than a word. It can be one complete character.

C. & s.c. Capitals and small capitals. In composition, used to specify words that begin with a capital letter and have the remaining letters in small capitals, which are the same height as the body of the lower-case letters.

Calender. A set, or "stack," of cast-iron rollers with chilled, hardened surfaces, resting on one another in a vertical bank at the end of the papermaking machine. The paper passes through all or some of these rollers to increase the smoothness and gloss of its surface. See also Supercalender.

Calendered paper. Paper with a smooth finish produced by its being passed through the calender (*which see*) of the papermaking machine.

California job case. Tray in which handset type is stored and from which it is set. The individual cubicles are arranged for a minimum of motion and are sized to accommodate letters in quantities related to frequency of use.

Caliper. The thickness of a sheet measured under specific conditions. The paper is measured with a micrometer and is usually expressed in thousandths-of-an-inch (mils or points).

Calligraphy. Elegant handwriting, or the art of producing such handwriting.

Cameo. A die-stamping process in which the lettering or design slants up in relief.

Camera-ready art. Copy assembled and suitable for photographing by a process camera with a minimum number of steps.

Capitals. Also known as *caps* or *upper-case*. Capital letters of the alphabet.

Caps and small caps. Two sizes of capital letters on one typeface, the small caps being the same size as the body of the lowercase letters. Indicated as c&sc. Looks LIKE THIS.

Caption. Explanatory text accompanying illustrations.

Carbon black. A fine, intensely black pigment obtained by burning natural gas or oil with restricted air supply. Used in the manufacture of ink.

Carbon tissue. In rotogravure printing, a paper sheet coated with gelatin, plasticizers, and pigments used for photoprinting. It is exposed to strong lights through a gravure screen to produce what will be used as a resist for etching gravure cylinders.

Cardboard. A general term used to describe a stiff, strong sheet made up of several layers of low-quality paper pasted together.

Case. A type tray. Each character in a font of type has its own section in the tray, called a *type case*. Also, the covers of a casebound or hardcover book.

Casebound. See Edition binding.

Casing-in. The process of inserting the signatures of a book into its cover, or case.

Cast-coated paper. Paper that goes through the process of cast-coating (*which see*).

Cast-coating. A process in which the paper is pressed against a heated, polished drum while the coating is in a highly plastic condition. Cast-coating gives the paper an exceptionally high gloss and smoothness similar to that of a glossy photograph.

Casting. A typesetting process in which molten metal is forced into type molds (matrices). Type can be cast as single characters or as complete lines. Also, the casting of metal printing plates (stereotypes) from matrices (mats) for newspaper or book work.

Casting box. Device used for casting flat stereotypes (*which see*).

Casting-off. Calculating the length of manuscript copy in order to determine the amount of space it will occupy when set in a given typeface and measure.

Cathode ray tube. In phototypesetting, electronic tube used to display letter images, in the form of dots (computer logic character formation) or lines (character projection), for exposure onto film, photopaper, microfilm, or offset plates.

Cell. In gravure printing, small etched depression (representing one halftone dot) in the surface of the gravure cylinder that carries the ink.

Centered type. Lines of type set centered on the line measure.

Center spread. See Spread.

Chad. In phototypesetting, the paper waste resulting from holes being punched in paper tape or cards.

Chain lines. Also called *chain marks*. The widely spaced watermark lines (usually about 1" apart), caused by chain marks. which run with the grain in laid papers. Chain lines are natural in handmade pa-

pers and can be imitated in machine-made papers.

Chalking. Also called *powdering*. In printing, a condition in which the pigment in the printing ink does not adhere properly to the printing surface and can be rubbed off as powder or chalk.

Chapter heads. Chapter title and/or number of the opening page of each chapter.

Character count. The total number of characters in a line, paragraph, or piece of copy.

Character generation. In CRT phototypesetting, the projection or formation of typographic images on the face of a cathode ray tube, usually in association with a highspeed computerized photocomposition system.

Characters. Individual letters, figures, punctuation marks, etc. of the alphabet.

Characters-per-pica (CPP). System of copyfitting (which see) that utilizes the average number of characters per pica as a means of determining the length of the copy when set in type.

Chase. In letterpress printing, the rectangular steel frame into which type and engravings are locked up for printing.

Chipboard. Low-grade binding board made from wastepaper, usually used for backing padded forms.

Choke. The opposite of spread (which see).

Chroma. Also referred to as *hue*. Pure color, free from white or gray.

Chrome. See Color transparency.

Circulating matrix. In composition, the mold (matrix) from which Linotype and Intertype linecasting machines cast type. Called "circulating" because the matrices are automatically returned to the magazine for reuse.

Clasp envelope. Envelope in which the flap closes with a metal clasp. Flap may also have glue for sealing.

Coalesce. To fuse the structure of a substrate such as paper or film by means of pressure in order to change its light-transmitting characteristics.

Coated paper. Paper with a surface treated with clay or some other pigment and adhesive material to improve the finish in terms of printing quality. A coated finish can vary from dull to very glossy and provides an excellent printing surface that is especially suited to fine halftones. Coated paper is a must for halftones printed by letterpress. Examples are pigmented or film-coated, conversion-coated, blade-coated, cast-coated.

Cockle finish. The pucker characteristic of many bond papers, especially rag bonds,

which adds a crispness to the paper.

Cold-set inks. Inks in solid form which are melted and applied to a hot press. They solidify again upon contact with the printing surface.

Collate. To arrange sheets or signatures (*which see*) in proper sequence so the pages will be in the correct order before sewing and binding. In photocomposition, to compare and merge two or more identically ordered sets of items into one ordered set.

Collotype. Also known as *photogelatin*. A photomechanical method of printing, similar to lithography, that utilizes an unscreened gelatin-coated plate rather than a halftone screen to print continuous-tone copy. Collotype is the only feasible form of halfone reproduction that does not require a halftone screen. Produces extemely true reproductions but is suitable for short runs only.

Color. In composition, the tone or density of type on a page.

Color bars. Carried on all four-color process proofs to show the printer the four colors that were used to print the image. Color bars show the amount of ink used, the trapping, and the relative densities across the press sheet. Used mainly as a guide for the platemaker and printer.

Color comp print. Paper print made from a transparency. Not up to the standards of a dye transfer (*which see*) and used primarily for layouts and presentations.

Color correction. Changing the color values in a set of separations to correct or compensate for errors in photographing, separation, etc. Color is usually corrected by masking, retouching, or dot etching (all of which see). Also, the act of indicating on a set of color proofs what color corrections are to be made by the printer.

Color filters. Transparent filters placed over the lens of the printer's camera that separate the colors in the original copy into the process colors for four-color process printing (which see). The original copy is photographed four times through color filters. A blue filter produces the yellow printer (the negative used to make the printing plate), a green filter produces the magenta (red) printer, a yellow filter produces the cyan (blue) printer, and a combination of all three is used to produce the black printer.

Color guide. Instructions on art or mechanical (usually flat color work) indicating the position and percentage of color required or an actual sample of the color.

Color-matching system. Method of specifying flat color by means of numbered color samples available in swatchbooks.

Color overleaf proof. Transparent acetate

sneets that are photomechanically developed and used as proofs or for presentations. Available in a wide range of colors, including the four process colors. Suitable for simulating pre-press proofs (*which see*) of full-color art.

Color print. Photographic print in color, such as Anscochrome, Cibachrome, dye transfer, Kodacolor, and Kodak Type C.

Color process. Term used to describe multicolor printing from process-separated materials, as opposed to multicolor printing in non-process colors.

Color proof. Printed color image which enables the printer to see what is on the film and the client to make sure the color is accurate and in register. Ideally, the proof should be printed on the same press and paper that will be used for the finished job.

Color scanner. See Electronic scanner.

Color separation. The operation of separating artwork into the four process colors by means of filters in a process camera or by electronic scanners. The result is four continuous-tone films (negatives or positives) which when screened are used to make printing plates.

Color separation negative. A single black and white negative which carries a record of the proportion and distribution of one of the process colors as found in the original full-color image. A set of separation negatives consists of four black and white negatives (called *printers*), one each for the yellow, red, blue, and black.

Color terminology. In the printing industry, color is described in terms of *hue* (chroma), *strength* (saturation), and *gray* (value). Hue is the pure color, strength refers to the color's strength, or saturation, and gray refers to how "clean" the color is. These are not terms used by the artist; they have been suggested by the printing industry to help communication between designer, client, and printer.

Color transparency. Also called a *chrome*. A full-color photographic positive on transparent film: Agfa Color, Cibachrome, Ektachrome, Kodachrome, etc.

Column inch. A measure commonly used by smaller newspapers based on a space 1" deep and a column wide.

Command. In phototypesetting, the portion of a computer instruction that specifies the operation to be performed. For example, *flush left, center,* etc.

Combination plate. Also called a *combo*. Halftone and line work combined on one plate.

Comp. See Comprehensive.

Comparison of type sizes. Although America and England use the piea system for measuring type, Europe uses the Didot sys-

tem. Here is a comparison between the two systems of the more common type sizes:

Didot	Pica
4	4.3
5	5.4
6	6.4
7	7.5
8	8.6
9	9.7
10	10.7
11	11.8
12	12.9
14	15.0

Composing room. That part of a type-setting shop or a printing plant in which type is set, or composed.

Composing stick. In metal composition, a metal traylike device used to assemble type when it is being set by hand. It is adjustable so that lines can be set to different measures.

Composition. Typesetting (which see).

Compositor. A person who sets and arranges type, either by hand or machine.

Comprehensive. More commonly referred to as a *comp*. An accurate layout showing type and illustrations in position and suitable as a finished presentation.

Computer. A device for performing sequences of arithmetic and logical processes used in typesetting to store information and make the mathmatical, grammatical, and typographic spacing and end-of-line decisions, *i.o.*, hyphenation and justification.

Computerized composition. Sometimes (erroneously) called computer composition. Composition produced with the aid of a computer, which when properly programmed, speeds up the mathematical decisions needed to drive a typesetting machine. An unjustified ("idiot") tape is produced on a keyboard and subsequently run through a computer which instantaneously adds up the set widths of every character and space on the line, makes all the end-of-line decisions such as hyphenation and justification, and then produces (outputs) a second, justified, tape used to drive the phototypesetter (or metal linecasting machine).

Connected dot. Halftone dots of 50% value or more which are joined together in negative or plate.

Consumable textbook. A self-contained book designed to be written in and completely consumed by the student and which does not depend on any other textbook or material. A consumable textbook would be used by one student for one term and then discarded, as opposed to a non-consumable textbook.

Condensed type. Narrow version of a regular typeface.

Consistency. See Body.

Contact print. Photographic print made by direct contact as opposed to enlargements or reductions made by projection where there is no direct contact. Prints are made from either a film negative or positive in direct contact with photographic paper, film, or printing plate. The size is a one-to-one relationship. Contact prints are usually made on a vacuum frame (contact printing frame).

Contact printing frame. See Vacuum frame.

Contact screen. A halftone screen placed in direct contact with the film. Used for screening halftones. The "sandwich" through which light passes is made up of the following: continuous-tone positive, contact screen, and the new, unexposed film which will receive the light, resulting in a screened film negative ready for platemaking.

Continuous-tone copy. Any image that has a complete range of tones from black to white: photographs, paintings, drawings, etc.

Contrast. Wide range of tonal gradations between highlights and shadows.

Conversion systems. Systems by which metal type or plates are converted into film images. Used in converting from one printing method to another. See Brightype, Cronapress, and Scotchprint.

Cool colors. Blue, green, and violet, as opposed to warm colors, red, yellow, and orange.

Copy. In design and typesetting, type-written copy. In printing, all artwork to be printed: type, photographs, illustrations. *See also* Continuous-tone copy *and* Line copy.

Copyfitting. Determining the area required for a given amount of copy in a specified typeface.

Counter. Space enclosed by the strokes of a letter, such as the bowl of the *b*, *d*, *p*, etc.

Counting keyboard. In phototypesetting, an input keyboard which adds up the unit widths of the characters and spaces set and indicates the space used and the space remaining in a line. The keyboard operator must make all end-of-line decisions regarding hyphenation and justification. The counting keyboard produces a perforated justified paper tape used to drive a typesetting machine. See also Noncounting keyboard.

Covering power. Also called *opacity*. In printing, an ink's ability to cover the material beneath it to produce a uniform, opaque (*which see*) surface.

Cover paper. Term applied to a variety of heavy papers used for the outside covers of brochures, booklets, and catalogs.

CPI. Characters Per Inch. The measurement of the packing density of a magnetic tape, drum, disc or any linear device that information is recorded on.

CPS. Characters Per Second. A measurement referring to the output speeds of phototypesetting equipment.

Crash finish. A paper finish that simulates the look and feel of coarse linen.

Crawling. Term applied to the contraction of ink after printing on a surface that it has not completely wet.

Crocking. Also called *rub-off*. Smudging or transfer of dry particles of ink by rubbing after job has dried.

Cronapress. A trade name for Du Pont's system of converting metal type or letter-press printing plates into film. This film can then be used to make offset plates, gravure cylinders, or very faithful duplicate letter-press plates. The material to be converted is covered with a special pressure-sensitive film and pressure is applied with vibrating steel balls or pins which coalesce the film to make it clear, or transparent, at the points at which the raised letterpress dots or type touch it. The material is then dyed to make the non-coalesced areas light-blocking. The result is a film negative. See also Brightype and Scotchprint.

Crop. To eliminate portions of copy so that it better fits the page design. Usually done by using cropmarks (*which see*) on the original copy to indicate to the printer where to trim the image.

Cropmarks. In design, the lines drawn on an overlay or in the margins of a photograph to indicate to the printer where the image should be trimmed.

CRT. See Cathode ray tube.

Crystallization. In printing, a condition in which a printed, dried ink film has insufficient tack to permit trapping, or the laydown of a second ink which is printed on top of it.

Cursives. Typefaces that resemble handwriting, but in which the letters are disconnected.

Curved plate. In letterpress and flexography, a press plate curved to fit the printing cylinder. In offset lithography, plates are thin metal sheets which are wrapped around the plate cylinder.

Cut. Also called (in Europe) *block*. A commonly used word for any typographic printing plate or engraving.

Cutoff. In web press, the distance, or interval, between cutting knives which chop the web into individual sheets.

Cutoff rule. A hairline that marks the point where a block of type moves from one column to another, or the end of a story in a column of type. Also, in newspapers, the horizontal dividing line between typographic elements.

Cut-out lettering. Self-adhering transfer type carried on acetate sheets that is cut out and placed on the working surface. Examples are Artype and Formatt.

Cyan. Also referred to as *process blue*. One of the process colors (*which see*). Also, one of the filters used in making color separations.

Cylinder press. A letterpress printing press in which a cylinder is used to impress the paper upon the type.

Dandy roll. Also called a *dandy*. The wire cylinder on the papermaking machine that impresses laid and wove patterns and watermarks on the surface of the paper.

Data. General term for any collection of information (facts, numbers, letters, symbols, etc.) used as input for, or desired as output from, a computer.

Data bank. The mass storage of information which may be selectively retrieved from a computer.

Data processing. A generic term for all operations carried out on data according to precise rules of procedure. The manipulation of data by a computer.

Day-Glow. Trade name for inks and papers containing fluorescent pigments.

Dead metal. In printing, areas on an engraving not intended for printing; these must be routed, or cut away after molding. If the engraving is to be molded for electrotyping or stereotyping, dead metal is carried on the plate as internal bearers to protect the live matter from damage.

Dead white. A neutral white that has no perceptible tint.

Decimal equivilants. Here are some of the more common fractions that you might be called upon to change into their decimal equivilants:

Sixteen 1/16 3/16 5/16 7/16 9/16 11/16 13/16 15/16	.0625 .1875 .3125 .4375 .5625 .6875 .8125 .9375	Eighths ½ % % % Quarter Thirds, ¼ ½	.125 .375 .625 .875
'9/16	.9375		

Deckle edge. Irregular, ragged edge on handmade papers, or the outside edges of machine-made paper produced by the "pisser" on the papermaking machine (so called because a jet of water "pisses" on the edge of the unformed pulp as it travels on the wire just before it becomes paper). This action "cuts" the edge of the unformed pulp. Because the deckle edge has esthetic value, fancy papers and cover stocks are sold with these edges untrimmed.

Deep etch. In printing, the process by which a printing plate is produced by two separate etching operations. Used when type and line work must be etched separately from tone work or illustrations so as to render the proper depth to ensure printability.

Deep-etched plate. In offset, a plate (made from a positive film) on which printing areas have been recessed below the surface so that the plate may be used for long runs.

Deep etching. In engraving, additional etching to the first bite given line plates or coarse-screen halftones.

Definition. The degree of sharpness in a negative or print.

Delete. A proofreader's mark meaning "take out." Looks like this:

Delivery end. In printing, that part of the press at which the finished, printed sheet is delivered.

Densitometer. An instrument having a light-sensitive photoelectric eye which measures density (*which see*). Used by the cameraman to get the correct exposure when shooting copy and by the printer to control the quality of the presswork. There are two types of densitometers: reflection and transmission

Density. In photography, measurement of the opacity of a transparent or translucent object. On a film negative, the greater the density area, the more black, or more developed, it is. Density is measured from 0 to 4.0.

Density range. The range of density, expressed numerically, from shadow reading to highlight reading, on negative or positive film, or on a printed sheet. Density range is measured by a densitometer (which see).

Descenders. That part of a lowercase letter that falls below the body of the letter, as in g, j, p, q, and y.

Diazo. In phototypesetting, a photographic diazo-process-developed proofing positive commonly used to produce positive photoproofs and better-quality photorepros from film positives by contact exposure.

Die cut. Paper or cardboard cut into shapes other than rectangular by means of die cutting (which see).

Die-cutting. The cutting of paper or cardboard by pressure or by a blow with thin steel blades made up on a form (called a *die*) so that part of the sheet is excised, or slit, so that it can be folded away from the rest of the sheet for a "pop-up" effect. Used in mailing pieces, folding boxes, greeting cards, and in sales displays.

Digital computer. A computer that represents and processes information consisting of clearly-defined, or discrete, data by performing arithmetic and logical processes on these data. As opposed to the analogue computer (*which see*).

Dimension marks. L-shaped points or short marks indicated on mechanicals or camera copy outside the area of the image to be reproduced, between which the size of reduction or enlargement is marked. Looks like this:

Direct impression composition. See Type-writer composition.

Direction of travel. In printing, the direction in which the printing stock or web moves through the press.

Direct process. In direct process color separation, the original copy is separated, screened, and sized in one step by a process camera using glass halftone screens. As opposed to the indirect process (*which see*).

Disc. In phototypesetting, the circular image-carrier of negative type fonts.

Display type. Type which is used to attract attention, usually 18 point or larger.

Distribution. In composition, the act of returning the type, leads, rules, slugs, furniture, and other printing materials to their storage places after use.

Ditto. Trade name for a type of office duplicator, manufactured by Ditto, Inc. Also, the name for typographic mark used as an abreviation for "repeat what is above." Looks like this: ".

Doctor blade. In gravure, a thin-edged, flexible metal blade fitted on rotogravure presses that scrapes off excess ink from the surface of the engraved printing cylinder prior to printing. This procedure cleans the surface, leaving only the cells (*which see*) filled with ink.

Dot etching. Local color correction, done by hand, on film containing screened color separations. Dot etching changes the size of the halftone dots, thereby changing the tone

Dots, halftone. Minute, symmetrical individual subdivisions of the printing surface formed by a halftone screen (*which see*).

Double-black duotone. A duotone (*which* see) in which both plates are printed in black.

Double burning. To expose the images of

two or more films onto a new film or a printing plate, thereby creating a single image.

Double-dot halftone. Two halftone negatives combined into one printing plate, producing a printed reproduction with a greater tonal range than a conventional halftone. One negative reproduces the highlights and shadows, the other reproduces the middletones. Used primarily in offset lithography.

Double-thick cover. Two thicknesses of regular-weight cover paper pasted together.

Double-tone halftone. Imitation of a duotone (*which see*) in which the color plate is purposely printed out of register to produce a duotone effect.

Downtime. The time interval during which a device (typesetting equipment, printing press, etc) is malfunctioning or not operating; or the time spent waiting for materials, instructions O.K.'s, etc., during which work is held up.

Drawdown. Ink film deposited on paper by a smooth-edged blade to enable an evaluation of the color and density of the ink.

Drawing paper. A general term for a wide assortment of papers used for pen or pencil drawing. Fiber composition ranges from rag stock to groundwood.

Driers. In printing, film-forming substances (oils, resins, etc.) or metallic additives added to inks to hasten their drying time.

Drilling. Perforating, by drilling, sheets to be bound in looseleaf folders or spiral-type bindings. Done by a special machine that has a row of drills, which can penetrate a greater thickness of sheets than can punches.

Dropout halftone. Also called a *highlight halftone*. In printing, a halftone in which the highlight areas have no screen dots; all that appears in the highlight areas is the white of the paper.

Dropout type. See Reverse type.

Dryer. In printing, a mechanical device used to accelerate the drying time of printing inks.

Drying time. In printing, the time required for an ink to form a rub- or tack-free surface. Also, the time needed for drying before the opposite side of a sheet can be printed or finished.

Dry-mounting. A method of adhering photographs to mounting boards by using a special wax-backed tissue that bonds under heat and pressure.

Dry offset. See Letterset.

Dry-transfer type. See Pressure-sensitive lettering.

Dummy. The preliminary layout of a printed

piece, showing how the various elements will be arranged. It may be either rough or elaborate, according to the client's needs.

Duotone. A two-color halftone made from a regular black and white photograph. One plate is made for the black, picking up the highlight and shadow areas; a second plate is made for the second color, picking up the middletones. When printed, these two plates produce a monochromatic color reproduction with a full range of tones.

Duplex. In linecaster machines, a matrix that carries two molds. Also refers to the character that occupies the secondary position in a duplex matrix.

Duplex paper. Paper or board with a different color or finish on each side.

Duplicate plates. Plates made from the same negative film, or in the case of letterpress, from a Cronapress (*which see*) negative made from the original plates. Also, molded duplicates of original plates produced by electrotyping, stereotyping, or other molding processes. Duplicate plates make it possible to print multiple images in the same sheet, as well as to use more than one press at a time (for example, in cases when one ad must appear in more than one publication at the same time). The most commonly used letterpress duplicate plates are stereotypes, electrotypes, plastic plates, and rubber plates.

Duplicate transparency. A duplicate of an existing photograph, in transparency form. Done when more than one piece of the same art is required, when the transparency must be retouched, when the transparency is to be ganged up with others on a flat for same-focus enlargement or reduction, or when the original is too valuable to release.

Duplicator. Small office-type printing machine that reproduces copy in small quantities: Mimeograph, Multigraph, Multilith.

Dycril. Trade name for Du Pont's PPDR plates (*which see*).

Dyes. A soluble coloring matter, as opposed to pigments, which are insoluble.

Dye transfer. A full-color print made on specially coated paper from reflective art or transparency copy. The process involves color separating the art into three colors, making gelatin matrices that selectively absorb dye, and transferring the dye (one color per matrix) to the gelatin-coated paper. Used by artists for doing retouching or as short-run quantity displays.

Dylux. Trade name for a fast, self-fixing, light-sensitive proofing paper manufactured by DuPont. Proofs can be made from either positive or negative film and are processed in as little as 30 seconds. The paper is sensitive on both sides, permitting the creation of accurate dummies.

Edge-gilding. In binding, the addition of gold leaf to the page edges of a book. Common practice with bibles or finely printed limited-edition books.

Editing. Checking copy for fact, spelling, grammar, punctuation, and consistency of style before releasing it to the typesetter.

Editing terminal. Also called an editing and correcting terminal. In phototypesetting, a tape-operated visual display unit (VDT), using a cathode ray tube on which is displayed the results of keyboarding (captured on tape) for editing purposes via its attached input keyboard prior to processing the copy in a typesetting machine.

Edition binding. Generally refers to all commercial bindings, such as wirestitched, perfect, mechanical, and casebound, as opposed to custom or handmade bindings. More specifically, it refers to just the latter, casebound, also referred to as hardcover. Edition binding is the most permanent of all binding methods: the signatures are gathered, sewn together, and cased-in (which see). This book is edition bound.

Eggshell antique. A soft, bulky paper with a finish that resembles the shell of an egg.

Egyptian. Type style recognizable by its heavy, square serif.

Electronic scanner. Photoelectric equipment for scanning full-color copy by reading the relative densities of the copy to make color separations. The scanner is capable of producing negative or positive film either screened or unscreened. The scanner can only separate copy that is thin enough to be wrapped around a drum, therefore limiting copy to transparencies and photographic prints. In printing, refers to an electric "eye" on a press that scans the printed sheet as it passes through the press for the purpose of register control, quality control, ink density, and register for cutoff, etc.

Electrotype. Also called an electro. A duplicate of an engraving or type form, produced by electroplating. A vinyl mold is made of the original, sprayed with silver and then electroplated with a coating of copper to form a shell-like cast. Extra hardness is obtained by overplating the copper with nickel or chromium after the shell is removed from the mold. After removal the shell is backed up (filled) with lead alloy to bring it to the proper height and give it the strength to withstand the pressure of the printing press. Where a lighter-weight plate is desirable for purposes of shipping or handling, the backing may be plastic, aluminum, or nylon instead of lead. Electrotypes may be flat, or curved to fit rotary cylinders. Electros are 11 points (0.1524") and shell electros 0.063" high.

Elite. The smallest size of typewriter type:

12 characters per inch as compared with 10 per inch on the pica typewriter.

Ellipses. Three dots (. . .) that indicate an omission, often used when shortening quoted matter.

Elliptical dot. A halftone dot with a shape like that of a football, rather than the conventional square-dot shape. An advantage of elliptical dots is that they produce a smoother gradation of tones across the 50% tint area of the halftone.

Em. Commonly used shortened term for em-quad (*which see*). Also, a measurement of linear space, or output, used by typographers, *i.e.*, how many ems does the copy make?

Embossing. Producing a raised image on a printed surface. Embossing is done on a heavy-duty press, using special female dies and creating a male counter by making ready with a special compound. See also Blind embossing.

Em-quad. Called a *mutton* to differentiate it from an en-quad, called a nut, which is one half the width of an em. In handset type, a metal space that is the square of the type body size; that is, a 10-point em-quad is 10 points wide. The em gets its name from the fact that in early fonts the letter *M* was usually cast on a square body.

Em-space. A space the width of an emquad (which see).

Emulsion. In photographic processes, the photosensitive coating that reacts to light on a substrate.

Emulsion side. The dull, or matte, emulsion-coated side—as opposed to the glossy side—of photographic material.

En. Commonly used shortened term for en quad (*which see*).

Enamel-finish paper. A smooth-coated paper, excellent for printing fine halftones.

End-of-line decisions. Generally concerned with hyphenation and justification (H/J). Decisions can be either by the keyboard operator or by the computer.

End papers. The sheets at the front and back of a casebound book that attach the pages of the book to the cover, or case. They are usually of a heavier stock than the book paper.

Engrave. To cut, etch, or incise a surface. In printer's language, to make engravings for any printing process.

Engraver. An individual or firm engaged in making printing plates and dies.

Engraving. A relief printing plate used in letterpress. Usually made of zinc, copper, or magnesium. Also refers to the handwork done in the engraving process. Also, the itaglio plate used for the production of engraved cards and stationery.

Enlarger font. Negative film font used by Alphasette to produce type sizes larger than 16 or 18 point.

En-quad. Also called a nut. The same depth as an em but one half the width: the en space of 10-point type is 5 points wide.

Envelope-stuffer. Also called Envelope enclosure. Any small printed promotional piece that can be inserted into envelopes with statements or business letters. Used to present selected features of products or services

Etch. The acid used by engravers to etch metal plates. In lithography, the fountain solution used to wet the offset plate when printing.

Etching. In photoengraving, the eating away of the non-printing areas of the printing plate by acid to produce a relief printing surface. In stone lighography, the chemical treatment of the non-printing areas of the printing stone or plate so that they will not accept ink. In gravure, the etching of the image into the copper printing cylinder by acid. Also refers to the fine art intaglio process, or the line engraving of zinc, steel, or copper plates.

Exception dictionary. In computer-assisted typography, that portion of the computer's memory in which exceptional words are stored. Exceptional words are those words which do not hyphenate in accordance with the logical rules of hyphenation. For example, ink-ling would be an exceptional word since computer hyphenation logic would break it inkl-ing

Exposure. In photography, the time and intensity of illumination acting upon the lightsensitive coating (emulsion) of film or plate.

Extended. Also called expanded. A wide version of a regular typeface.

Extender. In printing, transparent white pigment used to cut, or extend, printing inks to reduce intensity and opacity.

Face. That part of metal type that prints. Also, the style or cut of the type: typeface.

Facsimile. Exact reproduction of a letter, document, or signature.

Fade-out. See Ghosting.

Fake process. A very intricate and tedious method of reproducing artwork by having the artist or designer separate, or translate, the color areas by means of overlays, one overlay for each color. Or using a color chart, he can designate the screen values of each color on overlays to be used by the printer as a guide to laying down screens in these areas to make the negatives.

Family of type. All the type sizes and type styles of a particular type face (roman, italic, bold, condensed, expanded, etc.).

Fast-drying ink. A printing ink that dries soon after printing.

Feathering. A ragged, or feathered, edge on printed type or engravings. Caused by poor ink distribution, incorrect impression, too much ink, or because a printing ink was used that would not release cleanly (split) from the plate during printing. Usually caused by long-pigment inks.

Feeder. That section of the printing press that mechanically separates the sheets and feeds them into position for printing.

Feet. That part of a piece of metal type upon which it stands.

Felt side. In paper manufacturing, the top side of the sheet, as opposed to the underside, or wire side. In some papers, the felt finish is made by impressing still-wet paper with variously structured felts.

Filler. Coating material used to fill the interstices in paper or cloth to add bulk, opacity, and create a smoother surface. Fillers may be starch, clay, talc, titanium dioxide, diatomaceous earth, etc.

Filling-in. Also called filling-up. In printing, a condition in which ink fills the area between the halftone dots or plugs up the counters of the type.

Film advance. The distance in points by which the film in the photounit of a phototypesetting machine is advanced between lines. A film advance of 11 points for a 10-point font means that the text is set with 1-point leading.

Film makeup. See Film mechanical.

Film mechanical. Also called a photomechanical. A mechanical made with text. halftones, and display elements all in the form of film positives stripped into position on a sheet of base film. A film mechanical is the equivalent of a complete type form; from the film mechanical photorepros or contact films are made for the platemaker.

Film processor. Machine which automatically processes sensitized and exposed film and/or paper: develops, fixes, washes, and dries.

Filter. A device (gelatin or glass) placed between the subject being photographed and the film in order to reduce or eliminate certain colors while allowing other colors to be recorded on film.

Filter factor. A number that indicates the increase in exposure necessary when a filter is used.

Fine papers. A general term that refers to the grades of paper used for writing and book printing: bond, ledger, cover, and

Finish. The surface properties of paper.

Finishing. See Plate finishing.

First color down. In color printing, the first color printed on the sheet as it passes through the press.

First proofs. Proofs submitted for checking by proofreaders, copy editors, etc.

First revise. Also called corrected proof. The proof pulled after errors have been corrected in first proof. Additional corrections may call for second, third (or more) revises.

Fixing. The process by which a photographic image is made permanent.

Flash-in. The double-exposure of negative

Flat. An assemblage of various film negatives or positives attached, in register, to a piece of film, goldenrod, or suitable masking material ready to be exposed to a plate. Also, when referring to printed matter, flat refers to a lack of contrast and definition of detail, as opposed to sharp, or contrasty.

Flat-bed press. A letterpress containing a flat metal bed on which locked up forms of type and plates in a chase are positioned for printing. To print, the paper is forced against the printing surface by an impression cylinder.

Flat color. Generally refers to solid colors or tints other than process colors.

Flat-tint halftone. Also called a fake duotone. Printing a black halftone over a flat tint of second color.

Flexography. Formerly known as aniline printing. A relief printing process using wrap-around rubber or soft plastic plates and volatile, fast-drying ink. Widely used in the packaging industry.

Flooding. In printing, an excess of ink on the printing plate.

Flop. To turn over an image (for example, a halftone) so that it faces the opposite way.

Fluorescent inks. Inks with fluorescent qualities that result in extreme brilliance. A well-known example of this kind of ink is Day-Glo.

Fluorographic. A patented process (Kemart) in which dropout, or highlight, halftones can be produced photographically due to the fluorescence of the paper on which the art is rendered, or by treating existing art or photographs with a fluorescent solution.

Flush cover. A cover trimmed to the same size as the text page, as opposed to an overhang cover, which is slightly larger than the page trim size. An example of a flush cover is that used for paperbacks.

Flyer. Advertising handbill or circular.

Foil. Sized metallic or pigment leaf used in stamping lettering or designs on a surface. Used primarily for stamping book covers.

Folder. A printed piece with one or more folds, each section of which presents a complete page.

Folio. Page number. Also refers to a sheet of paper when folded once.

Font. Complete assembly of all the characters (upper and lowercase letters, numerals, punctuation marks, points, reference marks, etc.) of one size of one typeface: for example, 10-point Garamond roman. Font sizes (characters in a font) vary from 96 to 225, depending on the makeup of the font. Special characters (those not in a font) are called *pi* characters.

Foot. The bottom of a book or a page, as opposed to the top, or head.

Footnote. Note appearing at the bottom of a page referring to an item on same page. Indicated by superior numbers or by symbols such as asterisks, daggers, etc.

Foreword. Introduction to a book, usually written by someone other than the author.

Form. In letterpress, type and other matter set for printing, locked up in a chase, (which see) from which either a printed impression is pulled or a plate is made. In offset, refers to the flat (which see). Also refers to a printed piece or document containing blank spaces for the insertion of details or information and designed for use in office machines.

Format. General term for style, size, and allover appearance of a publication.

Formatt. A brand name for a self-adhering type, printed on acetate sheets to be cut out and applied to the mechanical.

Formatting. In phototypesetting, translating the designer's type specifications into format, or command, codes for the phototypesetting equipment. Formatting is gradually replacing markup.

Fotosetter. Trade name for a first-generation, circulating-matrix phototypesetting machine manufactured by Harris-Intertype. No longer made, but about 100 still in use.

Fototronic. Trade name for a line of second- and third-generation phototypesetting machines manufactured by Harris-Intype, now Harris Corp.

Fototronic CRT. Trade name for a thirdgeneration phototypesetting system incorporating high-speed cathode-ray tube technology, manufactured by Harris Corp.

Foundry type. Metal type characters used in hand composition, cast in special hard metal by type founders.

Foundry lockup. A form properly squared and tightly locked up for making molds for electrotypes, stereotypes, etc. Bearers surround the live matter. A proof of the locked-up form is called a *foundry proof*.

Fountain. On a printing press, the ink reser-

voir that holds the ink for immediate use while the press is printing, and from which the ink is metered to the form by the rollers. In offset lithography, it is also a reservoir for holding the etch for use in the dampening system. The fountain solution is metered onto the press plate by means of an engraved roller and a series of special cloth-covered rollers.

Fountain roller. On a printing press, the roller that revolves in the ink or dampening fountain and meters out the proper amount of ink to the distributing rollers.

Fountain solution. Also referred to as *etch*. In offset lithography, a mixture of alcohol or water, acid, buffer, and gum arabic that prevents the non-printing areas of the plate from accepting ink. Control of the *pH* (acidity and alkalinity) of the fountain solution in the dampening unit is crucial.

Four-color process. Method of reproducing full-color copy (original artwork, transparencies, etc.) by separating the color image into its three primary colors—magenta, yellow and cyan—plus black. This results in four printing plates, one for each color, which when printed one over the other produce the effects of all the colors of the original art.

Fourdrinier. Papermaking machine normally employed in the manufacture of all grades of paper.

French fold. A double fold: the sheet is printed on one side only, then folded twice, once vertically and once horizontally, resulting in an economical, attractive fourpage folder. Used for formal invitations, etc.

Frisket. In letterpress, selectively cut and excised protective paper used on the proofing press to cover any part of a printing plate so that it does not print. Friskets are used in process-color proofing to mask out the dead metal on the plates so that proofs can be pulled for customer submission. Also refers to any covering agent, such as Maskoid or masking tape, used to mask out areas when airbrushing art or photos.

Frontispiece. An illustration on the page facing the title page of a book.

Fugitive inks. Inks that are not lightfast or permanent: they fade or change color when exposed to light, heat, moisture, or other conditions. As opposed to permanent inks.

Full color. Process color (which see).

Furnish. The ingredients (pulp and additives) that go into the making of paper.

Furniture. In letterpress, the rectangular pieces of wood, metal, or plastic, below the height of the type, used to fill in areas of blank space around the type and engravings when locking up the form for printing.

Gallery. Cameras and darkroom of an engraving plant.

Galley. In metal composition, a shallow, three-sided metal tray that holds the type forms prior to printing. Also refers to the galley proof (*which see*).

Galley proof. Also called a *rough proof*. An impression of type, usually not spaced out or fully assembled, that allows the typographer or client to see if the job has been properly set.

Gang printing. Also called *ganging up*. In printing, running off any number of different jobs on the same sheet. After printing, the sheet is cut into the individual jobs and the printing cost is pro-rated.

Gate fold. A page that folds into the gutter, and when unfolded it is about twice the size of a normal page. Commonly used in magazines and catalogs in cases where the regular page is not large enough to contain all the information, or simply to create a special effect.

Gathering. Assembling individual sheets or folded signatures in proper sequence for binding.

Ghosting. A condition in which the printed image appears faint where not intended, caused by an abrupt change in ink take-off on the rollers. Ghosting often occurs when printing flat borders, L-shaped solids, and circles; it can generally be avoided in design by making sure the solid areas are well separated to permit a more even distribution of ink by the form rollers.

Gigo. Garbage in, garbage out. Programming slang for bad input produces bad output

Glossy. A photoprint made on glossy paper. As opposed to matte.

Goldenrod. In offset printing, a sheet of opaque orange paper into which the negative films are stripped to make up a flat from which a printing plate is made.

Grain. Predominant direction of the fibers in a sheet of paper. When folding, the direction of the grain is important: a sheet folded with the grain folds easily; a sheet folded across the grain does not. In photography, the minute variations of density in a developed photographic emulsion caused by the irregular distribution of the silver crystals.

Gravure. Printing method based on intaglio printing, in which the image area is etched below the surface of the printing plate. The gravure plate or cylinder is immersed in ink then wiped clean with a doctor blade, leaving ink only in the etched areas. The areas cut below the surface of the printing plate carry the image, which is transferred directly, by means of pressure, to the paper. There are two basic gravure presses: rotogravure, which prints from cylinders

onto a web of paper; and sheet-fed, which prints from flat plates curved around the cylinder of the press onto individual sheets.

Gray scale. A series of values of usually 16 or 21 steps from white through logorithmic (not arithmetic) gradations of gray to black. Used in processing film or photographically processed materials such as paper and plates.

Greige goods. (Pronounced *gray* goods.) The basic cloth, usually cotton, used for woven bookbinding materials.

Grid. In photocomposition, the rectangular carrier of a negative type font used in some systems. Also refers to the cross-ruled transparent grids over which all parts of a page or book layout will be assembled, or made up, in phototypography.

Gripper edge. The leading edge of a sheet of paper clamped by the grippers as it passes through the printing press. Allowance must be made on the stock to be printed for a gripper bite of from %" to ½", depending on the kind of printing press used.

Grippers. In printing, the mechanical "fingers" on the gripper bar that hold the paper onto the impression cylinder of the press during impression.

Guide. A mechanical device on a printing press that causes all sheets fed up to it to be printed with a uniform margin and in register.

Guide edge. Edge of the sheet that is fed to the guide.

Guideline. A line drawn on artwork to indicate the limits of the area to be printed.

Gutter. Blank space where two pages meet at the binding or blank space between the columns of type.

Gutter margin. Inner margin of a single page.

Gutenberg, Johann. Inventor of moveable type and letterpress printing (c. 1455) as we know it today. Although preceded by the Chinese and the Koreans (c. 705 A.D.), it is Gutenberg who is remembered as the father of mass production and the progenitor of the machine age.

Hairline. A fine line or rule, the finest line that can be reproduced in printing.

Halation. A blurring of the photographic image, particularly in highlight areas, caused by light reflected from the back surface of the substrate.

Half title page. The first page of a book after the endpapers. Carries the title of the book only and always precedes the title page.

Halftone. The photomechanical reproduction of continuous-tone copy (such as pho-

tographs) in which the gradations of tone are obtained by the relative size and density of tiny dots produced by photographing the original copy through a fine cross-line screen. For the kinds of halftones possible, see Dropout, Duotone, Double-dot, Highlight, Silhouette, Square, Surprint and Vignette halftones.

Halftone negative. Also called *screened negative*. The negative film produced by shooting continuous-tone copy through a halftone screen (*which see*).

Halftone positive. Also called a *screened* positive. A photographic positive containing screened continuous-tone copy in the form of dots representing the tonal values to be reproduced.

Halftone screen. A fine-line engraved glass or photographic film screen used to convert continuous-tone copy to line copy (dots) for halftone printing.

Halo effect. In printing, the piling up of ink at the edges of the printed letters and halftone dots, especially in letterpress printing. The centers of the dots, although printing, appear lighter, or less dense, than the edges.

Handbill. Generally applies to a single leaf, printed on one side, for distribution by hand from door to door.

Hanging indentation. In composition, a style in which the first line of copy is set full measure and all the lines that follow are indented

Hard copy. In phototypesetting, typewritten copy produced simultaneously with paper or magnetic tape and used to help keyboard operator spot errors as he types and to supply proofreaders with copy to read and correct before the tape is committed to typesetting. Also convenient for marking operating instructions to the photounit operator.

Hardcover. See Edition binding.

Hardwear. In phototypesetting and the word-processing field, a term referring to the actual computer equipment, as opposed to the procedures and programming, which are known as software.

Head. The top, as opposed to the botton, or foot, of a book or a page.

Heading. Bold or display type used to emphasize copy.

Headline. The most important line of type in a piece of printing, enticing the reader to read further or summarizing at a glance the content of the copy which follows.

Headliner. In phototypesetting, a trade name for a machine that produces display sizes of type, manufactured by VariTyper Corp.

Head margin. The white space above the first line on a page.

Heat-set inks. Letterpress and web offset printing inks which dry under heat.

Heavy bodied inks. Printing inks having a high viscosity and stiff consistency.

Hickey. A defect, or spot, appearing in the printed piece. Hickies are caused by dust, lint, or bits of ink skin on the printing plate, the type form, or the blanket (in offset) and show up as specks surrounded by a halo effect (*which* see).

High key. Refers to a photograph in which the majority of tonal values are higher, or lighter, than a middle gray.

Highlight. In a photograph, the highlight area is the lightest area. Represented by the smallest dot formation in a halftone.

Highlight halftone. See Dropout halftone.

Holding lines. Lines drawn by the designer on the mechanical to indicate the exact area that is to be occupied by a halftone, color, tint, etc.

Hot type. Slang expression for type produced by casting hot metal: Linotype, Intertype, Monotype, and Ludlow (*which see*), and sometimes handset foundry type.

Hue. That characteristic of color that we call "color": red, green, blue, etc., as opposed to shade, tint (*which see*).

Idiot tape. A common term for an unformatted, *i.e.*, unhyphenated, unjustified tape (*which see*). Cannot be used to set type until command (format) codes are added and processed by a computer that makes all the end-of-line decisions.

Illustration. General term for any form of drawing, diagram, halftone, or color image that serves to enhance a printed piece.

Image master. Also called a *type matrix*. In phototypesetting, the type fonts, *i.e.*, a disc, film strip, etc.

Impose. In typesetting and make-up, the plan of arranging the printing-image carrier in accordance with a plan. To make up.

Imposing stone. See Stone.

Imposition. In printing, the arrangement of pages in a press form so they will appear in correct order when the printed sheet is folded and trimmed. Also, the plan for such an arrangement.

Impregnated. In book manufacture, the coating of the cover cloth. Cloths can be pyroxylin-impregnated, vinyl-impregnated, or starch-impregnated.

Impression. In printing, the actual process of taking a printed copy from type or plates. Also, the pressure of the printing surface upon the paper. See Kiss impression.

Impression cylinder. Cylinder that holds the paper against the printing surface so that contact is made and an impression produced.

Imprint. The printing of a person's or a firm's name and address on a previously printed piece by running it through another printing press.

Incunabula. Early printing, specifically that done in the 15th century.

Index. Alphabetical list of items (as topics or names) treated in a printed work that gives each item the page number where it can be found. Also a character used to direct attention.

Indicia. Information printed by special permit on cards or envelopes that takes the place of a stamp.

Indirect letterpress. See Letterset.

Indirect process. In four-color process printing, the original copy is first separated into four continuous-tone (unscreened) negatives which are sized and screened later. As opposed to the direct process in which the copy is scaled, separated, and screened in one step.

Initial. The first letter of a body of copy, set in display type for decoration or emphasis. Often used to begin a chapter of a book.

Ink fountain. Also called the *fountain*. That part of the printing press that supplies ink to the inking rollers.

Ink holdout. A characteristic of paper that keeps the ink on the surface and prevents it from being absorbed into the paper's fibers. Too much absorption causes the printed image to lack sharpness and luster. Coated papers have better ink holdout than non-coated papers and are therefore capable of producing finer halftones.

Input. In computer composition, the data to be processed.

Insert. A separately prepared and specially printed piece which is inserted into another printed piece or a publication.

Intaglio. In fine art, a printing process in which the image or design is cut or etched into the surface of the plate. In printing, the intaglio process is referred to as gravure (which see), and steel or copper engraving.

Interleave. See Slip sheet.

Interlinespacing. Also called *linespacing*. In photocomposition, term for leading *(which see)*.

Internegative. In photography, the negative taken by a camera from which a color print or transparency will be made. Also, the negative resulting from copying color art or transparencies for blow-up or reduction from which a final-size print or duplicate transparency will be made.

Intertype. Trade name for a linecasting machine similar to Linotype. Manufactured by Harris-Intertype Corp., now Harris Corp.

Italic. Letterform that slants to the right: *looks like this*.

Jacket. Also called a *dust cover*. The paper dust jacket or over-cover of a casebound book.

Job press. A platen press (*which see*) used to print small jobs such as business cards, envelopes, tickets, etc. These presses are often referred to as *jobbers*.

Job shop. A commercial printing plant, as opposed to a publication, or "captive," shop.

Jog. To straighten or align by vibration the edges of a pile of papers so that they are even

Joint. That part of a book binding that forms the hinge at the spine.

Justified type. Lines of type that align on both the left and the right of the full measure

Justify. The act of justifying lines of type to a specified measure, flush right and left, by putting the proper amount of interword space between words in the line to make it even, or "true."

Kerned letters. Type characters in which a part of the letter extends, or projects, beyond the body or shank, thus overlapping an adjacent character.

Kerning. Adjusting the space between letters so that part of one extends over the body of the next. Kerned letters are common in italic, script, and swash fonts. In metal type, kerning is accomplished by actually cutting the body of the type for a closer fit. In phototypesetting, it is accomplished by backspacing, and composition set this way is often termed "set tight" or set with minus letterspacing.

Key. To code copy by means of symbols such as numbers or letters. Also refers to a device for tightening quoins (*which see*) or a device to tighten the hooks used with a patent base (*which see*).

Keyboard. In linecasting, phototypesetting, and typewriter or strike-on composition, that part of the typesetting machine at which the operator sits and types the copy to be set. *See also* Counting *and* Noncounting keyboards.

Keyboardist. Keyboard operator.

Keyed advertising. Advertisements that are coded to identify results. Used when the same ad is run in more than one publication.

Keyline. Mechanical (which see). Most paste-up art has key lines, which are the outlines of areas or of objects the designer has drawn, showing where a panel, color tint, or halftone is to be positioned.

Key negative. The negative (or positive) film that contains the basic format of the job

and onto which all other negatives of tints or other colors will be registered.

Key plate. The term "key negative" or "key plate" usually refers to a negative or plate that carries most or all the indications as a guide for the stripper.

Kicker. Also called a *teaser*. A short line above the main line of a head, printed in smaller, or accent, type.

Kid finish. A finish that resembles soft, undressed kid. Used on high-grade or Bristol paper.

Kill. To delete unwanted copy. Also, to "kill type" means to distribute or dump metal type from a form that has already been printed, or to destroy existing negatives or press plates.

Kiss impression. The ideal meeting of plate and paper: the ink is properly split from the plate and distributed evenly and the paper is properly impressed but not indented.

Kleenstick. A brand name for a pressuresensitive adhesive-backed paper. When repros are pulled on Kleenstick, they can be put down on the mechanical directly, without rubber cement.

Kraft. The name comes from the German word for "strong." A sturdy paper made from sulphate pulp, commonly used for wrapping.

Kromecote. A brand name for a cast-coated paper with a very glossy finish.

Lacquer. A clear, cellulose-derivative synthetic coating applied to the surface of a printed piece for protection and/or appearance. Before lacquering, the printer must use inks compatible with the lacquering process.

Laid paper. Paper having a laid pattern: a series of parallel lines simulating the look of the old handmade papers.

Laminating. Applying a thin plastic film (acetate or polyester) to a printed sheet for protection and/or appearance. A laminated surface has a hard, high gloss and is impervious to stains. Lamination may be applied in liquid form or in sheets. Liquid acetate is less expensive as it is done on a blade coater. Sheet acetate is applied by a laminating machine and is more expensive, but it is also thicker, has a higher gloss, and offers more protection. However, unlike liquid acetate, sheet acetate may peel if adhesion is not carefully controlled. Before lamination is considered, care must be exercised in notifying the printer to use inks compatible with the type of lamination proposed.

Lampblack. A carbon black pigment used to produce a dull, intensely black ink. Lampblack is prepared by the incomplete

combustion of vegetable oils, petroleum, or asphalt materials.

Lap. In color printing, the area where one color overprints, or overlaps, another adjacent color. The amount of lap is specified in points; the thinnest lap is a hairline.

Last color down. In color printing, the last color to be printed.

Laydown sequence. In color printing, the sequence in which the colors are printed.

Layout. The hand-drawn preliminary plan or blueprint of the basic elements of a design shown in their proper positions prior to making a comprehensive (which see); or showing the sizes and kind of type, illustrations, spacing, and general style as a guide to the printer.

L.C. Lowercase, or small letters of a font.

Leader. A row of dots, periods, or dashes used to lead the eye across the page. Leaders are specified as 2, 3, or 4 to the em; in fine typography they may be specified to align vertically.

Lead-in. The first few words in a block of copy set in a different, contrasting type-face.

Leading. (Pronounced *leading.*) In metal type composition, the insertion of leads (*which see*) between lines of type. In phototypesetting, the placement of space between lines of type: also called *linespacing* or *film advance*.

Leads. (Pronounced *leds.*) In metal type composition, the thin strips of metal (in thicknesses of 1 to 2 points) used to create space between the lines of type. Leads are less than type-high and so do not print.

Ledger paper. A tough, smooth, non-receptive paper generally used for keeping business records, such as ledgers.

Legibility. That quality in type and its spacing and composition that affects the speed of perception: the faster, easier, and more accurate the perception, the more legible the type.

Length. In printing inks, that property which enables the ink to be stretched out into a long, thin thread without breaking. Long inks have good flow. Short inks cut off cleaner, permitting the printing of very delicate type and illustrations.

Letraset. Brand name for a rub-off, or dry-transfer, type.

Letterfit. In composition, the quality of the space between the individual characters. Letterfit should be uniform and allow for good legibility. In body type, the typesetter has no control over letterfit because it is an integral characteristic of the font structure. In display types, the designer is responsible for obtaining proper letterfit by cutting and fitting the letters (set on paper or film) until

the optimum esthetic arrangement is achieved.

Letterpress. The printing method originally used to print using woodblocks or type. It is based on relief printing, which means that the image area is raised. The surface is inked by means of a roller and the image is transferred directly to the paper by pressure. See Flat-bed cylinder and Rotary.

Letterset. Also known as *dry offset* and *indirect letterpress*. A printing process in which a low-relief plate is used on a modified offset press. As in conventional offset printing, the ink is transferred from the plate to the paper by being offset from a blanket, but unlike offset printing, no dampening system is required.

Letterspace. The space between letters.

Letterspacing. In composition, adding space between the individual letters in order to fill out a line of type to a given measure or to improve appearance. In metal type, letterspacing is achieved by inserting thin paper or metal spaces, which are less than type-high and so do not print, between the letters. In phototypesetting, letterspacing is achieved mechanically by keyboarding extra space between letters or increasing the set width of the face. In phototypesetting, minus letterspacing (or kerning) is also possible.

Ligature. In metal or linecast type, two or three characters joined on one body, or matrix, such as *ff, Ifi, ffl, Ta, Wa, Ya*, etc. Not to be confused with characters used in logotypes cast on a single body.

Lightface. A lighter version of a regular typeface.

Lightfastness. The resistance of a printed piece or colored material to color change when exposed to high-intensity ultraviolet (UV) light (sunlight or artificial light).

Linecaster. A typesetting machine (Linotype, Intertype) that casts entire lines of type in metal, as opposed to those that cast individual characters (Monotype).

Line conversion. The conversion of continuous-tone copy to line copy through the use of conventional halftone screens or patterned special-effects screens.

Line copy. Any copy that is solid black, with no gradation of tones: line work, type, dots, rules, etc.

Line cut. See Line engraving.

Line drawing. Any artwork created by solid black lines: usually pen and ink. A drawing free from wash or diluted tones.

Linen. A kind or finish given to book-covering materials or to paper.

Line engraving. A printing plate which prints only black lines and masses.

Line gauge. Also called a type gauge or a

pica rule. Used for copyfitting (which see) and measuring typographic materials.

Line mechanical. An accurate paste-up of all line copy, ready to be shot (photographed).

Line negative. A high-contrast negative of line copy. Areas to be recorded are clear; all other areas are light-blocking.

Line overlay. Line work put on overlay to pre-separate line from halftone. Used in preparation of art for reproduction.

Line printer. In phototypesetting, a high-speed tape-activated machine that produces a hard copy printout for editing and correcting purposes. Specifically, a device capable of printing the line of characters across a page, *i.e.*, 100 or more characters simultaneously as continuous paper advances line by line in one direction past type bars, a type cylinder or a type chain capable of printing all characters in all directions.

Line printer proof. Proof printed by a line printer and used for reading purposes, or checking the outcome of typesetting before actual setting.

Linespacing. In phototypesetting, the term for leading (*which* see).

Line work. Artwork consisting of solid blacks and whites, with no tonal values.

Lining figures. Numerals the same size as the caps in any given typeface: 1, 2, 3, 4, 5, 6, 7, 8, 9, 10. As opposed to Old Style figures: 1, 2, 3, 4, 5, 6, 7, 8, 9, 10. Lining figures align on the baseline.

Linofilm. Trade name for a line of phototypesetting machines and a system manufactured by Mergenthaler Linotype.

Linotron. Trade name for high-speed cathode ray tube phototypesetting machines and systems manufactured by Mergenthaler Linotype.

Linotype. Trade name for a widely used linecasting machine that sets an entire line of type as a single slug. Manufactured by Mergenthaler Linotype.

Lithography. In fine art, a planographic printing process in which the inage area is separated from the non-image area by means of chemical repulsion. The commercial form of lithography is offset lithography (which see).

Lockup. In letterpress printing, a type form properly positioned and made secure in a chase for printing or stereotyping.

Logotype. Commonly referred to as a *logo*. Two or more type characters which are joined on one body as a trademark or a company signature. Not to be confused with a ligature, which consists to two or more normally connected characters.

Long ink. Length or stringiness in a printing

ink denotes printing, transfer, and waterresistant qualities.

Lowercase. Small letters, or minuscules, as opposed to caps.

Ludlow. Trade name for a typecasting machine for which the matrices are assembled by hand and the type is cast in line slugs. Used principally for setting large display type and newspaper headlines. Manufactured by Ludlow Typograph Co.

Lydel. Trade name for photopolymer offset printing plates manufactured by DuPont.

Machine composition. Generic and general term for the composition of metal type matter using mechanical means, as opposed to hand-composition. The use of machines incorporating keyboards and hot metal typecasting equipment, *i.e.*, Linotype, Monotype.

Machine finish. An uncoated paper with a smooth but not glossy finish.

Magazine. The slotted metal container used to store matrices in linecasting machines.

Magazine specifications. Specifications for the making of printing plates to conform to publishers' special printing requirements.

Magenta. Also referred to as *process red*. One of the process colors (*which see*). Also, one of the filters used in making color separations.

Magnetic inks. Inks made with iron pigments that can be magnetized after printing to enable the printed matter to be picked up by electronic sensing (reading), or MICR (magnetic ink character reading), equipment. Widely used by banks for printing and machine processing checks.

Magnetic tape. In typewriter composition and photocomposition, a tape or ribbon impregnated with magnetic material on which information may be placed in the form of magnetically polarized spots. Used to store data which can later be further processed and set into type.

Makeready. The process of arranging the form on the press preparatory to printing so that the impression will be sharp and even. In letterpress, makeready is done by evening-up the impression under the tympan packing to make certain all the printing elements are type-high and that the paper and form come together close enough to transfer the ink, but not so close that the surface will be bruised or the paper punctured. The object of makeready is to ensure a "kiss impression."

Makeup. Assembling the typographic elements (type and engravings) and adding space to form a page or a group of pages of

a newspaper, magazine, or book. Makeup is the management of white space; that is, the mechanical and esthetic arrangement of the elements of a piece into a legible format for final reproduction.

Manilla paper. A smooth, sturdy, buff-colored paper made from manilla hemp. Used for folders, envelopes, etc.

Manuscript. Copy to be set in type. Usually abbreviated to MS. (sing.) and MSS. (pl.). Can also refer to handwritten, as opposed to typewritten, material.

Margins. The areas that are left around type and/or illustrative matter on a page: the top, bottom, and sides.

Markup. In typesetting, to mark the type specifications on layout and copy for the typesetter. Generally consists of the typeface, size, line length, leading, etc. *See* Formatting.

Mask. Generally refers to any material used to block off, or mask, portions of an illustration or area in order to protect it. In photochemical work, light-blocking material is used to block off an area to prevent it from being exposed to light. In offset lithography, opaque material is used to protect non-printing areas of the printing plate during exposure. Also, an overlay supplied to create outline shapes for halftones by photography.

Masking. In process-color reproduction, a photomechanical method using equipment and special filters to control or modulate color contrast and detail over the total area of each separation negative used for printed color reproduction. Masking is used primarily to reduce the contrast of transmitted light so that maximum reproductive value for reflected light can be attained. It is also used to heighten contrast when this quality is lacking in the transparency. Photographic masks may be either positive or negative, depending on the desired correction.

Masking paper. See Goldenrod.

Masking tape. A translucent, light-blocking red or solid black pressure-sensitive tape used to mask out unwanted areas of copy on negative or positive film. Also, a pressure-sensitive brown or white opaque tape used extensively in preparing artwork and making mechanicals.

Master proof. Also called a *printer's proof* or *reader's proof*. A galley proof (*which see*) containing queries and corrections which should be checked by the client and returned to the typographer.

Masthead. Any design or logotype used as identification by a newspaper or publication.

Mat. In cast-type composition; the common (slang) term for a Linotype, Ludlow, or Monotype matrix (which see). In ster-

eotyping, the papier-mâché or plastic mold of type and engraving forms from which stereotypes are cast. In rubber-plate work (flexography), the mold from which the rubber printing plates are cast. Also refers to a decorative matboard "frame" used to support a picture, as well as for purely esthetic effect, when framing.

Match color. See Flat color.

Matrix. (More commonly called a *mat.*) In foundry-cast type, the mold from which the type is cast. In linecasting, the specially designed mold for casting a character; lines of matrices are assembled for casting a slug. In phototypesetting, the glass plate that contains the film font negative: also referred to as a *type master*.

Matte finish. A paper with an uncalandered, lightly finished surface. Also, in photography, a textured, finely grained finish on a photograph or photostat. As opposed to glossy.

Mean line. More often called the *x-line*. The line that marks the tops of lowercase letters without ascenders.

Measure. The length of a line of type, normally expressed in picas, or in piacs and points.

Mechanical. Camera-ready paste-up assembly of all type and design elements pasted on artboard or illustration board in exact position and containing instructions, either in the margins or on an overlay, for the platemaker.

Mechanical binding. A binding method in which the pages are held together by mechanical means, usually by metal or plastic coils.

Mechanical separations. Copy prepared by the designer with overlays showing each color to be printed: one overlay for each color, all overlays in exact register with the base mechanical.

Merge. In photocomposition, a technique for combining items from two or more sequenced tapes into one, usually in a specified sequence, using a computer to incorporate new or corrected copy into existing copy and produce a clean tape for typesetting.

Metallic inks. Inks containing metallic bronze or aluminum powders in a varnish base which produce the appearance of gold, silver, copper, or bronze.

Metals. In letterperss, the kinds of metals used in platemaking are as follows: copper, for fine detail line work and quality halftone reproduction; magnesium, for long-run jobs such as packaging; zinc, for line work and coarse-screen halftones. In lithography, aluminum, zinc, or bi-metal and trimetal combinations of these metals with copper or photosensitive polymers.

Kilometer 00.62137 mile meter 39.37 inches centimeter 00.3937 inch millimeter 00.03937 inch kilogram 02.2046 lbs. gram 15.432 grs. (av.) inch 02.54 cms. foot 00.3048 meter yard 00.9144 meter pound 00.4536 kilogram

Mezzotint. In fine art, a form of etching in which the entire surface is "burred." Also, a line conversion of a photograph which imitates the mezzotint effect.

Microfilm. Photographic reproduction of data in a size too small to be read without magnification. Usually done on standard-size 70mm, 35mm, or 16mm film. Microfilm is currently being produced by computer-assisted CRT phototypesetting devices.

Middle tones. The tonal range between highlights and shadows in a photograph or reproduction. Usually represents tones between 30% and 75% value of the copy.

Mimeograph. Brand name for duplicating machine based on a direct-stencil process: ink is forced through a stencil of the original copy and onto a highly absorbent paper. Manufactured by A.B. Dick Co.

Minuscules. Small letters, or lowercase.

Modern. Term used to describe the type style developed in the late 18th century.

Moiré pattern. (Pronounced moh-ray.) Undesirable patterns that occur when reproductions are made from halftone proofs. Caused by optical conflict between the ruling of the halftone screen and the dots or lines contained in the original; a similar pattern can occur in multicolor halftone reproductions due either to incorrect screen angles or misregister of the color impressions during printing. In four-color process work, the yellow printer (which see) is usually screened at a different screen (133-line) from the other three colors (120-line) to avoid a moiré.

Mold. See Matrix.

Monochromatic. Made up of tints and shades of only one color.

Monophoto. Trade name for a phototypesetting machine based on the same mechanical principles as Monotype (*which see*). Manufactured by The Monotype Corporation Ltd., England.

Monotone. Any type of artwork reproduced in one color only. Also black and white copy.

Monotype. Trade name for a typecasting machine that casts individual characters in lines (rather than lines of type as a solid slug, as in Linotype). Manufactured by The Monotype Corporation Ltd., England.

Montage. Single image made up of several images.

Morgue. Collection or file of reference material.

Mortising. Cutting of a rectangular cavity, or hole, in an engraving block to allow type or other engravings to be inserted.

Mottle. In printing, spotty, mottled, or uneven areas, especially noticeable in printed solids, caused by tacky, transparent inks whose film split badly during impression.

Mounting. Backing engravings with blocks of wood to make them type-high. Also refers to the pasting of photographic prints onto stiff mounting board.

Mullen tester. A machine used to determine the bursting strength of paper.

Multicolor printing. Printing in more than one color.

Multilith. Trade name for a small offset duplicator press used for small jobs such as cards, letterheads, envelopes, forms, etc. Manufactured by Addressograph-Multigraph Co.

Munsell system. A system of numerical gradation used to designate and specify colors.

Mutton quad. Also called a *mutt*. Nickname for an em-quad (*which* see).

M weight. The weight of 1,000 sheets of any given paper size. Not to be confused with basis weight (*which see*), which is the weight of 500 sheets of a specific paper size. For example, the basis weight of 500 sheets of 25" x 38" paper would be 50 lbs., but the M weight of the same sheet would be 100 lbs., generally written as 100M.

Natural. An off-white color of paper, like ivory. Also, a kind of finish given book-covering materials.

Negative. A reverse photographic image on film or paper: white becomes black and black becomes white; intermediate tone values are reversed. Also, a short form of the term "film negative" used in photography or in photomechanical processes to make printing plates.

Negative assembly. Assembling or combining negatives on a flat (*which see*) in exact position according to a layout so that a plate can be exposed, etched, and printed as a complete unit.

News inks. Printing inks used on newsprint. News inks dry by absorption.

Newsprint. A grade of paper containing about 85% groundwood and 15% unbleached sulfite. The weight is from 30 to 45 lbs. and the surface is coarse and absorbent. Used for printing newspapers and low-cost flyers or broadsides.

Nick. In hand composition, the grooves in the body of the type pieces that help the compositor assemble the letters. In film, a notch or notches in the edge of the film used to identify the type of film when handling in the darkroom.

Nickeltype. An electrotype (*which see*) plated with nickel or chromium instead of copper. In letterpress printing, the plates used to print red (magenta) inks are always chromium or nickel plated to prevent chemical reactions between plate and ink.

Non-consumable textbook. A textbook intended to be used and re-used over a number of terms (this book, for example). As opposed to a consumable textbook.

Non-counting keyboard. In phototypesetting, a keyboard at which the operator types the copy to be set, producing a continuous tape which is then fed into a computer to determine line length and hyphenation and justification.

Non-scratch inks. Inks that when dry are highly resistant to mars and abrasions.

Non-woven. In binding, any material that is not woven: paper, reinforced paper, and synthetic fibers.

Novelty printing. Non publication printing, such as on balloons, calendars, pencils, matchbook covers, badges, etc.

Numbering. Printing consecutive numbers on invoices, tickets, etc. with a numbering machine. Usually done by letterpress, although some offset presses have numbering attachments.

Nut. Nickname for an en-quad (which see).

Oblique. Roman characters that slant to the right.

Oblong. In book binding, refers to a book that is bound on the short end rather than on the long end.

Offline. Refers to equipment not directly controlled by a central processing unit or to operations conducted out-of-process. As opposed to online.

Offset. Commonly used term for offset lithography (*which see*). Also used interchangeably with set-off (*which see*).

Offset lithography. Also called photolithography and, most commonly, offset. The commercial form of lithographic printing. Offset lithography is a planographic printing method; it is the only major printing method in which the image area and the

non-image area of the printing plate are on the same plane. They are separated by chemical means, on the principle that grease (ink) and water (the etch in the fountain solution) do not mix. The ink is transferred from the plate onto a rubber blanket and then to the paper.

Offset paper. Paper specially made for offset printing. It may be coated or uncoated. It must be sized and strong enough to resist the pull of the tacky inks used and the washing away of the coating by the dampening system.

Old Style. A style of type developed in the early 17th century.

Old Style figures. Numbers that vary in size, some having ascenders and others descenders: 1, 2, 3, 4, 5, 6, 7, 8, 9, 10. As opposed to lining figures: 1, 2, 3, 4, 5, 6, 7, 8, 9, 10.

One-up, two-up, etc. In printing, making one impression of a job at a time. By using duplicate plates, or by step-and-repeating the job on one plate, jobs may be printed two-up, three-up and so on.

Onionskin. A term applied to lightweight, semitransparent bond-type paper used for making carbon duplicates when typing. Also used for airmail stationery to cut down on weight and save postage.

Online. Refers to equipment directly controlled by a central processing unit. As opposed to offline. The term generally refers to the operation of input/output devices.

Opacity. That quality in a sheet of paper that prevents the type or image printed on one side from showing through to the other: the more opaque the sheet, the less show-through it will have. Also, the covering power of an ink.

Opaque. Non-transparent; not allowing light to pass through. Also, to paint out unwanted areas on a film negative so they will not reproduce during platemaking.

Opaquing. The process of eliminating any portion of a film negative by painting over the unwanted areas with an opaque solution. Also, painting resist on areas of metal engravings not to be etched.

Optical center. A point 10% above the mathematical center of a page or layout.

Optical Character Recognition. The process of electronically reading typewritten, printed, or handwritten documents used in photocomposition. Copy to be set is typed on a special typewriter, then read by an OCR scanner which produces a tape for typesetting. This avoids the necessity for keyboarding by the keyboard operator, permitting typesetting by a typist.

Ornamented. A typeface that is embellished for decorative effect.

Orthochromatic. Photographic emulsion

sensitive to blue, green, and yellow, but not red light.

Outline. A typeface with only the outline defined.

Outline halftone. See Silhouette halftone.

Output. In phototypesetting, type that has been set. Also, the processed tape from a computer.

Overhang cover. A cover larger than the trim size of the pages it encloses, as opposed to a flush cover, which is the same size.

Overlay. Transparent paper or film flap placed over artwork for the purpose of (1) protecting it from dirt and damage, (2) indicating instructions to the platemaker or printer, or (3) showing the breakdown of color in mechanical color separations.

Overprinting. Also called *surprinting*. Printing one color over another, or surprinting type over a halftone reproduction.

Overrun. Printing a quantity in excess of what is ordered. Also, printing a quantity in excess of what is actually required. Buyers of printing should be aware of the extra charges that nonregulated overruns may add to the bill.

Ozalid. Photocopying machine used to produce paper proofs of strike-on or phototypeset typography.

Packing. In printing, the layers of paper between the impression cylinder and the tympan upon which the paper rests during printing in letterpress, or between the plate and the cylinder in offset lithography. Manipulating the packing to ensure a perfect printing impression is called *makeready*.

Page proofs. Impression or proof pulled of page before the print run for checking purposes.

Pagination. To number pages in consecutive order.

Pamphlet. Generally used interchangeably with the *booklet*. Also used to designate a minor booklet of a few pages.

Pamphlet binding. The binding of small pamphlets or booklets, usually by saddlewire stitching or side-wire stitching (*which see*).

Panchromatic. Photographic emulsion sensitive to all colors. The range of color sensitivity approximates that of the human eye.

Pantone Matching System. Brand name for a widely used color-matching system (which see).

Paper. The name given all kinds of matted or felted sheets of fiber (usually vegetable, but sometimes mineral, animal, or syn-

thetic) formed on a fine screen from a water suspension. Also, specifically, one of the two broad subdivisions of paper, the other being paperboard.

Paper basis weight. See Basis weight.

Paperboard. One of the two broad subdivisions of the general category of fibrous sheets known as paper, the other being the specific term paper. Generally, paperboard is heavier, thicker, and more rigid than paper. All sheets 12 points (0.012") or more in thickness are classified as paperboard.

Paper grades. Categories of paper based on such characteristics as size, weight, and grain. The grade is often defined in terms of use. For example, bond, offset, tag, book, newsprint, etc.

Paper surface efficiency (PSE). A method of determining the printability of a sheet of paper. It is dictated by how much ink the paper absorbs and the smoothness of the surface. Evenness of the caliper of paper will also influence printability.

Paper tape. A strip of paper of specified dimensions on which data may be recorded, usually in the form of punched holes. Each character recorded on the tape is represented by a unique pattern of holes, called the *frame* or *row*. Frames usually consist of 5, 6, 7, or 8 tracks or channels, although some tape-controlled typesetting equipment requires 15- or 31-channel tape.

Paragraph openers. Typographic elements use to direct the eye to the beginning of a paragraph ($\P \Box$). Often used when the paragraph is not indented.

Parameter. A variable that is given a constant value for a specific process. Commonly used in the printing industry to refer to the limits of any given system.

Parchment. A sheet of writing material made from goat or sheep skin. An imitation parchment is made from paper impregnated with vegetable oils.

Pass. A machine run: a complete cycle of one program or set of programs, input to output.

Pasteboard. Laminated chipboard used as binding board.

Paste-up. A mechanical (which see).

Patch film. Film added or stripped into film that has already been made up for the camera. This happens when repro patches are sent in late, shot, and stripped in film form (as opposed to being pasted on the mechanical and the entire mechanical page being reshot).

Patching. Method of making corrections in repros or film in which the corrected "patch" is set separately and pasted into position on the repros or shot and stripped into film (see Patch film).

Patent base. In letterpress, a diagonally slotted or honeycombed metal base on which unmounted 0.1524" plates or electrotypes are secured with locking hooks to bring them to type-high.

PE. Printer's error, or mistake made by the typesetter, as opposed to AA (which see).

Pebble finish. A finish made up of fine designs embossed on the paper. A pebble finish adds texture to the surface. A sheet can be pebbled prior to printing or it can be pebbled by a pebbler after printing.

Perfect binding. A relatively inexpensive method of binding in which the pages are held together and fixed to the cover by means of flexible adhesive. Widely used for paperbacks, manuals, textbooks, and telephone books.

Perfecting press. A printing press that prints both sides of a sheet or a web in a single pass through the press.

Perforating. The punching of a line of minute holes in a sheet so that a part may be easily torn away in the manner of postage stamps. In letterpress, perforating is done on press by steel perforating rules (which see). In offset and gravure, it is usually done off press as a binding operation, using a perforator or a perforating die.

Perforating rules. In letterpress printing, hardened steel rules, 1 or 2 points in width and slightly higher than type-high, which are made up in the form in the outline of the area to be perforated.

Perforator. In composition, a keyboard unit that produces punched paper tape. Each character and function is given a unique code which is punched across the tape. In bindery work, a machine that punches a series of closely spaced holes in paper.

Permanent inks. Inks which do not fade or change color when exposed to sun or artificial light. As opposed to fugitive inks, which do.

Photocomposing. To photomechanically arrange continuous-tone, line, or halftone copy for reproduction. Not a synonym for photocomposition. Also, the technique of exposing photosensitive materials onto film or press plates using a photocomposing machine (also called a step-and-repeat machine).

Photocomposition. See Phototypesetting.

Photocopy. A duplicate photograph, made from the original. Also, the correct generic term for Photostat, which is a trade name.

Photodisplay. Display matter set on paper or film by photographic means: phototype display type.

Photodisplay font. A font in the form of a grid, or negative film strip, that carries a display alphabet.

Photodisplay unit. Machine that photographically sets display type.

Photogengraving. Also called an engraving block (in Europe) or a cut. A relief printing plate produced by photochemistry, used in letterpress printing. Photoengravings can be produced as individual units or as multiple-page forms. Unmounted they're .063".

Photogelatin. See Collotype.

Photographic paper. The chemically sensitized paper used for photographic printing.

Photogravure. The process of printing from an intaglio plate or cylinder in which the image to be printed is screened and etched below the surface of the plate.

Photolithography. Lithography using photomechanically prepared plates, as opposed to hand-drawn stones or plates. See also Offset lithography.

Photomechanical. The complete assembly of type, line art, and halftone art in the form of film positives onto a transparent film base from which autopositive diazo proofs can be pulled for checking and from which a one-piece control film negative can be made for the production of printing plates.

Photomechanical Transfer materials (PMT). Photomechanical papers manufactured by Eastman Kodak: Kodak PMT Negative Paper, for making enlarged or reduced copies in a process camera; Kodak PMT Reflex Paper, for making reflex copies or contact proofs of line and halftone negatives in a contact frame; Kodak PMT Receiver Paper, a chemically sensitive paper for making positive prints in a diffusion transfer processor (can also be used to make photorepros).

Photon. Trade name for a line of typesetting machines, available in a variety of models. Manufactured by Photon, Inc.

Photopolymer plates. Printing plates made of light-sensitive, polymerizable plastic mounted on steel and aluminum. Photopolymer printing plates are used in letterpress as well as letterset and offset printing. Manufactured by Du Pont and by Eastman Kodak Co.

Photoprint. Also called a photorepro or photocopy. In phototypesetting, final proof with all typographic elements in position ready to be pasted into mechanical. Similar to a reproduction proof in metal typesetting.

Photoproof. In phototypesetting, a rough proof for proofreading. Similar to a galley proof in metal typesetting.

Photorepro. Reproduction-quality proof of phototype. Produced by phototypesetting on photosensitive paper or by contact printing (through a film negative) of phototypeset materials. (Term used mainly in New York City area.)

Photostat. Trade name for a photoprint, more commonly referred to as a stat. Stats are most commonly used in mechanicals to indicate size, cropping, and position of continuous-tone copy. The original copy is photographed by a special camera and produces a paper negative. From this a positive stat is made. Stats can be either matte or glossy in finish. The use of stats pasted in mechanicals as actual shooting copy is a common but quality-negating practice. Only absolutely sharp stats should be used. Matte-finish stats are preferred since aberration due to the gloss when photographing the mechanical is minimized.

Phototext. Text matter set by means of photocomposition.

Phototype. Photographically composed type: type set on a phototypesetting machine.

Phototypesetter. One of various machines used to photographically set, or compose, type images.

Phototypesetting. Also known as photocomposition and erroneously as cold type. The preparation of manuscript for printing by projection of images of type characters onto photosensitive film or paper which is then made up in mechanicals or photomechanicals, from which printing plates can be produced. Phototypesetting machines always produce positive images of type, either on photosensitive paper or film.

Phototypography. The process of producing matter from graphic reproduction via the use of all photomechanical means: phototypesetting machines, cameras, photoenlargers, photocomposing machines, and photosensitive substrates.

Photo Typositor. Semiautomated photodisplay unit manufactured by the Visual Graphics Corporation.

Photounit. The output unit or phototypesetter of a photocomposition system: the unit responsible for the actual setting and exposing of the type onto photosensitive film or paper.

Pi. Metal type that has become indiscriminately mixed, such as when a type form spills, so that it is unusable until it is put back in order.

Pica. A typographic unit of measurement: 12 points = 1 pica (1/16" or 0.166"), and 6picas = 1'' (0.996"). Also used to designate typewriter type 10 characters per inch (as opposed to elite typewriter type, which has 12 characters per inch).

Pi characters. Special characters not usually included in a type font, such as special ligatures, accented letters, mathematical signs, and reference signs. Called sorts by Monotype.

Picking. A removal of part of the paper sur-

face during printing. A condition that develops if the pulling force (the tack) of the ink is greater than the strength of the surface of or coating on the paper.

Piece fractions. In composition, combining two matrices to make a fraction when a matrix for the desired fraction is not available. Looks like this: $\frac{1}{3}$, in which case the $\frac{1}{3}$ is the other piece.

Pigment. Insoluble particles that give color to printing inks (as well as paints), as opposed to dyes, which are soluble.

Piling. The build-up of ink on rollers, plate, or blanket during printing.

Pilling. Flaking, scaling, or peeling of particles from the surface of a substrate, or the stripping off of small threads from the dampening rollers of an offset press.

Pinholes. Small imperfections in the form of light-passing holes in the emulsion of a photographic negative. These must be opaqued before platemaking.

Pinholing. Failure of a printing ink to cover the surface completely, leaving small holes in the printed area.

Planer. In metal type composition, the flat block of wood used to tap or push down the type in the form into a perfectly flat printing surface during lockup. This is done by striking the planer with a mallet.

Planographic printing. A printing process in which the image area and the non-image area of the printing plate are on the same surface (as opposed to relief printing, in which the image area is raised, and intaglio, in which the image area is incised). The principal example of planographic printing is lithography, the commercial form of which is offset lithography.

Plastic plate. Duplicate letterpress printing plate. A mold is made of the original plate and plastic is forced into the mold by hydraulic press, resulting in a lightweight duplicate plate which is ideal where ease of handling and low shipping costs are considerations. Also, a generic term used to describe any plate made of plastic, *i.e.*, a photopolymer plate.

Plate. See Printing plate.

Plate finish. A finish that gives paper a smooth, hard surface.

Plate finishing. In letterpress, to mechanically change the formation of dots on photoengravings in order to increase or decrease tonal values. See also Dot etching.

Platen press. A letterpress operating on the clamshell principle where both the printing form and the paper lie flat. The image is transferred directly from the plate to the paper by means of pressure. The word *platen* refers to the flat surface on which the paper is positioned and rests when it comes in contact with the printing surface. Platen

presses are often referred to as *jobbers*. They are slow and best suited for short-run jobs or for die-cutting.

Piy. One of several layers of paper pasted together to make Bristol board or similar stock: thus, 1-ply, 2-ply, 3-ply, etc.

PMS. See Pantone Matching System.

Point. Smallest typographical unit of measurement: 12 points = 1 pica, and 1 point = approximately 1/72 of an inch (0.01383"). Type is measured in terms of points, the standard sizes being 6, 8, 10, 12, 14, 18, 24, 30, 36, 42, and 48, 60, 72 point in body size.

Porosity. That quality in paper that allows the passage of air, gas, or liquid through the pores, or interstices.

Positive. A photographic reproduction on paper, film, or glass that corresponds exactly to the original: the whites are white (*i.e.*, clear), the blacks are black (*i.e.*, opaque), as opposed to a negative, in which the tonal values are reversed.

Poster. A single sheet printed on only one side. Generally posted in a public place to be read in passing.

Pot. In cast type composition, the receptacle on the casting machine in which the metal is melted and stored.

Powdering. See Chalking.

Powderless etching. An etching method in which photoengravings are produced in a single "bite" through the addition of oil additives to the acid solution which coat the edges of the area being etched and prevent undercutting (which see).

PPDR. Photopolymer direct relief printing plate. A plastic plate used in letterpress printing.

Preface. A formal statement by the author that precedes the text of the book (as opposed to the introduction, which is actually a part of the text, and the foreword, which is most often written by someone other than the author).

Preparation. Also called *prep work*. In printing, all the work necessary in getting a job ready for platemaking: preparing art, mechanicals, camera, stripping, proofing.

Pre-press proof. Proof made directly from film before the printing plate has been made

Preprinted. A general term that applies to material that is printed and delivered in rolls or sheets to be added to, inserted, or used in the production of books, magazines, newspapers, etc. In other words, the preprinted material is printed before, and separately from, the overall job.

Presensitized plate. An offset plate or any other printing plate on which the light-sensitive coating has been pre-applied by the manufacturer.

Press proof. A proof pulled on the actual production press (as opposed to a proofing press) to show exactly how the form will look when printed. Press proofs are expensive and are normally requested only as a final check at the time of printing. Press proofs are usually checked right at the printing plant while the press waits.

Press run. The length of the run or the number of sheets to be printed.

Pressure-sensitive lettering. Type carried on sheets that is transferred to the working surface by burnishing. Examples are Artype and Prestype.

Prestype. A brand name for a rub-off, or dry-transfer, type.

Primary colors. The three basic colors from which all other colors can be mixed: red, yellow, and blue. In four-color process printing, the three primary colors—magenta (process red), yellow, and cyan (process blue)—with black added, are used to reproduce the full range of colors.

Print. A paper photograph made from a negative: a black and white photograph.

Printability. The generalized or specific properties required of all materials and components in the printing process to produce an acceptable printed piece. The more compatible the components, the greater the possibility of quality.

Printer. An individual or firm engaged in the business of printing. Also refers to a device that produces typewriter-like copy by electrical impulses, such as a Teletype machine or a line printer. In process printing, a printer is a separation negative: the red filter separation produces the cyan (process blue) printer; the green filter produces the magenta (process red) printer; and the blue produces the yellow printer.

Printer's devil. A now-obsolete term for an apprentice or helper in a printing shop.

Printer's error. See PE.

Printing depth. The minimum amount of etched relief required in a photoengraving or duplicate plates.

Printing ink. Fluid or viscous material that is transferred from the printing plate to the paper or other surface, resulting in an impression. Printing inks may be any color, even metallic or fluorescent.

Printing plate. A surface, usually made of metal, that has been treated to carry an image. The plate is inked and the ink is transferred to the paper or other surface by a printing press. Printing plates are also made of rubber, synthetic rubber, and plastics. Plates are classified as originals or duplicates depending on their origin. To print from an original is to invite possible disaster if it is damaged.

Printmaking. A fine art term that applies to the reproducing of original works by printing methods.

Printout. In phototypesetting, printed output in typewriter-like characters, done by a line printer.

Process camera. Also called a *copy camera* or a *graphic arts camera*. A camera specially designed for process work such as halftone-making, color separation, copying, etc. Process cameras are usually large and sturdily built.

Process color. Also called *full color*. Refers to the four-color process reproduction of the full range of colors by the use of four separate printing plates, one for each of the primary colors—magenta (process red), yellow, and cyan (process blue)—and one for black. In process color reproduction, the colors are mixed optically by the eye of the viewer rather than mechanically, as in a painting. Process color also refers to specially separated and screened plates for printing in two or three colors.

Process inks. The magenta, yellow, and cyan inks used to produce process colors.

Process lettering. (Also called photolettering or photo process lettering.) A photodisplay method in which alphabets converted to film are assembled piece by piece from a file box by hand. Fonts are usually available in one size of each style and assembled words are enlarged or reduced to fit the layout. Assembly is done by skilled lettering artists who retouch, modify, or improve upon the finished result before releasing it.

Process plates. Halftone color plates for a four-color process job: each plate, made to a separate screen angle to avoid a moiré pattern (which see), contains one of the process colors, magenta (process red), yellow, and cyan (process blue), plus black, which when printed in register produce the full range of colors.

Program. In phototypesetting, the generic reference to a collection of instructions and operational routine, or the complete sequence of machine instructions and routines necessary to activate a phototypesetting machine, that is fed into and stored in the computer: the more sophisticated the programming, the more versatile and the higher the quality of composition the system will provide.

Progessive proofs. Proofs pulled of flat or process color plates showing each color alone and in combination with the others. Progressive proofs are used by the engraver in color correcting to determine the amount and density of the colors and their

effect on other colors when making ready and running his press. Normal progressive proofs are pulled in this sequence: yellow, red, yellow-red, blue, yellow-red-blue, black, yellow-red-blue-black. See also Bastard (or Hollywood) progressives.

Projection. A negative or positive made by exposure in a camera, as opposed to contact exposure.

Proofreader. A person who reads the type that has been set against the original copy to make sure it is correct and who also may read for style, consistency, and fact.

Proofreader's marks. Shorthand symbols employed by copyeditors and proofreaders to signify alterations and corrections in the copy. These symbols are standard throughout the printing industry and are illustrated in most dictionaries, and on page 19 of this book.

Proofs. A trial print or sheet of printed material that is checked against the original manuscript and upon which corrections are made. See also Bastard progressives, Galley proof, Line printer proof, Master proof, Photoprint, Photoproof, Reader's proof, Reproduction proof and Rough proof.

Protection shells. Electrotyper's molds made by publications or electrotyper when original plates are to be released to another publication or as insurance against possible loss or damage of the originals during shipping or printing.

Protype. Trade name for a manually operated photodisplay machine for display composition.

Prove. To pull a proof. Also refers to the testing of the accuracy of a computer program, *i.e.*, to verify the program.

Pull. In printing, to make a print by transferring ink to paper.

Pulp. Fiber material produced by chemical or mechanical means or a combination of the two from fibrous cellulose raw material and from which, after suitable treatment, paper is made.

Punched card. In photocomposition, a lightweight card punched with a pattern of holes in specific positions to represent data

Punched kraft jackets. Simple protective jackets, or dust covers, made of kraft paper that are supplied by the binder for shipping books. These jackets usually have a hole punched in the spine so that the title of the book can be read.

Punched tape. In typesetting, a tape into which a pattern of holes is punched by a keyboard-actuated punch. The tape activates the typesetting machine when it is fed through a tape reader.

Punching. See Slot punching.

Punch register. A way of getting fast and efficient register using a register punch. which is not unlike a three-hole binder punch. Copy, film, masks, internegatives, and plates can all be punched identically and precision-registered by placing the punched holes over carefully positioned register pins, or studs.

Pyroxylin. Liquid plastic used to reinforce book-covering materials. Also used to coat index tabs.

Quad. A piece of type metal less than typehigh used to fill out lines where large spaces are required. An em-quad is the square of the particular type size: a 10-point em-quad is 10 points x 10 points. An en-quad is half the width of an em-quad. Quads are also made in 1½-em, 2-em, and 3-em sizes.

Quadding. Setting quads, or spaces larger than the normal wordspaces, in a line of type. Traditionally, this meant inserting quads (*which see*) to justify lines of type. In linecasting or photocomposition it is also used to denote how to position the type by spacing it with quads: *quad left* is flush left, *quad right* is flush right, and *quad center* is centered. On command, the machine inserts space, in the form of quads or in increments of space representing quads, to perform the function desired.

Quoins. (Pronounced *coins.*) Expansible blocklike or wedge-shaped devices operated by the use of a *quoin key* and used to lock up a type form in the chase prior to putting it on press.

Rag papers. Papers containing a minimum of 25% rag or cotton fiber. These papers are generally made up in the following grades: 25%, 50%, 75%, and 100%.

Raised printing. See Thermography.

Reader. A specialized device that can convert data represented in one form into another form. Readers used in typesetting include OCR readers, magnetic tape or card readers, punched tape or card readers, and in specialized applications, marksensing readers.

Reader's proof. Also called a *printer's proof.* A galley proof (*which see*), usually the specific proof read by the printer's proofreader, which will contain queries and corrections to be checked by the client.

Reading head. A device capable of sensing information punched or recorded on tape and converting it to another form of storage, or into signals that will operate a computer or a typesetting machine.

Ream. A unit of measure for paper of any size: 500 sheets of paper.

Recto. The right-hand page of an open book, magazine, etc. Page 1 is always on a recto, and rectos always bear the odd-numbered folios. Opposite of verso.

Re-etch. To etch again. In platemaking, to deepen the plate to bring out detail or to otherwise modify the image.

Reflection copy. Also called *reflective copy*. Any copy that is viewed by light reflected from its surface: photographs, paintings, drawings, prints, etc. As opposed to transparent copy.

Register. In printing, the accurate positioning of one film (positive or negative) or printing plate over another so that both are in the correct relationship, one to the other, and the effect of a "single image" results. When plates are printed off-register, or out of register, the printed image will become fuzzy, and if in process colors change color; in extreme cases a shadow effect is caused.

Register marks. Devices, usually a cross in a circle, applied to original copy and film reproductions thereof. Used for positioning negatives in perfect register, or, when carried on press plates, for the register of two or more colors in printing. Register marks should not be confused with corner, bleed, or trim marks.

Register pins. Stubby pins usually attached to a small metal base. Pins correspond to the size of register punch holes. See Punch register.

Relief. A printing method that uses a raised image area. The commercial form of relief printing is letterpress.

Reproduction proof. Also called a *repro*. A proof made from type that has been carefully locked up and made ready. Repro proofs are pulled on a special coated paper and pasted into mechanicals.

Resin. Organic substance used as a binder in making printing inks and paper.

Resist. Any substance used to inhibit the action of the acid when etching a printing plate.

Retarders. Solvents added to printing inks to slow setting time.

Retouching. The correcting of imperfections in or the altering of a photograph or dye transfer print before it is reproduced. Retouching can be done by airbrushing or by using pencil, pen, brush, or dyes. Fluorescent white or colors should be avoided since they cause "hot spots" on the resulting film used for reproduction process which then must be corrected by the platemaker.

Return card. A card enclosed in a mailing to serve as a return postcard for the convenience of readers that may wish to respond to an offer.

Reversal film. Special contact film in which the black-white values are preserved in direct relationship to the original; that is, a positive produces a positive, and a negative another negative.

Reverse copy. Copy which is wrong-reading when printed.

Reverse plate. A printing plate in which the tonal values are exactly the opposite from the original art: the blacks are white, the whites are black. A reverse plate is made from a film positive instead of a film negative

Reverse type. In printing, refers to type that drops out of the background and assumes the color of the paper.

Revise. A change in instruction that will alter copy in any stage of composition.

Rice paper. A nonfibrous sheet (and so not a true paper) from the pith of a tree, with ivorylike texture, cut in thin layers.

Right-angle fold. In binding, refers to folds that are at 90° angles to each other.

Right-reading image. Any image that reads correctly from left to right, as opposed to wrong-reading image.

Ring binder. Most common form of looseleaf binder in which sheets are fastened by two or more rings that pass through prepunched holes along the binding edge of the paper.

Ripple finish. A paper finish with a wavy, or rippled, look produced by an embossing process.

Roll-out. Ink put down by a hand roller on glass or paper for testing or sampling purposes to determine color or other characteristics.

Roman. Letterform that is upright, like the type you are now reading. Also, more specifically, an upright letterform with serifs derived from the original Roman stone-cut letterforms.

Rotary printing. Any form of printing where the plate to receive ink is in cylinder form, rather than flat. Gravure, offset, flexography, and collotype are all rotary. Letterpress can be flatbed, or rotary, in which case the plates are curved. Most letterpress publication presses and newspaper presses are rotary. Rotary presses can be sheet-fed, which means single pretrimmed sheets are fed into the press, or web-fed. which means the paper is fed into the press as a web from rolls.

Rotogravure. Web-fed gravure printing done on a rotary press. Used for the Sunday supplements of newspapers, magazines, or packaging and excellent for economical medium-run and long-run jobs.

Rough. A sketch or thumbnail, usually done on tracing paper, giving a general idea of

the size and position of the various elements of the design.

Rough proof. Any proof pulled from type on a proofing press or from a plate without makeready showing what the material proofed looks like. Rough proofs are usually pulled for identification purposes only, before filing away type galleys or engravings for storage. Also, an in-house proof pulled to check the work.

Routing. In engraving, the mechanical cutting away of unwanted metal in the printing plate. Also used to deepen the non-image areas of the plate. A router is a high-speed, hand-guided tool, very much like a drill.

Rubber plate. A duplicate relief printing plate cast in rubber from a mold of the original plate. Rubber plates are used primarily in flexography and box and carton printing and sometimes in medium- or low-quality paperback book printing.

Rub-off type. See Pressure-sensitive lettering.

Rule. A black line, used for a variety of typographic effects, including borders and boxes. Rules are actual type-high typographic elements and come in a range of thicknesses called *weights* that are measured in points. Many rules are cast as duplex rules: two or more parallel lines of the same or of different thicknesses cast on the same body. Fine rules for letterpress work are often made of strip brass or steel. In addition to lines, rules may also be dotted or dashed, or they may contain fancy border designs.

Run in. To set type with no paragraph breaks or to insert new copy without making a new paragraph.

Running head. A book title or chapter head at the top of every page in a book.

Saddle-wire stitching. A common, inexpensive way of binding pamphlets and booklets if they are not too thick (usually less than 1/8"). The pages are bound together by wire staples inserted through the backbone, or folding line, and into the center spread where they are clinched. The folded sheets or pages are placed over a saddle to ensure proper positioning.

Safelight. A colored lamp used in darkroom work which gives enough light to see by yet does not affect the photographic material.

Sans serif. Without serifs (which see).

Sawtooth edge. Edge of a halftone that crosses the screen line at an angle causing symmetry of dots to break into the appearance of the teeth of a saw.

Scaling. The process of calculating the percentage of enlargement or reduction of

the size of original artwork to be enlarged or reduced for reproduction. This can be done by using the geometry of proportions or by the use of a desk or pocket calculator, logarithmic scale, or disc calculator.

Scanner. See Electronic scanner.

Scoring. Creasing paper mechanically so it will fold more easily. Usually necessary where paper is even moderately stiff or when the fold goes across the grain.

Scotchprint. Trade name for plastic, matterfinish transluscent proofing material for making contact positives or negatives, intermediate for photomechanical platemaking. Used on conventional repro proof presses to convert letterpress plates to film. Manufactured by 3M.

Scratchboard. A clay-coated cardboard covered with black ink. By scratching and scraping into the black ink, it is possible to produce wood-engraving effects as well as black and white reverse effects.

Screen. In printing, the finely cross-ruled glass plate placed before the lens of a camera (or a contact screen placed in contact with the film) to break up continuous-tone copy into dots for reproduction as halftone or line copy. Screens are designated by number of ruled lines they contain—from 50 lines per inch to 500 lines per inch. The greater the number of lines per inch, the sharper and finer the printed halftone will be. The selection of the screen is dictated by the paper, press, and to a certain extent the nature of the copy. For example, the coarser screens (50 to 85) are used for newspapers, while the finer screens (100line and up) are used on coated papers.

Screen angle. The angle at which two or more screens are turned in relation to one another to avoid the creation of an undesirable moiré pattern (*which see*) in the halftone dots. In four-color process printing, for example, the screens for the four plates might be angled as follows: 45°, 75°, 105°, and 120°.

Screened positive. The reverse, or opposite, of a screened negative. Term used to differentiate it from a continuous-tone positive.

Screen finder. A lined plastic template which when placed over a halftone can determine the screen ruling of a halftone.

Screen process printing. A printing method in which the image is transferred to the surface to be printed by means of ink squeezed by a squeegee through a stenciled fabric or metal wire screen stretched over a frame. Screen process printing is either a manual or mechanical operation, though it enjoys the benefits of photographic stencils, and automatic presses and driers. It allows the heavy application of paint on almost any material and is excel-

lent for short-run line work, especially posters. Posters and point-of-purchase displays requiring a thick layer of paint and/or fluorescent inks are usually silkscreened.

Screen ruling. The number of lines per inch on a contact screen or glass halftone screen.

Scribed lines. Lines scratched (scribed) into the emulsion of negative film as opposed to lines ruled on original copy.

Scribing. Scratching clear lines in the emulsion of a blackened film so they will print as black rules.

Script. A typeface based on handwritten letterforms. Scripts come in formal and informal styles and in a variety of weights.

Scum. In offset printing, a greasy film that can sensitize or clog non-image areas of the plate to accept ink and print.

Scumming. Also called *greasing*. A defect in offset printing caused by the unwanted sensitizing of a non-image area of the plate so that it accepts ink and prints.

Secondary color. The color that results from the mixing of two primary colors: orange (yellow and red), purple (red and blue), and green (blue and yellow).

Selectric. Trade name for a strike-on (type-writer) composition system manufactured by IBM.

Self-cover. A cover of the same stock (paper) as used in the rest of the book. Used for booklets or pamphlets when the cover stock does not have to be particularly strong or to save the cost of the extra materials and operations required to produce and bind a cover.

Self-mailer. A printed piece designed to be mailed without an envelope.

Separation. See Color separation.

Separation negative. See Color separation negative.

Series of type. Refers to all the sizes of one particular and unique typeface.

Serifs. The opening and closing cross-strokes in the letterforms of some type-faces. Sans serif typefaces, as the name implies, do not have serifs but open and close with no curves and flourishes.

Serigraphy. In fine art, the production of original color prints by pressing pigments through a silk screen with a stencil design. *See also* Screen process printing.

Set-off. Formerly called *offset*. The undesirable transfer of ink from one printed sheet to another.

Setting of ink. The initial phase of ink-drying. Printed sheets can be handled without smudging even though the ink is not yet fully dry when the ink has set.

Setup time. The time required to ready a job to run: to load the program, load and ready input/output devices, etc.

Set width. Also called set. In metal type, the width of the body upon which the type character is cast. In phototypesetting, the width of the individual character, including a normal amount of space on either side. This space, measurable in units, can be increased or decreased to adjust the letterspacing. Letterspacing can also be adjusted by using a larger or smaller than normal set size mode on the photounit. This function can also be performed in metal tyopgraphy by the Monotype machine.

Sewed soft cover. A binding process in which saddle-sewn signatures are fastened to each other and to a soft cover.

Shade. A modification of a color produced by adding small amounts of black or a complementary color. In ink manufacture, commonly used as a synonym for *hue*.

Shadow. An area that is relatively dark, as compared with light, or highlight, areas in original copy or reproductions. Control of these values in halftone preparation is accomplished by a supplemental "flashing" of the film by a filtered light. This reinforces the dot exposure in the dark areas of the photo only.

Sheet-fed. A method of applying paper to a press in printing in which the paper is fed into the press as sheets rather than a web.

Sheetwise. A method of printing in which each sheet of paper is printed, first on one side and then on the other, one at a time, using the same gripper and side gulde.

Shooting copy. The act of photographing copy for reproduction. Also, the copy, ready to be shot.

Short ink. Ink that cuts off cleanly because of its short fibers but with less ability to resist the dampening solution on an offset press. Short inks are preferred in screen process printing because they enable small type and halftones to be clearly and crisply printed. Opposite of long ink.

Shoulder. Space on the body of a metal type or slug which provides for ascenders or descenders. Also provides the minimum space required to separate successive lines.

Show-through. The phenomenon in which printed matter on one side of a sheet shows through on the other side.

Side-wire stitching. Also called *side stitching*. A method of binding books, catalogs, and magazines in which wires in the form of staples are inserted near the binding edge, passing from the first page through the entire thickness and out the back where they are clinched.

Silhouette halftone. More accurately called

an *outline halftone*. A halftone reproduction in which the main image area is outlined by removing the dots that surround it.

Silkscreen printing. Now called *screen process printing (which see).*

Sizing. In bookbinding, the process of applying a suitable bond between the binding material and the foil that is used for stamping. In paper manufacture, the material (also called *size*) added to produce a smooth, moisture-resistant surface.

Slip sheeting. Inserting blank sheets of paper between printed ones coming off the press to prevent set-off; that is, to prevent the ink from "offsetting" onto the back of the previously printed sheet or possible blocking.

Slitting. Cutting printed sheets or webs into two or more sections by means of a slitter. Slitting is done by cutting wheels on the press or the folding machine.

Slot punching. Punching, as opposed to drilling, holes into paper. Used in mechanical binding where holes that are not round (rectangular slots) are required. Slots permit insertion of looseleaf pages into binders that hold sheets by means of tapes rather than rings.

Slug. A line of type set by a linecasting machine. Also, the name of a thick, less than type-high spacing material in widths of 6, 12, and 24 points. These are usually cast on an Elrod machine in long strips which the printer then saws to the lengths he requires.

Slur. A printing fault caused by drag or slippage at the point of impression of paper, printing plate, image carrier, blanket, or a combination thereof. To detect slurring, many printers print the GATF slur guide on the tail of the press sheets.

Small caps. Abbreviated *s.c.* A complete alphabet of capitals that are the same size as the x-height of the normal typeface.

Smearing. In printing, a condition in which, due to careless handling or distribution, ink spreads or smears over areas of the paper where it is not wanted.

Soft cover. Any non-board cover, but usually a paper cover on a perfect-bound book.

Software. In computer systems, the procedures and programming, as opposed to the hardware (*i.e.*, equipment).

Solid. In composition, refers to type set with no leading between the lines. In printing, refers to areas that are completely covered with ink or areas that print 100% of a given color.

Solvent. A liquid that dissolves or suspends the pigment in the ink. Used as a reducer to "wet up" gravure inks or to clean the ink fountains.

Sorts. Individual letters in a font of type for use in replenishing used-up type in a case. Also used by Monotype to describe special characters not in the regular fonts.

Spacebands. Moveable wedges used by linecasting machines for wordspacing and to justify lines of type. After the line has been set as a row of matrices, the spacebands are forced up to tighten (*i.e.*, justify) the line prior to casting it.

Spaces. In handset type, fine pieces of metal type, less than type-high, inserted between words or letters for proper spacing in a line of type.

Spacing. The separation of letters and words in type or the separation of lines of type by the insertion of space.

Spec. To specify type or other materials in the graphic arts.

Spine. Backbone (which see).

Spiral binding. A binding in which a continuous wire or plastic spiral is threaded through pre-punched holes along the binding sides of the paper.

Split fountain. A color printing technique in which two or more distinct colors can be printed at the same time by dividing or splitting the ink fountain on the press, so that the left side prints one color and the right side another. A special rainbow effect can be achieved by splitting the fountain with narrow dividers. As the press runs, the oscillation of the rollers gradually blends the different colors. Where the two colors meet a third color is produced.

Spotting. The elimination of white dots on a photograph or negative by painting them out (called *opaquing*) with a fine camel's hair brush and water-soluble, light-blocking opaque.

Spray. In printing, material applied by spraying to prevent set-off (*which see*) of freshly printed sheets with a liquid which crystallizes, or a fine powder, to keep the next sheet from coming into contact with the ink on the preceding one. These are called *no-offset sprays*.

Spread. A pair of facing pages. Also, in photography and platemaking, the enlargement of an image to ensure lap (*which see*), accomplished by producing a film by holding it out of emulsion-to-emulsion contact by the use of a layer of clear film which permits the light to spread as it passes through the layers.

Spreading. In printing, the enlarging or thickening of printed areas caused by the bleeding or lateral creep of the ink.

Square halftone. Also called a *square-finish halftone*. A rectangular—not necessarily square—halftone, *i.e.*, one with all four sides straight and perpendicular to one another. So called because the edges

of the plate are machine-cut on a finishing machine.

Square serif. A typeface in which the serifs are the same weight or heavier than the main strokes.

S.S. Abbreviation for "same size."

Stabilization paper. Stabilization-processable (dry-processed) photopaper used in phototypesetting for output in the form of good-quality photorepros. Not the same as conventional photosensitive papers (Kodaline, Resisto), which are chemically wetprocessed in a tray or in a film or paper processor. Stabilization-processed materials are sensitive to ultraviolet light and have a lifespan of only about six weeks; if kept for a longer period of time they must be washed and fixed. The nature of these papers is such that they process in a way that causes problems in matching image densities from batch to batch; this is especially troublesome when making corrections in previously set matter.

Staging. A method of correction photoengravings by covering (painting over and stopping out) certain areas and re-etching others.

Stamping. A printing method in which type or designs, in the form of a relief die, are impressed with heat and pressure through metal foil onto the surface to be printed. Blind stamping uses no ink or foil, so that the impression of the die alone makes the image.

Stamping dies. Heavy, deeply routed steel or brass plates or female dies used in bindery work or box printing. Some are made of hard rubber for box printing work.

Standard colors. A half-dozen basic colors chosen by the AAAA for use by the printer primarily for publication work such as magazines and newspapers. These colors include standard red, yellow, green, blue, etc.

Steel engraving. An intaglio printing plate that is made by manually cutting away the non-printing areas on a metal plate (usually copper or steel), leaving only thin lines, which will print in relief. Intricate designs may be machine-engraved using a pantograph or an engine lathe. Steel engraved plates are used to print engraved banknotes, stock certificates, fine stationery, and business cards. Printing is done by inking the plate, wiping clean the surface, and then, under great pressure, transferring the ink onto the paper by pressing the paper into the fine grooves that hold the ink.

Steel-plate printing. Also called *steel-die printing*. Intaglio printing using metal plates which are inked, the surface wiped clean, and impressed under great pressure onto the substrate.

Step and repeat. A method of making mul-

tiple images from a master negative of the same subject in accurate register. Step-and-repeat operations are done photome-chanically (using a photocomposing machine (also called a *step-and-repeat machine*).

Stereotype. The oldest and least expensive way to make a duplicate letterpress plate. A papier-mâché or plastic mold is made of the original type or engraving. The mold (called a mat) is then filled with a molten metal to form a new plate that can be mounted on wood to make it type-high, shaved to electro-height, or cast in a curve to fit the cylinders of a rotary newspaper press. Stereotypes are very prevalent in newspaper printing where copy consists mainly of line art and coarse-screened halftones and printing is done at high speeds.

Stet. A proofreader's mark that indicates copy marked for correction should stand as it was before the correction was made. Copy to be stetted is always underlined with a row of dots usually accompanied by the word *stet*.

Stick. Composing stick (which see).

Stock. Also called *substrate*. Any material used to receive a printed image: paper, board, foil, etc. In papermaking, pulp which has been beaten and refined, and which after dilution is ready to be made into a sheet of paper.

Stone. Also called an *imposing stone*. The surface, originally of stone but now of machined metal, on which letterpress forms are assembled, locked up, and planed down prior to putting them on the bed of a press.

Stoneman. In letterpress printing, the worker at the printing plant who imposes the form; that is, assembles the typographic elements and locks them up in a chase on the stone.

Stone out. To remove minor unwanted areas or scratches from an offset printing plate by using an abrasive stone.

Storage. In computer-aided phototypesetting, pertaining to a device (a memory tape, disc, or drum) into which data can be entered, in which it can be held, and from which it can be retrieved at a later time.

Straight matter. In composition, body type (as opposed to display type) set in rectangular columns with little or no typographic variations.

Strike-on composition. See Typewriter composition.

Strike-through. In printing, the penetration of ink into the paper so that it shows through on the other side, or the embossed impression of the type in letterpress printing which can be seen on the opposite side of the sheet.

Stripper. Also referred to as a *make-up man*. Worker in a printing plant who assembles and strips negative or positive film onto a flat for making plates. Also refers to the person in a phototypesetting plant who makes up the job in film form (as a photomechanical), usually in positive form, after the job has been set on photodisplay and/or phototypesetting machines.

Stripping. Assembling photographic negatives or positives and securing them in correct position to the paper (goldenrod), film, or glass base which is to be used in making the press plates.

Stripping guide. Position layout or translucent layout tissue or rough paste-up which serves as a guide for stripping a film mechanical, etc.

Striprinter. Trade name for a machine that sets photodisplay type. The lens system is 1 to 1. Manufactured by Striprinter, Inc.

Strip test. A test using chemically treated paper to determine the *pH* of an offset fountain solution.

Substance. Also referred to as basis weight. The basis used to measure the weight of paper: the weight in pounds of a ream (500 sheets) of paper cut to standard size, or 1,000 sheets cut to the Mweight size.

Substrate. The base material to be printed: paper, board, metal, ctc., or the carrier or the emulsion or coating, such as film.

Sulphate wood pulp. Paper pulp made from wood chips cooked under pressure in a solution of caustic soda and sodium sulphide.

Sulphite wood pulp. Paper pulp made from wood chips cooked under pressure in a solution of bisulphite of lime.

Supercalender. An off-machine calendering process given coated papers to make the surface smooth and glossy. Also, the name given to a very smooth uncoated paper that was finished on the supercalendering machine. This paper, more commonly referred to as "super," is no longer made, having been replaced by less expensive coated papers.

Surprinting. The combining of images from two different negatives by superimposing them to produce one negative or one image on a press plate by double-burning (*which see*).

Swash. A cap letter with an ornamental flourish.

Swatchbook. A sample book put out by manufacturers of color-matching systems (such as Pantone Matching System) showing all the colors available. In the designer's edition, the colors are numbered for identification; in the printer's edition, ink-mixing instructions are also included. Also, books containing samples of papers.

Tabbing. Bindery operation in which tabs are cut into or adhered to the edge of a piece of paper.

Tack. The resistance offered by ink films during splitting. Tack is a measure of an ink's internal cohesion.

Tape. Punched paper ribbon (between 6-and 31-level) or magnetic (7- or 9-level) tape, produced by a keyboard unit and used as input to activate the photounit of a typesetting system or a computer for subsequent processing of the data thereon for phototypesetting machine input.

Tape editing. In phototypesetting, the transferring of information, via a visual display terminal or a line printer, from one tape to another to produce a corrected tape.

Tapemaster. Trade name of a line of phototypesetting machines manufactured by Photon. Inc.

Tape merging. In phototypesetting, a method of editing and correcting tapes in systems in which every line of type is numbered

Tap-out. A spot of ink applied to paper and tapped out by finger to reduce the ink to approximate thickness when printing and thus ascertain its true color.

Taskmaster. Trade name for a line of photocomposition machines manufactured by Photon, Inc.

Tear test. Method of determining the direction of the grain in a sheet of paper; paper tears easily with the grain. Also, a test made with calibrated instruments to establish tear strength of paper.

Tertiary colors. The colors produced by mixing any two of the secondary colors: orange-green, green-violent, violet-orange.

Text. The body copy in a book or on a page, as opposed to the headings.

Textmaster. Trade name for a line of phototypesetting machines manufactured by Photon, Inc.

Text paper. A general term that is applied to antique, laid, or wove papers. Used for booklets, programs, announcements, and advertising printing.

Text type. Main body type, usually smaller in size than 14 point.

Thermography. A finishing process that simulates the effect of steel-die engraving, producing raised letters. While the ink is still wet on the sheet, it is dusted with a resinous powder which adheres to the ink. The sheet is then passed through a heating unit that causes the particles of powder to fuse with the ink, imparting a raised effect to the letters.

Thinners. Clear liquids (solvents, diluents, oils, and vehicles) added to inks to reduce viscosity, or tack.

Thirty. The symbol "-30-" used by newspapers to end a story.

Three-color process. Almost the same as four-color process printing (*which see*), except that the black plate is eliminated.

Thumbnails. Small, rough sketches.

Tint. A color obtained by adding white to the solid color. In printing, a photomechanical reduction of a solid color by screening.

Tint block. A solid or a screened plate used to print a background color over which type or halftone art will be surprinted in a darker color or in black.

Tinting. In lithography, the discoloration of the background caused by the bleeding or washing of pigment in the fountain solution.

Tip-in. The process of pasting a leaf onto a printed page before or after binding. This is common in artbooks where a full-color reproduction is desired in a black and white signature (such as for a frontispiece).

Tissue paper. Also referred to as *tissue*. A general term that applies to all gauzy, lightweight papers that weigh less than 18 lbs. Used for a variety of purposes, but mainly for use with carbon paper for making copies in office correspondence.

Title page. The page of a book—usually page 3—that carries the title of the book, the author's name, and the name of the publisher.

Titling. An alphabet of foundry type in which the capital letters fill the full face of the type. This permits the setting of caps with a minimum of leading. Titling caps have no matching lowercase alphabet.

Tone. The variation in a color or the range of grays between black and white.

Tone-line. The conversion of continuoustone copy into a line copy by photography.

Toner. A full-strength, highly concentrated organic pigment containing no extender that is used to modify the hue or color strength of an ink.

Tooth. Refers to that quality of a paper's surface that feels and looks rough textured. Toothy paper is especially good for drawing in pencil or charcoal and for painting in watercolors, and is good for some printing needs: line or type printed by letterpress or by a lithographic process. It cannot be used by gravure because full contact between plate and paper is not possible, resulting in a snowflake effect.

Trademark. A unique device that identifies a product of the company that manufactures it.

Transducer. A photoelectric cell device for converting input energy of one form into output energy of another. Used in OCR devices.

Transfer key. Trade name of 3M for acetate proof (*which see*).

Transfer type. Type carried on sheets that can be transferred to the working surface by cutting out self-adhesive letterforms (cut-out lettering), or by burnishing (pressure-sensitive lettering). Examples are Artype, Formatt, Letraset, Prestype.

Transitional. A type style that combines features of both Old Style and Modern. Baskerville, for example.

Transparency. A positive colored photograph on transparent film, such as Anscochrome, Kodachrome, or Ektachrome films, usable as copy for color separation and viewed by transmitted light.

Transparency viewer. Also called a *light box*. A box containing special light bulbs (5000 Kelvins) filtered through a diffuser. Used for viewing transparency copy under the best possible light conditions. Used especially when color correcting four-color process printing against the transparency.

Transparent copy. Copy viewed by transmitted light (*i.e.*, transparencies).

Transparent inks. Inks that permit the color of a previous imprint, or the color of the paper, to show through. A transparent color surprinted on another color will produce a third color.

Transpose. Commonly used term in both editorial and design to designate that one element (letter, word, picture, etc.) and another should change places. The instruction is abbreviated tr.

Transposition. A common typographic error in which letters or words are not correctly placed: "hte" instead of "the" or "Once a Upon Time" instead of "Once Upon A Time."

Trapping. The ability of an ink film to properly accept a succeeding ink film, making it possible to superimpose one color over another both in wet and in dry printing.

Trim. To cut off and square the edges of a printed piece or of stock before printing.

Trim size. The final size of a printed piece, after it has been trimmed. When imposing the form for printing, allowance must always be made for the final trim size of the stock.

TTS. An abbreviation for Teletypesetter, a trade name for a device that produces a perforated tape which can in turn operate the keyboard of a linecasting machine equipped to receive such input.

Tusche. The liquid emulsion ink that is painted or drawn on the lithographic stone in direct lithography to form the image. Tusche can be used to effect corrections on offset plates if the run is short.

Two-tone paper. See Duplex.

Tympan. In letterpress printing, the sturdy oiled paper that covers the packing on the impression cylinder or platen of a printing press.

Type. The letters of the alphabet and all the other characters used singly or collectively, to create words, sentences, blocks of text, etc.

Typecasting. Setting type by casting it in molten metal either in individual characters or as complete lines of type.

Type family. A range of typeface designs that are all variations of one basic style of alphabet. The usual components of a type family are roman, italic, and bold. These can also vary in width(condensed or extended) and in weight (light to extra bold). Some families have dozens of versions.

Type gauge. Commonly called a *line gauge*. A metal rule with a hook at one end calibrated in points and picas on one edge and inches on the other. Used to measure in typography. Also, slotted copyfitting gauges made in various lengths and graduated increments of ens or ems of each type size. These are used to gauge the number of lines set in a given type size; they are also useful for copyfitting.

Type-high. The height of a standard piece of metal type: .918" (U.S.). A plate is said to be "type high" when mounted on wood or metal to the proper height to be used on a letterpress printing press.

Type metal. The metal used for cast type: alloy of lead, tin, and antimony, and sometimes a trace of copper.

Type series. One basic typeface design in its full size range, from 6 point up to 72 point, or sometimes even 120 point.

Typesetter. Term for a person (or persons) who sets type. Also, any device that sets type.

Typesetting. The assembling of typographic material suitable for printing or incorporating into a printing plate. Refers to type set by hand, machine (cast), typewriter (strike-on), and phototypesetting.

Typewriter composition. Also called *strike-on* or *direct impression* composition. Composition for reproduction produced by a typewriter.

Typographer. Person or persons who set type

Typographic errors. Commonly called *typos*. Errors made in copy while typing, either at a conventional typewriter, or by the compositor at the keyboarding stage of typesetting. Typos made by the compositor are PE's (*which see*) and are usually corrected free of charge.

Typography. The art and process of working with and printing from type. Today's technology, by mechanizing much of the

art, is rapidly making typography a science.

Tyvek. Trade name for a synthetic book-covering material manufactured by Du-Pont.

U. & L.C. Also written u/lc. Commonly used abbreviation for upper and lowercase. Used to specify text that is to be set in caps (usually initial caps) and lowercase letters as written.

Uncoated paper. The basic paper, produced on the papermaking machine with no coating operations.

Unit. A variable measurement based on the division of the em into equal increments.

Unitization. Designing the characters in a font according to esthetically pleasing width groups. These width groups are measurable in units and are the basis for the counting mechanism of the keyboards and photounits of phototypesetting equipment. Width units can be based on the em (square of a point size) or the set size of the font.

Unit system. A counting method first developed by Monotype and now used for some strike-on typewriters and all phototypesetting systems to measure in units the width of the individual characters and spaces being set in order to total the accumulated units and determine the measure when the line is ready to be justified, and determine how much space is left for justification.

Unit value. The fixed unit width of individual characters.

Unjustified tape. Also called an *idiot tape*. In photocomposition, an unhyphenated, unjustified tape (either magnetic or paper). The tape is keyboarded with no end-of-line signals (no hyphenation or justification), allowing the keyboard operator to type at maximum speed. The tape is then fed through a computer, which adds to the total units accumulated and resolves the hyphenation and justification according to a pre-programmed set of rules and produces a justified tape. The justified tape is used as input to operate the phototypesetting machine.

Unjustified type Lines of type set at different lengths which align on one side (left or right) and are ragged on the other.

Update. In photocomposition, to incorporate into the master tape the changes required to reflect recent corrections or changes.

Uppercase. The capital letters of a type font: A, B, C, etc.

Upright. A book or catalog that is bound along its longest dimension. As opposed to oblong, in which the book or catalog is bound along its shortest dimension.

Vacuum frame. Also called a contact printing frame. In photoengraving, offset lithography and phototypography, a glasstopped printing frame used for exposing plates or making contact negatives and positives. Close contact between the film and the plate is maintained by the action of the vacuum pumps which expel the air trapped between the two layers of substrate.

Value. The degree of lightness or darkness of a color or of a tone of gray, based on a scale of graduated tonal values running from pure white through all the gradations of gray to black.

Van Dyke. Also known as a *brownline* or a *brownprint*. A photocopy having its image in a dark brown color, used as a proof.

VariTyper. Trade name for a special typewriter capable of setting type directly onto paper. It composes type in a number of different styles and can produce justified type semiautomatically. VariTyper is one of several devices producing direct impression, or strike-on, typography. Manufactured by VariTyper Divsion, Addressograph-Multigraph Co.

Varnish. A thin, protective coating applied to the printed piece like ink on the printing press. Also refers to part or all of the vehicle in the ink.

Varnishing. Finishing process done onpress with ink rollers and blank plate or offpress with spray guns or blade coaters. Varnish may be added to protect the printed piece or for esthetic reasons. Press varnish can be selectively applied to spots (called *spot varnishing*) when a press plate is made to cover only the areas to be varnished. Care must be exercised to print the job with inks that are compatible with the varnish.

Vehicle. The liquid ingredient in ink. It serves as the carrier for the pigment, binds the pigment to the substrate, and gives the ink the quality of workability and drying.

Vellum. A term used to designate a certain paper finish: a strong, toothy, cream-colored, and relatively absorbent paper. Also, a kind of finish given woven book-covering materials

Velox. A term, derived from the trade name Velox. Print, for a high-quality screened photographic print used in the preparation of mechanicals. As it is line art, it can be shot right along with the line copy, thus saving stripping costs.

Velox Print. Trade name for glossy photoprint papers manufactured by Eastman Kodak.

Verso. The left-hand side of a spread, as opposed to the recto, which is the right-hand side of a spread. The verso always

carries an even-numbered folio. Also refers to the reverse side of a printed sheet.

Vignette halftone. A halftone produced to print so that the edges fade imperceptibly into the white of the paper.

Viscosity. That quality of printing inks that encompasses the properties of flow.

Visual. A layout or comp (which see).

Visual display. A visual representation of computer output. This may be in the form of lines of type shown on the cathode ray tube of a visual display terminal (VDT) or a few words shown on a screen similar to those used on electronic calculators of the keyboard. Both permit the operator to edit and make corrections.

Visual display terminal. A device containing complete logic, a tape reader, a tape punch (or a magnetic tape head), a keyboard, and a cathode ray tube on which copy will be displayed as a composed tape as read by the reader. The operator can edit and correct copy by keying in the corrections. As he does this, a new tape is created for subsequent use in activating a phototypesetting or linecasting machine.

Warm colors. Red, yellow, and orange, as opposed to the cool colors, blue, green, and violet.

Wash drawing. Drawing done with black ink or paint diluted to various degrees to produce a range of grays. Also, halftone art characterized by light, even tones washed on illustration board by means of a brush Darker tones are obtained by successive layers of washes.

Wash up. The process of cleaning the press: the rollers, the plate, and the fountain. Every time the color used in the printing press is changed, a wash-up is necessary.

Watermark. The slightly translucent design produced in paper during manufacture by a raised pattern made of wire soldered onto the dandy roll. The watermark is usually a distinctive symbol or logo, identifying the brand of paper or the manufacturer.

Water-soluble inks. Also called *watercolor inks*. Inks in which the pigments are soluble in water. Used in screen process printing, printing from rubber plates, and in gravure.

Waxed paper. Paper that has been waxed. There are two waxing methods: wet waxing, in which the paper is dipped into a wax bath and immediately chilled; dry waxing, in which the paper is passed through rollers immediately after it comes out of the wax bath, so that the wax is driven into the paper and the paper feels dry.

Web. A continuous roll of paper (used in

web or rotary presses) in the process of manufacture in a machine, such as a printing press. After being printed, the web is cut into short lengths at the delivery end of the press, or run on other equipment such as packaging machinery.

Web-fed. A general term applied to presses that print from continuous rolls (webs) of paper.

Web printing. Also called *roll-fed printing*. Printing method in which paper is fed into the press from continuous rolls (webs), as opposed to flat sheets as in sheet-fed printing. Webs are used in rotary letterpress (for publication printing), rotogravure (for newspaper and magazine presses), and for packaging presses and, increasingly, for offset presses for all types of work.

Weight. In composition, the variation of a letterform: light, regular, bold. In paper measurement, the weight of 500 sheets (a ream) of paper of standard size.

Wet printing. The printing of one process color over another before the first has dried.

WF. Abbreviation for "wrong font." Used by proofreaders to indicate that letters of type fonts have been mixed in typesetting.

Widow. The end of a paragraph or of a column of reading matter that is undesirably short: a single, short word; or the end of a hyphenated word, such as "ing." Widows are usually corrected editorially either by adding words to fill out the line or by deleting a word in the preceding line so that the widow moves up, becoming part of it. Widows can also be overcome by decreasing the set of the last several lines or of the ending paragraph. Decreasing the set is kerning (*which see*).

Width. Variations of letterforms: condensed extended

Window. A clear, usually rectangular or square panel in a litho negative. Halftone negatives are positioned (*i.e.*, stripped) in this window, with tape.

Wire side. Also referred to as the *wrong side*. That side of the paper that has rested on the wire during manufacture. As opposed to the felt, or right, side.

Wire stitching. See Saddle-wire stitching and Side-wire stitching.

With the grain. A term used to describe the directional character of paper, often applied to the folding of a sheet of paper parallel to the grain. Paper folds more easily and tears straighter with the grain than against the grain.

Woodcut. Also called a *wood engraving*. A print made from a relief image cut into a block of wood. The block is inked with a roller and the image is transferred directly to paper by pressing the inked surface against it. Woodcuts are the grain side of

the wood block while wood engravings are the end grain.

Woodtype. Type made from wood. Usually used for the larger display sizes over 1". Wood type is made in sizes measured in lines, a line being 1 pica in depth. A 10-line face is thus 120-point type.

Wordspace. The space between words.

Wordspacing. In composition, adding space between words to fill out line of type to a given measure.

Work and tumble. Printing the second side of a sheet by turning it over from gripper edge to back so that a new edge meets the gripper and using the same guide edge. This printing technique also allows the printer to print both sides of the sheet without having to change the printing plate.

Work and turn. Similar to work and tumble except that the sheet is turned over from left to right so that the same gripper edge is used for both sides.

Work-up. In letterpress printing, the unwanted deposit of ink caused by quads, spaces, or other material normally below type-high that work up by pressure so that they come in contact with the paper and print. Work-up is usually caused by poor lockup (which see).

Woven. In binding, any material that is woven: cloth.

Wove paper. An uncoated paper that has a uniform surface with no discernable marks.

Wrap-around plate. Flexible relief printing plates made of thin zinc, magnesium, copper, or synthetic materials that are clamped around the plate cylinder of a rotary letterpress. Similar in appearance to an offset plate

Wrinkles. In printing, creases in the paper that occur during printing, usually due to uneven absorption of moisture from the atmosphere. In inks, an uneven surface that forms during drying.

Writing paper. A kind of paper with a smooth, sized surface to prevent ink from being absorbed into the fibers.

Wrong font. An error in typesetting in which the letters of different fonts become mixed. Indicated by proofreader by "wf."

Wrong-reading. An image that reads the reverse of the original. A mirror image.

Xerograhy. An inkless printing process that uses static electricity. Xerox, a trade name for this process, is a good example of this

X-height. The height of the body of lower-case letters, exclusive of ascenders and descenders.

X-line. Also called *mean line*. The line that marks the tops of lowercase letters.

Zinc engravings. Referred to as *zincs*. Line of halftone etchings made on zinc for letterpress printing.

Zip-a-Tone. Trade name for a series of screen patterns imprinted on plastic sheets that can be used to achieve tone of various kinds on art work. Zip-a-Tone comes in dots, lines, stipples, etc.

Illustration Credits

page 16 VCT Photo 80 17 Two small photographs by VCT Photo; large photograph by Ed Carroll 18 Photograph courtesy of Vandercook Division, ITW, Inc. 19 VCT Photo 83 20 Two photographs in center by VCT Photo 21 Photograph courtesy of Mergenthaler Linotype 22,23 Photographs courtesy of Monotype Corp. 24 Photographs courtesy of Ludlow Typograph Co. 25, 26 Photographs courtesy of Black, Inc. 28 Photograph courtesy of VariTyper 29 Illustrations courtesy of Versatec; type illustrations courtesy of Alphatype 30 Illustrations (less type) courtesy of AKI 32 Three type specimens courtesy of AKI 34 Computer photograph courtesy of AKI 35 Typesetter courtesy of Photon 36, 37 Photographs courtesy of Inc. 35 Typesetter courtesy of Photon 36, 37 Photographs courtesy of Individual manufacturers 37 Illustration courtesy of Carl Palmer 38, 39 Photographs courtesy of AKI, Versatec, and Singer 40 Photographs courtesy of Harris Corp.; photographs courtesy of Harris Corp.; photographs courtesy of Harris Corp.; photographs courtesy of Mergenthaler Linotype. 42, 43 Illustrations courtesy of VariTyper 41 Photographs courtesy of Harris Corp.; photographs courtesy of Harris Corp.; photographs courtesy of Harris Corp.; photographs courtesy of Mergenthaler Linotype. 44 Type courtesy of Visual Graphics Corp. 45, 46 Photographs courtesy of Individual manufacturers 48, 49 Type specimens set courtesy of Alphatype 51–55 Chart set courtesy of Berthold Fototype 57–63 Type specimens set courtesy of the individual manufacturers 6134, 74 Photographs courtesy of Harris Individual manufacturers 6134, 74 Photographs courtesy of Individual Manufacturers 613	Deutsches Museum, Munich Modern web press courtesy of Harris Corp. Engraving courtesy of Deutsches Museum, Munich Photographs courtesy of Motter Printing Press Co. Lithograph from the Museum of Modern Art, New York Photographs courtesy of Azoplate Photographs courtesy of individual manufacturers VCT Photo Photographs courtesy of GATF
18 Photograph courtesy of Vandercook Division, ITW, Inc. 19 VCT Photo 83 20 Two photographs in center by VCT Photo 84 21 Photograph courtesy of Mergenthaler Linotype 85 22,23 Photograph courtesy of Monotype Corp. 86 24 Photograph courtesy of Ludlow Typograph Co. 87 25, 26 Photographs courtesy of IBM 87 27 Type set courtesy of Black, Inc. 88 28 Photograph courtesy of Versatec; type illustrations courtesy of Versatec; type illustrations courtesy of Alphatype 103 30 Illustrations (less type) courtesy of Alphatype 105 31 Illustrations (less type) courtesy of Alphatype 115 32 Three type specimens courtesy of Alphatype 116 33 Illustrations (less type) courtesy of Alphatype 117 34 Computer photograph courtesy of Graphic Services, Inc. 117 35 Typesetter courtesy of Photon 117 36, 37 Photographs courtesy of Photon 117 38, 39 Photographs courtesy of AKI, Versatec, and Singer 123 40 Photographs courtesy of Harris Corp.; photographs courtesy of Harris Corp.; photographs courtesy of Harris Corp.; photographs courtesy of Mergenthaler Linotype. 124 41 Type courtesy of Visual Graphics Corp. 145, 46 Photographs courtesy of Individual manufacturers 148, 49 Type specimens set courtesy of Alphatype 151–55 Chart set courtesy of Berthold Fototype 134, 7	Early presses courtesy of Deutsches Museum, Munich Modern web press courtesy of Harris Corp. Engraving courtesy of Deutsches Museum, Munich Photographs courtesy of Motter Printing Press Co. Lithograph from the Museum of Modern Art, New York Photographs courtesy of Azoplate Photographs courtesy of individual manufacturers VCT Photo Photographs courtesy of GATF 03 Photographs from the Museum of Modern Art, New York Photograph of swatchbook courtesy of Pantone, Inc. Transparency courtesy of Sidney Janis Gallery, New York Print courtesy of St. Bride Printing Library, London Chinese prints courtesy of Tec Systems, Inc.
19 VCT Photo 20 Two photographs in center by VCT Photo 21 Photograph courtesy of Mergenthaler Linotype 22,23 Photographs courtesy of Monotype Corp. 24 Photograph courtesy of Ludlow Typograph Co. 25, 26 Photographs courtesy of IBM 27 Type set courtesy of Black, Inc. 28 Photograph courtesy of VariTyper 29 Illustrations courtesy of Versatec; type illustrations courtesy of Alphatype 30 Illustrations (less type) courtesy of AKI 32 Three type specimens courtesy of AKI 34 Computer photograph courtesy of AKI 35 Typesetter courtesy of Photon 36, 37 Photographs courtesy of Individual manufacturers 37 Illustration courtesy of Carl Palmer 38, 39 Photographs courtesy of Harris-Corp.; photographs courtesy of Individual manufacturers 48, 49 Type specimens set courtesy of Alphatype 51–55 Chart set courtesy of Berthold Fototype 57–63 Type specimens set courtesy of the	ris Corp. Engraving courtesy of Deutsches Museum, Munich Photographs courtesy of Motter Printing Press Co. Lithograph from the Museum of Modern Art, New York Photographs courtesy of Azoplate Photographs courtesy of individual manufacturers VCT Photo Photographs courtesy of GATF 03 Photographs from the Museum of Modern Art, New York Photograph of swatchbook courtesy of Pantone, Inc. Transparency courtesy of Sidney Janis Gallery, New York Print courtesy of St. Bride Printing Library, London Chinese prints courtesy of St. Bride Printing Library, London Photograph courtesy of Tec Systems, Inc.
Photo 21 Photograph courtesy of Mergenthaler Linotype 22,23 Photographs courtesy of Monotype Corp. 24 Photograph courtesy of Ludlow Typograph Co. 25, 26 Photographs courtesy of IBM 27 Type set courtesy of Black, Inc. 28 Photograph courtesy of Versatec; type illustrations courtesy of Versatec; type illustrations courtesy of Alphatype 30 Illustrations (less type) courtesy of AkI 32 Three type specimens courtesy of Alphatype 33 Illustrations (less type) courtesy of AkI 34 Computer photograph courtesy of Graphic Services, Inc. 35 Typesetter courtesy of Photon 36, 37 Photographs courtesy of Individual manufacturers 37 Illustration courtesy of Carl Palmer 38, 39 Photographs courtesy of AKI, Versatec, and Singer 40 Photographs courtesy of Harris-Intertype 41 Photographs courtesy of Harris-Intertype 42, 43 Illustrations courtesy of Harris-Corp.; photographs courtesy of Mergenthaler Linotype. 44 Type courtesy of Visual Graphics Corp. 45, 46 Photographs courtesy of individual manufacturers 48, 49 Type specimens set courtesy of Alphatype 51–55 Chart set courtesy of Berthold Fototype 57–63 Type specimens set courtesy of the	Engraving courtesy of Deutsches Museum, Munich Photographs courtesy of Motter Printing Press Co. Lithograph from the Museum of Modern Art, New York Photographs courtesy of Azoplate Photographs courtesy of individual manufacturers VCT Photo Photographs courtesy of GATF 03 Photographs from the Museum of Modern Art, New York Photograph of swatchbook courtesy of Pantone, Inc. Transparency courtesy of Sidney Janis Gallery, New York Print courtesy of St. Bride Printing Library, London Chinese prints courtesy of St. Bride Printing Library, London Photograph courtesy of Tec Systems, Inc.
genthaler Linotype 22,23 Photographs courtesy of Monotype Corp. 24 Photograph courtesy of Ludlow Typograph Co. 25, 26 Photographs courtesy of IBM 27 Type set courtesy of Black, Inc. 28 Photograph courtesy of VariTyper 29 Illustrations courtesy of Versatec; type illustrations courtesy of Alphatype 30 Illustrations (less type) courtesy of AKI 32 Three type specimens courtesy of Alphatype 33 Illustrations (less type) courtesy of AKI 34 Computer photograph courtesy of Graphic Services, Inc. 35 Typesetter courtesy of Photon 36, 37 Photographs courtesy of Individual manufacturers 37 Illustration courtesy of Carl Palmer 38, 39 Photographs courtesy of AKI, Versatec, and Singer 40 Photographs courtesy of Harris-Intertype 41 Photographs courtesy of Harris-Intertype 42, 43 Illustrations courtesy of Harris Corp.; photographs courtesy of Mergenthaler Linotype. 44 Type courtesy of Visual Graphics Corp. 45, 46 Photographs courtesy of individual manufacturers 48, 49 Type specimens set courtesy of Alphatype 51–55 Chart set courtesy of Berthold Fototype 57–63 Type specimens set courtesy of the	Photographs courtesy of Motter Printing Press Co. Lithograph from the Museum of Modern Art, New York Photographs courtesy of Azoplate Photographs courtesy of individual manufacturers VCT Photo Photographs courtesy of GATF O3 Photographs from the Museum of Modern Art, New York Photograph of swatchbook courtesy of Pantone, Inc. Transparency courtesy of Sidney Janis Gallery, New York Print courtesy of St. Bride Printing Library, London Chinese prints courtesy of St. Bride Printing Library, London Photograph courtesy of Tec Systems, Inc.
Corp. 24 Photograph courtesy of Ludlow Typograph Co. 25, 26 Photographs courtesy of IBM 27 Type set courtesy of Black, Inc. 28 Photograph courtesy of VariTyper 29 Illustrations courtesy of Versatec; type illustrations courtesy of Alphatype 30 Illustrations (less type) courtesy of AKI 32 Three type specimens courtesy of Alphatype 33 Illustrations (less type) courtesy of AKI 34 Computer photograph courtesy of Graphic Services, Inc. 35 Typesetter courtesy of Photon 36, 37 Photographs courtesy of Individual manufacturers 37 Illustration courtesy of Carl Palmer 38, 39 Photographs courtesy of AKI, Versatec, and Singer 40 Photographs courtesy of Harris-Intertype 41 Photographs courtesy of Harris-Intertype 42, 43 Illustrations courtesy of Harris-Corp.; photographs courtesy of Mergenthaler Linotype. 44 Type courtesy of Visual Graphics Corp. 45, 46 Photographs courtesy of individual manufacturers 48, 49 Type specimens set courtesy of Alphatype 51–55 Chart set courtesy of Berthold Fototype 57–63 Type specimens set courtesy of the	Lithograph from the Museum of Modern Art, New York Photographs courtesy of Azoplate Photographs courtesy of individual manufacturers VCT Photo Photographs courtesy of GATF 03 Photographs from the Museum of Modern Art, New York Photograph of swatchbook courtesy of Pantone, Inc. Transparency courtesy of Sidney Janis Gallery, New York Print courtesy of St. Bride Printing Library, London Chinese prints courtesy of St. Bride Printing Library, London Photograph courtesy of Tec Systems, Inc.
Typograph Co. 25, 26 Photographs courtesy of IBM 27 Type set courtesy of Black, Inc. 28 Photograph courtesy of VariTyper 29 Illustrations courtesy of Versatec; type illustrations courtesy of Alphatype 30 Illustrations (less type) courtesy of AKI 32 Three type specimens courtesy of Alphatype 33 Illustrations (less type) courtesy of AKI 34 Computer photograph courtesy of Graphic Services, Inc. 35 Typesetter courtesy of Photon 36, 37 Photographs courtesy of Individual manufacturers 37 Illustration courtesy of Carl Palmer 38, 39 Photographs courtesy of AKI, Versatec, and Singer 40 Photographs courtesy of VariTyper 41 Photographs courtesy of Harris-Intertype 42, 43 Illustrations courtesy of Harris Corp.; photographs courtesy of Mergenthaler Linotype. 44 Type courtesy of Visual Graphics Corp. 45, 46 Photographs courtesy of individual manufacturers 48, 49 Type specimens set courtesy of Alphatype 51–55 Chart set courtesy of Berthold Fototype 57–63 Type specimens set courtesy of the	Photographs courtesy of Azoplate Photographs courtesy of individual manufacturers VCT Photo Photographs courtesy of GATF O3 Photographs from the Museum of Modern Art, New York Photograph of swatchbook cour- tesy of Pantone, Inc. Transparency courtesy of Sidney Janis Gallery, New York Print courtesy of St. Bride Printing Library, London Chinese prints courtesy of St. Bride Printing Library, London Photograph courtesy of Tec Sys- tems, Inc.
25, 26 Photographs courtesy of IBM 27 Type set courtesy of Black, Inc. 28 Photograph courtesy of VariTyper 29 Illustrations courtesy of Versatec; type illustrations courtesy of Alphatype 30 Illustrations (less type) courtesy of AKI 32 Three type specimens courtesy of Alphatype 33 Illustrations (less type) courtesy of AkI 34 Computer photograph courtesy of Graphic Services, Inc. 35 Typesetter courtesy of Photon 36, 37 Photographs courtesy of Individual manufacturers 37 Illustration courtesy of Carl Palmer 38, 39 Photographs courtesy of AKI, Versatec, and Singer 40 Photographs courtesy of VariTyper 41 Photographs courtesy of Harris-Intertype 42, 43 Illustrations courtesy of Harris-Corp.; photographs courtesy of Mergenthaler Linotype. 44 Type courtesy of Visual Graphics Corp. 45, 46 Photographs courtesy of individual manufacturers 48, 49 Type specimens set courtesy of Alphatype 51–55 Chart set courtesy of Berthold Fototype 57–63 Type specimens set courtesy of the	manufacturers VCT Photo Photographs courtesy of GATF O3 Photographs from the Museum of Modern Art, New York Photograph of swatchbook courtesy of Pantone, Inc. Transparency courtesy of Sidney Janis Gallery, New York Print courtesy of St. Bride Printing Library, London Chinese prints courtesy of St. Bride Printing Library, London Photograph courtesy of Tec Systems, Inc.
28 Photograph courtesy of VariTyper 29 Illustrations courtesy of Versatec; type illustrations courtesy of Alphatype 30 Illustrations (less type) courtesy of AKI 32 Three type specimens courtesy of Alphatype 33 Illustrations (less type) courtesy of AKI 34 Computer photograph courtesy of Graphic Services, Inc. 35 Typesetter courtesy of Photon 36, 37 Photographs courtesy of Individual manufacturers 37 Illustration courtesy of Carl Palmer 38, 39 Photographs courtesy of AKI, Versatec, and Singer 40 Photographs courtesy of VariTyper 41 Photographs courtesy of Harris-Intertype 42, 43 Illustrations courtesy of Harris Corp.; photographs courtesy of Mergenthaler Linotype. 44 Type courtesy of Visual Graphics Corp. 45, 46 Photographs courtesy of individual manufacturers 48, 49 Type specimens set courtesy of Alphatype 51–55 Chart set courtesy of Berthold Fototype 57–63 Type specimens set courtesy of the	VCT Photo Photographs courtesy of GATF O3 Photographs from the Museum of Modern Art, New York Photograph of swatchbook courtesy of Pantone, Inc. Transparency courtesy of Sidney Janis Gallery, New York Print courtesy of St. Bride Printing Library, London Chinese prints courtesy of St. Bride Printing Library, London Photograph courtesy of Tec Systems, Inc.
28 Photograph courtesy of VariTyper 29 Illustrations courtesy of Versatec; type illustrations courtesy of Al- phatype 30 Illustrations (less type) courtesy of AKI 32 Three type specimens courtesy of Alphatype 33 Illustrations (less type) courtesy of AKI 34 Computer photograph courtesy of Graphic Services, Inc. 35 Typesetter courtesy of Photon 36, 37 Photographs courtesy of individual manufacturers 37 Illustration courtesy of Carl Palmer 38, 39 Photographs courtesy of AKI, Ver- satec, and Singer 40 Photographs courtesy of VariTyper 41 Photographs courtesy of Harris-In- tertype 42, 43 Illustrations courtesy of Harris Corp.; photographs courtesy of Mergenthaler Linotype. 44 Type courtesy of Visual Graphics Corp. 45, 46 Photographs courtesy of individual manufacturers 48, 49 Type specimens set courtesy of Al- phatype 51–55 Chart set courtesy of Berthold Fo- totype 57–63 Type specimens set courtesy of the	Photographs courtesy of GATF O3 Photographs from the Museum of Modern Art, New York Photograph of swatchbook courtesy of Pantone, Inc. Transparency courtesy of Sidney Janis Gallery, New York Print courtesy of St. Bride Printing Library, London Chinese prints courtesy of St. Bride Printing Library, London Photograph courtesy of Tec Systems, Inc.
lilustrations courtesy of Versatec; type illustrations courtesy of Alphatype 30 Illustrations (less type) courtesy of AKI 32 Three type specimens courtesy of Alphatype 33 Illustrations (less type) courtesy of AKI 34 Computer photograph courtesy of Graphic Services, Inc. 35 Typesetter courtesy of Photon 36, 37 Photographs courtesy of individual manufacturers 37 Illustration courtesy of Carl Palmer 38, 39 Photographs courtesy of AKI, Versatec, and Singer 40 Photographs courtesy of Harris Corp.; photographs courtesy of Harris Corp.; photographs courtesy of Mergenthaler Linotype. 42, 43 Illustrations courtesy of Harris Corp.; photographs courtesy of Mergenthaler Linotype. 44 Type courtesy of Visual Graphics Corp. 45, 46 Photographs courtesy of individual manufacturers 48, 49 Type specimens set courtesy of Alphatype 51–55 Chart set courtesy of Berthold Fototype 57–63 Type specimens set courtesy of the	O3 Photographs from the Museum of Modern Art, New York Photograph of swatchbook courtesy of Pantone, Inc. Transparency courtesy of Sidney Janis Gallery, New York Print courtesy of St. Bride Printing Library, London Chinese prints courtesy of St. Bride Printing Library, London Photograph courtesy of Tec Systems, Inc.
AKI 32 Three type specimens courtesy of Alphatype 33 Illustrations (less type) courtesy of AKI 34 Computer photograph courtesy of Graphic Services, Inc. 35 Typesetter courtesy of Photon 36, 37 Photographs courtesy of individual manufacturers 37 Illustration courtesy of Carl Palmer 38, 39 Photographs courtesy of AKI, Versatec, and Singer 40 Photographs courtesy of VariTyper 41 Photographs courtesy of Harris-Intertype 42, 43 Illustrations courtesy of Harris Corp.; photographs courtesy of Mergenthaler Linotype. 44 Type courtesy of Visual Graphics Corp. 45, 46 Photographs courtesy of individual manufacturers 48, 49 Type specimens set courtesy of Alphatype 51–55 Chart set courtesy of Berthold Fototype 57–63 Type specimens set courtesy of the	tesy of Pantone, Inc. Transparency courtesy of Sidney Janis Gallery, New York Print courtesy of St. Bride Printing Library, London Chinese prints courtesy of St. Bride Printing Library, London Photograph courtesy of Tec Systems, Inc.
Alphatype 33 Illustrations (less type) courtesy of AKI 34 Computer photograph courtesy of Graphic Services, Inc. 35 Typesetter courtesy of Photon 36, 37 Photographs courtesy of individual manufacturers 37 Illustration courtesy of Carl Palmer 38, 39 Photographs courtesy of AKI, Versatec, and Singer 40 Photographs courtesy of VariTyper 41 Photographs courtesy of Harris-Intertype 42, 43 Illustrations courtesy of Harris Corp.; photographs courtesy of Mergenthaler Linotype. 44 Type courtesy of Visual Graphics Corp. 45, 46 Photographs courtesy of individual manufacturers 48, 49 Type specimens set courtesy of Alphatype 51–55 Chart set courtesy of Berthold Fototype 57–63 Type specimens set courtesy of the	Janis Gallery, New York Print courtesy of St. Bride Printing Library, London Chinese prints courtesy of St. Bride Printing Library, London Photograph courtesy of Tec Systems, Inc.
AKI 34 Computer photograph courtesy of Graphic Services, Inc. 35 Typesetter courtesy of Photon 36, 37 Photographs courtesy of individual manufacturers 37 Illustration courtesy of Carl Palmer 38, 39 Photographs courtesy of AKI, Versatec, and Singer 40 Photographs courtesy of VariTyper 41 Photographs courtesy of Harris-Intertype 42, 43 Illustrations courtesy of Harris Corp.; photographs courtesy of Mergenthaler Linotype. 44 Type courtesy of Visual Graphics Corp. 45, 46 Photographs courtesy of individual manufacturers 48, 49 Type specimens set courtesy of Alphatype 51–55 Chart set courtesy of Berthold Fototype 57–63 Type specimens set courtesy of the	Library, London Chinese prints courtesy of St. Bride Printing Library, London Photograph courtesy of Tec Systems, Inc.
Graphic Services, Inc. 35 Typesetter courtesy of Photon 36, 37 Photographs courtesy of individual manufacturers 37 Illustration courtesy of Carl Palmer 38, 39 Photographs courtesy of AKI, Versatec, and Singer 40 Photographs courtesy of VariTyper 41 Photographs courtesy of Harris-Intertype 42, 43 Illustrations courtesy of Harris Corp.; photographs courtesy of Mergenthaler Linotype. 44 Type courtesy of Visual Graphics Corp. 45, 46 Photographs courtesy of individual manufacturers 48, 49 Type specimens set courtesy of Alphatype 51–55 Chart set courtesy of Berthold Fototype 57–63 Type specimens set courtesy of the	Printing Library, London Photograph courtesy of Tec Systems, Inc.
36, 37 Photographs courtesy of individual manufacturers 37 Illustration courtesy of Carl Palmer 38, 39 Photographs courtesy of AKI, Versatec, and Singer 40 Photographs courtesy of VariTyper 41 Photographs courtesy of Harris-Intertype 42, 43 Illustrations courtesy of Harris Corp.; photographs courtesy of Mergenthaler Linotype. 44 Type courtesy of Visual Graphics Corp. 45, 46 Photographs courtesy of individual manufacturers 48, 49 Type specimens set courtesy of Alphatype 51–55 Chart set courtesy of Berthold Fototype 57–63 Type specimens set courtesy of the	tems, Inc.
manufacturers 37 Illustration courtesy of Carl Palmer 38, 39 Photographs courtesy of AKI, Versatec, and Singer 40 Photographs courtesy of VariTyper 41 Photographs courtesy of Harris-Intertype 42, 43 Illustrations courtesy of Harris Corp.; photographs courtesy of Mergenthaler Linotype. 44 Type courtesy of Visual Graphics Corp. 45, 46 Photographs courtesy of individual manufacturers 48, 49 Type specimens set courtesy of Alphatype 51–55 Chart set courtesy of Berthold Fototype 57–63 Type specimens set courtesy of the	
38, 39 Photographs courtesy of AKI, Versatec, and Singer 40 Photographs courtesy of VariTyper 41 Photographs courtesy of Harris-Intertype 42, 43 Illustrations courtesy of Harris Corp.; photographs courtesy of Mergenthaler Linotype. 44 Type courtesy of Visual Graphics Corp. 45, 46 Photographs courtesy of individual manufacturers 48, 49 Type specimens set courtesy of Alphatype 51–55 Chart set courtesy of Berthold Fototype 57–63 Type specimens set courtesy of the	
satec, and Singer 40 Photographs courtesy of VariTyper 41 Photographs courtesy of Harris-Intertype 42, 43 Illustrations courtesy of Harris Corp.; photographs courtesy of Mergenthaler Linotype. 44 Type courtesy of Visual Graphics Corp. 45, 46 Photographs courtesy of individual manufacturers 48, 49 Type specimens set courtesy of Alphatype 51–55 Chart set courtesy of Berthold Fototype 57–63 Type specimens set courtesy of the	sociation of Printing Ink Manufac- turers
41 Photographs courtesy of Harris-Intertype 42, 43 Illustrations courtesy of Harris Corp.; photographs courtesy of Mergenthaler Linotype. 44 Type courtesy of Visual Graphics Corp. 45, 46 Photographs courtesy of individual manufacturers 48, 49 Type specimens set courtesy of Alphatype 51–55 Chart set courtesy of Berthold Fototype 57–63 Type specimens set courtesy of the	Illustrations courtesy of We- yerhaeuser Co.
41 Photographs courtesy of Harris-Intertype 125 42, 43 Illustrations courtesy of Harris Corp.; photographs courtesy of Mergenthaler Linotype. 126–1 44 Type courtesy of Visual Graphics Corp. 45, 46 Photographs courtesy of individual manufacturers 48, 49 Type specimens set courtesy of Alphatype 131 51–55 Chart set courtesy of Berthold Fototype 134, 157–63 Type specimens set courtesy of the	Illustration courtesy of Mead Paper
Corp.; photographs courtesy of Mergenthaler Linotype. 44 Type courtesy of Visual Graphics Corp. 45, 46 Photographs courtesy of individual manufacturers 48, 49 Type specimens set courtesy of Alphatype 51–55 Chart set courtesy of Berthold Fototype 57–63 Type specimens set courtesy of the	Photographs courtesy of American Paper Institute and Finch Pryun &
Type courtesy of Visual Graphics Corp. 45, 46 Photographs courtesy of individual manufacturers 48, 49 Type specimens set courtesy of Al- phatype 131 51–55 Chart set courtesy of Berthold Fo- totype 134,	
manufacturers 48, 49 Type specimens set courtesy of Alphatype 131 51–55 Chart set courtesy of Berthold Fototype 134, 57–63 Type specimens set courtesy of the	Paper Institute, Beloit Corp., West Virginia Pulp and Paper Co., Finch Pryun & Co., Ecusta Paper Co., and
phatype 131 51–55 Chart set courtesy of Berthold Fototype 134, 57–63 Type specimens set courtesy of the	Packaging Corp. of America; line illustration courtesy of Andrew, Nel-
totype 134, 57–63 Type specimens set courtesy of the	son, Whitehead Opacity guage from Oxford Paper
57–63 Type specimens set courtesy of the	Co.
	Paper Institute, S.D. Warren, and Mead Paper Co.
Chart courtesy of Printing Indus- tries of America; set courtesy of	Illustration based on GATF manual "Black and White Stripping" (1969)
Berthold Fototype 143 66 Photographs courtesy of IBM and	Illustration based on Dexter folding impositions
Photon 148, 1	Muller Corp. and Harris Corp.; il-
and Formatt 71 Illustration courtesy of St. Bride 155	lustrations courtesy of Harris Corp. Blind stamping Brigham Young
Printing Library, London 72, 73 Copy camera courtesy of Consoli- 150-1	University Press 57 VCT Photo
dated International Corp. 155 72 Densitometer courtesy of MacBeth	
Color 163 79 Illustration courtesy of St. Bride	Die-cutting from Hammermill Paper Co.
Printing Library, London; photo- 165 graph by VCT Photo	

Bibliography

Advertising Agency and Studio Skills. Tom Cardamone. New York: Watson-Guptill, 1970.

Anatomy of Printing. John Lewis. New York: Watson-Guptill, and London: Faber and Faber, 1970.

ATA Advertising Production Handbook. Don Herold. Advertising Typographers of America.

ATA Type Comparison Book. Frank Merriman. Advertising Typographers of America

ATA Standard Type Book. Advertising Typographers of America.

Basic Typography. John Biggs. New York: Watson-Guptill, and London: Faber and Faber, 1968.

Bookmaking: The Illustrated Guide to Design and Production. Lee Marshall. New York: R.R. Bowker, 1965.

Computer Terms for the Typographic Industry. Washington, D.C.: International Typographic Composition Association, 1973.

Design with Type. Carl Dair. Toronto: University of Toronto, 1967.

Designing with Type. James Craig. New York: Watson-Guptill, 1971.

The Dictionary of Paper. New York: American Pulp and Paper Association, 1965.

Exercises on the Whole Art of Printing. Moxon. Oxford.

Five Hundred Years of Printing. Sitt Steinberg. London: Pelican.

Graphic Arts Encyclopedia. George A. Stevenson. New York: McGraw-Hill, 1968.

Graphic Arts Handbook. Rochester, New York: Eastman Kodak Co.

Graphic Design and Reproduction Techniques. Peter Croy. New York: Hastings House, 1968.

Graphic Reproduction Photography. J.W. Burden. New York: Visual Communication Books. 1972.

Ink on Paper. Edmund C. Arnold. New York: Harper & Row, 1963.

Lettering for Reproduction. David Gates. New York: Watson-Guptill, 1969.

The Lithographer's Manual. Graphic Arts Technical Foundation.

Papermaking: The History and Technique of an Ancient Craft. Dard Hunter. New York: Knopf, 1947.

Pocket Pal. International Paper Company, 1973.

Preparing Art for Printing. Bernard Stone and A. Eckstein. New York: Van Nostrand Reinhold, 1965.

The Printing Industry. Victor Strauss. New York: Printing Industries of America, and R.R. Bowker, 1965.

Printing Types, Their History, Forms, and Use. (2 vols.). Harvard: The Belknap Press of Harvard University, 1962.

The Story of Papermaking. Edwin Sutermeister. Boston: S.D. Warren Co., 1954.

Techniques of Typography. Cal Swann. New York: Watson-Guptill, and London: Lund Humphries, 1969.

Type. David Gates. New York: Watson-Guptill, 1973.

Type and Typography. Ben Rosen. New York: Van Nostrand Reinhold, 1963.

Index

Absorbency (of paper), 135

Absorption (ink-drying process), 117

unit), 45; type specimens, 56 American Type Founders Co., (distributors for) Monotype Studio Lettering (photodisplay unit), 45

Alphatype Corp.: Filmotype (photodisplay

Antique. See Uncoated papers. Art, original: quality of, 97; scaling, 158-159 Artype. See Cut-out lettering.

Basis weight, 130 Berthold Fototype Co.: Diatype Headliner (photodisplay unit); 45; Ministar (photodisplay unit), 45; Staromat and Superstar (photodisplay units), 46; type specimens, 57 Binder board. See Binding boards. Bindery facilities, 155 Binding, 147-155 Binding boards, 154 Binding materials, 152-153, 154 Binding methods, 148-151 Black and white printing, 69-97

Blade-coated. See Coated papers. Bleeding. See Printing problems. Blind embossing, 155

Blind stamping, 155 Bond. See Writing papers.

Book-covering materials, 152; manufacturers of, 152, 153; nonwoven, 153; woven, 152 Book linings. See Endpapers.

Book papers, 133-134

Brightype. See Conversion systems.

Bulk (of paper), 130

Business papers. See Writing papers.

Calenders (and calendering), 129 Camera, process, 72-73 Casing in, 151 Cast-coated. See Coated papers. Cast type. See Machine-set type. Cathode ray tube systems. See CRT systems. Cerlox. See Mechanical binding.

CG 7000 (photodisplay unit), 45 Chalking. See Printing Problems.

Character generation, methods of CRT, 42

Clamshell. See Platen press. Cloths, book-covering, 152

Coated papers, 134 Cold-set inks, 119

Collotype, 91

Color-correcting separations, 106, 110-111

Color, flat, 100, 102-104 Color imposition, 140

Color keys. See Pre-press proofs.

Color-matching systems, 104

Color mechanicals, 172-173 Color (of paper), 132

Color printing, 99-113

Color separation(s), 106; correcting, 106, 110-111

Combination line and halftone, 77 Composition. See Typesetting.

Compugraphic Corp.: CG 7200 (photodisplay unit), 45; type specimens, 57

Compuscan. See OCR systems.

Computer composition. See Phototypesetting. Computer unit (of phototypesetting systems),

Continuous-tone copy, 70; converting to line, 164; methods of reproduction, 76-77; reproducing without a screen (collotype), 91; screening, 74

Conversion-coated. See Coated papers. Conversion systems, 80

Copy, 70-72; handling, 171; mounting, 170 Copy camera. See Process camera. Correcting, editing and (in phototypsetting systems), 38-39 Corrections, in color separations, 106, 110-111 Cover papers, 133 Crawling. See Printing problems. Crofield Magnaset 226. See CRT systems. Cronapress. See Conversion systems. Cropmarks (on a mechanical), 167 CRT systems, 42 Crystallization. See Printing problems. Cut-out lettering, 67

Cuts. See Engravings.

Cutting Chart (paper), 145

Dandy roll, 128 Datatype. See OCR systems. Design, and quality control, 97 Diagonal line. See Scaling art. Diatype Headliner (photodisplay unit), 45 Die-cutting, 155 Direct impression. See Typewriter composi-Discretionary (method of resolving linebreaks), 34 Double-black duotone, 103 Doubling. See Printing problems. Dropout halftone, 77 Drying, poor. See Printing problems. Drying processes, ink, 117 Duotone, 103

systems), 38-39 Editing and correcting terminal. See Visual display terminal. Edition binding, 151 Eggshell. See Uncoated papers. Electronic color separation, 106 Embossing, 155 Emulsification. See Printing problems. Endleafs. See Endpapers. Endpapers, 154 English finish. See Uncoated papers. Engravings, 79 Envelopes, 145 Evaporation (ink-drying process), 117 Exception dictionary (method of resolving linebreaks), 35

Editing and correcting (in phototypesetting

Film-coated. See Coated papers. Filmotype (photodisplay units), 45 Finish (of paper), 132 Flat-bed. See Platen press. Flat-bed cylinder press, 82 Flat color, 102-104; mechanicals, 172; process color as, 112; specifying, 103 Flat-tint halftone, 103 Flexography, 90; inks, 118 Flocculation. See Printing problems. Fluorescent inks, 119 Flyleafs. See Endpapers. Foils and pigments (for stamping), 154 Folders, 144; self-mailing, 145 Folding, 143-145 Folding lines (on a mechanical), 167 Folds, basic, 144 Formation (method of CRT character generation), 42 Formatt. See Cut-out lettering. Fototronic. See CRT systems. Four-color process printing, 105-113

Fourdrinier (papermaking machine), 128 Full color. See Four-color process printing.

Galley proofs, 18 Gang-ups, imposition and, 141 Ghosting. See Printing problems. Grain (of paper), 130; and folders, 144 Graphic arts camera. See process camera. Graphic Systems, Inc., type specimens, 58. See also OCR systems. Gravure, 84; inks, 118; paper, 135; plates, 84; presses, 84. Greige goods, 152 Guidelines, drawing (on a mechanical), 166 Gutenberg, Johann, 16, 82, 116

Halation. See Printing problems. Halftone(s), 74; combination line and, 77; dropout, 77; flat-tint, 103; moiré pattern in, 94; silhouette, 76; square, 76; vignette, 77 Halftone copy, pasting down (on a mechanical), 169 Halftone screens, 74 Handset type, 16-19; compared with other typesetting methods, 65 Harris-Intertype, Fototronic CRT. See CRT systems. See also Intertype. Headbands, 154 Heat-set inks, 119 Hickies. See Printing problems. High-gloss inks, 119 Highlight halftone. See Dropout halftone. Holding lines (on a mechanical), 167 Hot type. See Machine-set type. Hyphenation and justification, 34-35 Hyphenless (method of resolving linebreaks),

IBM. Selectric typewriter composition system, 25, 27; type specimens, 58 Idiot tape. See Unjustified tape. Implac. See OCR systems. Impositions, 137–141; basic, 138–139; and color, 140; and gang-ups, 141 Indirect letterpress. See Letterset. Ink-drying processes, 117 Inks, 115-119; ingredients of, 116; and the printing process, 118; specialty, 119 Intaglio printing, 84 Intertype: Linotype and, 20; type specimens, 59. See also Harris-Intertype.

Jobbing platen. See Platen press. Justified tape, 30

Kerning, 15 Keyboard (of phototypesetting systems), 30; counting, 30; non-counting, 32 Keyline. See Mechanicals.

Laid papers, 128 Lanston, Tolbert, 22 LBI (Library Binding Intitute), 152 Leading, 14 Ledger. See Writing papers. Letraset. See Pressure-sensitive lettering. Letterpress, 79-82; converting plates to offset, 80; indirect (letterset), 91; inks, 118; paper, 135; presses, 82 Letterset, 91; inks, 118 Letterspacing, 13 Line, combination halftone and, 77 Linebreaks, resolving (in phototypesetting systems), 34-45

Linecasting machines, 20 Line conversions, 164-165

Line copy, 70; converting continuous-tone to, 164; pasting down (on a mechanical), 168 Linen. See Book-covering materials.

Line negative, 70

Line printer (of phototypesetting systems), 39 Lines, holding and folding (on a mechanical), 167

Linotype and Intertype, 20. See also Mergenthaler Linotype.

Lithography, 86. See also Offset lithography. Logic (method of resolving linebreaks), 35 Ludlow, Washington I., 24

Ludlow (typesetting machine), 24

Machine finish. See Uncoated papers Machine-set type, 20-24; compared with other typesetting methods, 65

Magnetic inks, 119

Match color. See Flat color. Mechanical binding, 150

Mechanicals, 157-173; preparing, 166-173

Mergenthaler, Ottmar, 20

Mergenthaler Linotron 505. See CRT systems. Mergenthaler Linotype, type specimens (cast), 59; (photo), 60. See also Linotype and Intertype

Metallic inks, 119

Ministar (photodisplay unit), 45

Modified silhouette (halftone), 76

Moiré, 94

Moisture-set inks, 119

Monotype, 22; type specimens (cast), 60; (photo), 61

Monotype Studio Lettering (photodisplay unit), 45

Mottle. See Printing problems.

Multicolor printing, 102

Mult-O. See Mechanical binding.

NASTA (National Association of State Textbook Administrators), 152

Natural. See Book-covering materials, woven. News inks, 119

Newsprint, 133

OCR systems, 40 Off color. See Printing problems.

Offset lithography, 86-89; converting letterpress plates to, 80; inks, 118; paper, 135; plates, 86; presses, 88

One-color printing, 100

Opacity (of paper), 131

Outline halftone. See Silhouette halftone.

Overlay, adding (on a mechanical), 172

Oxidation/polymerization (ink-drying process), 117

Pantone Matching System, 104

Paper(s), 121-135; characteristics of, 130-132; choosing the right, 135; coated, 134; cutting chart, 145; history of, 122-123; ingredients of, 124; making, 124-129; printing, 133-134; and the printing process, 135; and quality control; 97; uncoated, 133-134

Paper book-covering materials. See Bookcovering materials, non-woven.

Paper curling. See Printing problems.

Papermaking, 124-129

Pasteboard. See Binding boards.

Patching, 39

Penetration. See Absorption.

Perfect binding, 150

Perfecting presses, 82

Photocomposing systems, 41, 42 Photocomposition. See Phototypesetting.

Photo Display 70 (photodisplay unit), 45 Photodisplay units (of phototypesetting sys-

tems), 44-46

Photoengraved printing plates, 79

Photogelatin. See Collotype

Photographic color separation, 106

Photographs, handling, 171

Photon Headline Machine (photodisplay unit), 45

Photon, Inc., type specimens, 61. See also CRT systems.

Photon 7000. See CRT systems.

Photopolymer direct relief printing plates, 80

Photoprints. See Veloxes.

Photostats, 160-161

Phototypesetting, 29-55; compared with other

typesetting systems, 66-67

Phototypesetting systems: list of manufacturers of, 47; names of typefaces in (cross-

reference chart), 64; table of, 48-55 Photo Typositor (photodisplay unit), 45

Photounit (of phototypesetting systems), 36

Picking. See Printing problems.

Pigment (in inks), 116; for stamping, 154

Pigmented. See Coated papers.

Piling. See Printing problems. Platemaking, 78, 79-80, 84, 86, 90. See also

Process camera.

Platen press, 82

Plates, printing. See Printing plates.

PMS. See Pantone Matching System.

Polymerization. See Oxidation/polymerization.

PPDR plates, 80

Precipitation (ink-drying process), 117

Pre-press proofs, 110

Presses, printing. See Printing presses.

Presses, proofing. See Proofing.

Press proofs, 110

Pressure-sensitive lettering, 67

Prestype. See Pressure-sensitive lettering.

Printer, and quality control 97

Printing; black and white, 69-97; color, 99-113

Printing papers, 133-134

Printing plates, 78-91; collotype, 91; gravure, 84; letterpress, 79-80; offset, 86; rubber (flexography), 90

Printing presses: gravure, 84; letterpress, 82; offset, 88

Printing problems, 93-96

Printing processes, 79-91; collotype, 91; flexography, 90; gravure, 84; letterset, 91; letterpress, 79-80; offset, 86; screen printing, 90; thermography, 91

Printing processes, and inks, 118

Printing quality, controlling, 97

Printing terms and techniques, 92

Process camera, 72-73

Process color, 105; as flat color, 112; mechanicals, 173

Process printing. See Four-color process printing.

Progressive proofs, 110

Projection (method of CRT character generation), 42

Proofing, 18

Proofs, color, 110; correcting, 111

Proofs, galley, 18

Proofs, and quality control, 97

Proofs, reproduction, 18

Proportional scale. See Scaling art.

Pulp (paper), 125-127

Pyroxyline, 152

Quality control, 97 Quick-setting inks, 119

Reade, A., 24

Redactron. See Typewriter composition. Red flexible board. See Binding boards. Registration, poor. See Printing problems. Relief printing, 79. See also Letterpress. Remington. See Typewriter composition. Reproduction proofs, 18; handling, 166 Rotary presses: letterpress, 82; offset, 88

Rotogravure, 84 Rubproof inks, 119

Rules, drawing (on a mechanical), 167

Saddle-wire stitching. See Wire stitching. Scale, proportional. See Scaling art.

Scaling art, 158-159 Scheduling, and quality control, 97

Scoring, 155

Scotchprint. See Conversion systems.

Screening, 74; for gravure, 84 Screen printing, 90; inks, 118

Screens, halftone, 74

Scuffing. See Printing problems. Scuffproof inks, 119

Scumming. See Printing problems.

Selectric. See IBM Selectric typewriter composition system.

Self-mailing folders, 145

Senefelder, Aloys, 86

Separation, color, 106

Set-off. See Printing problems. Setting type. See Typesetting.

Seurat, Georges, 105

Show-through, 131. See also Printing problems

Side-sewn. See Edition binding Side-wire stitching. See Wire stitching.

Signatures, basic, 138-139

Silhouette halftone, 76 Silkscreen printing. See Screen printing.

Singer Friden. See OCR systems.

Singer Graphic Systems: Photo Display 70 (photodisplay unit), 45; type specimens, 62

Sizing (in paper), 127 Slurring. See Printing problems.

Smyth-sewn. See Edition binding. Snowflaking. See Printing problems.

Specialty inks, 119

Spiral. See Mechanical binding.

Spreading. See Printing problems.

Stamping, 151, 154; blind, 155 Star Graphic Systems, type specimens, 62 Staromat and Superstar (photodisplay units),

Starch-filled cloth, 152

Stats. See Photostats. Stencils, for screen printing, 90

Sticking. See Printing problems. Strike-on composition. See Typewriter com-

position Strike-through, 131. See also Printing prob-

lems

Strip Printer (photodisplay unit), 46 Superstar, Staromat and (photodisplay units),

Sure-lox. See Mechanical binding

Surface (of paper), 135

Swatchbooks (for flat-color matching), 104

Synthetic book-covering materials. See Book-

covering materials, non-woven.

Tally-ho. See Mechanical binding. Tape: justified, 30; unjustified, 32 Tape editing, 39 Tape merging, 39 Terms: phototypesetting, 29; printing, 92; typographic, 12-14 Thermography, 91 Tinting. See Printing problems. Transfer type, 67 Trapping, poor. See Printing problems. Ts'ai Lun, 122 Type 12; arranging line, of, 14; enlarging (in phototypesetting), 67; handset, 16-19; machine-set, 20-24; matching (in phototypesetting), 67; measuring, 12; measuring in units, 15; transfer, 67 Typefaces (in phototypesetting): mixing, 67; names of, 64

Typesetting, 11-67

Typesetting, choosing the right system, 65–67 Typesetting methods: handsetting, 16-19; machine setting, 20-24; phototypesetting, 29-55; typewriter composition, 25-28. See also Transfer type.

Type specimens, 56-63

Typographer (phototype), choosing a, 66 Typographic terms, 12-14; in phototypesetting, 29

Typography, 12-15

Typewriter composition, 25-28; compared with other typesetting methods, 66

Tyvek. See Book-covering materials, non-woven.

Uncoated papers, 133-134 Unit system, 15 Unjustified tape, 32

Typewriter composition. VariTyper Headliner (photodisplay unit), 46 Vehicle (in inks), 116 Vellum. See Book-covering materials, woven. Veloxes, 162-163 Vignette halftone, 77 Visual display terminal (of phototypesetting systems), 38 Visual Graphics Corp., Photo Typositor (photodisplay unit), 45 Visutek 750 (photodisplay unit), 46 Volatization. See Evaporation.

VariTyper Corp.: type specimens, 63. See also

Wang. See Typewriter composition. Watercolor inks, 119 Watermarks, 128 Wax-set inks, 119 Weight (of paper), 130 Wire stitching, 148 Wire-O. See Mechanical binding. Wordspacing, 13 Work and tumble, 92 Work and turn, 92 Wove papers, 128 Writing papers, 133

Zincs. See Engravings. Zip-a-Tone. See Cut-out lettering.

Z244 .C78 1974

CU-Fol

Craig, James, 1930-/Production for the graphic des

3 9371 00043 4332

Z 244 .C78 1974 Craig, James, 1930-Production for the graphic designer

DATE DIE						
DATE DUE						
	-					
			7			

CONCORDIA COLLEGE LIBRARY

2811 NE Holman St. Portland, OR 97211